THE POLITICS OF CULTURE IN CONTEMPORARY TURKEY

T0322497

Books in the series (published and forthcoming)

edinburghuniversitypress.com/series/esmt

THE POLITICS OF CULTURE IN CONTEMPORARY TURKEY

Edited by Pierre Hecker, Ivo Furman and Kaya Akyıldız

EDINBURGH
University Press

Edinburgh University Press is one of the leading university presses in the UK. We publish academic books and journals in our selected subject areas across the humanities and social sciences, combining cutting-edge scholarship with high editorial and production values to produce academic works of lasting importance. For more information visit our website: edinburghuniversitypress.com

Edinburgh University Press Ltd
The Tun – Holyrood Road
12 (2f) Jackson's Entry
Edinburgh EH8 8PJ

First published in hardback by Edinburgh University Press 2022

Typeset in 11/15 Adobe Garamond by
IDSUK (DataConnection) Ltd, and
printed and bound by CPI Group (UK) Ltd, Croydon, CR0 4YY

A CIP record for this book is available from the British Library

ISBN 978 1 4744 9028 3 (hardback)
ISBN 978 1 4744 9029 0 (paperback)
ISBN 978 1 4744 9031 3 (webready PDF)
ISBN 978 1 4744 9030 6 (epub)

CONTENTS

Part II Satire and Agitprop in 'New Turkey'

Part III Civil Society and the Politics of Gender

Part IV Mediating Neo-Ottomanism in Popular Culture

FIGURES

ABBREVIATIONS

AD	Ateizm Derneği (Atheism Association)
AKP	Adalet ve Kalkınma Partisi (Justice and Development Party)
BTK	Bilgi Teknolojileri ve İletişim Kurumu (Information and Communications Technologies Authority)
CHP	Cumhuriyet Halk Partisi (Republican People's Party)
CSO	Civil society organisation(s)
CUP	Committee of Union and Progress
DP	Demokrat Parti (Democrat Party)
EdRom	Edirne Roman Kültürünü Araştırma Geliştirme Yardımlaşma ve Dayanışma Derneği (Edirne Roman Association)
ERRC	European Roma Rights Centre
EU	European Union
FBoK	First Battle of Kut
FETÖ	Fethullahçı Terör Örgütü (Fethullahist Terror Organisation), a derogative term for the socio-religious movement of the Islamic preacher Fethullah Gülen
FIFA	International Federation of Association Football
HDP	Hakların Demokratik Partisi (Peoples' Democratic Party)
İSAV	İslami İlimler Araştırma Vakfı (Foundation for Research in Islamic Sciences)
ISIS	Islamic State of Iraq and Syria

KADEM	Kadın ve Demokrasi Derneği (Women and Democracy Association)
KONDA	KONDA Araştırma ve Danışmanlık (KONDA Research and Consultancy)
MAK	MAK Danışmanlık (MAK Consultancy)
MEB	Milli Eğitim Bakanlığı (Ministry of National Education)
MHK	Merkez Hakem Kurulu (Central Council of Referees)
NFD	Northern Forests Defense (Kuzey Ormanları Savunması)
NGO	Non-governmental organisation
PKK	Partiya Karkerên Kurdistanê (Kurdistan Workers' Party)
RTÜK	Radyo ve Televizyon Üst Kurulu (High Council on Radio and Television)
SETA	Siyaset, Ekonomi ve Toplum Araştırmaları Vakfı (Foundation for Political, Economic and Social Research)
TFF	Türkiye Futbol Federasyonu (Turkish Football Federation)
TOKİ	Toplu Konut İdaresi Başkanlığı (Public Housing Development Administration)
TRT	Türkiye Radyo ve Televizyon Kurumu (Turkish Radio and Television Corporation)
TÜBİTAK	Türkiye Bilimsel ve Teknolojik Araştırma Kurumu (Scientific and Technological Research Council of Turkey)
TÜİK	Türkiye İstatistik Kurumu (Turkish Statistical Institute)
UEFA	Union of European Football Associations
VAT	Value-added tax
WHO	World Health Organization
YSK	Yüksek Seçim Kurulu (Supreme Election Council)

ACKNOWLEDGEMENTS

Today, humankind finds itself at an impasse, surrounded by the spectres of crushing inequality, climate change and a global health crisis. In such a bleak moment of human history, it is challenging to begin this book on an optimistic note. We face complex challenges, yet our answers for them are scarce. While the seemingly insurmountable challenges faced by the world loom large, the nefarious shadow of authoritarianism has all but strangled any semblance of hope, sense and progress in Turkish society. Much like a matchstick fire illuminating the howling winter night, we hope that this book will serve as a guiding light to those trying to understand how everything has gone terribly wrong in Turkey over the past decade. For many of us, for those who live in Turkey and the friends of Turkey abroad, the clock remains frozen on 28 May 2013, during those moments during the Gezi Park protests when we thought that the chronically malignant *ancient regime* was finally being replaced with a more equitable, democratic and prosperous society. Yet as of November 2020, things have only gotten progressively worse, with Turkish society finding itself poorer, unhappier and ever more so divided. Sadly enough, perhaps the only comforting thing to hold onto is a lingering feeling that the nightmare's end is nigh, and the first rays of dawn are beginning to show.

Despite this sombre introduction, there are many things to still be thankful for. Beginning with our first workshop held at the Centre for

Near and Middle Eastern Studies at the Philipps University of Marburg during February 2018, this book has allowed us, the editorial team, to travel around the world and experience a myriad mosaic of mind-expanding encounters and experiences. If this book had a soul, we would describe it as part German, part Turkish and, curiously enough, part Texan.

For their brilliant contributions, we would like to individually thank Ayşe, Burak, Can, Caner, Danielle, Diliara, Douglas, Erol, Gülşen, Josh, Julia, Petek and Valentina. As such, this book is truly the product of a global collaboration spanning three continents and many countries. For this, we would like to thank Stiftung Mercator for generously sponsoring our research project 'Atheism & the Politics of Culture in Contemporary Turkey'. We would also like to thank Ertuğ Tombuş, Tuğba Yalçınkaya and Bettina Emir from Mercator's 'Blickwechsel: Contemporary Turkey Studies' team for their tireless support. Without the Blicksechsel team, this book would have simply not happened.

Likewise, we would like to express very special thanks to our teammate Betül Sakinir for her enthusiasm towards our project, her amazing organisational skills and, of course, her critical input during workshops and discussions. Furthermore, we would like to thank Amine Arslan for lending her support to preparing the book's final typescript. Changing punctuation and spelling of an entire book from American English to British English is an arduous and tiresome task, and it was good not to be alone in this. Others to whom we owe a debt of gratitude are our book's proofreader, Alex Burkhardt (great job!), as well as our team at Edinburgh University Press, Emma Rees and Kirsty Woods.

Sincere thanks also go to Martin Stokes for writing the foreword of this book. Long before we thought about initiating a research project on the politics of culture in contemporary Turkey, Martin's study of Turkish popular music, *The Arabesque Debate*, provided a rich source of inspiration for where our own work could go.

Last but not least, we need to sincerely thank Sümeyye Kesgin for the incredible cover artwork. Her contribution will most certainly make this the coolest book to sit in the Turkey Studies section of an academic bookseller.

Some personal notes before we begin!

From Pierre . . .

Ivo and Kaya, it has been a fantastic experience and even more fun working with you on this project. Since our next academic road trip is looming, I find myself happily looking towards the future. To my colleagues at the CNMS, I owe a particular debt of gratitude to Albrecht Fuess. His constant support, encouragement and unshakeable sense of humour is one of the reasons why I have not turned my back on academia yet. I am also greatly indebted to Ayşe Çavdar for sharing her inexhaustible knowledge on Turkish politics and society with me. With regard to my chapter in this book, I would like to extend my sincere thanks to the many people at Ateizm Derneği, whose help and relentless activism have made my research a lot easier. On a more personal note, I would like to extend my deepest gratitude to Murat Hinçal, Bora Tanlak and Murat Argon for their hospitality, warmth and friendship. You not only gave me countless pleasant hours of discussing the intricacies of life and politics, but, more importantly, a place that felt like home. What keeps me going in this life, however, are Ines (*Danke für Dich!*) and the three loveliest, pig-headed kids in the world: Eda, Till and Béla (*meine drei Lieblingskinder!*). I hope one day you will take a look at this book and better understand what was so fascinating to me, and why I spent so much time in Turkey.

Ivo . . .

On a personal note, I would like to thank Kaya and Pierre for giving me the chance to be part of this amazing and, at times, tumultuous endeavour. What an adventure this has been. Also, I am indebted to Alper, Aslı Erkan, Nazan and all my colleagues at Istanbul Bilgi University's Faculty of Communication for their patience and unceasing encouragement. I really hope you enjoy reading this book. From my family, I would like to thank Beyza, Bilge, Macide and Aslı for their everlasting compassion and kindness. They were always ready to lend a steady hand during moments of turbulence and stormy weather. And finally, a big hug to my cat Lulu, who gave me so many moments of laughter and joy over the years. In the words of a song by band My Morning Jacket: 'Our earthly bodies will surely fall / But the love we share outlives us all / What's done is done at the end of the day / Now, only memories remain'.

and Kaya . . .

First and foremost, I am indebted to Pierre and Ivo. Without their continuous encouragement, hard work and kindness, this study would not have been possible. I am already excited about our prospective projects. The Department of Sociology at Bahçeşehir University and my colleagues there were very supportive throughout the project and my work on this book. On a more personal note, I would like to thank my partner, Angelica Minaya; my words cannot truly express my gratitude for her trust in me.

Pierre, Ivo and Kaya, 2020

NOTES ON CONTRIBUTORS

Kaya Akyıldız is Assistant Professor in the Department of Sociology at Istanbul Bahçeşehir University. He completed his PhD in the Philosophy, Interpretation and Culture programme at Binghamton University. His research has been supported by numerous institutions, including Stiftung Mercator and the Scientific and Technological Research Council of Turkey (TÜBİTAK). His recent research interests are related to political memory, Sunniness and the strategies of cultural hegemony in 'New Turkey'.

Diliara Brileva is a research fellow at A. Krymskyi Institute of Oriental Studies, National Academy of Sciences of Ukraine. She wrote her PhD thesis (2012) on public discussions on social reforms in the Tatar press of the early twentieth century (*Shura*, 1908–17). In 2018, she received a master's degree at the University of Kazan in Islamic theology. Diliara Brileva's research interests are related to Islam in Turkic-speaking communities, the history of Islam in Russia and the politics of memory.

Gülşen Çakıl-Dinçer is a lecturer in the Department of Sociology at the Adıyaman University, Turkey. She completed her PhD thesis entitled 'Islamist Movement in Turkey from 1970s to Present' at Mimar Sinan Güzel Sanatlar University, Istanbul, in 2017. Her research focuses on Islamism and women in Turkey. Recently, she has been working on Islamic institutions in southeastern Turkey.

Josh Carney is Assistant Professor in the Department of Sociology, Anthropology and Media Studies at the American University of Beirut, where he teaches on media. His research focuses on media from Turkey, with recent projects on popular television, cinematic censorship and the role of media screens in public demonstrations. He is currently working on a book exploring the cultural and political stakes that emerge when the national past is made the subject of popular dramatic television. He received his PhD in Communication and Culture and completed an MA in Turkish Studies from Indiana University in 2015. His personal website (with links to some publications) is http://joshlcarney.com

Ayşe Çavdar graduated from Ankara University, Journalism Department, and received an MA in History from Boğaziçi University. She completed her PhD thesis entitled 'The Loss of Modesty: The Adventure of Muslim Family from Neighbourhood to Gated Community' at the European University of Viadrina in 2014 (supported by the Global Prayers Project, initiated by MetroZones). Her studies focus on Islamism and nationalism in Turkey in the context of Urban Studies and Cultural Anthropology. Recently, she has been affiliated with Philipps University in Marburg as a postdoc researcher. She co-edited (with Volkan Aytar) *Media and Security Sector Oversight, Limits, and Possibilities* (2009); (with Pelin Tan) *The State of Exception in an Exceptional City* (2013).

Can Evren holds a PhD in Cultural Anthropology from Duke University. His PhD dissertation, 'Global Sport, Territorial Ambition: How Professional Soccer Remade Turkey', centres on the various ways in which professional soccer contributed to the making and remaking of Turkey's public culture since the early twentieth century. He works at the intersections of historical and ethnographic methods and studies global sport history, the political economy of sport, and sport governance. He is more widely interested in the ways in which globalisation and the nation state co-exist and conflict inside the private transnational order of FIFA.

Ivo Furman is Assistant Professor in Istanbul Bilgi University's Faculty of New Media and Communication. He completed his PhD in Sociology at

Goldsmiths College, University of London, in 2015. His research has been supported by numerous institutions, including the Arts and Humanities Research Council (AHRC), the Danish Agency for Science and Higher Education, the Turkish Science and Technology Foundation (TUBITAK) and Stiftung Mercator. Featured on *Policy & Internet*, his most recent publication, 'End of an Habermasian Ideal? Political Communication on Twitter during the Night of the 2017 Turkish Constitutional Referendum', uses network analysis to explore political polarisation on social media. He is part of the research group '"Ne mutlu ateistim diyene". Atheism and the Politics of Culture in Contemporary Turkey', funded by Stiftung Mercator.

Pierre Hecker is a Senior Researcher and Lecturer at the Centre for Near and Middle Eastern Studies (CNMS) at Philipps-University Marburg, Germany. He holds a PhD in Near and Middle Eastern Studies from the University of Leipzig and is the author of the book *Turkish Metal. Music, Meaning, and Morality in a Muslim Society* (2012; 2016). His recent publications include 'Islam. The Meaning of Style' (2018) and 'The "Arab Spring" and the End of Turkish Democracy' (2019). He is the head of the research group '"Ne mutlu ateistim diyene". Atheism and the Politics of Culture in Contemporary Turkey', funded by Stiftung Mercator.

Julia Lazarus is an artist, curator and film-maker based in Berlin. She studied at the University of the Arts, Berlin, and at the California Institute of the Arts, Los Angeles. Her most recent documentary film *Northern Forests* invites the viewer to take a closer look at Turkey's ecological movement. Her films and video installations have been on display at film festivals and exhibitions, most recently at DEPO Istanbul, NGBK Berlin, Manifesta 8, Film Forum NRW, rencontres international, Paris/Berlin/Madrid, Globale, Berlin, Rotterdam Filmfestival, Diagonale Graz, Istanbul Filmfestival, Kasseler Dok-Fest. For many years, she has been actively engaged in supporting the interests of the visual artists in Berlin at 'To Have and to Need' and the 'Coalition of the Free Scene'.

Valentina Marcella is a postdoctoral researcher in Turkish Studies at L'Orientale University of Naples, Italy, where she is carrying out research on

the satirical press in twentieth-century Turkey, while teaching Turkish language. She is a former research fellow at the Istanbul Studies Center of Kadir, Has University, Istanbul, and visiting researcher at the School for Advanced Studies in the Social Sciences in Paris. She obtained her PhD in History from the European University Institute of Florence. Her dissertation on the political role of satire in the aftermath of Turkey's 1980 coup was awarded the James Kaye Memorial Prize for Best Thesis in History and Visuality. Her research interests cover satire, authoritarian regimes, power and counter-culture, urban development and Italo-Turkish relations. She is co-founder of the cultural association and online magazine on contemporary Turkey *Kaleydoskop – Turchia, cultura e società* at https://kaleydoskop.it/.

Douglas Mattsson is a PhD candidate in the Department of Religious Studies at Södertörn University in Stockholm, Sweden. He has held senior scholarships from the Swedish Research Institute in Istanbul and the German Orient Institute in Istanbul for his research on the Turkish black metal scene. His most recent publications include the co-authored chapter 'The Enemy Within: Conceptualizing Turkish Metalheads as the Ideological "Other"' in the forthcoming anthology *Living Metal* (2021), as well as 'I Am Satan! Black Metal, Islam, and Blasphemy in Turkey and Saudi Arabia' (2018). He is currently working on his dissertation, which is an ethnographic study of the Turkish black metal scene.

Burak Onaran is Associate Professor in the Department of Sociology at Mimar Sinan Güzel Sanatlar University, Istanbul. He received his PhD in History from the École des hautes études en sciences sociales (EHESS, Paris) (2009). His research interests cover mainly social, political and culinary histories of the Ottoman Empire and Republican Turkey. He is the author of two books: *Détrôner le Sultan, Deux conjurations à l'époque des réformes ottomanes: Kuleli (1859) et Meslek (1867)* (2013) and *Mutfak Tarih: Yemeğin Politik Serüvenleri* (History [in the] Kitchen: The Political Adventures of Food) (2015).

Petek Onur is a Marie Curie Fellow in the Department of Cross-Cultural and Regional Studies at the University of Copenhagen. She received her PhD from the Department of Sociology at the Middle East Technical University

with the thesis 'Changing Discourse on Women and Islam in Turkey in Ethnographic Studies'. She worked as a part-time instructor at Bilkent University and as a full-time instructor at Başkent University in Ankara. After receiving her PhD, she expanded her areas of interest to include fields of nostalgia and neo-Ottomanism in Turkey. Her research, 'The New Ottoman Henna Nights: Women in Palace Nostalgia', received the Şirin Tekeli Research Award in 2018. Onur's current project is also on gender and neo-Ottomanism, with a specific focus on Islamist women's media.

Erol Sağlam is a social anthropologist working on conspiracy theories, treasure hunts and masculinities at Istanbul Medeniyet University, Turkey. Following his doctoral studies at Birkbeck, University of London, with his research on Greek-speaking communities of Turkey, he worked as a postdoctoral fellow at Stockholm University and explored everyday makings of authoritarianisation, as well as its bureaucratic reverberations. His publications deal with reconfigurations of Islamic piety, everyday dynamics that forge and maintain cis-heteronormative masculinities, and the challenges that ethnographic praxis faces in the contemporary world. Alongside his interdisciplinary collaborations for heritage preservation, his current project explores the interrelationship between masculinities, conspiracies and changing configurations of statecraft.

Danielle V. Schoon is a Senior Lecturer in the Department of Near Eastern Languages and Cultures and a Lecturer in the Department of Sociology at the Ohio State University. Her research focuses on Roma identity and political engagement in Turkey, with recent work on the politics of minority inclusion and the role of communities of practice in urban rights activism in Istanbul. Dr Schoon's work is interdisciplinary and influenced by her background in dance and performance studies. She received a dual PhD from the University of Arizona in Anthropology and Middle Eastern Studies in 2015.

Martin Stokes is the King Edward Professor of Music at King's College London. He studied first music, then social anthropology at Oxford. He taught at the Queen's University of Belfast (1989–97), the University of Chicago (1997–2007) and Oxford University (2007–12). He was a Howard

Foundation Fellow at the Chicago Humanities Institute in 2002–3. He has been a visiting professor at Boğaziçi University in Istanbul on two occasions, and currently holds an honorary professorship in the Department of Arts and Cultural Studies at the University of Copenhagen. In 2013, he gave the Bloch Lectures at the University of California, Berkeley.

Caner Tekin is a Lecturer at the Centre for Mediterranean Studies at the Ruhr University Bochum, where he teaches the history of migration between Turkey and Germany. He received his doctorate at the same university. The publication of his thesis was funded by *Frankfurter Allgemeine Zeitung*. He previously worked at the Georg-Eckert Institute for International Textbook Research as a postdoctoral fellow. His most recent book publications include his monograph entitled *Debating Turkey in Europe: Identities and Concepts* (2020) and the volume *History and Belonging: Representations of the Past in Contemporary European Politics* (co-edited with Stefan Berger, 2018). He is part of the DFG Research Network 'Contemporary History of Turkey'.

FOREWORD

Martin Stokes

This volume brings together discussions of football, mass media, cooking, shopping, drinking, advertising and more – signs of, and routes into, the profound struggles over gender, class, sexuality, ethnic and religious identification that have shaped the emergence of the 'New Turkey'. It marks a consolidation of the field of Turkish cultural studies, about two decades in the making. It is hard to remember a time when thinking about these everyday signs, so intricate, so full of life, was a rather unusual activity, and one that required constant justification.

About thirty years ago that was very much the case though. *Arabesk*, Turkey's strangely enduring popular music, was once considered such a threat to the nation that no respectable intellectual would go near it. A few thoughtful souls did (see Eğribel 1984). But the issue of *arabesk*, from the outset, was always conceived as a 'problem', or a symptom of one. There were no shortage of candidates for what it supposedly symptomised: the state's failure to Westernise and modernise, to control a market economy, to hold the cynical manipulations of its ruling powers in check or the failure, somehow, of the city itself to civilise, educate and produce good citizens. What it was most emphatically *not* was music. The kinds of things that music (elsewhere) was considered able to do – to make meaning and value, to create spaces of subcultural communication, to articulate fields of identity or gender politics, to shape counter-publics and so forth – were things that could not be attached

to *arabesk*. I blundered into the field of *arabesk* in the mid-1980s. My efforts to understand it – as music – elicited various shades of bemusement and incredulity from my Turkish friends. It would have to be said that there were not that many models in my own field, ethnomusicology and popular music studies, to guide me either. Unsurprisingly, this is a project I have been picking up and putting down for the best part of three decades, never satisfied with the results.

Meral Özbek's study of Orhan Gencebay (Özbek 1991) fundamentally changed the picture of *arabesk*, and with it, Turkish cultural studies as a whole. Despite the valiant efforts of publishers like İletişim in these years, the key cultural studies texts, texts that would animate an idea of popular culture as a space of political contest and communication, of value and meaning making, of affective and emotional engagement, had not yet been translated or much circulated. The intellectual culture in those years was still, understandably, extremely nervous about openly engaging with the Western Marxian traditions. Important theoretical terms like 'articulation' still needed translation. The means by which a *popular* cultural text might be read like *any* kind of text – as complex, open-ended, multilayered – had yet to be developed. *Arabesk*, as a sign of deeper and more 'real' problems, was something to be looked *through*, rather than looked *at*, or engaged in conversation *with*. And it was this that Özbek's study achieved. It involved a sustained and systematic, book-length, Turkish-language engagement with the ideas of Raymond Williams, Stuart Hall, Dick Hebdige and others. In the process, she translated many of the key theoretical terms into Turkish for the first time.

The spread of cultural studies over the last three or four decades has raised questions that have been much discussed elsewhere (see Kenny 1995). One is a question of translation, by which I mean partly the question of the translatability of specific concepts like 'hegemony', and partly the translatability of Gramsci's broader analysis of Italy, firstly to post-war Britain in the world of the British New Left, and then elsewhere. 'Hegemony', as Hecker implies in his introduction to this volume, has become a tricky concept, even if it is still an indispensable one. Another is the romance with resistance, a habit of seeing the signs of subaltern struggle in the most banal and routine of everyday transactions. On the one hand, cultural studies have taught us to hold our gaze on the 'everyday' because this is where, and how, the key contests

of modern society take place, hidden in plain sight. This is surely one of its most valuable lessons. On the other, as has often been observed, there is a troubling methodological rigidity involved in selectively focusing only on objects that seem to permit this kind of analysis, and in reading them only with this particular end in sight. As though this is the only kind of 'politics' that 'culture' can have . . .

Another, perhaps less discussed, is the difficulty of extending the cultural studies model across colonial and post-colonial spaces – the familiar lessons of Spivak, Bhabha and Said arguably still not fully digested. This poses particular difficulties in a modern nation state like Turkey, historically partly coloniser, partly colonised. The question of religion, is, from the outset, a fraught and highly charged one from a post-colonial perspective, and particularly so in Turkey. Is the political resurgence of a Sunni Islam in Turkey to be understood in terms of reaction to an authoritarian secularism in the early years of the Republic that did the West's bidding? As the continuation of an Ottoman imperial project to fortify the boundaries of the state against its Shia neighbours, and the minorities within? As another identity for sale within the logic of contemporary consumer capitalism? As a process of governmentality in an authoritarian state? Various chapters of this volume show that the everyday signs and symbols of minority religious affiliation – as well as of secularism and atheism – pose complex and sharp questions. They are still hard to resolve, but the Turkish case studies continue to be thought provoking.

Nearly twenty years have passed since the publication of Deniz Kandiyoti and Ayşe Saktanber's *Fragments of Culture: The Everyday in Modern Turkey* (Kandiyoti and Saktanber 2002). Reflecting on the bewildering and constantly changing cityscapes and mediascapes of the post-Özal years, this landmark volume established a dynamic Turkish cultural studies agenda. It suggested the urgent need for new ways of thinking about the politics of culture in Turkey, ways no longer constrained by thinking about secularisation, modernisation, Westernisation, urbanisation and other tired, but oddly persistent, tropes of modernisation theory. Fragmentation – bought about by globalisation and an emerging neo-liberalism – was the keyword of the Kandiyoti and Saktanber volume. The questions it raises, now, are what, then, connected those fragments? What, then, that enabled the for-

midable hegemony of the 'New Turkey' to subsequently emerge? Hegemony and myth – brought about by the populism of the Erdoğan years – are the keywords of *The Politics of Culture in Contemporary Turkey*. The question it raises is: what signs of fragmentation are already implicit in the 'New Turkey' hegemony? The AKP defeat in the rerun of the June 2019 mayoral elections strongly suggests that change is already upon us. It will be fascinating to read these two volumes, together, in ten years' time.

The *Politics of Culture in Contemporary Turkey* significantly extends the interdisciplinary reach of the cultural studies agenda set out in *Fragments of Culture*. The latter worked on the assumption that anthropology and sociology served as master disciplines. That is less the case here. As well as sociology and anthropology, the authors and editors of this volume identify themselves with a broad and highly interdisciplinary array of area, religious, media and political studies fields. Something is, arguably, lost in terms of comparison, and the ability to argue or to theorise across broader historical and social spaces. But other things are, arguably, gained – a deeper sense of conversation with, and commitment to, the subjects of this research, a more reflexive and engaged politics and a sense of activism, for instance. This is probably so elsewhere, thinking about cultural studies more broadly. I suspect the Gezi Park protests of 2013 had an important effect in Turkey, though, in deepening the sense of commitment and activism implicit within the Turkish cultural studies project.

The Politics of Culture in Contemporary Turkey also extends its internationalism. *Fragments of Culture* certainly reflects a moment of buoyant and optimistic intellectual cosmopolitanism. But it did so at a time when 'local' and 'outside' research on Turkey were often firmly distinguished. My own work had just started to be translated into Turkish around then. It was routinely, and particularly in the press, described as 'a foreigner's view of *arabesk*' ('*bir yabancı gözüyle arabesk . . .*') – perhaps to excuse me for my mistakes, perhaps to soften or deflect what may have appeared as criticisms, perhaps just to whip up interest. This designation – generously – granted me a certain kind of license. But it seemed to me that it was also intended to remind local (*yerli*) scholars that they had both different responsibilities and different standards. For various reasons, the line needed to be clearly maintained. Twenty years on, 'Turkish cultural studies' is an irreversibly international affair, and that line is becoming hard to

perceive. The contributors to this volume are Turkish, European and American, trained in one or another place, living and working in one or another place, or moving in between. Intellectually speaking, ideas about Turkish popular culture now circulate globally. It is the product – the distributed creativity as we might now say – of groups of researchers, communicating electronically, attending one another's conferences, sustaining their collective work through collaborative research grants and fellowships and other kinds of relationships. This is clearly a good thing. As well as internationalising Turkish scholarship, it decolonises that produced in Europe and North America. Turkish cultural studies are now, as they should be, on a global footing.

We should not ignore the problems, though. The line has not entirely disappeared, and significant inequalities take shape across it. Exchange rates and punitive visa regimes in Europe and the United States make extended academic visits for Turkish scholars expensive and difficult. And ideas might freely circulate in one place, without much in the way of consequence or risk, but not in another. At the time of writing, this should not need much elaboration. Too many scholars in Turkey have paid an unacceptably high price for their critical thinking and activism. The globalisation of 'Turkish cultural studies' is, however, ongoing, and this volume marks one more solid step in that direction. It will, necessarily, be progressively drawn into other regional study (Southern European, Mediterranean, Caucuses and Central Asian, Middle Eastern) and diasporic (Armenian, Kurdish, Roma) fields. At which point a question mark over the word 'Turkish' – already a rather unstable placeholder – will emerge. But we can cross that bridge when we come to it.

Bibliography

Eğribel, Ertan. *Niçin Arabesk Değil?* Istanbul: Süreç, 1984.

Kandiyoti, Deniz and Ayşe Saktanber, eds. *Fragments of Culture: The Everyday of Modern Turkey*. London: I. B. Tauris, 2002.

Kenny, Michael. *First New Left: British Intellectuals After Stalin*. London: Lawrence and Wishard, 1995.

Özbek, Meral. *Popüler Kültür ve Orhan Gencebay Arabeski*. Istanbul: İletişim, 1991.

1

THE POLITICS OF CULTURE IN 'NEW TURKEY'

Pierre Hecker, Ivo Furman and Kaya Akyıldız

Final Destination: 'New Turkey'

Here we go! Speeding away from 'Old Turkey'. It is time to do away with the rule of those rootless, upper class 'White Turks', disrespectful to our traditions and beliefs. Ignorant and repressive, those dandies sipping their whiskeys by the Bosphorus while we toil away. But in the glare of the headlights, we can see the promised land approaching. All of us, together, cruising down the highway towards 'New Turkey'. Towards a better land. A better future. A future of prosperity, pride, piety and freedom. This is where we are going . . . But are we really? Or did we already speed past our destination? Was there a terrible accident? Did we spin off the track? Are we still on the move? We're no longer so sure . . . But, yes, of course, of course we are. We still believe in the cause. In what we are being told. Constantly. In mass meetings, on TV, at school and on almost every social media channel. We are still on the move. Still on track. We did not miss the exit. We are close. Still cruising. Despite all the odds. Just a few yards left to the promised land, only a few more years left to 2023, and to bringing this blessed march, our heroic journey, to its final destination. After almost a thousand years. After Alp Arslan defeated the mighty Byzantine Empire and Sultan Mehmet, 'The Conqueror', scaled the walls of Istanbul. We resumed the struggle of the Ottoman sultans, and we will reclaim what is ours. Now is the moment to recover what was lost. To restore our dignity and pride. All under the command of one strong leader committed to realizing the will of the Turkish people.

Speaking in metaphors might not be the most conventional way of opening an academic discussion. Envisioning a road trip to 'New Turkey', however, does help to illustrate the mythical nature of authoritarian populism. Indeed, myth has become a key component of Turkish politics. This book is underpinned by the basic contention that, under the political dominance of Recep Tayyip Erdoğan's Justice and Development Party (Adalet ve Kalkınma Partisi, AKP), Turkey has been undergoing an ideological transition from one hegemonic project to another, from 'Old' to 'New Turkey'.

The effects of this change and the question of what exactly is new about 'New Turkey' have been addressed and answered in various ways in a wide array of studies conducted by researchers from different academic disciplines. In contrast to other works, however, this book aims to explain how the transition from 'Old' to 'New Turkey' is negotiated on the field of culture. This transition, it will be argued here, is facilitated by modern-day myths that aim to persuade the public into consenting to the ruling elite's claim to power.

This volume builds on the British tradition of Cultural Studies. It is profoundly influenced by classic works in this tradition, such as *Culture and Society* (Williams 1958), *Resistance Through Rituals* (Hall and Jefferson 2003 [1975]), *Subculture: The Meaning of Style* (Hebdige 1979), *Policing the Crisis* (Hall et al. 1978) and *The Politics of Thatcherism* (Hall and Jacques 1983). Its theoretical foundations and terminology directly originate from these works and the debates they have given rise to. Such debates have ranged over moral panics and the breakdown of societal consensus, cultural practices and ideological commitment, incorporation and resistance, cultural representations and signifying practices and, last but not least, political power and authoritarian populism.

Against this backdrop, the present book seeks to contribute to a better understanding of the rise of authoritarian populism and the decline of democracy in Turkey.[1] In doing so, it also aims to link the Turkish case to a wider debate on the global ascent of contemporary authoritarianism. Turkey under Erdoğan shares certain commonalities with the ascendance of other right-wing populist politicians who came to power through democratic elections and proceeded to dismantle the democratic institutions of state and society. Arguably, similar processes have occurred in, for instance, Hungary under Orbán, the United States under Trump or Poland under Kaczynski and Duda.

Turkey's new ruling elite has moved to disintegrate the democratic framework of Turkish politics, shatter the idea of societal consensus as based on the principles of democratic pluralism and manipulate the public into a mood of bellicose, patriotic fervour. At the time of writing this introduction, this last factor had brought Turkey to the brink of war with neighbouring Greece and embroiled the country in unpredictable military adventurism in Syria, Iraq and Libya. Certainly, 'New Turkey' set out to reverse the achievements of 'Old Turkey's' secularist modernity and erase the cultural legacy of Kemalism. Moreover, inspired by a sense of imperialist nostalgia, Sunni supremacism and traditional patriarchalism, 'New Turkey' aims to restore the nation's imagined former greatness.

In August 2020, the Republic of Turkey's Directorate of Communications released a professionally produced agitprop video replete with references to the military victories of the past and the visual iconographies of Turkish nationalism and modern Islamism. This symbolism was complemented with a heroic background tune in fulsome praise of the 'Red Apple' (*kızıl elma*). The red apple holds a firm place in Turkic mythology and modern Turkish nationalism. It is a polysemic symbol used in literature and poetry, where it often functions as a metaphor for an imaginary place of longing. However, it also signifies the Ottoman Empire's urge to expansionism and its ultimate claim to world domination. According to this worldview, the Muslim Turk is destined to conquer and rule. In particular, for the Christian lands to the west of the Ottoman Empire, the idea of the red apple represented a constant threat to their very existence. During the Ottoman age of conquest, the red apple was inevitably equated with European cities such as Rome, Budapest or Vienna (Setton 1992, 29–46; Gökyay 2002, 559–61). For much of the twentieth century, however, Kemalist realpolitik rendered the myth of the red apple obsolete. Its re-emergence in a state-funded, high-profile agitprop video signals 'New Turkey's' departure from the 'peace at home, peace in the world' paradigm that guided Turkish foreign policy for decades. The message conveyed here indicates a more aggressive stance in world politics. Indeed, the Directorate of Communications itself describes the red apple anthem as 'the sacred march of our nation that made history from Manzikert to July 15'.[2] In an audacious act of self-aggrandisement, the propaganda video not only announces Turkey's re-emergence as a world power in the twenty-first

century; it also spurs fantasies of future expansionism. The four-minute visual narrative ends with an aerial view of the Temple Mount and the Dome of the Rock in Jerusalem – a feature that the State of Israel might certainly consider disturbing.

The production of the video incorporates elements of an old school leadership cult, nationalist folklore and the aesthetics of a popular TV series. The ruling elite's capacity to exploit the appeal of nationalism and Islam through popular culture and to mobilise the population across political camps should not be underestimated. Most opposition parties find it increasingly difficult to distance themselves from the use of such grotesque forms of patriotic mobilisation – unless, of course, they want to risk being denounced as traitors to the nation, flag and fatherland.

Turkey's democratic breakdown and the rise of pious conservatism under AKP rule did not come completely out of the blue, however. Some authors argue that present political developments are the outcome of a protracted process that has its roots in the history of modern Turkey. One might cite the bloody end of the Menderes era and the policies of the centre–right, conservative Democrat Party (Demokrat Parti, DP) as important milestones towards Erdoğan's authoritarian rule. Others might stress the state's ideological shift towards the political doctrine of the Turkish–Islamic synthesis at the height of the Cold War. These events and developments undoubtedly paved the way for the rise of political Islam and pious conservatism. Nonetheless, the present volume focuses exclusively on the era of authoritarian populism that has characterised what the present ruling elite calls 'New Turkey'.

Accepting culture as a site of political struggle, *The Politics of Culture in Contemporary Turkey* seeks to tie in with Deniz Kandiyoti and Ayşe Saktanber's 2002 book *Fragments of Culture: The Everyday of Modern Turkey*. The authors who contributed to *Fragments of Culture* provided a unique insight into the social and cultural transformation of daily life in Turkey around the turn of the new millennium, immediately before the AKP came to power. Their studies covered issues such as national culture, populist nostalgia, articulations of Islamic identity in popular culture and, last but not least, the politicisation of culture in everyday life.

The present volume aims to fill a gap that has emerged in the field of contemporary Turkish cultural studies since the publication of *Fragments of*

Culture. The chapters of this book function much like the pieces of a jig-saw puzzle; once assembled, they form a single, comprehensive picture of the politics of culture in 'New Turkey'. Prior to writing their chapters, the authors agreed on a particular theoretical framework and a set of predetermined analytical concepts ('culture', 'hegemony', 'myth' and so on). These concepts will be outlined on the following pages of this introductory chapter. However, before entering into the discussion of the theoretical framework, it seems essential to share some thoughts on Turkey's 'authoritarian turn', and the (ideological) impact this has had on everyday life in Turkey.

Taking a Wrong Turn on Democracy Road

The AKP has held power uninterruptedly since November 2002; indeed, the party has set a record as the longest-serving government in modern Turkish history. During this period, Erdoğan's most loyal supporters have established themselves as Turkey's new ruling elite. The last remnants of Turkey's once secularist regime have been more or less erased. The AKP has successfully consolidated its power over the state, absorbed or paralysed broad sections of civil society and the media (Akser and Bayburt-Hawks 2012; Yesil 2016) and nurtured its contacts with conservative businessmen in order to gain a strong and profitable foothold in Turkey's thriving economy.

Moreover, the ruling elite's unbridled appetite for power has resulted in a change to Turkey's political system, from a parliamentary democracy to an authoritarian presidential system that no longer operates on the basis of the functional separation of powers (Öztürk and Gözaydın 2017; Yılmaz 2018). In a controversial referendum held on 16 April 2017, Turkey's pious conservative power bloc successfully convinced the Turkish electorate – or, at least, significant sections of it – to consent to the abolition of the democratic foundations of the Turkish constitution. This rather discomfiting success was preceded by the ruling elite's vehement attempt to generate societal consensus, and to naturalise its own political views as the commonly accepted norm.

A few years earlier, many observers were still praising the 'Turkish model'. They did so not only because of this model's apparent reconciling of political Islam with the principles of secularism, human rights and a free market economy (Özbudun 2006, 547–8; Tuğal 2016, 4), but also for its generation of a pro-European discourse of liberal democracy, human rights and

the rule of law (for example Yavuz 2006; Uzgel and Duru 2009). The ideological reorientation of Turkish political Islam as represented by the AKP has been described variously as Turkey's 'Islamist "New Thinking"' (Çavdar 2006), an 'Anatolian Revolution' (Şen 2010), 'post-Islamism á la Turca' (Dağı 2013), a 'passive revolution' (Kuru 2006) or the triumph of an 'Islam without extremes' over militant Islamism (Akyol 2011).

To be sure, the AKP's early years in power did yield a set of thorough – though temporary – reforms in the field of human rights and the rule of law. This essentially liberated Turkey's political system from military tutelage. Against this backdrop, it was even suggested that Turkey could serve as a genuine model for the rest of the Islamic world and become a cornerstone of political stability in the Middle East. The term 'New Turkey' was popularised in the light of this success story and initially used to describe the new political era that perceivably began with the AKP's accession to power in 2002.

A key aspect of the AKP's rise to power was an unprecedented economic boom during its first decade of government. Turkey's inflation rate dropped to single figures for the first time in decades, billions of dollars of foreign direct investment stimulated the national market, Turkish companies expanded trade with foreign markets around the world and ordinary citizens experienced a considerable rise in real incomes and spending power. The political scientist Soner Cağaptay had cause to assert that Turkey would 'become the twenty-first century's first Muslim global power' (2014, 11) and possibly catch up with Europe economically. This would ensue, he suggested, if Turkey continued to adhere to its recipe for success; a combination of liberal democracy, free market economics and reformist determination. Turkey's newfound economic power became an important source of national pride and confidence, one that could be instrumentalised by the government to legitimise its rule. The vision of 'New Turkey' glistened in the glare of prosperity and power.

This unambiguously positive image lost much of its appeal after the government, in an attempt to quell democratic protests against its rule, resorted to a wide array of repressive measures against its opponents. More recent publications commonly associate the term 'New Turkey' with the 'authoritarian turn' that became obvious during and after the protest-laden summer of 2013 (for example David and Toktamış 2015; Waldman and Çalışkan

2016; Cabas 2017; Yılmaz 2018). Furthermore, more recent publications claim the advent of a new 'Islamist turn' (Yılmaz 2019) and the dawn of a post-Kemalist (Aytürk et al. 2019), post-secularist (Öztürk 2019) era driven by the ruling elite's intention to Islamise Turkish society (Kaya 2015).

In the wake of the political crisis that followed the Gezi Park protests, the ruling party, in an apparent rallying cry to its supporters, began to conjure the image of 'New Turkey' as a populist political concept (Yesil 2016, 11). Slogans such as 'On the Way to New Turkey' ('*Yeni Türkiye Yolunda*'), 'New Turkey Will Be Strong' ('*Yeni Türkiye güçlü olacak*') or 'All Together For New Turkey' ('*Hep Birlikte Yeni Türkiye*') popularised the term among the ruling bloc's electorate. According to the policy think tank SETA, 'New Turkey' was the most frequently used catchphrase in the run-up to the 2015 national elections. It was also highly popular among those intellectuals who urged a yes vote for the adoption of an authoritarian presidential system in the constitutional referendum of 16 April 2017 (Bayram 2016, 47–8). 'New Turkey' came to represent not only the ruling elite's political agenda, but a rather mystical object of utopian longing, the realisation of which was being hindered by the perfidious kingpins of 'Old Turkey'.

Consequently, however, 'New Turkey' can only be invested with meaning in relation to what is imagined as 'Old Turkey'. 'New Turkey' is thus intended to signify the advent of a new hegemonic project that seeks to replace 'Old Turkey', its hegemonic adversary. Even so, despite the rather pretentious aspirations to a 'New Turkey', the concept remains somewhat vague. Its main function is obviously to obtain discursive supremacy over the ruling elite's political opponents. In the end, the mutually exclusive 'New Turkey' – 'Old Turkey' dichotomy stands for the political polarisation of Turkish society under AKP rule. However, it also points to a far-reaching shift in the balance of power.

In her ethnographic study *Nostalgia of the Modern* (2006), Esra Özyürek attested to a reversal in the balance of power between the centre and periphery in Turkish politics. The theoretical paradigm of the centre–periphery model was famously formulated by Şerif Mardin in an article for *Daedalus* in 1973. According to this paradigm, there exists a cultural divide between, on the one hand, the pious conservative sections of society and, on the other, the modernised bureaucratic state elite. While the numerically dominant

conservatives remain socially and politically marginalised, the secularist elite dominates the political and economic system. Both groups differ from each other in their lifestyles and political views, thereby generating constant conflict on a political level.

Mardin's binary framework has been strongly criticised as oversimplifying and failing to address a far more complex sociopolitical reality of fragmented, fluid power relations. As an organising framework for research on Turkey, it therefore appears somewhat outdated and, at least in terms of its strict binarism, perhaps even obsolete (see Bakiner 2018). However, this should not obscure the fact that the binarism portrayed by Mardin still holds populist appeal and significance in political discourse. In particular, the idea of a secularist top-down modernisation that never reached the peripheral religious masses is still highly influential. Indeed, such a narrative is deployed by the ruling elite in order to argue that *they* have been victimised and deprived of their right to rule. If we follow Mardin's argument that Islam is the culture of the periphery (Mardin 1973, 185), then the current ruling elite's attempt to re-legitimise Islam as the core of the Turkish nation marks a change in this power relationship.

Özyürek examined how ordinary citizens shifted the formerly dominant culture of Kemalism to the private sphere of the home. She further argued that the public visibility of secularist modernity has been replaced by 'the privatisation of state ideology', or simply the privatisation of politics (Özyürek 2006, 4, 7). This notion of a reversal of power relations elides with the findings of a survey conducted under the supervision of Binnaz Toprak (2009) at Boğazici University. This study aimed to analyse the relation between religiosity, conservatism and neighbourhood pressure (*mahalle baskısı*). It reached the conclusion that the otherisation and repression of individuals whose lifestyles differ from the pious conservative norm (for example non-Muslims, Alevis, homosexuals, secularists) can be directly associated with the AKP's rise to power. This also indicates that the former secularist pressure on Islamist lifestyle practices has been reversed.

A few years after Özyürek's and Toprak's studies, Jenny B. White published *Muslim Nationalism and the New Turks* (2013). This contribution highlighted the AKP's aspiration to establish its own version of national identity and Turkishness as the commonly accepted norm. White argued that Turkey's new ruling class sought to discard the image of the Kemalism-inspired Muslim

Turk who favours a lifestyle based on secularist values. This image has been steadily replaced with the concept of the pious Muslim Turk whose identity is deeply rooted in a re-imagined Ottoman past. Designed as an anachronism to Kemalism, the ruling elite's favoured form of new Turkishness also came with a revised politics of memory that apparently aimed at a disremembering of Turkish secularist modernity and a reinvention of neo-Ottomanist nostalgia. White (2013, 9) exemplifies this by stressing the symbolic significance of paying public tribute to what the regime has identified as the key figures and events of Ottoman history; for example, the conquest of Istanbul by Sultan Mehmet Fatih in 1453 or, more recently, the First Battle of Kut in World War I (see Chapter 11 by Burak Onaran in this book).

The politics of (dis)remembering history and reinventing Turkish national identity revolves around the question of what is visible or invisible in public discourse. The new leadership quickly understood that the national education system provides an efficient tool for making 'things' (in)visible and adapting the younger generation to its version of Turkishness and national identity. The AKP is often said to be responsible for the privatisation and (neo)liberalisation of Turkey's educational institutions and services (İnal and Akkaymak 2012). To be sure, the government has, indeed, permitted private providers to capitalise on education. Moreover, however, the AKP has also successfully integrated its pious conservative ideology into the public education system.

Indeed, several studies, such as Iren Özgür's *Islamic Schools in Modern Turkey* (2012), Ceren Lord's *Religious Politics in Turkey* (2018) or Elif Gençkal Eroler's *Raising a Religious Generation* (*Dindar Nesil Yetiştirmek*, 2019), provide detailed insight into the ruling elite's comprehensive efforts to strengthen religious discourse in the field of education. In this context, the government has introduced new school textbooks and curricula focusing on religion. Furthermore, it has systematically strengthened public religious high schools at the expense of secular state schools, fully in keeping with President Erdoğan's call to educate a new pious generation.

From Fragments to Fault Lines of Culture

The key battleground wherein the contending hegemonic adversaries of Turkish society meet is, arguably, the realm of culture. It is here where they clash over norms, practices, representations and values. But the term 'culture'

is itself nebulous and slippery. Indeed, it has been described as 'one of the most difficult concepts in the human and social sciences' (Hall 1997, 3). Even though it is widely treated as a universal, commonly understood concept, it has been defined in a multitude of different ways. Within the scope of this book, culture is conceptualised in accordance with Antonio Gramsci's concept of hegemony and relies in great part on the tradition of British Cultural Studies. The cultural is thus *always* linked to the political, and can only be fully understood if questions of power are taken into account.

It has been argued that political power works primarily on both a mental and a physical level, as a balance between consensus and coercion, ideology and force (Mitchell 1990, 545). For the Marxist philosopher Antonio Gramsci, ruling primarily through consensus rather than coercion provided the real key to political power in modern capitalist societies (Clarke et al. 2003 [1975], 38–41). What Gramsci referred to as cultural hegemony involves a constant process of negotiation. This process, even though it includes both dominant and subordinate groups (Storey 2016, 81), is less about negotiating consensus on the basis of societal compromise than about establishing the worldview of one particular group as the commonly accepted norm. It thus appears that consensus through dominance, rather than through compromise, determines Gramsci's notion of hegemony.

Ultimately, then, hegemony depends on the ruling elite's ability to establish and maintain control over public discourse. Discursive dominance is the power to control public narratives by popularising one narrative at the expense of others, or by preventing alternative, counter-hegemonic narratives from emerging. Such dominance enables the ruling elite to naturalise its interpretations of the world and to persuade the public into consenting to its rule. Hegemony thus works on a primarily ideological level, with coercive power required only temporarily in times of crisis.

At the time of writing, 'New Turkey's' dominant power bloc holds control over (almost) the entire economic resources and institutions of the state. It successfully uses these resources and institutional tools of intervention to exert control over Turkey's cultural industries (Kontny 2017, 55–7). In this way, Turkey's key political powerbrokers directly influence public discourse and convince the populace of the 'truthfulness' of their own particular narratives. We might conceptualise these narratives as 'modern-day myths'.

The term 'myth', as it is used here, draws on a series of essays published by the French cultural critic and literary theorist Roland Barthes in the French magazine *Les Lettres Nouvelles*. In these essays, Barthes coined the term 'modern-day myth' in order to unmask the ideological dimension of popular narratives in post-war French consumer culture (Barthes 2009 [1957]). Barthes was less interested in the supposedly fictional character of modern-day myths, and more in exposing their ideological foundations. According to Barthes, modern-day myths present themselves as universal, unquestionable narratives that *go-without-saying*. In fact, however, they are historically specific, artificial and ideologically coloured. Myths thus do not necessarily have to correspond with historical facts or hard evidence, because their main function is to preserve the status quo and facilitate the consolidation of dominant power structures.

The main purpose of myth is to circumvent possible conflicts over meaning, to overcome contradictions and to make the world explicable in a simplistic, 'mythical' way (Fiske 2001 [1987], 44; Storey 2016, 115). Barthes suggests that 'the oppressed' can resist the hegemony of the ruling class by forging alternative discourses against what is dominant. The ruling elite usually aims to restrict or deny access to the means of articulating alternative discourses 'with which to speak and think . . . opposition' (Fiske 2001 [1987], 44).

In the Turkish case, the ruling elite fully understands the significance of suppressing alternative narratives. It therefore uses its power to deny critics any recourse to the means of cultural production suitable for reaching a mass audience. On a related note, it imposes far-reaching restrictions to the right to freedom of expression and channels state resources only to those who support and promote dominant discourse. Though Barthes never directly referred to Gramsci, his notion of myth brings him close to Gramsci's idea of cultural hegemony. The purpose of this book is to expose the ideological abuse of modern-day myths by Turkey's ruling elite in its attempt to gain discursive supremacy over its political opponents and to expand its hegemonic powers over state and society.

One such popular myth is the reinvention of Sultan Abdülhamid II in Turkish public memory. In recent years, this myth has been engendered through TV series, schoolbooks, public commemoration ceremonies and other means of cultural production. Ousted from power in the Young Turk

Revolution of 1908, Abdülhamid II initially represented the 'natural adversary' of early Turkish republicanism (that is, today's 'Old Turkey'). The 'Kemalist' narrative depicted him as an illegitimate despot who tried to repress the fundamental principles of modern society, namely constitutionalism, nationalism and secularism. In order to maintain his absolute power and preserve imperial unity, Abdülhamid II was said to have awakened the spirits of an unruly Islamism.

In recent years, however, the sultan's memory has been imbued with new meaning, especially in and through Turkish popular culture. In 'New Turkey', the Ottoman Empire's last powerful sultan is depicted as a just, selfless, God-fearing leader who aimed to defend Muslim lands from 'Western' tyranny. The reinvention of Abdülhamid II as a modern-day myth can be pointedly observed in the recent popular drama series *Payitaht: 'Abdülhamid'*. In his chapter for this volume, Caner Tekin carefully examines this series, which is striking in the extent to which it makes reference to contemporary politics. Indeed, the fictional character of Abdülhamid II appears to have been modelled on no less a figure than Recep Tayyip Erdoğan. *Payitaht*, however, constitutes only one among many attempts to politically rehabilitate the legacy of the Ottoman Empire. In two separate chapters, Burak Onaran and Diliara Brileva also discuss the politics of memory as practised in other cinematic and televisual sources. Popular re-imaginations of Ottoman history in Turkish cinema and TV series blatantly insinuate the existence of meaningful connections between the political situation of the past (Sultan Abdülhamid's late Ottoman Empire) and the present (President Recep Tayyip Erdoğan's 'New Turkey'). From this perspective, the reinvention of Abdülhamid II can be seen as an ideological manipulation of the Turkish public through the invention of a meaningful connection between the ruling elite's present-day policies and a re-imagined Ottoman past. The popular movies and TV series discussed in this volume represent an attempt to prevent a struggle over meaning by naturalising a particular conception of history as 'common sense' for the Turkish nation. From the point of view of 'New Turkey', it now seems impossible to conceive a history of Turkey that is neither Islamic nor Ottoman.

'New Turkey' is thus committed to investing the Turkish nation's Ottoman–Islamic heritage with new glory. But this attempt to reclaim the Ottoman past

(Ömür 2014, 125) has also found its way into the field of urban planning. In her contribution, Petek Onur scrutinises how 'New Turkey's' reinvention of the Ottoman past is manifest in the urban transformation of two historic neighbourhoods of Ankara, Turkey's capital city. Applying Svetlana Boym's concept of reflective and restorative nostalgia, Onur demonstrates how the politics of memory work through architectural structures. The spatial representations of neo-Ottomanism, however, appear to be directly influenced by Turkish popular culture or, more precisely, by popular TV series.

But aside from television, there are many forms of popular culture that are being effectively (ab)used in the struggle for 'New Turkey'. These include elaborately produced, and apparently generously financed, propaganda videos. The quality and visual aesthetics of these videos closely resemble internationally popular cinema and TV productions. In his chapter, Josh Carney analyses the 'zombie politics' of 'New Turkey' as represented in the visual rhetoric of the 2014 election ad 'The Nation Does Not Bow!'. This ad is commonly seen as a reaction to the Gülen movement's attempt to incriminate the government of Recep Tayyip Erdoğan by releasing compromising audio recordings and raising corruption charges against several ministers and their relatives. Carney shows how this video overtly borrows imagery from the Hollywood zombie movie *World War Z*. The metaphoric implications of this, he argues, are the projection and prediction of Erdoğan's vision of a 'New Turkey' in which the ideal citizen is a zombie.

'Yes! We Shall Be Glorious!' is the title of yet another propaganda video released in the run-up to the constitutional referendum of April 2017. This video is analysed by Can Evren in order to demonstrate how, in Turkey, Steven Levitsky and Lucan Way's notion of competitive authoritarianism works through the cultural repertoire of football. Evren reads Turkish politics through the lens of football metaphors, which are used to make political claims and establish hegemony over the ruling elite's political opponents. In the football clip under scrutiny here, this effect is mainly achieved through a recital of popular myths, such as the victimisation of the Turkish nation at the hands of the treacherous 'West', or its resurrection in the face of despair. The patronising 'West' is represented here in the form of an antagonistic, predominantly white football team and a partisan referee. Both Carney's and Evren's case studies provide evidence for the significance of popular media

culture in emotionalising and mobilising the Turkish masses for the struggle to bring about 'New Turkey'.

This struggle also comprises a systematic attempt to conceptualise the Turkish nation as a coherent cultural entity unified by its commonly shared language, religion and history. Insofar as it tends to conceal and deny the various cultural differences of Turkish society, 'New Turkey' is an intrinsically ideological project. In recent years, Turkey's pious conservative power bloc has been consistently narrowing down the parameters for what it means to 'be Turkish'. As early as 2009, a representative study by Binnaz Toprak et al. suggested that, under AKP rule, it has become increasingly difficult to be somehow 'different' in Turkey. The public visibility of ethnic, religious, sexual and lifestyle differences is accompanied by mounting social and institutional pressure. The ruling elite's claim to be in sole possession of the right to define what Turkishness means has thus spawned resistance towards its new hegemonic project on various levels, especially among those sections of society that see their individual lifestyle choices under threat.

In particular, the dominant discourse of 'New Turkey' around national identity and the cultural parameters of Turkishness shows its immense complexity when faced with the question of how to deal with ethnic minorities. In this book, these issues of ethnicity are discussed in three consecutive chapters. While Kaya Akyıldız critically engages with the Turkish government's Sunni supremacist policies towards the country's Alevi community, Danielle V. Schoon and Erol Sağlam explore two different cases of supposedly successful ethnic incorporation.

Firstly, Schoon addresses the ambiguous relationship of incorporation and resistance with respect to Turkey's Roma population. In 'New Turkey's' discourse on national identity, the state's policy towards the *Romanlar* has been set up as an example of 'good practice'. These policies supposedly attest to the ruling elite's tolerance towards cultural diversity and pluralism. Schoon analyses how Turkey's *Romanlar* help to maintain the political status quo by publicly pledging their support for the government. On the other hand, however, they also successfully seek to establish their presence in Turkey's national discourse through cultural performances that only draw considerable public attention due to the community's proximity to the government. To be sure the *Romanlar*'s 'art of presence' does not pose a direct political challenge to 'New

Turkey's' hegemonic project. Nonetheless, it can be regarded as ideologically contentious, insofar as the community's supposedly immoral, deviant cultural practices, such as drinking alcohol, lascivious dancing or musical entertainment, openly contradict the ruling elite's ideas of pious conservatism.

Erol Sağlam's contribution, meanwhile, focuses on the Romeyka-speaking communities of Trabzon. This chapter expounds on how the region's originally non-Turkish population, through discretion of certain sociocultural differences, developed a staunch sense of Turkishness – but without renouncing these distinctions altogether. Based on extensive ethnographic field research, the author carves out in detail how particular non-conforming or supposedly 'non-Turkish' sociocultural aspects are accommodated. He further shows how this process of accommodation contributes to the long-term preservation of Romeyka.

The concept of culture used in this volume is by no means supportive of the idea of culture as a 'container' – that is, of the existence of a coherent and cohesive national culture. Nor does this book conceive culture as something restricted to the realms of the arts, or as something that can be easily divided into 'high' or 'low' cultural forms. On the contrary, this book explicitly includes the realm of the ordinary and everyday life within the concept of 'culture' that it adopts.

Accordingly, the authors featured in this volume do not confine their study of culture to artistic production.[3] In fact, they seek to analyse performative acts of cultural production in everyday life. This might include wearing a particular form of dress or style, consuming alcoholic beverages, kissing in public, performing or non-performing religious rituals or using a specific rhetoric in terms of favouring particular words and phrases while deliberately avoiding others. The choices a person makes in everyday life, to use a particular gesture, dress, word or haircut – all of these choices constitute the way that a person lives.

However, these choices can also be seen as expressive of particular ideological commitments, and thus of maintaining or contesting the dominant hegemonic order. It is the choice to conform or not to conform that makes an individual's personal life convey ideological meaning. For instance, in the Turkish context, whether or not a person fasts during Ramadan tells us little more than that he or she is conforming to a societal norm. However, should

this individual one day completely stop fasting or engaging in any religious practices, then this can be interpreted as a contestation of this norm.

Against this backdrop, this volume aims to critically engage with questions of everyday cultural politics and institutionalised cultural policies alike. Engaging with the politics of culture in 'New Turkey' means developing an understanding of culture as a medium of both maintaining and contesting political power. Culture must thus be seen as a site of ideological struggle. On this terrain, a constant process of negotiation between dominant and subordinate groups in society plays out. This process is marked by acts of resistance and containment (see Storey 2016, 76). Culture thus works as a medium of maintaining and contesting political power.

When Barthes wrote his 'Mythologies of the Month', he discussed topics that had been rather arbitrarily selected. These ranged from 'The World of Wrestling' and 'Soap-powders and Detergents' to 'Toys', 'Striptease' or 'The New Citroen'. In 'Wine and Milk' (Barthes 1991 [1957], 58–61), he analysed the signifying function of wine in French society. The meaning of wine, as Barthes stressed, is full of contradictions: it can be sustenance for the worker, a sign of virility for the intellectual; in winter it keeps you warm, in summer it refreshes. In France, Barthes argued, wine is never associated with the desire to get drunk or with crime – as it is, for instance, in Turkey. For Barthes, the contradictory meanings attached to wine can only be sustained because, ultimately, wine signifies French identity. To drink wine is to be part of France – it is to be French. This is the manner in which myths function in modern society. Myth takes a purely cultural and historical object such as wine and transforms it into the sign of a universal value: in this case, collective French identity (see also Allen 2003).

More than sixty years after Barthes wrote his famous essay, the politics of wine – or, more precisely, the politics of *rakı* and *ayran* – can be observed today in 'New Turkey'. In spring 2013, a well-known photo of Mustafa Kemal Atatürk sparked public controversy over the 'true' nature of the Turkish nation. From a Barthean perspective, the photographic image under scrutiny here consists of multiple layers of meaning that need to be uncovered one by one in order to elicit the modern-day myth lying hidden beneath. Barthes differentiates between first-order, denotative (or 'literal') meanings and second-order, connotative meanings. The latter evoke more abstract

concepts in the observer's mind. With respect to first-order meanings; the image at stake here depicts a middle-aged man dressed in an old-fashioned suit that is half-hidden under a black coat. In his right hand, he holds a transparent glass filled with a white coloured liquid. His head slightly bowed, the man's gaze is directed to a point hidden from the camera.

If we bring a little bit of historical knowledge to bear, we can quickly identify the image as a photograph of Mustafa Kemal Atatürk, the founding father and first president of the Turkish Republic, who lived from 1881 to 1938. It is, however, the realm of second-order meanings where ideology and politics enter the equation. Shifting perspective to second-order meanings, the observer encounters a cultural representation of Mustafa Kemal. Even today, Kemal is treated as an almost sacred figure in Turkey's official state discourse, even though he signifies very different 'ideas' to the various political groups in today's society. To be sure, Turkish Islamists still widely despise him for bringing down the righteous religious order of the Ottoman Empire. And yet Turkey's founding father remains an untouchable icon, even for his most powerful political opponents. He signifies modern Turkey more than anything (or anyone) else. He thus represents a myth. Within the discourse on 'New Turkey', Mustafa Kemal clearly holds signifying power. This needs to be understood when discussing the meaning of the present photographic image.

However, it was not the cultural representation of Mustafa Kemal which sparked public controversy over the true nature of Turkishness. Rather, it was the milky white liquid in his right hand. Is it *rakı*? Is it *ayran*? From the visual depiction, both options seem possible. But how would it change dominant notions of Turkishness if the founding father of modern Turkey was seen to be holding a glass of *ayran* and not *rakı* in his hand? What if an anise-flavoured alcoholic beverage signifies Turkish identity more than a similarly refreshing yogurt drink?

This question poses an ideological and political challenge to the representatives of 'New Turkey' *and* to its opponents. Recep Tayyip Erdoğan and his supporters were quick to declare that Turkey's national drink is *ayran*, and thus that Mustafa Kemal was undoubtedly holding a glass containing this beverage. But Turkey's secularist opposition insisted that the image depicted Atatürk having a fine glass of *rakı* – which, needless to say, represents Turkey's true national drink.

For Turkey's pious conservatives, *ayran* stands for religiously induced abstinence from alcohol. In their mindset, Turkishness apparently means being a Muslim. Thus, Turks do not drink alcohol. This notion of national identity, which is closely connected to particular daily practices, does not correspond to social reality, but to 'New Turkey's' ideological project. Consequently, the issue of *rakı* or *ayran* becomes a matter of consensus and conflict, incorporation and resistance.

Even for Turkey's ruling power bloc, the idea of openly denouncing Mustafa Kemal over his lifestyle habits appears to have been a bridge too far. Consequently, the *rakı*-or-*ayran* controversy can also be seen as an attempt to incorporate Mustafa Kemal into the ruling elite's new hegemonic project of pious conservatism. If it is not possible to directly criticise the symbolic father of Turks, who evidently died from a cirrhosis of the liver caused by his drinking habits (Mango 1999, 513–25), then he must be reinvented and incorporated into the new hegemonic project. The message to be taken from the photographic image thus reads: 'Look! Mustafa Kemal was a good Muslim. He preferred to drink *ayran* over *rakı*. He is one of us. He wouldn't have opposed the present government over its lifestyle policies'.

Consequently, the consumption of alcohol becomes an act of deviance from the hegemonic project and an open contestation of power. Anyone drinking alcohol suddenly comes to represent the ideological other. In the same way, hanging a copy of the aforementioned photograph on the wall of a bar or restaurant must be seen as an expression of ideological commitment to the values of secularism, and an act of cultural resistance to the ideological implications of 'New Turkey'. The signifying function of *rakı* and *ayran* thus lies in its potential for cultural incorporation and resistance, and the attempt to establish a particular worldview as the commonly accepted norm.

In his contribution to this volume, Ivo Furman expands upon the cultural symbolic significance of alcohol in 'New Turkey'. His observation illustrates how the ruling elite has used alcohol to draw a symbolic line between the ideological grounds of 'Old Turkey' and 'New Turkey', thereby claiming political hegemony over the future of the Turkish nation. The attempted elimination of alcohol related practices from the public sphere can thus be seen as part of a drive towards discursive supremacy over the political (secularist) other. The ultimate aim is to entrench the ideological

views of pious conservatism as the commonly accepted norm. Alcohol has become such a deeply divisive, contentious issue that even a mundane practice like drinking a glass of beer or *rakı* in public has turned into an act of defiance and political activism, especially when done collectively. The ruling elite's obsession with alcohol is, furthermore, symptomatic of how Turkey's new power bloc seeks to intervene in people's individual lifestyle choices by imposing a regulatory regime on whatever behaviour is considered deviant from the new hegemonic norm.

The question of how a person lives – or, more precisely, how a person publicly displays his or her way of life – is a matter of ideological commitment, and an essential aspect of the hegemonic power struggle in present-day Turkey. Particular lifestyles and the everyday practices associated with them have the potential to challenge the legitimacy of the ideological 'other', thus laying claim to or contesting political power (Hecker 2018, 14). A given lifestyle practice can either signify resistance to the ruling class's dominant ideology and a breakdown of consensus within society, or it can contribute to stabilising or endorsing the dominant order.

In the early Republican era, women's bodies were ascribed a central function in the struggle for a modern nation. The image of the enlightened, Western-looking woman who had consciously removed her veil was meant to represent modern Turkish society. From now on, this society would be defined by secularism, constitutionalism and nationalism (for example Yılmaz 2013, 78ff.). During the heyday of Islamic revivalism in the mid-1990s, Turkish political Islam also made use of the female body – only this time, as part of an attempt to challenge the Kemalist state. Piously veiled women took to the streets and demanded their right to wear the Islamic veil in public offices and at university, thereby contesting the legitimacy of Turkey's secularist hegemony. The struggle for 'New Turkey' was fought, to a very considerable degree, at the behest of women. Women not only resisted the Kemalist state in the public sphere – they also organised highly effective networks for neighbourhood mobilisation in support of political Islam and today's ruling elite (White 2002, Doğan 2016). Veiling, however, not only functioned as an expression of ideological commitment, but also as a means of women's self-empowerment. It constituted a claim to the right to participate in those public spaces formerly controlled by men.

The prominent position of female activism and women's associations in the struggle for 'New Turkey' is analysed in two consecutive chapters of this book. Gülşen Çakıl-Dinçer draws on her extensive fieldwork with KADEM, a high-profile pro-government women's rights association. She explores 'New Turkey's' notion of a new womanhood. To put this differently, she analyses 'New Turkey's' ideal of a new female self-conception that is positioned in opposition to egalitarian feminism and defined by a pious conservative way of life. In doing so, she not only addresses KADEM's religiously inspired 'justice over equality' agenda in relation to feminism; she also draws attention to cracks within the hegemonic project, thereby problematising the inherently complicated relationship between KADEM and the AK Party's Women's Section.

Ayşe Çavdar revisits Turkey's women's rights debate from a different angle. She touches upon an even more recent, and all the more contentious, issue: the politics of unveiling. At the height of the #10yearschallenge, young women from conservative families posted photos of themselves before and after abandoning the Islamic headscarf. Women have functioned as the agents of a new era of pious conservatism ever since Turkish political Islam pitted itself against the Kemalist project. The Muslim woman wearing her headscarf in defiance of the secularist state represented, perhaps more than any other symbol, the myth of Islam's supremacy over secularism. Seeing the very same women publicly remove their headscarves represents a clear challenge to the cultural hegemony of pious conservatism itself. Moreover, however, Çavdar shows that the reactions of men towards women's unveiling also constitutes a rupture in the masculine hegemonic project of Islamism. The act of unveiling also poses a direct challenge to Recep Tayyip Erdoğan's self-declared aim of raising a new, pious generation. Unveiling thus represents a counter-hegemonic move and a prelude towards leaving Islam and committing apostasy.

Pierre Hecker's contribution on atheism and non-belief in 'New Turkey' directly ties in with Çavdar's observations. The rise of pious conservatism has forced many non-believers into hiding. However, it has also triggered an awakening of atheist activism, which has resulted in the formation of Turkey's first ever Atheism Association (Ateizm Derneği). Hecker chooses organised atheism and the more recent debate on 'religious fatigue' as a starting point for his broader argument: that the ruling elite's striving for cultural hegemony has triggered a new secularist movement from below. Significantly, the intellectual

roots of this movement no longer lie solely in the Kemalist past. Based on a set of biographical interviews, Hecker's study also engages with the individual consequences of leaving Islam and being atheist in 'New Turkey'.

The Atheism Association formed as a direct result of Turkey's pro-democracy movement of 2013. In fact, the so-called Gezi Park protests provided the initial spark for the emergence of a number of non-governmental organisations which aimed to mount a defence of individual human rights, political pluralism and personal lifestyle choices. Berlin film-maker and artist Julia Lazarus widens the perspective of the present volume by providing an intimate insight into the counter-hegemonic discourse of ecological activism in Istanbul. She bases her chapter on the research conducted for her latest documentary film on the Northern Forests Defense activist group. Lazarus confronts the reader over both the practical and theoretical means, and the possibilities, of environmental resistance under the conditions of an authoritarian regime.

Gezi, which began with the protest of a few environmentalists against the demolition of a park of the same name in central Istanbul, gave birth to a dynamic creative impulse. This impulse has manifested itself in an unprecedented wave of artistic expression. The struggle between consensus and conflict, incorporation and resistance has also surfaced in the form of rock songs (such as Duman's *Eyvallah*, Murder King's *Demokrasi* and *Susma* or Serhad Raşa's *Çapulcu'nun Şarkısı*), rap (for instance Şanışer's *#Susamam* or Ezhel's *Olay*), dance performances (famously remembered is the dance of the 'tear-gassed dervish', *gazlı derviş*), pop art illustrations (by Berkay Dağlar, Okan Bülbül and countless others), comic strips (such as, for instance, those by Sümeyye Kesgin), graffiti, satirical cartoons and various other forms of art expressed through a variety of mediums.

What most of these forms of artistic expression have in common is the attempt to convey an alternative narrative of events. The official narrative propagated by Turkey's ruling elite through the state media and the educational system contradicts this reading and interprets Gezi as an attempted coup d'état instigated by 'Western' foreign powers against Turkey's democratically elected government. But these new artistic impulses aim to narrate the Gezi Park protests as a pro-democracy movement that was meant to resist authoritarian rule.

In this book, Valentina Marcella investigates the counter-hegemonic discourse in the Turkish satirical magazines *Gırgır, Penguen, LeMan* and *Uykusuz* during the summer of Gezi. Her research gives a stunning account of how these magazines, over a long period of time, successfully challenged the dominant narrative through the power of wit and humour. Another form of (sub)cultural resistance is analysed by Douglas Mattsson. In his chapter on Islamic semiotics in Turkish black metal, he explores the counter-hegemonic potential of blasphemy in the struggle against the cultural dominance of pious conservatism.

To conclude this long argument about hegemony and resistance, let us now re-emphasise the overall purpose of this book. This volume brings together sixteen empirical case studies that, together, aim to make a broader argument: that the struggle between the forces of incorporation and resistance primarily takes place on the field of culture (Fiske 2001 [1987]; Storey 2016). Subordinate groups attempt to counter the ruling elite's striving for hegemony by challenging the dominant discourse with the help of cultural representations and signifying practices that deviate from the norm. By studying the politics of culture in 'New Turkey', this book contributes to a better understanding of the success of authoritarian populism and the decline of democracy in Turkey.

The interdisciplinary team of authors that contributed to this book came together and exchanged ideas long before this publication could be realised. A set of predefined concepts (myth, culture, hegemony, resistance, authoritarianism, popular culture and so on) were key to creating coherence between the various strands of research discussed in this book. The present volume is organised in five clusters, namely 'Subcultures and the Politics of Lifestyles', 'Satire and Agitprop in "New Turkey"', 'Civil Society and the Politics of Gender', 'Mediating Neo-Ottomanism in Popular Culture' and '"New Turkey's" Ethno-Religious Others'. The individual contributions in these clusters touch upon a wide range of subjects, including lifestyle practices, artistic expression, civil activism, media entertainment, minority politics and the politics of memory as represented in dominant and counter-narratives alike. As such, this volume does not exclusively address an academic audience, but also those more broadly interested in cultural studies and contemporary Turkish culture and society.

Notes

1. In the mid- to late 2000s, the government's reform efforts appeared to have initiated an inexorable transition from deficient to liberal democracy in Turkey. The authors do by no means intend to imply that a well-established liberal democracy had been in place prior to the AKP. It is the reversal of this process of democratic transition that we are referring to here.

2. Quoted from the Directorate of Communication's official website, https://www.iletisim.gov.tr/turkce/haberler/detay/directorate-of-communications-releases-red-apple-anthem-to-mark-the-949th-anniversary-of-malazgirt-victory (last accessed 20 November 2020).

3. It is no rare phenomenon that the terms 'culture' and 'art' are used indiscriminately. An author may speak of 'culture' while actually meaning 'art', or even restrict his or her study of culture to artistic production only. This may include *performing arts*, such as music, dance or theatre; visual arts, such as film, painting or calligraphy; applied arts, with a special focus on architecture; and, perhaps most importantly, literature. What these various forms of cultural production have in common is a creative impetus that intends to express particular ideas, emotions or experiences. Artistic production is, furthermore, widely assumed to require particular sets of advanced skills that need to be learned and trained beforehand (Hecker and Johannsen 2017, 6).

Bibliography

Akser, Murat and Banu Baybars-Hawks. 'Media and Democracy in Turkey: Toward a Model of Neoliberal Media Autocracy'. In *Middle East Journal of Culture and Communication*, vol. 5 (2012): 302–21.

Akyol, Mustafa. *Islam Without Extremes: A Muslim Case for Liberty*. New York and London: W. W. Norton & Company, 2011.

Allen, Graham. *Roland Barthes*. London and New York: Routledge, 2003.

Aytürk, İlker, Yüksel Taşkın, Yalın Aplay, Korkmaz Alemda and Selçuk Orhan, eds. 'Post-Kemalizm'. In *Varlık. Aylık Edebiyat ve Kültür Dergisi*, 86. Yıl, Sayı 1337 (2019). Istanbul: Varlık Yayınları.

Bakiner, Onur. 'A Key to Turkish Politics? The Center-Periphery Framework Revisited'. In *Turkish Studies*, vol. 19, no. 4 (2018): 503–22.

Barthes, Roland. *Mythologies*. London: Vintage Books, 2009 [1957].

Bayram, Salih. *Türkiye'de Başkanlık Sistemi Tartışmaları. Algılar, Argümanlar ve Tezler*. Istanbul: SETA Yayınları, 2016.

Cabas, Mirgün. *Eski Türkiye'nin Son Yılı*. Istanbul: Can Sanat Yayınları, 2017.

Cagaptay, Soner. *The Rise of Turkey: The Twenty-First Century's First Muslim Power*. Washington: Potomac Books, 2014.

Çavdar, Gamze. 'Islamist *New Thinking* in Turkey: A Model for Political Learning?' In *Political Science Quarterly*, vol. 121, no. 3 (2006): 477–97.

Clarke, John, Stuart Hall, Tony Jefferson and Brian Roberts. 'Subculture, Cultures and Class'. In *Resistance Through Rituals: Youth Subcultures in Post-war Britain*, edited by Stuart Hall and Tony Jefferson, 9–74. London and New York: Routledge, 2003 [1975].

Coşkun, Mustafa Kemal and Burcu Şentürk. 'The Growth of Islamic Education in Turkey: The AKP's Policies Toward Imam-Hatip Schools'. In *Neoliberal Transformation of Education in Turkey. Political and Ideological Analysis of Educational Reforms in the Age of the AKP*, edited by Kemal İnal and Güliz Akkaymak, 165–77. New York: Palgrave Macmillan, 2012.

Dağı, İhsan. 'Post-Islamism á la Turca'. In *Post-Islamism: The Changing Faces of Political Islam*, edited by Asef Bayat, 71–108. Oxford and New York: Oxford University Press, 2013.

David, Isabel and Kumru F. Toktamış, eds. *'Everywhere Taksim': Sowing the Seeds for a New Turkey at Gezi*. Amsterdam: Amsterdam University Press, 2015.

Doğan, Sevinç. *Mahalledeki AKP. Parti İşleyişi, Taban Mobilizasyonu ve Siyasal Yabancılaşma*. Istanbul: İletişim, 2016.

Fiske, John. *Television Culture: Popular Pleasures and Politics*. London and New York: Routledge, 2001 [1987].

Gençkal Eroler, Elif. *'Dindar Nesil Yetiştirmek'. Türkiye'nin Eğitim Politikalarında Ulus ve Vatandaş İnşası*. Istanbul: İletişim, 2019.

Gramsci, Antonio. *Selections from the Prison Notebooks*, edited and translated by Quintin Hoare and Geoffrey Nowell Smith. New York: International Publishers, 1971.

Hall, Stuart. 'Introduction'. In *Representation. Cultural Representations and Signifying Practices*, edited by Stuart Hall, 1–11. London: Sage, 1997.

Hall, Stuart and Martin Jacques, eds. *The Politics of Thatcherism*. London: Lawrence and Wishart in association with *Marxism Today*, 1983.

Hall, Stuart and Tony Jefferson, eds. *Resistance Through Rituals: Youth Subcultures in Post-war Britain*. London and New York: Routledge, 2003 [1975].

Hall, Stuart, Chas Critcher, Tony Jefferson, John Clarke and Brian Roberts. *Policing the Crisis: Mugging, the State, and Law and Order*. London and Basingstoke: The Macmillan Press, 1978.

Hebdige, Dick. *Subculture: The Meaning of Style*. London and New York: Routledge, 1979.

Hecker, Pierre. 'Islam. The Meaning of Style'. In *Sociology of Islam*, vol. 6 (2018): 7–28.

Hecker, Pierre and Igor Johannsen. 'Concepts of Culture in Middle Eastern and Islamic Studies'. In *Middle East – Topics & Arguments*, vol. 7 (2017): 5–13.

İnal, Kemal and Güliz Akkaymak, eds. *Neoliberal Transformation of Education in Turkey. Political and Ideological Analysis of Educational Reforms in the Age of the AKP*. New York: Palgrave Macmillan, 2012.

Kandiyoti, Deniz and Ayşe Saktanber, eds. *Fragments of Culture: The Everyday of Modern Turkey*. London and New York: I. B. Tauris, 2002.

Kaya, Ayhan. 'Islamisation of Turkey under the AKP Rule: Empowering Family, Faith and Charity'. In *South European Society and Politics*, vol. 20, no. 1 (2015): 47–69.

Kontny, Oliver. 'From Dissensus to Conviviality: Cultural Politics of Difference in Turkey'. In *Middle East – Topics & Arguments*, special issue on 'Culture', vol. 7 (2017): 51–63.

Kuru, Ahmet. 'Reinterpretation of Secularism in Turkey. The Case of the Justice and Development Party'. In *The Emergence of a New Turkey: Democracy and the AK Parti*, edited by Hakan M. Yavuz, 136–59. Salt Lake City: The University of Utah Press, 2006.

Lord, Ceren. *Religious Politics in Turkey. From the Birth of the Republic to the AKP*. Cambridge and New York: Cambridge University Press, 2018.

Mango, Andrew. *Atatürk*. London: John Murray, 1999.

Mardin, Şerif. 'Center-Periphery Relations: A Key to Turkish Politics?' In *Daedalus*, vol. 102, no. 1, 'Post-Traditionalist Societies' (1973): 169–90.

Mitchell, Timothy. 'Everyday Metaphors of Power'. In *Theory and Society*, vol. 19, no. 5 (Oct. 1990): 545–77.

Okyay, Şaik Orhan. 'Kızılelma'. In *TDV Islam Ansiklopedisi*, 25. Cilt (2002): 559–61. Ankara: TDV Islam Araştırmaları Merkezi.

Ömür, Harmanşah. 'Urban Utopias and How They Fell Apart: The Political Ecology of Gezi Parkı'. In *The Making of a Protest Movement in Turkey*, edited by Umut Özkırımlı, 121–33. London: Palgrave Macmillan, 2014.

Özbudun, Ergun. 'From Political Islam to Conservative Democracy: The Case of the Justice and Development Party in Turkey'. In *South European Society and Politics*, vol. 11, no. 3–4 (2006): 545–57.

Özgür, İren. *Islamic Schools in Modern Turkey: Faith, Politics, and Education*. Cambridge and New York: Cambridge University Press, 2012.

Öztürk, Ahmet Erdi and İştar Gözaydın. 'Turkey's Constitutional Amendments: A Critical Perspective'. In *Research and Policy on Turkey*, vol. 2, no. 2 (2017): 201–24.

Öztürk, Şeyda, ed. 'Laiklikten Sonra'. *Cogito*, Sayı: 94, Yaz 2019. Istanbul: Yapı Kredi Yayınları.

Özyürek, Esra. *Nostalgia for the Modern. State Secularism and Everyday Politics in Turkey*. Durham, NC and London: Duke University Press, 2006.

Şen, Mustafa. 'Transformation of Turkish Islamism and the Rise of the Justice and Development Party'. In *Turkish Studies*, vol. 11, no. 1 (2010): 59–84.

Setton, Kenneth M. *Western Hostility to Islam and Prophecies of Turkish Doom*. Philadelphia: American Philosophical Society, 1992.

Storey, John. *Cultural Theory and Popular Culture. An Introduction*. 5th edn. London: Pearson Longman, 2016.

Toprak, Binnaz, İrfan Bozan, Tan Morgül and Nedim Şener. *Being Different in Turkey: Religion, Conservatism and Otherization. Research Report on Neighborhood Pressure*. Istanbul: Boğazici University, 2009.

Tuğal, Cihan. *The Fall of the Turkish Model: How the Arab Uprisings Brought Down Islamic Liberalism*. London and New York: Verso, 2016.

Uzgel, İlhan and Bülent Duru, eds. *AKP Kitabı. Bir Dönüşümün Bilançosu*. Ankara: Phoenix, 2009.

White, Jenny B. *Islamist Mobilization in Turkey*. Washington: University of Washington Press, 2002.

White, Jenny B. *Muslim Nationlism and the New Turks*. Princeton and Oxford: Princeton University Press, 2013.

Williams, Raymond. *Culture and Society: 1780-1950*. New York: Anchor Books, 1958.

Yavuz, Hakan M., ed. *The Emergence of a New Turkey. Democracy and the AK Parti*. Salt Lake City: The University of Utah Press, 2006.

Yesil, Bilge. *Media in New Turkey. The Origins of an Authoritarian Neoliberal State*. Urbana, Chicago and Springfield: University of Illinois Press, 2016.

Yılmaz, Battal. *The Presidential System in Turkey. Opportunities and Obstacles*. Basingstoke and New York: Palgrave Macmillan, 2018.

Yılmaz, Hale. *Becoming Turkish*. New York: Syracuse University Press, 2013.

Yılmaz, Ihsan. 'Islamist Turn in Turkey, State Transnationalism and Transnational Islamist Unofficial Law'. Working Paper, 12 October 2019, https://ssrn.com/abstract=3485403 or http://dx.doi.org/10.2139/ssrn.3485403 (last accessed 13 August 2020).

Yılmaz, Zafer. *Yeni Türkiye'nin Ruhu*. Istanbul: İletişim, 2018.

PART I

SUBCULTURES AND THE POLITICS OF LIFESTYLES

2

BATTLING OVER THE SPIRIT OF A NATION: ATTITUDES TOWARDS ALCOHOL IN 'NEW TURKEY'

Ivo Furman

For most of the twentieth century, Turkey has enjoyed a relatively liberal relationship with alcohol. In keeping with the secular vision of Mustafa Kemal Ataturk, the Turkish Republic's venerated founder, the state has decriminalised and even encouraged the consumption and production of alcoholic beverages in a predominantly conservative Muslim society. As a result, drinking has become an accepted social norm amongst Turkish citizens, particularly amongst those pertaining to a secular lifestyle (Zat 2012). However, the previous decade has witnessed some dramatic reversals in both social and state attitudes towards alcohol. Ever since the accession to power of the neo-liberal and pious conservative Justice and Development Party (Adalet ve Kalkınma Partisi, AKP) in 2002, alcohol has become a deeply divisive, contentious issue in contemporary Turkish society. Successive AKP governments have greatly increased taxes on alcoholic beverages and enacted draconian regulatory legislative measures aimed at curtailing the presence of alcohol-related imagery in public spaces. And yet the AKP has not attempted to implement an explicitly prohibitory regime. Instead, it has pursued three strategies: a) the declaration of a regulatory 'crusade' on alcohol, b) the politicisation of alcohol's cultural symbolism, with the intention of contesting the myth of nationhood espoused by Turkey's secular establishment and c) the use of alcohol to intensify a populist, majoritarian form of politics which assumes polarisation as a social norm. Alcohol, in other words, has become

the frontline in the AKP's attempts to (re)invent Turkish national identity and culture within the parameters set by Islamic pious conservatism.

'We Don't Want a Wasted Generation' – The AKP's Crusade on Alcohol

The AKP is a political movement rooted in Islamism. Given this, one might expect an AKP government to justify the regulation (or even outright prohibition) of alcohol in Turkey through the deployment of a discourse based on Koranic authority. Instead, however, a kind of nanny state has emerged, one which systematically uses public health concerns to legitimise an ever-expanding regulatory regime around alcohol. With his provocative attitude and often inflammatory remarks, current president Recep Tayyip Erdoğan has emerged as a figurehead for the AKP's self-proclaimed health crusade on alcohol. In his speeches, Erdoğan has relied on clichéd dystopian imagery of 'young children wandering around drunk in the streets' and a 'wasted generation' in order to justify legislative and regulatory state action (Bianet Staff 2013).

In 2005, the first alcohol-related regulation enacted by the AKP sought to restrict advertising of alcoholic beverages in the public sphere.[1] This regulation banned commercials advertising alcoholic beverages to minors and the employment of minors in such commercials. It also banned adverts from making any reference to potentially curative, stimulating or relaxing benefits of alcoholic beverages. The endorsement of such beverages by celebrities or public personalities was similarly prohibited.

Later the same year, the AKP announced a second round of legislation aimed at regulating the number of alcohol permits given to commercial establishments such as bars or restaurants.[2] Article 29 of this legislation stipulated that commercial establishments serving alcohol are barred from operating outside of designated 'alcohol zones' or special entertainment districts. The next article of the same legislation provided a long list of locations where selling or serving alcohol is explicitly prohibited. Some examples include art institutions, service stations, locations within 200 metres of highways or roads and bus stations. Most importantly, any location within 100 metres of public and private school buildings, elementary and middle-school dormitories and kindergartens were banned from selling

or serving alcohol. This legislation did not specify who is responsible for the enforcement of these provisions. However, an official circular published by the Ministry of the Interior empowered provincial governors and local security forces to enforce sections of the regulation relevant to public recreation and entertainment venues.[3]

Soon after these laws were passed, the mass media began to run stories of alleged abuses of power by overzealous conservative governors. According to these reports, the actions of such governors were forcing businesses throughout Turkey to shut down. Public administrators were apparently instrumentalising the new regulations in order to pressure alcohol-serving establishments into relocating, either to the peripheries of provincial cities or to ghettos within metropolitan city centres. One of the inadvertent effects of the legislation was the gentrification of inner city historical neighbourhoods such as Asmalımescit, Cihangir or Karaköy (areas located in Beyoğlu, Istanbul). Such areas have since become nightlife hotspots.[4] In the meantime, the same legislation also caused most state-owned establishments, guesthouses and venues for state workers to stop serving alcohol.

In essence, the 2005 legislature can be interpreted as an attempt by the AKP to a) reduce the presence of alcohol-related advertising in the public sphere, b) relocate or displace sites of alcohol consumption and c) eliminate alcohol consumption in spaces owned or managed by the state.

A more recent round of regulatory measures sought to build upon the 2005 legislation. These laws were introduced in the immediate aftermath of the 2013 Gezi Park protests. They prohibited alcohol companies from using logos, brands and any other references to their products in public spaces. This meant that alcohol companies were no longer allowed to sponsor organisations and events, such as concerts, festivals or other cultural activities. Furthermore, all establishments serving alcohol were compelled to ensure that both the sale and consumption of alcohol be shielded from public view. New measures introduced to restrict the sale of alcohol included a ban on the sale of alcoholic beverages at off-license stores between 10pm and 6am, as well as a ban on the sale of alcoholic beverages from the Internet.[5] These measures can be interpreted as a concerted attempt on the part of the AKP to a) entirely eliminate alcohol-related imagery from public spaces and b) introduce restrictions on the sale of alcoholic beverages from supermarkets and off-license liquor stores.

These efforts work in tandem with dramatic increases in the tax applied to alcoholic beverages. Indeed, the final (and perhaps most dramatic) aspect of the AKP's heavy-handed strategy to regulate alcohol consumption is the levying of special consumption taxes on beverages purchased from supermarkets and off-license stores. These taxes directly target the consumer at the point of sale, and were a matter of contention well before the events of spring and summer 2013. They function as a key component of the AKP's long-term strategy on alcohol.

In 2002, the government instituted a special consumption tax (*Özel Tüketim Vergisi, ÖTV*), raising VAT on alcohol from the regular rate of 18 to 48 per cent, with a further increase to 63 per cent in 2009 (Matthee 2014). As of 2019, the total ratio of tax levied by the state on the sale per bottle of beer is 64.5 per cent and 82.5 per cent per bottle of *rakı* (Silsüpür 2019).

These tax hikes have pushed alcohol products beyond the means of most citizens in Turkey. Prices for a 70 millilitre bottle of *rakı* have surged nearly 500 per cent since 2004 to $23.5 a bottle. This is far in excess of Turkey's consumer price index, which saw a 161.8 per cent increase over the same period.[6] An inadvertent effect of exorbitant prices has been the resurgence of a bootlegging black market for homemade 'bathtub *rakı*' beverages. These are often produced in unsanitary, underground conditions. They are poor quality products made by mixing cheap grain alcohol with water and flavourings such as aniseed oil and glycerin. In recent years, these products have been responsible for numerous alcohol-related deaths (T24 Staff 2019).

'Cheers Tayyip!' – Challenging the AKP's (Neo)Ottomanist Governmentality

Most scholars agree that dominant Islamic teachings forbid alcohol. Nonetheless, history is replete with accounts of imbibing and inebriation throughout the Islamic world (see, for instance, Powell 2004).[7] Furthermore, when one compares the trajectories of different societies in the Muslim world, one sees a mostly ambiguous stance towards alcohol (Matthee 2014). On one end of the spectrum are Saudi Arabia or Iran, while on the other are countries such as Turkey or Jordan (Michalak and Trocki 2006). Making generalisations about alcohol and Islam becomes even more problematic when we consider that the attitude of different governments or rulers within a specific

country can shift according to historical trends. Given such complications, approaching alcohol with generalising assumptions of a universally singular 'Muslim attitude' is misguided. The lack of a universal attitude regarding alcohol throughout the Muslim world means that social and historical contexts need to be carefully incorporated into the discussion.

This is clear in the case of Turkey. Throughout Turkish history, one of the most constant aspects of the place of alcohol in society has been its fluid status and shifting acceptability (Evered and Evered 2015). And yet alcohol also has an important place in the history of Anatolia and Turkey. As the late Vefa Zat explains (2008), alcohol in Anatolia is rooted in traditions preceding the arrival of Turks and Islam, while early Turkic migrant groups from Central Asia also consumed fermented beverages. With the emergence of the Ottoman Empire and its evolution into a multi-ethnic and multi-denominational society, Muslims began to share social spaces with communities who distilled and consumed alcohol. Close proximity to grape cultivation/fermentation, and alcohol-related transactions and practices, led to an increase in the number of imbibing Muslims (Georgeon 2002, 7–9).

Such practices varied according to social background. Commoners who drank would either secretly sneak off into taverns located in the back alleys of non-Muslim quarters or seek refuge in the back room of a local grocer. Conversely, the wealthy upper classes considered alcohol as an entitlement. They would drink within the private confines of their grand homes (*konak*) and seaside mansions (*yalı*). Piousness – and thus abstention from alcohol – was most prevalent among the middle classes (Georgeon 2002). At the turn of the twentieth century, the Ottoman Shaykh al-Islām (supreme religious authority) declared it legal for Muslims to drink (Matthee 2014, 114–15). Prior to this, imbibing during the early modern period of the Ottoman Empire was mostly a practice hidden from public view.

Though Ottoman legal practices were inspired by Islamic orthodoxy, they also demonstrated a certain leniency towards alcohol. Corporal punishment was normally replaced by either a short stay in prison or, more often, a fine. Furthermore, prohibition laws in the Ottoman Empire tended to predominantly target public acts of inebriation rather than private consumption. Ottoman prohibitionism was thus more focused on displacing alcohol-related activities from public/moral view, rather than with suppressing them entirely

(Evered and Evered 2015). For Ottoman authorities, the existence, commerce and consumption of alcohol were less objectionable than public visibility and the disruptions caused by inebriation. Therefore, the declared religious underpinnings for prohibition often originated from decidedly political motivations, reflecting desires 'to prevent public disorders, to avoid public assembly, [and] to limit instances of promiscuity between social strata and different communities which might occur in taverns' (Georgeon 2002, 9–10).

The relatively consistent attitude of the Ottoman authorities prior to the nineteenth century signals the presence of a certain *governmentality* towards Muslim alcohol drinkers. The concept of governmentality can be understood as the organised practices (rationalities and techniques) through which subjects are governed (Mayhew 2004). The goal of these practices is to produce a citizenry best suited to fulfil the needs of those in power; that is, the biopolitical control of human populations. As such, governmentality is simultaneously the art of government, as well as a paradigm of governance (Gordon 1991).

It is not necessary that governmentality be implemented in an overt manner. Instead, the policies of governmentality are usually normalised (Foucault 1991) or even hidden (Scott 1990) through a range of state institutions. The key characteristic of Ottoman governmentality towards alcohol was the creation and maintenance of a regime wherein alcohol consumption was tolerated, yet concealed. This regime was implemented through Ottoman laws, policing and even neighbourhood pressure (*mahalle baskısı*) exerted by pious Muslims on their fellow brethren.

The current regulatory regime created by the AKP in the past decade bears some striking resemblances to the governmentality of Ottoman prohibitionism. 'Alcohol zones', the banning of alcohol sales in spaces owned or managed by the state, restrictions on the sale of alcoholic beverages from supermarkets and off-license liquor stores, the elimination of alcohol-related advertising from public spaces – much of this signals the AKP's intent to (re) introduce the governmentality of Ottoman prohibitionism. The goal of such an intent is to once again render the consumption of alcohol as an invisible, 'marginal' practice.

For a number of reasons – mainly the loss of significant tax revenues – the AKP is manifestly unable to completely prohibit imbibing. Instead, the party

aims to exert control over what it considers to be deviant cultural practices by removing them from public view. As it was in the time of the Ottomans, this form of control signifies a *politics of (in)visibility*. Within such a model, the visibility of certain groups, identities, practices or performances in spaces (both physical and symbolic) depends on their relative proximity (and relationship) to those in power.[8] Within such a context, visibility becomes an expression (or effect) of hegemonic power relations within society.

Marginalising certain groups or practices and pushing them into the shadows is a form of control which supposedly renders deviancy non-existent. For those marginalised, visibility becomes an act of defiance, while the desire for visibility often provides the basis for politics. This puts a different slant on acts of drinking, producing or even referencing alcohol at demonstrations through shouts, signs or T-shirts. Such actions can be read not only as an expression of discontent towards the prohibitionist policies of the AKP (Evered and Evered 2015), but also as tactical resistance towards the hegemonic, (neo)Ottomanist governmentality of Erdoğan's regime.

From this perspective, the popular Gezi slogan 'Cheers Tayyip!' (*Şerefine Tayyip!*) becomes more than merely a sarcastic expression of dissent towards the teetotal AKP. Instead, it appears as a symbolic call for the authorities to dialogically acknowledge the presence of imbibers in Turkish society. After all, toasting to the honour of a person is also a call to be seen or acknowledged by that same individual. By iterating a call for recognition, the slogan resists the politics of (in)visibility imposed by the AKP's neo-Ottomanist governmentality.

Ayran, Our National Drink – Rejecting the Republican Myth of Modernisation

We might dismiss the increasingly draconian regulatory measures introduced by the AKP as undesirable by-products of paternalistic administrators pursuing an overzealous public health agenda. Nonetheless, the peculiarly bellicose attitude of government officials (and in particular President Erdoğan) towards alcohol suggests that their actions may be motivated more by the perceived symbolism of alcohol, rather than by the urge to simply regulate the act of imbibing.[9]

Perhaps the most symbolic (and also vitriolic) remarks made by Erdoğan regarding alcohol came during an afternoon address to the Global Alcohol

Policy Symposium, hosted in Istanbul in April 2013. Organised by the anti-addiction NGO Turkish Green Crescent Society (Türkiye Yeşilay Cemiyeti) and co-sponsored by the World Health Organisation (WHO), the event brought together over 1,200 attendees from fifty-three countries. In his speech, Erdoğan resolutely criticised the abolishment of the Law on Alcohol Prohibition (*Men-i Müskirat Kanunu*). This piece of legislation was enacted by the first Turkish national parliament between 1920–4 to outlaw alcohol consumption during the Turkish War of Independence.[10] Erdoğan proceeded to claim that, by promoting beer as the national drink, the secular opposition Republican People's Party (Cumhuriyet Halk Partisi, CHP) was encouraging drunkenness amongst primary school children.

At the conclusion of his denunciation, Erdoğan decried what he viewed as a false tradition of promoting alcoholic beverages as the nation's drink. Instead, he argued that *ayran* (an alcohol-free, yogurt-based beverage) is 'Turkey's true national drink'. These comments need to be understood not only as an attempt to tackle a public health issue. In fact, they constitute a willingness to stigmatise symbols deeply connected with secular national identity in Turkey. As such, Erdoğan's comments work in tandem with regulatory legislation introduced since the accession of the AKP to power at the turn of the century. Evidently, the AKP perceives alcohol as a substance in dire need of regulation. Apparently, however, the AKP also perceives alcohol as a symbol that can be instrumentalised to contest the myth of secular national identity espoused by the Kemalist establishment in Turkey.

Symbols are one of the ways through which nation states personalise the 'imagined nation' and build national identities (Anderson 1991).[11] Their power enables individuals to feel emotionally and ideologically integrated into a particular national ideal (Giddens 1985, 212–16). They allow individuals who share a particular set of characteristics to believe that they also share some kind of mutual bond. Accordingly, one can imagine symbols, myths, rituals and practices as the glue holding national identity together, thus enabling the formation of 'communities of belonging' (Berezin 2002). These bonds of national collectivity evolve out of common historic memories, myths, symbols and ceremonies that showcase a nation's exceptionalism and include 'the obvious attributes of nations – flags, anthems, parades, coinage, capital cities, oaths . . . as well as more hidden aspects, such as . . . fairy

tales . . . styles of architecture . . . legal procedures . . . and military codes'
(Smith 1991, 77).

Against this background, it could be argued that beverages and their
culture(s) also play an important role in fermenting bonds of national collec-
tivity. Beverages and drinking culture(s) are sites onto which connotations of
nationalist sentiment are imposed and collective bonds of belonging gener-
ated. National beverages do not simply symbolise social bonds and divisions
in a society; they also facilitate their creation and recreation.

In her study, Marie Demossier (2010) argues that, in France, wine is viewed
by the population as a homogeneous mythical element of the French nation
and shared feature of French culture. This is despite the fact that the concept
of wine is also undercut by class and urban/rural cleavages. Until recently,
drinking wine provided a means for the French to cultivate a sense of belong-
ing to the nation in a way that was impossible for other alcoholic products.

The sense of belonging conjured up by wine was also discussed by Roland
Barthes in *Mythologies* (1989). Barthes argues that, for the French, the sym-
bolic connotations of wine are so compelling that an inclination to consume
the beverage with passion seems entirely 'natural'. He argues that this creates
a national mythology of wine to which every French person is expected to
subscribe. Rejecting an offer of wine can even mean running the risk of being
labelled as socially deviant. At the same time, the myth allows fellow imbibers
to entirely ignore the implicit relationship between wine and French impe-
rialism. By presenting something as symbolically 'natural', myths are deeply
bound up with *forgetting*. They obfuscate the political economy behind cul-
tural objects such as wine.

To return to the debate on Turkey's national drink; we might say that
alcoholic beverages (in particular, *rakı*) are also powerful symbols, invested
with the capacity to create their own myths about national culture in
Turkey. Within the context of the Kemalist revolution, it has been argued
that, other than the open display of women's hair, the consumption of alco-
hol was perhaps the most contentious (and distinctive) practice introduced
into daily life at the turn of the twentieth century (White 2010). The act
of consuming alcohol is very much connected with national identity pro-
moted by Kemalist ideology and the narratives of modernity promoted by
the Kemalist nation state.

Typically, this narrative begins with the reforms of Sultan Mahmut II (r. 1808–39). Mahmut II modelled himself on other European rulers and included alcohol as a feature of public occasions such as official dinners and receptions (Georgeon 2002). One of the outcomes of these reforms was the emergence of a new bureaucratic class of Ottoman administrators. Adopting the tastes of their benefactor, these bureaucrats became the first group of Ottoman Muslims to enjoy alcohol in public. To cater for them, a new type of refined and opulent tavern or *meyhane* came into existence, with a professional guild of tavern keepers and their assistants trained in the arts of serving drinks and its accompaniment of mezze.

Much of this new culture of drinking revolved around the newly fashionable *rakı*, which became an identity marker as the native drink of the progressive Ottomans. Over time, *rakı* became the national drink not just of the Ottomans but also of the Turks. Mahmud II's new bureaucracy evolved firstly into the proto-nationalist Young Ottomans, then into the Young Turks (who deposed the conservative, authoritarian Sultan Abdülhamid II) and finally into Kemalist revolutionaries. During this period, *rakı* and *meyhane* culture played an important role as a marker of genealogical continuity between early Ottoman modernity and Kemalism.

After the establishment of the Turkish Republic, alcohol continued to be an important aspect of secular Kemalist culture and the modern elites and bourgeoisie associated with it. In their desire to separate Turkey from the Ottoman past and its 'Oriental' associations, the Kemalist revolutionaries were keen to embrace cultural practices that were more akin to modern European lifestyles. In contrast to the abstinent cultures of Islam, Kemalist revolutionaries saw the consumption of alcohol as something typically European – and thus something to be fully endorsed.

Indeed, Turkey's founding father, Mustafa Kemal Atatürk, was often portrayed to the public as someone who enjoyed *rakı* with gusto. Atatürk played an important role in naturalising the association between alcohol consumption and Turkish national identity. One might go so far as to make the claim that Mustafa Kemal Atatürk was the key figure responsible for building a mythology around *rakı* as the national beverage of the Turkish Republic.

Yet the Kemalist vision of making alcohol consumption an important aspect of Turkish national identity also created a process of social demarca-

tion. Increasingly, those who abstained were symbolically excluded from the narrative of Kemalist national identity. To put it another way, one became a 'modern' citizen of Kemalist Turkey through imbibing. This naturally created a moral dilemma for those who identified themselves as nationalist, devout Muslims. It prevented them from fully embracing some of the nation-building rituals encouraged by the Kemalist nation state. It could be argued that the resulting disenchantment and resentment is a key reason for Erdoğan's insistent promotion of *ayran* over alcohol. His behaviour can be read as a retaliation against the decades-long exclusion of pious Muslims from the psyche of Turkish national identity.

Whether or not we agree with this reading, Erdoğan's words evidently do not constitute a mere rejection of Kemalist nationalism's most enduring myths. They are also part of a revanchist bid to imbue another beverage with the same symbolic significance as alcohol. The promotion of *ayran* as the national drink is, in effect, a top-down imposition, however. It thus breeds social polarisation and provides fuel for the ongoing cultural war in Turkey.

'Don't be Cool, Be Yourself' – New Mythologies for the AKP's 'New Turkey'

Polarisation is not a simple buzzword in Turkey; it is an everyday reality. This reality manifests itself in interpersonal relations. Many people have cut themselves off from their relatives who support opposing parties. This happens not only on social media, but also in real life. Friends become foes, couples drift apart and marriages fail due to partners having different political views. The findings of a recent report titled 'Dimensions of Polarisation in Turkey'[12] suggests that polarisation in Turkey is extremely strong, with populist politicians from both sides of the spectrum exploiting it for their own cynical purposes.[13] One might argue that, within such a context, symbols are used to demarcate political boundaries, mobilise the electorate and ensure inner group cohesion. After all, political movements throughout history have typically used symbols to draw a line in the sand between opposing social groups (Kertzer 1996, 6).

Yet the notion of social collectivity is not as immutable as it might appear. Laclau and Mouffe (2001) argue that categories of social life (nations, communities or societies) which we think of as cohesive totalities are, in fact, a

set of temporary and unpredictable aggregates of differences that have been fused together. What this means is that political strategies are based on the capacity to articulate concepts which describe social relations through a series of differences. Power achieved through politics becomes hegemonic when it can fix aggregates of differences into specific constellations for a temporary period of time.

Within such a framework, it has been argued that populism is a political strategy that relies on articulating difference through the concepts of 'the people' and 'the elite' (Mudde 2004). By playing to the 'hearts' rather than the 'minds' of the people, populist politics typically challenge moribund institutional systems on a symbolic level (Brysk 1995, 561–4). As described in the introductory chapter of this book, the AKP has relied on populist political strategies to attain discursive supremacy over its opponents, and to implement its own hegemonic project within the framework of contemporary Turkey.

When articulating 'the people', populism relies on empty signifiers: symbols and words whose connotative meanings are deliberately vague (Laclau 1977). Empty signifiers allow 'chains of equivalence' to be constructed amongst those engaged with populist politics; the empty signifier represents the fundamental distinctiveness of those challenging the establishment. In moments of organic crisis, populist politics use empty signifiers to rupture the normative representations advanced by the status quo. When successful, populist politics transform what Raymond Williams (1958) described as 'collective structures of feeling', leading to the manifestation of new hegemonic myths and rituals in popular culture (Edelman 1967).

In this light, it is possible to read Erdoğan's symbolic valorisation of *ayran* as a populist attempt to rupture normative representations of national identity. Implicit in the president's comments is an assumption that the status quo of Turkish society is in crisis. His words transform a yogurt-based, non-alcoholic beverage into the tip of a symbolic spear, one intended to puncture the normative assumption that Turks are imbibers. Upon impact, the spear triggers a series of seismic waves that cause shifts in the hegemonic meanings associated with *ayran*. Manifestations of new myths and rituals in popular culture are intentional outcomes of this tectonic tremor.

One example of this shift can be observed in a series of adverts circulated by Sütaş, one of the biggest dairy producers in Turkey. These were broadcast in 2016 and carried slogans such as 'Don't be Cool, be Yourself' and 'Being yourself is the most natural, so drink some Sütaş *Ayran*'. The commercials depicted several imaginary encounters between young people (Sütaş 2018). In these encounters, an internal voice-over (intended to metonymically represent the audience) is used to talk about the notion of 'being cool' as a youth:

> If you call it *mangal*, that's not okay but if you call it BBQ that's cool,
> If you eat *lahmacun* at the *kebab* shop that's not cool, but if you eat it by the seaside that's cool,
> If you call it *makarna* [macaroni] that's not ok, but if you call if spaghetti that's cool

Almost immediately after these comments are made, a young man shaking and drinking a bottle of *ayran* turns his face towards the screen, while the internal voice addresses the audience:

> Whatever you do, some will find it cool and some will not,
> Forget about all this fuss and crack open a Sütaş *ayran*,
> What is most important is that you feel good, are natural and yourself,
> Don't be cool, be yourself

The advertising agency responsible for this commercial released a brief in connection with it. According to this brief, the message of the Sütaş adverts was tailored to target youth between eighteen and twenty-five who struggle to fit in with their peer group.[14] To the target audience, the advert carries a straightforward message of empowerment – popularity is not important, you need to feel good about yourself first. According to the advert, the path to 'being yourself' passes through drinking *ayran* – a beverage apparently imbued with symbolic potency.

On the other hand, coolness (a symptom causing estrangement) is posited through a series of terms and practices carrying Western connotations. Within the paradigm of the advert, eating *lahmacun* by the seaside, using Italian words and calling *mangal* 'BBQ' all serve to signify representations of the Westernised status quo. As such, they are also signifiers of a life separate

from the audience. Within such a framework, *ayran* emerges as the object reconciling the conflict between the worldview of the audience and the status quo.

On one level, the advert implies that *ayran* is something enjoyed by all, regardless of culture, class and lifestyle. This message is demonstrative of the shift in the hegemonic meanings of *ayran* in popular culture. The new myth constructed out of this shift is that *ayran*, as the preferred beverage of Turkish national identity in the AKP era, carries the symbolic power to heal all existing rifts within society. From Erdoğan's point of view, *rakı* or other alcoholic beverages have created a non-inclusive national drinking culture in Turkey. By contrast, *ayran* is the true inclusive beverage into which all segments of society are able to invest nationalist sentiment.

Yet it is important to bear in mind that this shift occurs within a context of extreme political polarisation. There exists no social consensus which designates *ayran* as the national drink of Turkey. Given this, Erdoğan's words, as well as the popular culture representations generated from them, only end up strengthening political polarisation. *Ayran* can only become a national drink within Erdoğan's (New) Turkey. This means that, as a symbol, it only empowers those invested in the political aspirations of the AKP. This seems to be mirrored in the advert, where *ayran* is presented as a beverage empowering the audience against the stigmatising glare of an imaginary, hegemonic other. *Ayran* allows the drinker to not care. Drinking it is portrayed as an act of defiance against the 'game of coolness' imposed by the establishment. As such, one can read the advert as an attempt to turn *ayran* into an empowering symbol of youth rebellion.

At the same time, however, the presence of an imaginary other attests to the impotency of the symbol. Much like rebellious adolescents smoking in front of their parents, the connotative power of *ayran* is only provocative if the hegemon perceives it. As such, it can only be a symbol that consolidates and empowers those who imagine themselves to be outside the establishment. The place of *ayran* within populist political discourse makes it a typical empty signifier. When adopted into populist discourse, the connotations associated with *ayran* become the values through which this distinctiveness is articulated. The interpellative effects of the symbol are expressed within parameters delineated by connotations and myth.

The adoption of *ayran* as the symbolic drink of 'New Turkey' demonstrates both the adaptability of populist political strategy as well as its Achilles heel. Given the lack of a core set of ideological precepts, the 'thin ideology' of populism is in continual need of new signifiers that can penetrate public discourse. The ability to recreate the normative distinction between 'the elite' and 'the people' in political discourse is vital to the propagation and success of populism. Hence, anything can be adopted into the strategy of populist politics – even a watery yogurt-based soft drink.

The populist goal of using symbols and their equivalents is to simplify a highly heterogeneous reality and construct a discursive enemy. Without symbols, populism's Manichean world of 'us' versus 'them' cannot be fully operationalised. This is because the capacity of populist discourses to impel people to action is partly dependent on the degree of antagonism and polarisation present within society. Polish anthropologist Zdzislaw Mach suggests that 'the more antagonistic a social situation, the more active role symbolic actions play, integrating a group, canalizing conflicts or, often, generating open action against opponents or enemies' (1986, 265). Symbols in polarised societies 'enhance oppositions between partners, and define them in clear terms ideologically patterned and saturated with emotions' (Mach 1986, 265–6). Populist political strategies thus work most effectively in polarised societies. Within such a paradigm, mundane cultural objects such as *ayran* can be instrumentalised in order to ensure that populist politics can hammer on incessantly – business as usual.

Conclusion

This chapter has sketched out – in very broad brushstrokes – several different approaches to one of the most understudied subjects in contemporary Turkish cultural studies. As such, the nature of the inquiry pursued here is more exploratory than definitive. The conclusions to draw from this attempt to understand the modus operandi of the AKP with respect to alcohol is as follows:

a) The AKP, from its position of governmental power, has not opted to implement an outright prohibition on alcohol. Instead, it has aimed to impose a rather ham-fisted regulatory regime. Through a mountain of

legislation, this regime seeks to eliminate the visibility of alcohol-related practices from the public sphere. In the meantime, exorbitant taxation is used to curb demand and make alcoholic beverages inaccessible to ordinary citizens. In the long run, the AKP's legislation and taxation policies will turn alcohol into a tolerated substance, only accessible to those able to afford the privacy of luxury hotels and members-only drinking clubs. As noted in the first section of the chapter, the governmentality guiding these policies bears a strong resemblance to Ottoman prohibitionism in the early modern period. These policies have elicited a strong pushback from imbibers, while slogans such as 'Cheers Tayyip!' are formulated acts of resistance to the AKP's politics of imposed invisibility. Within this context, imbibing becomes a symbolic cultural practice to resist the hegemonic tendencies of 'New Turkey'.

b) Alcohol and the culture(s) of imbibing have strong associations with secularism (more specifically, Kemalism) in Turkey. In looking for a way to distance themselves from the Ottoman past, Kemalist revolutionaries wholeheartedly embraced imbibing. They saw this as a 'European' habit. Alcohol consumption thus became a conspicuous marker of secular national identity in Republican Turkey. At the same time, however, it marginalised those who identified themselves as nationalist, devout Muslims, preventing them from fully embracing rituals encouraged by the Kemalist nation state. Therefore, the bellicose attitude of the AKP – and Erdoğan in particular – can be interpreted as a retaliation against what these actors considered to be the exclusion of pious Muslims from the psyche of Turkish national identity.

c) President Erdoğan's words are not just a rejection of Kemalist nationalism's most enduring myths. They also constitute an attempt to imbue an alternative beverage with the same symbolic significance as alcohol. As a populist, his incessant promotion of *ayran* fuels the ongoing cultural war in Turkey. It is an attempt to turn *ayran* into a symbol that ruptures normative representations and causes a shift in the collective structures of feeling. This shift leads to the manifestation of new hegemonic myths and rituals in popular culture. As the Sütaş advert demonstrates, one such myth that has begun to circulate in popular culture is that *ayran* is the only truly inclusive national beverage, enjoyed by all. Yet as this shift occurs within a

context of extreme political polarisation, *ayran*'s connotations as a symbol only empower those invested in the political aspirations of the AKP. *Ayran*'s status as the national drink of Turkey can only empower in opposition to *rakı* – and more hegemony. *rakı* represents. Ultimately, the contradictory position of the symbol signals its impotency within the wider realm of cultural hegemony. It also reveals the AKP's cynical use of mundane cultural objects such as *ayran* to ensure the perpetuation of populist politics.

Notes

1. *Alkollü İçki Reklamlarında Uyulacak İlkeler Hakkında Tebliğ*, http://www.resmigazete.gov.tr/eskiler/2005/01/20050118-15.htm (last accessed 21 November 2020).
2. *İşyeri Açma ve Çalışma Ruhsatlarına İlişkin Yönetmelik*, http://www.resmigazete.gov.tr/eskiler/2005/08/20050810-4.htm (last accessed 23 November 2020).
3. *Umuma Açık İstirahat ve Eğlence Yerlerine Ait Genelge* (2005/2), https://mengenpolis.tr.gg/Umuma-A%E7&%23305%3Bk-Yerler.htm (last accessed 27 November 2020).
4. The relative autonomy of these neighbourhoods from municipal and state interference came to an end in July 2011 when local authorities, citing the need to restore public order, clamped down on alcohol serving establishments and removed tables set out on the streets of Beyoğlu. This unfortunate development occurred during business hours and led to a rather surreal situation wherein startled diners were forced to pick up their plates of food and leave the premises. Soon afterwards, the ban on dining in the streets became permanent, causing many alcohol serving establishments to shut down or move to new locations.
5. *Bazı Kanunlar İle 375 Kanun Hükümünde Kararnamede Değişiklik Yapılması Hakkında Kanun*, http://www.resmigazete.gov.tr/eskiler/2013/06/20130611-1.htm (last accessed 23 November 2020).
6. Ataman, Joseph. "Climing Taxes Ferment Turkey's Home-Made Booze". *AP News*, 26 October 2017, https://archive.fo/0ZGvV#selection-215.0-215.256 (last accessed 27 November 2020).
7. The Koran, Islam's sacred text, ultimately condemns grape wine (*khamr*) for its effect, intoxication, which interferes with the clear-headedness needed for the proper execution of its religious commands.
8. For this observation, I am indebted to my colleague Cengiz Haksöz and his excellent presentation at the *Politics of Culture in Contemporary Turkey* workshop in Marburg in February 2018.

9. The president himself often engages in provocative polemics around alcohol – for instance, labelling all imbibers alcoholics, or suggesting that those involved in the repealing of 1920–194 prohibition laws (an allusion to Mustafa Kemal Atatürk and his commander-in-chief, İsmet İnönü) were 'a pair of drunkards'.

10. For more about the history of prohibition in Turkey during the early twentieth century, see Evered and Evered (2016) or Karahanoğulları (2008).

11. For Benedict Anderson, nationality and nationalism are cultural artefacts of an imagined political community that is both limited and sovereign and that came to exist in the imagination of people as a result of technological and economic changes.

12. Dimensions of Polarisation in Turkey (*Türkiye'de Kutuplaşmanın Boyutları*). A summary of the key findings is available at: https://goc.bilgi.edu.tr/media/uploads/2018/02/06/dimensions-of-polarizationshortfindings_DNzdZml.pdf (last accessed 23 November 2020). The research has been turned into a book: Erdoğan, Emre and Pınar Uyan Semerci. *Fanusta Diyaloglar* (Dialogues in a Bell Jar), Istanbul Bilgi University, 2018.

13. In this particular study, respondents were asked to identify a party whose supporters they felt close to (own party) and a party whose supporters they felt most distant from (other party). Afterwards, these two points of reference were used to measure the dimensions of polarisation, such as social distance, perceived moral superiority and political intolerance. The results of the research revealed a striking degree of polarisation in Turkish society.

14. Öztamur, Kaan. "Sütaş Ayran'dan cool reklam filmi . . ." *Halkla İlişkiler*, 13 September 2016, http://halklailiskiler.com.tr/Sutas_Ayrandan_cool_reklam_filmi.php (last accessed 27 November 2020).

Bibliography

Anderson, Benedict. *Imagined Communities: Reflections on the Origin and Spread of Nationalism*, revised and extended edition. London and New York: Verso, 1991.

Barthes, Roland. 'Wine and Milk'. In *Mythologies*, translated by A. Lavers. London: Paladin Grafton Books, 1989.

Berezin, Mabel. 'Secure States: Towards a Political Sociology of Emotion'. In *The Sociological Review*, vol. 50 (2002): 33–52.

Bianet Staff. 'Kafası Kıyak Nesil İstemiyoruz'. In *Bianet*, 24 May 2013, https://m.bianet.org/bianet/yasam/146874-kafasi-kiyak-nesil-istemiyoruz/ (last accessed 23 November 2020).

Brysk, Alison. '"Hearts and Minds": Bringing Symbolic Politics Back In'. In *Polity*, vol. 27 (1995): 559–85.

Demossier, Marion. *Wine Drinking Culture in France: A National Myth or a Modern Passion? French and Francophone Studies.* Cardiff: University of Wales Press, 2010.

Edelman, Murray J. *The Symbolic Uses of Politics.* Urbana: University of Illinois Press, 1985.

Evered, Emine Ö. and Kyle T. Evered. 'A Geopolitics of Drinking: Debating the Place of Alcohol in Early Republican Turkey'. In *Political Geography*, vol. 50 (2016a): 48–60.

Evered, Emine Ö. and Kyle T. Evered. 'From *Rakı* to *Ayran*: Regulating the Place and Practice of Drinking in Turkey'. In *Space and Polity*, vol. 20 (2016b): 39–58.

Foucault, Michel. 'Governmentality'. In *The Foucault Effect: Studies in Governmentality: With Two Lectures By and An Interview With Michel Foucault*, edited by Graham Burchell, Colin Gordon and Peter Miller, 87–103. Chicago: University of Chicago Press, 1991.

Georgeon, François. 'Ottomans and Drinkers: The Consumption of Alcohol in Istanbul in the Nineteenth Century'. In *Outside In: On the Margins of the Modern Middle East. The Islamic Mediterranean*, edited by E. L. Rogan, European Science Foundation, 7–30. London and New York: I. B. Tauris, 2002.

Giddens, Anthony. *The Nation-State and Violence. A Contemporary Critique of Historical Materialism.* Berkeley: University of California Press, 1987.

Gordon, Colin. 'Governmental Rationality: An Introduction'. In *The Foucault Effect: Studies in Governmentality: With Two Lectures By and An Interview With Michel Foucault*, edited by Graham Burchell, Colin Gordon and Peter Miller, 1–51. Chicago: University of Chicago Press, 1991.

Haksöz, Cengiz. 'The Politics and Culture of (In)Visibilities in Turkey: Practices, Regulations and Discourses around Alcohol Consumption'. Paper presented at the workshop *The Politics of Culture in Contemporary Turkey.* Marburg, 15 February 2018.

Karahanoğulları, Onur. *Birinci meclisin içki yasağı: men-i müskirat kanunu.* Ankara: Phoenix Yayınevi, 2008.

Kertzer, David I. *Politics and Symbols: The Italian Communist Party and the Fall of Communism.* New Haven: Yale University Press, 1998.

Laclau, Ernesto. *On Populist Reason.* London and New York: Verso, 2005.

Laclau, Ernesto. *Politics and Ideology in Marxist Theory: Capitalism, Fascism, Populism.* London: Verso, 1977.

Laclau, Ernesto and Chantal Mouffe. *Hegemony and Socialist Strategy: Towards a Radical Democratic Politics.* 2nd edn. London and New York: Verso, 2001.

Mach, Zdzisław. *Symbols, Conflict, and Identity: Essays in Political Anthropology.* Albany: State University of New York Press, 1993.

Matthee, Rudi. 'Alcohol in the Islamic Middle East: Ambivalence and Ambiguity'. In *Past & Present*, vol. 222 (2014): 100–25.

Mayhew, Susan. *A Dictionary of Geography*, 4th edn. Oxford and New York: Oxford University Press, 2009.

Mudde, Cas. 'The Populist Zeitgeist'. In *Government and Opposition*, vol. 39, no. 4 (2004): 541–63.

Powell, Arthur James. 'Only in Paradise: Alcohol and Islam'. In *Religion & Alcohol: Sobering Thoughts*, edited by C. K. Robertson, 95–110. New York: P. Lang, 2004.

Scott, James C. *Domination and the Arts of Resistance: Hidden Transcripts.* New Haven: Yale University Press, 1990.

Silsüpür, Sinan. 'Alkol Dosyası I: Alkol yasakları vergiler ve tüketim'. In *Teyit.* 1 February 2019, https://teyit.org/alkol-dosyasi-i-alkol-yasaklari-vergiler-ve-tuketim (last accessed 23 November).

Smith, Anthony D. *National Identity, Ethnonationalism in Comparative Perspective.* Reno: University of Nevada Press, 1991.

Sütaş. 'Barbekü Oğlan'. In *Sütaş Reklam Filmleri.* 17 April 2018, https://www.sutas. com.tr/tr/medya/reklam-filmleri/ayran-reklamlari/barbeku-oglan (last accessed 23 November 2020).

T24 Staff. 'Metil alkolden ölenlerin sayısı 13e yükseldi'. In *T24.* 12 July 2019, https://t24.com.tr/haber/metil-alkolden-olenlerin-sayisi-13-e-yukseldi,830364 (last accessed 23 November 2020).

White, Jenny. 'Fear and Loathing in the Turkish National Imagination'. In *New Perspectives on Turkey*, vol. 42 (2010): 215–36.

Williams, Raymond. *Culture and Society, 1780–1950.* New York: Columbia University Press, 1958.

Zat, Vefa. *Biz Rakı İçeriz (Rakının Geçmişi ve Bugünü).* Istanbul: Overteam Yayınları, 2012.

3

'SPREADING VX GAS OVER KAABA': ISLAMIC SEMIOTICS IN TURKISH BLACK METAL

Douglas Mattsson

'KUTUYU YAK! KUTUYU YAK!' ('Burn the box! Burn the box!') is chanted in the concert venue located one floor underground. Almost solely dressed in black with fists raised, the one-hundred-person strong audience is eagerly awaiting the Istanbul-based black metal band Sarinvomit to start their next song. As demanded by the audience, vocalist Tyrannic Profanatör announces the next song with a growl, 'SPREADING VX GAS OVER FUCKING KAABA!', and a roar of approval fills the venue. Once the first chord is struck by the guitarist Godslayer, a mosh-pit begins, and the front row is pulled into a (controlled) frenzy of bodies and hair slamming into one another. – field note, Ankara 2017.

Black metal, one of the most extreme subgenres of metal music, is famous for its brutal, multimodal expression in lyrics, imagery and music. The genre's metanarrative is centred around a disdainful and provocative stance towards religion, one infused with an anti-establishment and anti-authoritarian rhetoric. Blasphemy commonly lies at the heart of this meta-narrative. Black metal bands make conscious use of blasphemous verbal expressions and images (exemplified by the musicians' choices of alias). The aim is to conjure and commemorate evil, death and suffering, both lyrically and on stage. To this end, bands of this genre use corpse paint (a style of black-and-white face paint) and sometimes engage in extreme stage

behaviour, with some black metal bands known to soak themselves and their audience in pig blood (Kahn-Harris 2007; Patterson 2013).

To this day, Turkish black metal is mainly an underground phenomenon. There have been few significant scholarly attempts to study black metal in Muslim majority societies, or in Turkey more specifically (the present author's previous work being a rare exception) (Mattsson 2016, 2018; Otterbeck et al. 2018). *Heavy Metal Islam* (2008), Mark LeVine's pioneering work on metal music in the Middle East, does not address black metal, and nor do his later articles (see for example LeVine 2009, 2011). Orlando Crowcroft's journalistic book about metal music in the Middle East, *Rock in a Hard Place* (2017), does cover black metal in, for example, Lebanon and Saudi Arabia, but it does not address Turkey.

The only exception to this overall trend is Pierre Hecker's research (2010, 2011, 2012), and particularly his book *Turkish Metal* (2012). This is the most ambitious work on metal in Turkey currently available, and it also includes a chapter on black metal. In this book, Hecker observed that most Turkish black metal bands avoid engaging in the public desecration of Islamic symbols in their lyrics and artwork (Hecker 2012, 137ff). But since the book was first published in 2012, this situation has changed, as the anecdote at the beginning of this chapter indicates. Today, Turkish black metal bands deliberately target Islam.

This chapter investigates this change within the Turkish black metal scene towards incorporating Islamic semiotics in a multimodal fashion through lyrics, artwork and audio. It is based on extensive fieldwork, conducted between 2014–18, and interviews with twenty-four people affiliated with the Turkish black metal scene. It poses two key questions: first, why are these developments occurring now? And second, which meanings are ascribed to them by fans and musicians of the genre in Turkey? In response to these questions, it is argued here that the growing references to Islam in Turkish black metal are closely related to a dialectical relationship with international, as well as national, expectations of subcultural concepts such as authenticity and identity. Furthermore, these newly emerged expressions must be recognised as a subcultural response and counter-hegemonic resistance against the AKP's growing dominance and the concomitant rise of pious conservatism.

This chapter thus challenges the popular myth that there exists a hegemonic respect for religion in Muslim majority societies. After a short introduction to the genre in Turkey, the chapter proceeds to examine two textual, one visual and one audio example of this new subcultural expression, and from there to discuss why this change has occurred.

Black Metal in Turkey

Black metal music has a long history in Turkey. In 1990, the iconic Norwegian band Mayhem played in Izmir. This concert has come to be considered an important historical event by people in the Turkish black metal scene (Hecker 2012, 132–3). And yet, the first Turkish black metal band, the Ankara-based Witchtrap, was actually formed in 1988, two years prior to the Mayhem concert (Hecker 2012, 135). Witchtrap, along with Infected, Pagan, Ehrimen and Ebonsight, constitute the first generation of Turkish black metal bands. Thematically, these earlier bands generally conformed to the pattern evident within the broader international black metal scene, which entailed a focus on anti-Christian or satanic, rather than Islamic, religious themes (Hecker 2012, 136ff.).

By the early 1990s, 'metal' and metalheads had acquired a new public visibility in Turkey. As had been the case in other countries (Weinstein 2000; Kahn-Harris 2007; LeVine 2008; Brown 2011; Crowcroft 2017), the reaction from Turkish society was not one of approval (Hecker 2012). Following a metal concert in Istanbul in the autumn of 1990, the popular journalist Engin Ardıç wrote a polemical piece about metal music in the Turkish *Daily Sabah*. In this article, metalheads were depicted as sexually, socially, religiously and politically deviant and subversive. They were further accused of participating in black masses, drinking alcohol and 'copulating like dogs' (qtd. in Hecker 2012, 82ff.).

This negative portrayal of metal continued throughout the 1990s and culminated in a full-blown moral panic. The first indications of this came with the Turkish press blaming metal music for causing a series of teenage suicides (Hecker 2012, 89–90). In September 1999, when the murderers of a girl in Ortaköy, Istanbul, claimed that they had committed the act by order of Satan, Turkey was throw into a full-scale moral panic (Hecker 2012, 91). The crackdown on metal that resulted was intense; metal bars were raided

and closed, bands dissolved, fanzines went bankrupt, parents cancelled their children's guitar lessons and burned their metal albums. Indeed, some male fans even cut their long hair because of fear of reprisals.

This extensive harassment of metalheads has since receded, but it remains a testimony to how (black) metal culture constitutes a contested presence in the public sphere. Several of the transgressive qualities of metal culture observed by Hecker (2010, 2011, 2012) still hold true today, with metalheads continuing to experience harassment due to their subcultural engagement (Mattsson 2018). What now follows are a few examples of Turkish black metal bands who have taken the practice of artistic transgression even further than before. Whereas previous Turkish black metal bands avoided references to Islam in their cultural production, today there are some bands that actively engage in it.

The Shift towards Islamic Semiotics

Let us now turn to some explicit examples of the Turkish black metal scene's use of Islamic semiotics to communicate an anti-Islamic message. It should first be mentioned that the public display of anti-Islamic expressions is a rather new and unusual phenomenon, and by no means representative of all Turkish black metal bands. Out of a sample of ninety-five Turkish black metal records, demos and EPs produced between 1992–2018, only fifteen openly utilised Islamic semiotics in a demeaning way (Mattsson 2018). The remainder relied instead on different and more familiar aspects of the black metal metanarrative, such as anti-Christian and satanic themes, while much of the sample avoided the topic of religion altogether (Mattsson 2018).

Of those cultural artefacts that did indeed use Islamic semiotics, the first lyrical example dates back to 2003, whereas the first audial and visual examples were released in 2007 and 2011 respectively. However, the bulk of anti-Islamic black metal was produced after 2012. The empirical material analysed here will be interpreted according to the general principles of social semiotics. These provide a language and a means of adequately analysing the material due to its multimodal (visual, aural and textual) nature (Van Leeuwen 2005). The lyrics are reproduced as found (grammatical mistakes intact), though in capital letters, to stress the sheer volume of their articulation when screamed or growled in a live setting.

'Medina' by Zifir – *Kingdom of Nothingness* (2017)

I AM THE DEVIL,
COME AND STONE ME,
PAY MONEY TO THE ARAB,
COME AND STONE ME,
REVOLVE AROUND A STONE,
FIND ALLAH,
ONCE YOU GET OUT OF THERE,
COME AND STONE ME,
HEAT, DIRT, SWEAT AND SHIT,
GET CLOSER TO ALLAH,
THEN COME AND FIND ME,
NO MATTER HOW YOU TIRE YOUR ARM
THE STONE YOU THROW WILL NOT TOUCH ME,
NO MATTER HOW MUCH YOU BEG,
ALLAH WILL NOT SEE YOU

This first example is the song 'Medina' by the band Zifir ('pitch black'). Even the song's title features an Islamic semiotic resource. Alongside Mecca, Medina is considered one of the holiest cities of Islam; it is the place where the prophet Mohammad sought refuge after he was forced to leave Mecca. The city thus enjoys a special status among Muslims, and it evokes feelings of respect and reverence (Hammoudi 2006). Moreover, in modern history, entry to Mecca and Medina was strictly limited to Muslims, which emphasises their religious significance.

However, though the title refers to the city of Medina, the song actually describes the failure to complete the ritual of stoning the devil at Mina, in Mecca. This performative act, which is part of the obligatory pilgrimage (*hajj*), commemorates the rejection of Satan by the prophets Ibrahim, Hajar and Ismael. It is performed by stoning three pillars, which represent the temptation to disobey God (Hammoudi 2006, 231ff.). The pilgrims then precede to shave their heads, symbolising ritual cleanness, an idea that is ridiculed in the song by emphasising the physical conditions that surround the ritual ('heat, dirt, sweat and shit'). Stoning the devil should signify the pilgrims' allegiance with God. In the song, however, the narrator is positioned as the Devil, and the pilgrims

fail to honour their allegiance. This not only implies the Devil's supremacy over God, but it could be read as a call to disobedience. Apart from targeting religious rituals, the song also critiques the economic aspects of pilgrimage. The phrase 'pay money to the Arab' alters the purpose of the pilgrimage to one of base economics rather than devotion. It also implies a possible anti-Arab racism.

An awareness of the theological importance of stoning the Devil requires some previous knowledge of Islamic history. This indicates that the song's target audience is Turkish and has been socialised in an Islamic culture. That said, the *hajj* is globally recognised. Coupled with the narrative of the song, and the inclusion of the word 'Allah', the message of 'Medina' should be easy to decipher for Muslims and non-Muslims alike. But if the title leaves any ambiguity in the mind of the reader or listener, then the same certainly cannot be said of the next song analysed here:

'Spreading VX Gas Over Kaaba' by Sarinvomit – *Baphopanzers of the Demonical Brigade* (2015)

INFINITE AEON BEGAN FOR HELLISH NUCLEAR DOMINANCE
PANDEMONIUM ORDERED TO DEVASTATE THE HOLINESS
GOETIC DEMONS GATHERED, TUBES OF VX GAS WERE FILLED
DURING THE CIRCUMAMBULATION KAABA WAS ENCIRCLED

PLEASURES OF MASSACRE, ESCAPE OF WORSHIPPERS
SHAMEFUL RELIGIOUS SUPPLICATION
DROWNED IN THEIR VOMIT WHILE THEY'RE PRAYING
PARAMOUNT VIEWS OF DEPRAVATION
ISLAMIC SCRIPTURES WERE TOTALLY DESTROYED
BY THE SACRILEGIOUS ABHORRENCE

EJACULATION OF GOATLORD WHO STANDS ON DEAD PROPHETS
HADJIS ARE AGONIZING UNDER THE RADIOACTIVE MASS

SUFFERING GABRIEL ARE SUCKING IMPURIFIED BLOOD
OF THE DEVIL-STONERS IN MINA
EMBLAZONED GOATS ARE INSEMINATING THEIR WIFES
WITH SEMEN MIXED WITH VX GAS
GENOCIDE WEAPONS CREATED MIASMATIC BLACK SKY
END OF FUCKING SANCTIFIED LIVES

TEMPESTUOUS LETHAL GAS FOR THE VICTORY OF
SLAUGHTER RITES
PHENOMENAL DEVASTATION WAR AGAINST THE HUMAN KIND

CELEBRATION OF CHEMICAL ARMAMENT AGAINST THE
DEVOTEES
BEFOULED DIVINE BODIES EXPLODED AND SPILLED OUT
AROUND
THOSE WHO FLED TO SHELTERS WERE IMPALED ON POLES
IN HEAT
SPREADING VX GAS OVER KAABA, LUST OF MASS POISONING

SPREADING VX GAS OVER FUCKING KAABA
FINALLY COMING OF RADIATIONAL WHIRLWINDS
SPREADING VX GAS OVER FUCKING KAABA
COLLAPSING OF FUCKING MUSLIM EMPIRE

To my knowledge, these lyrics constitute the most explicit and extreme example to date of the utilisation of Islamic semiotic resources for conveying an anti-Islamic message. The Kaaba in Mecca holds a central place in Muslim mythology. According to Islamic beliefs, it was constructed by the prophet Ibrahim as the first temple devoted to God. The Kaaba is said to be the first place Mohammed journeyed to after gaining control over Mecca in order to rid it of idols and to restore it to its original purpose, which was forgotten during the 'time of ignorance' (*jahiliyyah*).

Thus, the significance of the Kaaba cannot be overstated. And in this song, it is this site which is symbolically attacked with lethal nerve gas (VX gas). The lyrics give a detailed description of how demons, demon-goats and Baphomet[1] surround the Kaaba during the *hajj* and proceed to slaughter the pilgrims ('hadjis'). Women are raped and inseminated with a mixture of VX gas and goat semen, and those who try to escape perish in flames. As a further humiliation, a victorious goat lord stands on top of the dead prophets and ejaculates. Islamic scriptures and the Muslim empire are desecrated and destroyed.

In addition to utilising Islamic semiotics, the lyrics make use of anti-Christian semiotics that are common in black metal. References to the 'goat lord' and 'Baphomet' clearly indicate an ambition to communicate to a global black metal audience, and to stress that the band is not only anti-Islamic but

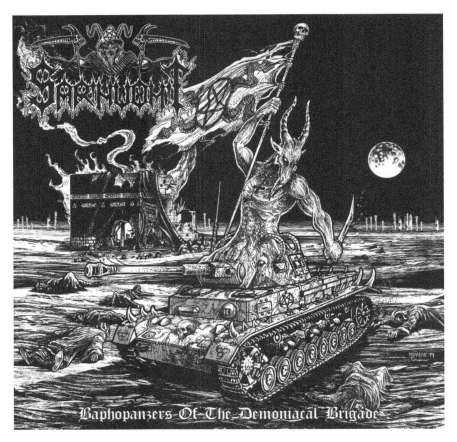

Figure 3.1 Sarinvomit, *Baphopanzers of the Demoniacal Brigade*. Seven Gates of Hell, 2015 (Artwork by Chris Moyen)

also anti-Christian. This hateful message towards religion is further emphasised in the cover of the album.

The cover artwork for Sarinvomit's album *Baphopanzers of the Demoniacal Brigade* (2015) is obviously inspired by this song. The black and white composition was drawn by the French artist Chris Moyen (a well-established artist in the genre of extreme metal covers). It depicts a gruesome scene. In the centre of the composition is a hybrid creature, the Baphopanzer – half tank, half Baphomet – who triumphantly raises a flag emblazoned with a pentagram. The reason for his victorious stance is visible in the background. The Kaaba is demolished and the black, heavily embroidered garment that usually

covers its structure is burning. Spread on the ground around the Baphopan-zer, the drawing depicts the dead bodies of apparently slain pilgrims. Fur-thermore, the moon is full, not half or formed as a crescent, while the night sky further reinforces the sense of 'darkness triumphing over light'. There are three sixes in a circle (symbolising the number of the beast) on the front of the Baphopanzer, as well as a pentagram on its side.

The representation makes no attempt to be realistic; there is no sign of the mosque, *al-masjid al-haram*, surrounding the Kaaba, not even in the form of rubble. The city of Mecca is likewise not represented. Instead, the artwork aims to be communicative. It thus draws attention to two key aspects of the image: the destroyed Kaaba and the triumphant Baphopanzer. The message embodied in the cover artwork is simple: death to Islam.

Turkish black metal bands also invoke Islam on the sonic (as well as the verbal and visual) level. The growled or screamed vocals of black metal invari-ably distort the lyrical references to Islam, rendering them hard to decipher without the aid of printed lyrics. However, it is far easier to recognise a sample of, for instance, the call to prayer (*ezan*). Moreover, the multimodal context surrounding the sample has the potential to alter its original purpose (in this case, calling people to prayer). For example, the song 'W.A.R.', from Ehri-men's 2009 EP *Unholy Metal*, features a drum break into which a sampled *ezan* is incorporated. The break is preceded by lyrics, forcefully delivered with growling vocals and aggressive music, about how a war is approaching. The chorus reminds listeners that they should not forget which side they are fight-ing for. The *ezan* ends with a bomb blast, suggesting that the target was the mosque. Here, the Islamic semiotic resource of the *ezan* is transferred from a context of worship into a symbol of Islam that can be opposed with a mes-sage of hate.

It should be mentioned that not every song utilising explicit references to Islam focuses on pilgrimage. Other lyrics target Muslims, Allah or Moham-med. Many songs rely on explicit references and clearly hateful, murderous and humiliating contexts in order to convey their central ideas. One ten-dency is to target 'the message' of Islam. Imams and preachers' tongues are cut out, while the ideas, morals and scriptures of Islam are destroyed. It is hard to interpret the message as anything other than hatred towards religion, and especially Islam.

As already stated, the incorporation of Islamic semiotics into black metal is a new and unusual phenomenon. So why has this become an increasingly prominent aspect of Turkish black metal music? This is not an easy question to answer; nor is the answer likely to be straightforward. But, as the following argument suggests, any serious attempt to answer this question must draw on subcultural expectations of identity and authenticity, as well as attempted acts of subcultural resistance.

Authenticity, Identity and Subcultural Expectations

This chapter argues that the recently emerging phenomenon of blasphemous anti-Islamic representations in Turkish black metal is related to the scene's constant appeal to notions of authenticity, and their self-reflective subcultural and subversive identity. Numerous discussions were conducted with Turkish black metal protagonists about other cultural representations of blasphemy, such as anti-Christian sentiment, within this musical genre. During these discussions, it became obvious that the process of incorporating Islamic semiotics into Turkish black metal culture is closely linked to a discourse of authenticity. One member of a black metal band expressed it this way:

> Because it is our originality I mean, if we used inverted crosses and . . . churches being burned in our covers it would mean nothing in this country. I mean these symbols have not any meaning like if you put an inverted cross in Turkey and you are walking around the street. They would think that you are Christian, not anti-Christian so it's just meaningless. And since we are from here since we are against . . . we are provocative against the traditions of this country and this society, so it is very normal actually for me to use traditional symbols of this country and the religion of this country. – SB14.[2]

Besides stating that the use of Islamic semiotics in an anti-Islamic fashion is connected to a sense of originality and authenticity, the quote also provides insight into one of two common understandings held by some members of the scene regarding anti-Christian symbols. On the one hand, they argued that inverted crosses are not deciphered as an attack on religion, but rather as an embracement of Christianity; to use such symbols is therefore not an effective means of conveying the intended message. On the other, they suggest that anti-Christian sentiments, instead of being understood as an attack

on religion, would be understood as an attack on Christianity, which would be supported, not denounced, by many in Turkey. Whether or not this is an accurate analysis is up for debate, but there does, indeed, exist a widespread resentment towards Christians in Turkey (Karlsson 2011).

Either way, there is evidence here of a clear perception that the desired transgression and provocation cannot be accomplished solely through the use of anti-Christian expressions. Furthermore, the inclusion of anti-religious and satanic themes in music and lyrics was, for the majority of the interlocutors, absolutely determinative of whether or not something could be considered black metal. This was not only perceived as music, but more importantly, as an ideology:

> The lyrics are extremely important of course. No matter how good a band sounds, without satanic concepts dealing around themes like destruction, evil, desecration, fanaticism and devil worship, it will never be a real black metal band in my eyes. Black metal has become more than 'just music'. One has to provide more than just some riffs and shrieks to be considered a black metal band. – ADG6.

It does not suffice to have the right sound in order to be regarded as black metal. Indeed, for many, the lyrics are at least as important as the music, if not more so. In many cases, bands without explicit anti-religious lyrics and titles were excluded from the interlocutors' definition of black metal. Of course, the fact that members of subcultures impose an internal categorisation system, creating their own hierarchy of 'insider and outsider' (Williams 2011, 126–44) – or in this case, what constitutes 'true black metal' – is not particularly revelatory (Kuppens and van der Pol 2014). Here, however, it is not music or clothes that serve as the main divider, but a band's or a scene member's ability to participate in discursive transgression. To articulate – in words and actions – a rejection of religion and Islam; this provides the key element in the construction of this particular subcultural identity.

The change in attitude is noteworthy. It indicates a clear shift in how the Turkish metal and black metal community articulates its relation to religion. In the past, many Turkish metalheads openly described themselves as 'secular Muslims' with a belief in God (Hecker 2012, 139). Now, at least within the

black metal community, all but one of those interviewed described themselves as atheists and claimed to have no spiritual belief.

This change in self-perception was also considered important when communicating with international record labels or concert organisers. Some bands felt a need to 'prove themselves' – to prove their authenticity – by explicitly exemplifying that they really were an anti-religious black metal band. They aimed to accomplish this through lyrics, artwork and action. While touring abroad, Turkish black metal bands frequently found themselves confronted with skepticism that anyone from a Muslim country could play metal or, more importantly, anti-religious black metal. At a metal festival in Bucharest, one band even had to show their passports to festival attendees in order to prove that they really were a black metal band from Turkey.

This points to the fact that a particular band's claim to authenticity is not the only factor in their promotion of an explicit anti-religious identity through an active choice in semiotic composition (Van Leeuwen 2005). Of huge significance here are national and international expectations of what constitutes black metal. The exclusion of bands that do not promote an anti-religious agenda from black metal could be considered an attempt to meet and cope with these demands of subcultural identity. But it also indicates an ambition to communicate to a wider national and international audience. Alone, however, this ambition is inadequate as the sole explanation for these new artistic expressions. Another key factor is linked to subcultural resistance.

Islamic Semiotics and Subcultural Resistance

As should be clear from the introductory chapter of this volume, the political, religious and social climate in Turkey has changed dramatically since the AKP came to power. The novel form of artistic expression whereby black metal music has come to deliberately target Islam can thus be seen as acts of subcultural counter-hegemonic resistance.

According to subcultural theorist Patrick J. Williams, subcultures provide a form of resistance to power achieved through hegemony. This is because subcultures 'offer alternative frames of reference wherein young people learn to think outside the box, or at least learn to think inside a different box' (Williams 2011, 91). For many interlocutors, the discursive

transgression of religious norms, and those of Islam more specifically, constitute an important and empowering aspect of the genre. Devotees of black metal now felt that, through this music, it was possible to voice opinions about life and religion that could not otherwise be expressed. For instance, to metaphorically proclaim the death of Islam and wish for lethal nerve gas to be released over Kaaba could, if voiced in public, carry severe social and even legal consequences. However, expressing them in lyrics, or listening to foreign bands voicing criticism and hatred towards religion, is considered both achievable and cathartic. As one interlocutor said: 'To see the Kaaba burn gives me an emotional erection'.

One might say that the bands' music should not be regarded as *actual* resistance, because few people outside of the subculture actually hear it. But as Williams (2011, 95) argues, the important aspect of this equation is how the subculturalists *themselves* perceive their actions. In that sense, to transgress a perceived – and clearly widespread – hegemonic societal respect for Islam should be regarded as a form of (c)overt resistance. It is covert in the sense that outsiders are unlikely to be exposed to it. This owes partly to the channels through which it is communicated (such as online metal forums, or the booklets of records that can only be found at special locations), as well as the style with which it is usually communicated (growled or screamed). However, it is overt in the sense that a subcultural interconnectedness is created.

In this subculture, these types of attitudes towards religion are not only voiced, but to a large extent encouraged and recognised by the rest of the scene as resistance towards religion. The pseudonyms used by many black metal artists further add to this (c)overt dimension. In this respect, the cultural production of Turkish black metal enables the participants to engage in (c)overt resistance similar to that noted by Kirsten Schilt in her study of *Riot Grrrl* fanzines. Schilt concludes that these zines enabled girls 'to overtly express their anger, confusion and frustration publicly to like-minded peers but still remain covert and anonymous to authority figures' (Schilt 2003, 81).

That these new expressions were inspired by the rise of the AKP and its politics of pious conservatism can be seen in the following quote. The question was posed to members of one black metal band regarding why they had

started to include explicit references to Islam in their later work, since they had not done so previously:

> So, he [the lyric writer] started to write it, that's one thing and then in our lives things also started to change because of the environment in the country. Like 2012, 2013 there had been, you know the issues, 2014 and more and more we got pushed. Then we say 'ok, think of us as a tank, let's say: ok, we put the barrel of the gun pointing here [pointing straight] and then someone is shooting us from here [shows the side] so we need to focus on this [the side]'. It was always in our minds but because of the [change in] environment, and the politics, [the] demographic [in this] country, we started now. – DZ43.

> Because I live in here and I started to [be] anti-Islamic because it's important now. Twenty years ago it was not important in here, ok? But it is important now. Because twenty years ago in Turkey we didn't see any pressure here, they didn't push me you know? But they push me now. – RT02.

For this band, the process of writing anti-Islamic lyrics is directly related to the recent years of AKP rule and the concomitant rise of pious conservatism in Turkey. The band members continued to express that their main discord is with God generally, rather than Islam specifically. Nonetheless, they still felt that the recent societal and political change in Turkey required a musical response. The incorporation of these explicit anti-Islamic and anti-religious expressions coincided with, and intensified during, AKP's time in power. The vocalist and lyricist of a black metal band in Ankara stated that these changes are a direct consequence of AKP politics:

> Well, of course, it changed . . . let's see, I remember the times before [Recep] Tayyip [Erdoğan]. People were more relaxed back then. For example, one of the most popular TV-shows in Turkey was about one apartment [building] and the relations of neighbours in that apartment. It lasted for like twelve years. One of the most famous TV-shows. There were scenes when they were hanging out together in one apartment, in one house drinking beer together. So we were able to watch them drink beer in Turkey. After Tayyip's government, after they came to power, it started to change and now you can never see Turkish guys drinking alcohol on television. It's a rare thing. So, of course, it started with the AKP government. Before that, before those times, would I ever write lyrics like that [referring to anti-Islamic lyrics]? I don't think so.

Because people . . . Turkey was always a Muslim country, but people were more relaxed back then . . . so, no I wouldn't write those [back then]. But of course, it changed badly over the last fifteen years, it sure changed. – AU05

So do you think that people started to write these kind of [anti-Islamic] lyrics in reaction to the government?

Exactly, with a government ruled by Islamic beliefs, being an atheist is a political thing, a political act, so of course people, the black metal guys started to act more aggressive towards these movements nowadays because yeah Turkey was always a Muslim country, but it is turning more into an Islamic dictatorship right now and people are reacting to that. – AU05

In this respect, black metal in Turkey needs to be acknowledged as an active and conscious act of subcultural resistance to the recent years of political and social change – though without, of course, providing a political alternative.

Many of those interviewed for this study positioned themselves and their music as apolitical. This is common within the black metal subculture. Indeed, this has traditionally made it difficult to apply labels such as 'protest music' to the genre (Peddie 2006; Kahn-Harris 2007; Street 2012; Scott 2013). However, interviewees did acknowledge the political potential of using anti-Islamic references. Although they generally refrained from describing themselves or their band as explicitly political, many of those interviewed here used strong language in describing their personal opinion of the AKP government:

Yeah they stole my life. Since 2002 I think they are in the government and in 2002 I was fifteen. They stole fifteen years, and my best fifteen years between, fifteen and thirty, my best years are gone because of them. – TEB1

They have ruined . . . they managed to ruin a lot of things, they have managed to create a herd of sheep violent sheep violent . . . sorry not violent, aggressive brainless sheep that's somehow ignorance has become the new 'IT' they are very sure of themselves and the more ignorant they are the braver they are. They feel entitled to everything now. Some random guy on the street feels entitled to direct my life, comment on my life, just tell me what's right and what's wrong, and ah, or attack me, violently attack me because they think their leader has given them the right to do so. They are destructive. – TG55.

The majority of those interviewed for this study either grew up or spent their early teens in an AKP-governed Turkey. As can be seen from these quotes, the government is blamed for much that is considered wrong with the country. Engagement in the black metal subculture is seldom politically motivated. However, in the polarised climate of Turkey, it becomes an empowering act of resistance towards the social hegemony propagated by the government and its supporters.

Concluding Remarks

From the outset, black metal has been a contested subculture in Turkish society. The genre's controversial history, coupled with false accusations of satanism, make engagement in the subculture a transgressive practice. However, the social transgressions that (black) metal constitute in relation to several majoritarian aspects of Turkish society are further complicated by a recently added legal dimension: an explicit critique of Islam.

Since 2012, Article 216, 'Provoking the Public to Hatred, Hostility or Degrading', under the fifth section, 'Offenses Against Public Peace', of the Turkish Penal Code, have been increasingly used to prosecute people (Council of Europe 2016). The article regulates hate crimes, blasphemy and religious insults. As the jurist Tolga Şirin notes: '[E]specially in recent years, the limits of tolerance for critiques towards Islam . . . have been enormously narrowed', while 'the religion of Islam is virtually protected in Turkey' (Şirin 2014, 76).

To critique Islam is thus controversial from both a social and legal point of view, and to do so steers these new cultural representations into the realm of politics. The majority of the bands interviewed here stressed that their engagement with the subculture was not primarily motivated by politics. However, all interviewees were appreciative of the new subcultural representations, viewing them as a necessity in the current political climate, underlining their empowering qualities and the platform they provided for expressing opinions not deemed permissible in public. And although the black metal bands analysed here describe themselves as non-political, this is no hindrance to framing their artistic production as political, or as framing its consumption as an act of defiance. These newly emerged cultural representations must

be recognised as conscious subcultural acts of counter-hegemonic resistance, especially given the attitudes voiced by some in the scene towards the current ruling party and government.

It should be noted that, in terms of providing a political alternative with respect to organising society or engaging in government politics, black metal is, indeed, apolitical. But from a perspective that regards culture as a site of ideological struggle, black metal can be regarded as political, especially in a contemporary Turkish context. This approach to culture enables us to see the political potential and subcultural resistance of black metal. As one of the interlocutors put it: '[I]f religion produces this much propaganda, there needs to be that kind of harsh propaganda back'.

Notes

1. The figure of Baphomet appears in Christian polemics targeting Islam and Mohammad. During the Inquisition, knights of the Temple Order were accused of worshipping the false God Baphomet, which is a distortion of Mohammad. As such, it is ironic to let Baphomet destroy Kaaba. It is more probable, however, that the band's interpretation of Baphomet is derived from the Church of Satan, whom, since 1966, have used it as a symbol for satanism. Today, Baphomet is a common reference in black metal. Synonymous with Satan, his goat–human body is a well-known symbol in popular culture satanism (Lewis 2001). In that regard, Baphomet, in comparison to Islamic names for the devil, such as Iblis or Shaytan, is more comprehensible for an international audience.

2. Due to the controversial nature of the present material, the author has decided to enforce strong anonymity in relation to the interlocutors of the study. In order to safeguard the interlocutors anonymity to outsiders, as well as to other participants of the Turkish black metal scene, names, dates and the location used during interviews have been left out if they were not deemed crucial for the analysis.

Bibliography

Brown, Andy R. 'Heavy Genealogy: Mapping the Currents, Contraflows and Conflicts of the Emergent Field of Metal Studies, 1978–2010'. In *Journal for Cultural Research*, vol. 15, no. 3 (2011): 213–42.

Council of Europe. 'Opinion on Articles 216, 299, 301, and 314 of the Penal Code of Turkey'. In *The European Commission for Democracy through Law*,

15 March 2016, http://www.venice.coe.int/webforms/documents/default. aspx?pdffile=CDL-AD(2016)002-e (last accessed 11 May 2018).

Crowcroft, Orlando. *Rock in a Hard Place: Music and Mayhem in the Middle East*. London: Zed Books, 2017.

Hammoudi, Abdellah. *A Season in Mecca: Narrative of a Pilgrimage*. Cambridge: Polity Press, 2006.

Hecker, Pierre. 'Heavy Metal in the Middle East: New Urban Spaces in a Translocal Underground'. In *Being Young and Muslim: New Cultural Politics in the Global South and North*, edited by Asef Bayat and Linda Herrera, 325–39. New York and Oxford: Oxford University Press, 2010.

Hecker, Pierre. 'Contesting Islamic Concepts of Morality: Heavy Metal in Istanbul'. In *Muslim Rap, Halal Soaps, and Revolutionary Theater: Artistic Developments in the Muslim World*, edited by Karin van Nieuwkerk, 55–84. Austin, Texas: University of Texas Press, 2011.

Hecker, Pierre. *Turkish Metal Music, Meaning, and Morality in a Muslim Society*. Farnham and Burlington, VT: Ashgate, 2012.

Kahn-Harris, Keith. *Extreme Metal: Music and Culture on the Edge*. Oxford and New York: Berg, 2007.

Karlsson, Andrea Sophie. 'Religionsfrihet i Turkiet Och EU-Medlemsskapsprocessen'. In *Mänskliga Rättigheter Och Religion*, edited by Dan-Erik Andersson and Johan Modée, 202–14. Malmö: Liber, 2011.

Kuppens, An H. and Frank van der Pol. '"True" Black Metal: The Construction of Authenticity by Dutch Black Metal Fans'. In *Communications*, vol. 39, no. 2 (2014): 151–67.

LeVine, Mark. *Heavy Metal Islam: Rock, Resistance, and the Struggle for the Soul of Islam*. 1st edn. New York: Three Rivers Press, 2008.

LeVine, Mark. 'Doing the Devil's Work: Heavy Metal and the Threat to Public Order in the Muslim World'. In *Social Compass*, vol. 56, no. 4 (2009): 564–76.

LeVine, Mark. 'How a Music about Death Affirms Life: Middle Eastern Metal and the Return of Music's Aura'. In *Popular Music and Human Rights*, edited by Ian Peddie, 53–72. Farnham, Surrey, and Burlington, VT: Ashgate, 2011.

Lewis, James R. *Satanism Today: An Encyclopedia of Religion, Folklore, and Popular Culture*. Santa Barbara: ABC-CLIO, 2001.

Mattsson, Douglas. 'Från Det Heliga till Det Vanhelgande'. In *Dragomanen*, no. 18 (2016): 79–90.

Mattsson, Douglas. 'Black Metal in Turkey: Islamic Semiotics and Subcultural Resistance'. Master, Lund: Lund University, 2018.

Otterbeck, Jonas, Douglas Mattsson and Orlando Pastene. '"I Am Satan!" Black Metal, Islam and Blasphemy in Turkey and Saudi Arabia'. In *Contemporary Islam*, vol. 12, no. 3 (2018): 267–86.

Patterson, Dayal. *Black Metal: Evolution of the Cult*. Port Townsend, WA: Feral House, 2013.

Peddie, Ian, ed. *The Resisting Muse: Popular Music and Social Protest. Ashgate Popular and Folk Music Series*. Aldershot and Burlington, VT: Ashgate, 2006.

Schilt, Kristen. '"I'll Resist With Every Inch and Every Breath": Girls and Zine Making as a Form of Resistance'. In *Youth & Society*, vol. 35, no. 1 (2003): 71–97.

Scott, Niall. 'Heavy Metal and the Deafening Threat of the Apolitical'. In *Heavy Metal: Controversies and Countercultures*, edited by Titus Hjelm, Keith Kahn-Harris and Mark LeVine, 228–43. Sheffield and Bristol, CT: Equinox, 2013.

Şirin, Tolga. 'Freedom from Religion in Turkey'. In *Freedom of Religion and Belief in Turkey*, edited by Özgür Heval Çınar and Mine Yıldırım, 59–88. Newcastle upon Tyne: Cambridge Scholars Publishing, 2014.

Street, John. *Music and Politics*. Cambridge: Polity, 2012.

Van Leeuwen, Theo. *Introducing Social Semiotics*. London and New York: Routledge, 2005.

Weinstein, Deena. *Heavy Metal: The Music and its Culture*. Rev. edn. Cambridge, MA: Da Capo Press, 2000.

Williams, J. Patrick. *Subcultural Theory: Traditions and Concepts*. Cambridge and Malden, MA: Polity Press, 2011.

Discography

Ehrimen. *Unholy Metal*. Independent, 2009.

Sarinvomit. *Baphopanzer of the Demonical Brigade*. Seven Gates of Hell, 2015.

Witchtrap. *Witching Black*. Hammer Müzik, 1997.

Zifir. *Kingdom of Nothingness*. Duplicate Records, 2017.

4

TIRED OF RELIGION: ATHEISM AND NON-BELIEF IN 'NEW TURKEY'

Pierre Hecker

'New Turkey's' ideological fixation on Islam represents only the latest stage of a decade-long process of merging religious identity with Turkish nationalism (see, for instance, Navaro-Yashin 2002; White 2013; Lord 2018; Yavuz and Öztürk 2019). Even though Turkish political Islam often claims otherwise, Turkish secularism has never been anti-religious. However, it did seek to control religious institutions, eliminate religious sources of power and establish the state's unconditional *Deutungshoheit* on religious matters (Azak 2010, 9ff.). A commonly shared religious identity has thus been an essential component of Turkish nationalism ever since the early Republican era.

This chapter provides insight into the awakening of organised atheism in Turkey and investigates the recent debate on 'religious fatigue' among conservative youths. It also directly touches upon the issue of why young people from conservative Muslim families are leaving Islam. For this purpose, it draws upon biographical interviews conducted by the author in Turkey between the summer of 2017 and the spring of 2019. With the help of these individual stories of becoming atheist, this chapter also seeks to provide possible answers to why Turkey's 'Islamic adventure is falling apart' (Böhürler 2017), especially if we consider the dominant religio-normative environment as it currently exists in 'New Turkey'.

The very existence of atheists and non-believers contradicts the dominant narrative of the 'Muslim nature' of the Turkish nation and, on a related note,

the discursive supremacy of the ruling elite. Atheism and non-belief thus pose a potential threat to the success of 'New Turkey's' hegemonic project. This is also why the AKP-dominated state institutions commonly deny the existence of atheists and non-believers in Turkish society or, at least, obscure the fact that a significant number of people have left Islam in recent years. Denying visibility to atheism and non-belief is part of the present struggle for cultural hegemony and the ruling elite's attempt to establish its worldview as the commonly accepted norm.

Substantiating the 'Muslim Nature' of the Turkish Nation

The dispute over the alleged insignificance – or even inexistence – of atheism and non-belief usually starts out by talking about numbers. State sources commonly claim that more than 99 per cent of Turkey's population is Muslim, while the remaining few adhere to other religious faiths, such as Christianity and Judaism. The category of 'none' or 'non-religious' usually does not even appear in official statistics.

A large-scale governmental survey on *Religious Life in Turkey* published in 2014 appeared to provide strong evidence for the 'Muslim nature' of the Turkish nation. The study was commissioned by the Directorate of Religious Affairs and conducted in close cooperation with Turkey's federal institute of statistics (TÜİK). Based on a sample of 37,624 households (2014, xxv), it claimed to be representative of all Turkey. The Directorate of Religious Affairs explained its decision to commission the study with the alleged need for a reliable scientific basis on which it would be able to realign its future strategies with the religious needs of the people and fulfil its mission of offering religious services in the fields of faith (*itikat*), worship (*ibadet*) and moral conduct (*ahlak*) (Görmez 2014, xvii–iii; Subaşı 2014, xix–xxii). Yet if we look at the study, its structure and results from a political perspective, it might be interpreted as commissioned to substantiate the myth of the 'Muslim nature' of the Turkish nation – a cultural entity that is solely defined by its commonly shared religious beliefs and practices.

Religious homogeneity is the primary message that the findings of the study obviously seek to convey. The key statistical results read as follows: 99.2 per cent of Turkey's population profess Islam, while only 0.4 per cent adhere to other religions; 0.5 per cent of the interviewees did not respond

(2014, 3–4). The study even incorporated a set of parameters in order to detect possible societal differences in terms of religious identity. None of them (location of residence, sex, age, education, employment, marital status) did, however, show any significant variation. The number of Muslim believers only slightly dropped among respondents with a university education (96.7 per cent).

Religious cohesion as related to personal belief and conduct was another key issue. The organisers of the study apparently intended to verify the respondents' belief in the 'six principles of the Islamic faith' (*arkān al-imān*) and, on a related note, whether they performed particular religious practices in everyday life. The belief in the six principles of the Islamic faith is an integral part of Sunni orthodoxy and includes the belief in the existence and oneness of God; the belief in the existence of the angels, the demons and the devil; the belief in the existence and the truth of God's holy books, namely the Koran, the Gospels, the Torah and the Psalms; the belief in the existence of God's prophets; the belief in the existence of the Day of Judgment and the Hereafter; and the belief in the existence of divine predestination. By including a set of questions that address each of these principles separately, the survey eventually assessed whether the Turkish population is collectively acknowledging a particular belief system or not. Had the respondents preponderantly failed to acknowledge these principles, this would have been proof of a lack of religious cohesion in society and, indirectly, evidence of the government's failure to disseminate its ideas of pious conservatism throughout society. The results did, however, indicate strong belief in the aforementioned religious doctrine.[1]

As far as religious practices in everyday life are concerned – such as, for instance, praying five times a day, attending Friday prayers, fasting during Ramadan or wearing the Islamic headscarf – the picture painted by the survey is more complex. Even so, the results indicated considerably high ritual performance rates. To give but one example, 83.4 per cent of the respondents confirmed that they always (!) fast during Ramadan; 6.1 per cent stated that they sometimes fast; another 7.3 per cent declared that, due to health issues, they were unable to do so. In other words, the religious practice of fasting is met with unanimous (96.8 per cent) approval in Turkish society. The survey also investigates the popularity of religious practices that the Directorate of Religious Affairs apparently regards as deviant from, or even contradictory to,

Islam (for example, tying ribbons to wish trees or visiting shrines). The survey suggests that the vast majority of the population rejects these unorthodox practices (2014, 33–6).

The results of the investigation attest to a high level of religious coherence in Turkish society, which then functions as the cohesive power of the Turkish nation. The survey's methodology does, however, raise considerable doubt about the validity of these results. The investigation starts out from a clearly normative position, even though it claims to be obliged to the principles of impartiality. In his introduction to the study, Mehmet Görmez, then president of the Directorate of Religious Affairs, speaks of Islam as 'our supreme religion' (2014, xvii). The assumption of the supremacy of Islam over other religions and belief systems thus becomes apparent. The statement furthermore reveals a bipartite way of thinking that divides the social world into 'us' – thereby referring to those who acknowledge the supremacy of Islam – and 'them' – presumably all those who refuse to acknowledge this supremacy. This ideological commitment coincides with the fact that the response options for some questions were distortingly limited. The category of 'none', let alone 'atheist' or 'without religion', were not even offered to the respondents of the study. The sole orientation towards Sunni Islam furthermore completely neglected Alevi principles of belief and conduct. It is also highly questionable if a household survey can produce reliable data on such a sensitive issue as religious belief and identity. Social expectations and coercion within the realm of the family are commonly high, especially when it comes to questions of atheism and apostasy.

The Discovery of Atheism

The research results of two private research institutes cast further doubt on the reliability and validity of the Directorate of Religious Affairs' aforementioned survey. The statistical data collected by MAK Consultancy and KONDA Research and Consultancy in 2017 and 2018, respectively, openly contradicts the findings of the religious life survey.

MAK's 'Overview on Religion and Religious Values in Turkish Society', which was conducted in June 2017, and KONDA's 'Report on Societal Change', a ten-year comparison of the change of lifestyles between 2008 and 2018, provided statistical data that, for the first time, included information

on the number of atheists and deists in Turkish society. While MAK specified that 6 per cent of Turkish society was made up of deists and 4 per cent classified as atheists (2017, 10), KONDA detected an increase of Turkey's atheist population from 1 to 3 per cent and a rise in non-believers from 1 to 2 per cent. In relative terms, this might seem insignificant. Thinking about these figures in absolute terms, however, makes them appear in a different light. At the end of 2018, Turkey's population stood at just over 82 million (TÜİK 2019). Even if we look at MAK's and KONDA's figures critically, it seems necessary to assume that several million Turkish citizens have either lost or never held a religious belief in the first place.

While KONDA holds an overall positive reputation in Turkish academia, MAK has a rather negative standing in the academic community in terms of accuracy and reliability. Even more so, because MAK has a history of pro-government leaning and, therefore, has a reputation for not following the principles impartiality.[2] MAK's study on religion and religious values confirms this impression. The methodological procedures used are widely normative and sloppy. Therefore, the aforementioned findings can be hardly seen as reliable or representative. Nevertheless, the study holds particular relevance.

MAK classified those who responded to the question 'Do you believe in the existence and oneness of God and that he created us and gave us life?' with 'No. I don't believe in God' as 'atheists' and those who believed in God but not in divine intervention as 'deists'. This approach does not, of course, necessarily represent the perspective of the interviewed person. Why would someone who believes in God but not in divine intervention necessarily describe him- or herself as deist? Indeed, the report does not provide clear criteria or a definition for who is to be considered 'atheist' or 'deist', respectively.

It quickly becomes clear that MAK is pushing a political agenda. The authors of the study not only describe unbelief as a 'sickness' (*inanma hastalığı*), but also suggest that a person who does not believe in the existence of angels should be seen as an apostate (2017, 5). This, however, takes the whole discourse on atheism and non-belief to a new level. Classifying a person as 'apostate' opens up a whole new debate on how to treat those who leave Islam or, due to their mindset and behaviour, are to be considered to have left Islam. Observing the phenomenon of atheism and non-belief through this lens, necessarily assumes that there is only one true religion and

that there are specific, objectifiable criteria according to which a person can be considered an unbeliever or apostate. Apostasy, however, comes with a vast theological debate on whether the alleged apostate should be punished in this world (on behalf of the believers) or in the other world (on behalf of God). Steering the debate on religious identity in this direction might provoke hate crimes against atheists and those religious communities (for example, Alevism) that do not conform to the narrow perspective on Islam as supported by MAK. Even more disturbingly, MAK called on the government to launch a campaign of 'moral recovery' and to counter the erosion of faith and degeneration in society (2017, 9).

MAK divides Turkish society into three categories: Muslim, deist and atheist. Since this sudden visibility of non-believers in public statistics evidently is not the result of increased tolerance, it needs to be asked why atheism and deism have just now come into focus and in the public interest. The answer lies in the recent discourse on organised atheism and the alleged rise of 'religious fatigue' among conservative youths.

Organised Atheism

The ruling elite's claim of the 'Muslim nature' of the Turkish nation and its attempt to deny visibility to atheism and non-belief has yielded the emergence of organised atheism in Turkey. The so-called Atheism Association (Ateizm Derneği, AD) was officially registered under Turkey's Association Law on 14 April 2014. Since then, it has been relentlessly championing for the right to the freedom *from* religion and the visibility of atheists and non-believers in the public sphere. The founding of the association initially drew considerable attention from the media, wherefore the issue of atheism became known to a wider public.

Considering the secularist history of the Turkish Republic, it might seem surprising that the first body to represent Turkish atheists was only created in 2014 and not years or even decades earlier. What appears safe to say is that the motivation to establish a representative body is a direct response to Turkey's authoritarian turn and the ruling elite's policies of Islamisation.[3] More and more people saw their and their children's right to freedom *from* religion at risk. Erdoğan's announcement (2012) of prioritising the education of a new pious generation (*dindar nesil*) amplified this fear. Measures to implement this

goal were almost immediately put into effect. This included a rapid increase of religious high schools (İmam Hatip Liseleri, İHL) throughout the country, a revision of school curricula for the purpose of aligning them with religious doctrine (for instance, by eradicating evolutionary theory from school textbooks) (Gülsaçan 2009; MEB 2017) and the introduction of mandatory classes on 'Religious Culture and Moral Knowledge' (Din Kültürü ve Ahlak Bilgisi) (Gençkal Eroler 2019, 153ff.). For non-religious parents, it has become increasingly difficult to have their children exempted from mandatory religious education at state schools.

The final impulse for establishing AD came from the Gezi Park protests in the summer of 2013. The pro-democracy movement involved people from various sections of society, all of them united in their demand for the protection of individual rights and freedoms. One of the effects of Gezi was that it also brought together a considerable number of like-minded, atheist individuals who suddenly realised that they were not alone. This new collective experience also reflected on the official slogan adopted by AD from the very beginning: 'We are no longer alone!' ('Artık yalnız değiliz!'). The solidarity aspect inherent to this statement also appears important for the group's common identity. Gezi, moreover, provided atheist activists with the opportunity to see and learn from other civil society groups, especially with regard to how they get organised and communicate with the public. The overall positive feedback of other civil society actors on going public also had an encouraging effect. AD was established to function as a joint body of atheists and non-believers irrespective of their political affiliation and attitudes.

By early 2014, the pro-democracy movement had come under increased pressure. The Gezi Park protests had been crushed by force and Turkey's 'authoritarian turn' was in full swing. Civil society was systematically intimidated and increasingly paralysed by having to fight a rising tide of lawsuits filed against them by public prosecutors. The pretext for this scenario was the government's official reading of events, which classified Gezi as a coup attempt against Turkey's democratically elected government. Against this backdrop, the founding members of AD expected their application for official registration either to be rejected or to be delayed for an indefinite period of time. The Ministry of the Interior, however, approved the registration of the association almost immediately. As if that were not enough, some state

officials even spoke out in public about allowing an atheist association to be established. In retrospect, AD suspects the prompt approval of their application as an attempt by the government to publicly demonstrate its alleged commitment to social pluralism. Another explanation could be that the government considered atheism a too insignificant phenomenon to pose a real challenge to its hegemonic project.

Initially, AD turned out to be committed and active. At least temporarily, it managed to make atheism visible in the public sphere. Its members gave interviews to the media, attended TV talk shows, participated in public celebrations (May Day, Republic Day, Newroz and so on) and organised social events for fellow atheists (summer camps, public readings, meet-and-greets and so on). Maybe most importantly, AD set out to provide legal protection.

In August 2014, AD tried to open a court case against the popular theologist Nihat Hatipoğlu on spreading hatred against atheists. During a live broadcast on ATV's Ramadan programme, Hatipoğlu had addressed the audience with the crude explanation that the father of all atheists is Satan and, since Satan does not deny the existence of God, atheists also would not really deny the existence of God. He concluded by saying that even 'Satan is more decent than them [that is atheists]'.[4] The Public Prosecutor of Istanbul, however, dismissed the case, thereby assenting to the defendant's argument that the comments had only been made in accordance with the Holy Koran and the Sunnah. AD's lawyer subsequently accused the Public Prosecutor's Office of no longer complying with the principles of the Turkish Penal Code, but handing down verdicts on the basis of the Islamic Shariah instead.

The case can be seen as reflecting the ongoing struggle for hegemony in 'New Turkey', as an attempt of the subaltern to resist the dominant culture of the ruling elite. Even though the case was dismissed, AD succeeded in temporarily creating public space for discussion on atheism and thus established visibility. Due to the intense media coverage of the case, the association was able to add an alternative narrative to the discourse on atheism in Turkey and to challenge Islamic mythology about atheists being in league with Satan.

Even though AD has been quite effective in at least temporarily challenging the dominant discourse on atheism in Turkey, more recently it has come under severe pressure from the authorities. As a result of Turkey's 'authoritarian turn', the Turkish state has tightened up control on civil society. Since

October 2018, for instance, all associations are legally required to register their members with the Ministry of the Interior's information system (ICNL 2019). As a consequence, people have become afraid of being listed as a member of civil society associations that are disliked by government. Concrete measures were taken by the authorities in terms of closing down AD's official website on several occasions and denying permission for holding public rallies. Besides, a considerable number of former members and voluntary supporters have either left the country as part of the ongoing repression-related brain drain or they have suffered from what several interviewees described as 'activist burnout'. In this sense, AD is still far from fulfilling its goal of effectively fighting 'religious, philosophical, and ideological views that are used to exert pressure upon atheists and/or non-believers' and to 'ensure that Turkey's atheists and non-believers can freely express their views within the scope of Turkish Law' (Atheism Association 2014).

Religious Fatigue

The civic activism of a small group of organised atheists does not give the ruling elite a serious headache. Ultimately, the Atheism Association (Ateizm Derneği, AD) is not considered much of a threat. From the perspective of Turkish political Islam, it merely represents a petty remnant of long-disempowered Kemalist secularism. What really triggers the concern of pious conservatives today is a phenomenon that came to be known as 'religious fatigue'. This term is nowadays used to describe the alleged loss of religious faith among conservative youths. If this holds true, it not only poses a challenge to Erdoğan's agenda of raising a new pious generation (*dindar nesil*), but to the Islamist myth of Islamic supremacy over secularism itself. A loss of religious faith among the ruling elite's conservative base of supporters thus comes as a serious threat to 'New Turkey's' hegemonic project.

The first mention of the term 'religious fatigue' is commonly attributed to Necdet Subaşı, a theologian and sociologist of religion, who also served as the head of the Directorate of Religious Affairs' Department of Strategy Development. During that time, he also supervised the afore-discussed survey on *Religious Life in Turkey*. At a conference organised by İSAV, the Foundation for Research in Islamic Sciences, and held on 6–7 May 2014 in Konya, Subaşı argued that as soon as popular culture spreads in society, it suppresses

all forms of human spirituality and functions as a source of 'harassment' and 'coercion' against Islam. Subaşı did not clarify what he meant exactly by 'popular culture'. It appears obvious, however, that he associates popular culture with consumption culture, which, as he contends, has intruded into the field of religion. Here, it dissolves the once clear-cut boundary between the sacred and the profane, the religious and the secular. Profane things, such as holidays, music or fashion, are branded as Islamic for the sole purpose of allowing Muslims to consume, while maintaining the image of piety (what he most likely had in mind was, for instance, non-alcoholic champagne, modest fashion magazines and religious pop music). Religion, in Subaşı's perception, has thus turned into a commodity. It nowadays functions as an instrument of individual satisfaction and no longer as a source of spirituality. At times, he criticises, religion is even used as an instrument to enforce political aims. He furthermore observed a loss of religious devotion (*takva*) and morals (*ahlak*) or, to put it another way, a process in which inner values give way to super-ficiality. From this, he concluded that religion has become devoid of what he considers the 'true' nature of religious faith. In other words, he describes a trivialisation of religion in modern consumer society. In Subaşı's view, this crisis of religion is what 'religious fatigue' comes down to (Subaşı 2016).

In a widely received comment published in *Yeni Şafak* on 30 September 2017, Ayşe Böhürler, a well-known Islamic writer and founding member of the AKP, made the term 'religious fatigue' known to a wider public. Böhürler, however, used the term differently from Subaşı. What apparently alarmed her was the observation that an increasing number of young people from con-servative families were in the process of losing their religion. It was no longer the youngsters from secularist families who somehow naturally felt alien-ated from religion, but the kids from 'our' neighbourhoods, 'our' families, 'our' community. Böhürler attributed this development to the fact that 'our generation' – hereby referring to herself and the parents of today's young – had a distinctly clear, bipartite worldview of 'us' versus 'them'. 'Us' was the Islamic movement, 'them' the secularist elite of the state. While her genera-tion had a supposedly clear 'cause', strong 'ideals' and an obvious 'enemy', today's generation, in Böhürler's view, suffers from a loss of perspective and idealism. The cause for this, she sees in the failure of religious institutions and parents to address the religious and psychological needs of the younger

generation. The young live in a globalised world that is defined by new parameters. Therefore, the young need guidance. Especially at a time when 'partial truth' and 'post-truth' have become common concepts. She concludes that today a new feeling can be observed in Turkish society, the feeling that 'the Islamic adventure is falling apart!' (Böhürler 2017).

Parallel to the debate on 'religious fatigue', a debate on 'deism' has caused concern among Turkish conservatives. In August 2017, the Directorate of Religious Affairs' monthly journal, *Diyanet Dergisi*, published a special issue with the title of 'Humanity in the Grip of Deism, Atheism and Nihilism'. Portrayed as a pre-stage to atheism, deism was said to be spreading among students from religious high schools and students of theology. Western relativism and the negative impact of the Internet were consequently named as the main reasons for this alleged development. The debate peaked in early 2018, after İhsan Fazlıoğlu, a Professor of Philosophy at Istanbul Medeniyet University, claimed that over the past one-and-a-half years no less than seventeen female students had confided in him that they no longer believed in God. The most shocking detail about his claim was the assertion that all seventeen students wore the Islamic headscarf and came from traditional families (Fazlıoğlu 2018).

The present discourse on 'religious fatigue', 'deism' and the existence of 'headscarved atheists' is highly contentious. Not only does it entail an implicit critique of President Erdoğan, who had promised the nation to educate a new pious generation; it also appears to indicate a crisis of pious conservatism in 'New Turkey' that might hint at a possible failure of the ruling elite's hegemonic project.

Tired of Religion

Religious belief is not something that goes-without-saying, neither is it 'natural' or acquired at birth. People need to be socialised into religion in order to develop a particular religious belief in the first place. Nevertheless, it is frequently treated as something that is essential to human existence and, in the present case, to Turkish national identity. Leaving one's religion in a social environment that is characterised by religio-normativity is a potentially contentious endeavour.

In Erdoğan's 'New Turkey' hegemony and religio-normativity are closely intertwined. Being religious or, more precisely, being Muslim is seen as the

commonly accepted norm and an essential component of Turkish national-ism. The confession 'I am an atheist' or terms like 'non-religious' (*dinsiz*), 'faithless' (*imansız*) or 'godless' (*allahsız*) are by no means neutral categories. They are loaded with negative meaning that evoke disapproval and some-times open hostility. Stereotypes that brand atheists as immoral or inferior to religious believers are widely common. Coming out as an atheist therefore carries significant stigma and hiding one's atheist identity by performing reli-gious practices in everyday life is not uncommon. The consequences that may arise from being a non-believer include social ostracism, the risk of job loss and even physical violence. Within the context of the present book's focus on the (counter)hegemonic struggle for 'New Turkey', atheism and non-belief hold symbolic significance in terms of posing a potential threat to the ruling elite's hegemonic project.

The following empirical examples seek to shed light on what triggers indi-vidual processes of becoming atheist in 'New Turkey'. Turkey's atheist field is considerably complex and heterogeneous. The interview extracts used here can therefore only provide a very limited insight into this complexity. The interviews originate from a wider study on becoming atheist in Turkey con-ducted by the author between the summer of 2017 and the spring of 2019. The following paragraphs only contain statements from persons who, at a certain point in their lives, had defined themselves as strongly religious, and who had grown up in what they personally described as religiously conserva-tive or traditionalist families. At the time of conducting the interviews, they identified themselves as either having left Islam or as professing atheists. The scope of the present investigation has been narrowed down to this particular group of conservative-born atheists in order to follow up on the debate on 'religious fatigue' and the ruling elite's fear that a rampant spirit of unbelief is spreading among Turkey's conservative youth.

The first quote is from a young woman in her early thirties. She is married with one daughter and works as a schoolteacher. Her personal story of leav-ing Islam begins a few years prior to this interview, when she was pregnant with her first child. During that time, she felt her faith weaken. The feeling of religious doubt that mounted in her caused her unease regarding her pre-vious life. Strong faith in God and religion had been the defining elements in her life until then. As a result, she first tried to compensate her doubts by

intensified reading of religious books and writings. At a later stage, she even decided to re-strengthen her faith by making the pilgrimage to Islam's holy city of Mecca, a duty every Muslim is expected to perform at least once in a lifetime. The journey, however, did not quell her doubts about religion and apparently did not provide the spiritual experience she had been hoping for. At the time of the interview, she describes herself as having left Islam, even though her faith in some form of unspecified divine power still persists. The following extract reveals some of her reflections about what made her quit religion and leave Islam:

> I don't exactly know how it happened . . . It was a period in which I tried to get to know myself better. I started questioning my [previous] decisions. I am wearing a headscarf. Yes. But to what degree was it my own decision? I did not experience any pressure from my family to be religious or wear the veil. But when I look at it now, I understand that I did not have a choice. It was clear what I was expected to do and I did it – trying to be a good child. The perception of women in Islam is pretty bad. Patriarchy has affected religion way too much . . . How can I believe in something that [has been affected by] patriarchy so badly . . . I gave up wearing the headscarf about five months ago . . . I can't say I am an atheist or a non-believer. I can say that I feel that there is a power, but no-one can say what it is. And it is certainly not a question that needs to be answered.

Leaving Islam, in the present case, appears to have started as a more or less unconscious process that only later resulted in questioning religious faith itself. In the speaker's social environment, the practice of wearing the Islamic headscarf represents the commonly accepted (and expected) norm ('I did not have a choice', 'I was expected to [wear a headscarf]'). The decision to no longer conform or, to put it another way, to no longer perform this religious practice has a negative effect on the speaker's social relationships. One of her aunts, for instance, asked her to leave the house after she understood that her niece would no longer wear the Islamic headscarf.[5] The speaker's decision to leave Islam is obviously closely related to the question of gender relations. She describes Islam as having a negative perception of women and being strongly affected by patriarchy. At the end of the full interview, she states that she is happy about discovering a new open-mindedness in herself and that she is part of a social network of like-minded women, who initially met each other through social media.

The second example is a young university student in his early twenties. He came out as an atheist in his late teens after a long process of questioning religious texts and teachings. His transition from Islam to atheism also affected his family. After a phase of conflict and long discussions with his parents and older siblings, he now claims that even his once religiously conservative mother is on the brink of leaving Islam. The breaking points in his biography in terms of leaving Islam are well pronounced and partly relate to early childhood memories:

> I went to a Koran class when I was a child. My teacher was a paedophile. And he tried to kiss us and wanted to show us [his] body hair. He asked me to come to his room a few times, but I was a lucky child. I knew how to say 'no'. I said 'no' many times . . . but so many [other] children could not say 'no'.

He further explains how he recently approached one of his childhood friends in order to talk about what happened back then and to possibly build a case against their former teacher. The friend, however, even though he acknowledged the abuse, refused to talk about it. As a consequence of a widespread culture of denial and shame, the imam goes free and still teaches boys how to read the Koran. In addition to his frustration that the paedophilic imam goes unpunished, he mentions other issues that caused him discomfort about Islam:

> The Koran [preaches] inequality. No gender equality. And I don't like that God calls some people 'dogs' or 'pigs' . . . Why do you have such an ego? He [God] is like a big boss. Why are you bossing around like that? . . . I didn't like it and I felt like 'this is not my god'. He talks to men. Why doesn't he talk to women? Isn't this also a religion of women? The [Koran] talks like that and I didn't like it.

All in all, he holds an overtly negative image of Islam. Not only does he point to the unethical behaviour of many Muslims, such as, for instance, turning a blind eye on the sexual abuse of little boys by imams, but he also criticises gender inequality in religion and refuses to accept the dominant conception of an ultimately unjust, patriarchal God ('big boss').

The next example is more closely related to politics and to what, in this book, has been described as the struggle for 'New Turkey'. The interviewee, a university teacher in his early forties, describes himself as a former radical

Islamist who, at a young age, was even connected to a group that later turned militant. His trajectory of becoming an atheist actually starts with this group. His time as an Islamist was accompanied by a serious intellectual investment in political Islamic writings and the observation of Islamist activism. What negatively affected his religious beliefs in this process was the Islamists' obsession with apostasy and the constant attempt to denounce other Islamic groups as unbelievers. This struggle over who holds the only true version of Islam made him doubt the concept of truth in Islam. However, his atheist awakening took place many years later:

> My old life changed with the Gezi Park protests. I don't know why, but I felt like it was such a just and peaceful and civic uprising so that I had to be part of it . . . At that time, I just stopped fasting and praying . . . and I really began to think Muslims in general are not good [people] . . . Until then, I had so many friends from AKP circles, but with my positioning [during Gezi], they began to hate me. They were threatening me and all . . . The response of many Muslim friends against the Gezi people was really irritating, and I really began to question faith itself. How faith generates these [kind of] people and so on . . . So I lost most of my belief after Gezi, but the moment I gave up all my faith was one single day in fact. And that's the 'Ankara massacre'. You know the day when more than a hundred people died [in an Islamist suicide attack]. And that was the day, when I just quit. Some of the [inhumane] responses by Islamists and all. And I just stopped. I mean. I don't want to be part of any of this anymore. I had lost most of my intellectual aspects of belief already and now I am just quitting. I don't believe anymore. That was the turning point and since then I feel very liberated. And also a bit lost, but that's okay. [laughs]

This individual narrative of becoming atheist is striking in various respects. Not only does it establish a direct link between the decision to leave Islam and recent political events (the Gezi Park protests, the 'Ankara massacre'),[6] it also denounces the behaviour of the ruling elite and its supporters as unethical. The political opposition as represented by the Gezi Park protesters and the demonstrators at Ankara's 'Labour, Peace and Democracy' rally are, in contrast, depicted as 'just', 'peaceful' and 'civic'. This argument, which appears to be framed in a wider discourse on human rights in relation to Turkey's 'authoritarian turn', is built upon the interviewee's personal experiences, namely the hatred of his former friends from AKP circles towards the Gezi Park protesters, as well as their unwillingness

to show compassion for the victims of the Ankara massacre, whom they considered leftists and, therefore, most likely non-Muslims. This logic also reveals the degree to which the ruling elite has built its political identity on religion. For the speaker, religious and political identity appear to coalesce, wherefore he ascribes the unethical behaviour of government supporters to religion itself ('I really began to think Muslims in general are not good [people]' and 'how faith generates these [kind of] people').

In the present case, the process of becoming atheist is causally related to a process of alienation from the AKP's political project. It is also accompanied by the interviewee's conscious decision to no longer perform religious practices in everyday life ('fasting and praying'). This, however, can be seen as an action of highly symbolic value. In the present political context, the public performance of religious practices in everyday life may be seen as signifying support for the ruling elite, while the non-performance of religious practices, by the same token, might be perceived as signifying disagreement or even resistance to the ruling elite's political project.

The final example to be discussed here is the case of an atheist student of Islamic theology. Now in his early twenties, he has known the Koran by heart from an early age. He grew up in an Eastern Anatolian town and moved to Istanbul when he commenced his studies of theology. There, he lives in a relatively isolated social environment. While he does not have much contact with people from beyond his faculty, he says that he is friends with a group of other students of theology who also consider themselves atheists. For him, being atheist is a highly sensitive issue that must not be revealed to his university teachers or parents out of fear of being expelled from university or bringing grief and shame to his family. The only person in his family who knows about his atheist identity is his older sister, who, more recently, has also left Islam. Within the social context of their hometown and family, they both hide their atheist identity by continuing to perform religious practices in everyday life. The following interview excerpt only provides a very brief insight into what it is like for him to be an atheist in a religio-normative society:

> Back then, I experienced a couple of problems. I was working somewhere [during the summer break]. I was talking to my friends at work. They [were uneducated and] had only finished primary school. They asked me 'Do you drink vodka?' – 'I do', I said. And I drank [some vodka with them]. I am

not really used to it, but from time to time I drink alcohol. While drinking, I started to talk. About faith and so on. I told that I do not believe. 'So you don't believe in anybody? You don't worship anybody? You also don't venerate God?', they asked. 'No', I said. [What I felt next was] a punch in the middle of my nose. Five people attacking me. I started to run. They were chasing after me. I fell and tried to protect my head. They kicked and beat me. 'Are you aware of what you are saying? This is a Muslim country! You will have to renounce! Don't come here again', they said. There were five of them. And they also had weapons to kill . . . Now, think: They are Muslims. They drink alcohol. They commit adultery. Things they are not supposed to do. They don't pray. They don't fast. They lie. They behave in ways that contradict Islam. And when an atheist comes along, they suddenly forget about all that [their own illicit behaviour].

The violent incident depicted here is not so much about exposing double standards in terms of moral behaviour as it is about pointing towards an ideological understanding of Islamic supremacy that puts atheists and non-believers in a highly volatile situation. What this particular portrayal of violence comes down to is that a person can basically do anything ('drink alcohol', 'commit adultery', 'lie', resort to violence against others) as long as he (or she) is still Muslim. A Muslim can be a bad person, and he may be punished for his sins by God in the afterlife, but as long as he acknowledges the existence of God, he is still considered superior to a non-believer or, as one of my interviewees sarcastically put it: 'You can be anything as long as you are Muslim'. The risk of being exposed to hate crimes in a religiously conservative social environment is still high in Turkey. Therefore, many atheists prefer to conceal their identity by conforming to the norm. This, however, also raises the question of whether non-performance in terms of refusing to conduct religious practices is always an option.

Conclusion

Atheism and non-belief signify 'New Turkey's' hegemonic adversary. Its existence not only contradicts the narrative of an all-Muslim Turkey, but also the ruling elite's claim to cultural continuity between the reinvented history of the Ottoman Empire (see Chapters 11 and 12 by Burak Onaran and Caner Tekin respectively) and the all-encompassing vision of a 'New Turkey'. If

we see 'New Turkey' as the attempt to replace one hegemonic project with another, and as a political project that seeks to reverse the achievements of 'Old Turkey's' secularist modernity and erase the cultural legacy of Kemalism, then atheism and non-belief certainly represent the latter. The attempt to re-identify the nation with the culture of the Ottoman Empire – which is imagined as purely Islamic – positions atheism and non-belief as the outcome of a supposedly 'Westernised' culture that had been forcefully imposed upon Turkish society by the secularist aspirations of 'Old Turkey' (see Chapter 1).

'New Turkey's' ideological commitment to the nationalist myth of an all-Muslim Turkey has put Turkey's atheist population in a volatile situation. Widespread prejudices against non-believers and atheists has opened the door for public discrimination, hate speech and even violence. Combined with a lack of protection by state institutions, this puts individuals under immense pressure in everyday life, up to the point that they hide their identities in the public sphere. In this respect, Turkish atheists can be seen as 'the oppressed' in a wider struggle for cultural hegemony. The case of atheism and non-belief also gives proof of how Turkey's authoritarian populism infringes the principles of democratic pluralism. It must be acknowledged, however, that Turkish atheists also play an active role in 'New Turkey's' power game. Ateizm Derneği, for instance, has at least temporarily succeeded in breaking the ruling elite's control over the public narrative, thereby forging an alternative discourse that advocates the right to the freedom *from* religion.

What appears safe to say with regard to the debate on 'religious fatigue' is that (some) young people from religiously conservative families have indeed left Islam in recent years. The individual processes of becoming atheist are highly complex. What needs to be emphasised, however, is that there is a feeling of repulsion towards the unjust, corrupted and immoral behaviour of fellow Muslims and the political instrumentalisation of religion at the hands of the ruling elite. People's personal alienation from religion goes hand in hand with an alienation from the ruling elite's hegemonic project of 'New Turkey', which, for them, apparently represents the source of moral corruption. Turkey's present authoritarian turn and the ongoing process of human rights violations might further contribute to this process.

The discourse on 'religious fatigue' is dominated by pious conservative intellectuals whose complaints about the trivialisation of religion (Subaşı 2016) and

the supposed failure of the 'Islamic adventure' (Böhürler 2017) entail implicit and rare criticism of President Erdoğan himself. He who had promised to educate a new pious generation, now faces the alleged decline of religious faith among Turkey's conservative youth. The discourse on 'religious fatigue' thus indicates a crisis of pious conservatism that might be even indicative of a general failure of the ruling elite's hegemonic project. The question that needs to be addressed now is whether 'New Turkey's' hegemonic adversary, secularism, is about to re-emerge in a new guise. Are we in the process of witnessing a new secularist movement from below whose roots do not lie in the Kemalist past, but in the pious conservative present? (see also Chapter 9 by Ayşe Çavdar).

Notes

1. 98.7 per cent of the respondents acknowledged that they believe in the existence and the oneness of God (2014, 12); 95.3 per cent acknowledged their belief in the existence of the angels, the demons and Satan (15–16); 96.5 per cent did so with regard to the belief in the truth and the universality of the Koran (17–18); 97.7 per cent confirmed that they believe in the existence of the prophets and their divine inspiration (20); 96.2 per cent acknowledged that they believe in the Resurrection and the Day of Judgement (26–8); and 97.9 per cent of the respondents asserted that they believe in the concept of divine predestination (29–30).
2. The abbreviation MAK stands for Mehmet Ali Kulat. Kulat is the head and owner of the company and a former AKP candidate for parliament in Ankara.
3. Between 2016 and 2019, the author of this chapter conducted interviews with about a dozen former and present members of Ateizm Derneği in order to establish background information on the motivation, founding process and present challenges of the organisation.
4. Hatipoğlu's statement can be watched on YouTube: https://www.youtube.com/watch?v=QLBnjK0Xphc (last accessed 20 November 2020).
5. This reaction is mentioned at a later stage of this interview.
6. On 10 October 2015 more than a hundred civilians were killed and approximately 500 wounded when two Turkish Islamists blew themselves up during the so-called 'Labour, Peace, and Democracy' rally that was organised by several centre–left and leftist political parties, civil society organisations and intellectuals in Ankara. The AKP government was slow to condemn the attacks and was later blamed by the opposition of not having taken the necessary security measures to protect the rally.

Bibliography

Atheism Association. *Ateizm Derneği Tüzüğü.* İstanbul, 2014.

Azak, Umut. *Islam and Secularism in Turkey. Kemalism, Religion and the Nation State.* London and New York: I. B. Tauris, 2010.

Böhürler, Ayşe. 'Din yorgunu gençler'. In *Yeni Şafak*, 30 September 2017.

Diyanet İşleri Başkanlığı. *Türkiye'de Dini Hayat Araştırması.* Ankara, 2014.

Diyanet İşleri Başkanlığı. *Deizm, Ateizm, Nihlizm Kıskaçıda İnsanlık.* Special issue of Diyanet Aylık Dergi, Ağustos 2017, Sayı: 320. Ankara: Dini Yayınlar.

Diyanet TV. 'Ankara Üniversitesi İlahiyat Fakültesi 70'inci Yıl Kutlama Töreni yapıldı'. 6 November 2019, https://www.diyanet.gov.tr/tr-TR/Kurumsal/Detay/26080/ankara-universitesi-ilahiyat-fakultesi-70inci-yil-kutlama-toreni-yapildi (last accessed 30 November 2019).

Fazlıoğlu, İhsan. 'Şeylerin Arasında Yaşamak Hayatın Anlamı Üzerine Dairevi Akıl Yürütmenin İmkanı Var Mı?', public talk organised by Teknik Elemanlar Derneği (TEKDER). İstanbul, 25 February 2018.

Gençkal Eroler, Elif. *'Dindar Nesil Yetiştirmek'. Türkiye'de Eğitim Politikalarında Ulus ve Vatandaş İnşası (2002-2016).* İstanbul: İletişim, 2019.

Görmez, Mehmet. 'Önsöz'. In *Türkiye'de Dini Hayat Araştırması*, edited by Diyanet İşleri Başkanlığı, xvii–iii. Ankara, 2014.

Gülsaçan, Murat. 'Maymun Korkusu'. In *Bianet*, 11 Adar 2009, https://bianet.org/kurdi/bilim/113058-maymun-korkusu (last accessed 22 November 2020).

International Center for Not-for-Profit Law (ICNL). *Civic Freedom Monitor: Turkey*, 12 July 2019, http://www.icnl.org/research/monitor/turkey.html (last accessed 3 November 2019).

Lord, Ceren. *Religious Politics in Turkey. From the Birth of the Republic to the AKP.* Cambridge and New York: Cambridge University Press, 2018.

Milli Eğitim Bakanlığı (MEB). *Biyoloji Dersi Müfredatı.* 2017, http://mufredat.meb.gov.tr/ProgramDeay.aspx?PID=170 (last accessed 3 August 2017).

Navaro-Yashin, Yael. *Faces of the State: Secularism and Public Life in Turkey.* Princeton and Oxford: Princeton University Press, 2002.

Özgür, Iren. *Islamic Schools in Modern Turkey. Faith, Politics, and Education.* Cambridge: Cambridge University Press, 2012.

Subaşı, Necdet. 'Giriş'. In *Türkiye'de Dini Hayat Araştırması*, edited by Diyanet İşleri Başkanlığı, xix–xxii. Ankara, 2014.

Subaşı, Necdet. 'Din Yorgunluğu ya da Gündelik Popüler Kültürün Tükettiği "Islami Yorumlar"'. Paper presented at the conference *Gelenek ve Modernite Arasında*

İslâmî Yorumlar, organised by İslami İlimler Araştırma Vakfı (İSAV). Konya, 6–7 May 2016.

Türkiye İstatistik Kurumu (TÜİK), ed. 'Yıllara ve cinsiyete göre il/ilçe merkezleri ve belde/köyler nüfusu, 1927–2018', http://tuik.gov.tr/UstMenu.do?metod=temelist (last accessed 1 November 2019).

White, Jenny B. *Muslim Nationalism and the New Turks*. Princeton and Oxford: Princeton University Press, 2013.

Yavuz, Hakan M. and Ahmet Erdi Öztürk. 'Turkish Secularism and Islam under the Reign of Erdoğan'. In *Southeast European and Black Sea Studies*, vol. 19 (2019): 1–9. London and New York: Routledge.

PART II

SATIRE AND AGITPROP
IN 'NEW TURKEY'

5

DEMOCRA-Z: ELECTION PROPAGANDA, A FAILED COUP AND ZOMBIE POLITICS IN 'NEW TURKEY'

Josh Carney

Introduction

It was my first trip on the metro in the eight days since the coup attempt, so I was pleasantly surprised to find it free. As I settled into my seat for the hour-long ride to the airport, I looked up at one of the ubiquitous video screens that populate Istanbul's transit network and was startled to see a banned ad. The premise of the ad is straightforward: a mysterious villain destroys the mechanism suspending a large Turkish flag, and citizens from across the nation unite in a race against time to prevent the flag from falling, all to the voice of President Tayyip Erdoğan reading selections from the Turkish national anthem.[1] In March of 2014, the ruling Justice and Development Party (Adalet ve Kalkınma Partisi, AKP), led by Erdoğan, who was then prime minister, had released the ad in the run-up to municipal elections. It was banned from television by Turkey's Supreme Election Council (Yüksek Seçim Kurulu, YSK) for its use of national and religious symbols, both prohibited in campaigns. At the time, the villain in the ad was widely understood to be Fethullah Gülen, an Islamic cleric living in the US. In the wake of the July 2016 coup attempt, which clearly involved Gülen affiliates, the AKP began to run the ad in municipal transportation, such as metros and ferries, to celebrate the role of the people in thwarting the coup.

91

In 2014, many found the ad striking because it seemed to quote directly the imagery of zombie film *World War Z* (2013), without apparent irony.[2]

In the wake of the 2016 coup attempt, however, the ad and its visual rhetoric warrant further consideration, as President Erdoğan's call of the people to the streets, including to their possible death, was credited for its role in foiling the coup. This call was presaged in the ad, which might now be seen as a projection of the political fantasy behind Erdoğan's so-called 'New Turkey', the programme of fostering a more religious, conservative, self-sufficient and ethnically homogenous Turkey, led firmly by a strong leader.[3] My analysis of this fantasy begins with the ad and its visual and textual rhetoric, including context to explain its original reception. I then examine the metaphoric implications of the ad with reference to scholarship on horror and zombie cinema. I next turn to the ad's predictive power in light of W. J. T. Mitchell's notion of biopictures. I conclude with a brief discussion of crowd dynamics, and a vision of alternatives for Turkey.

Millet Eğilmez (The Nation Does Not Bow)

A giant Turkish flag blows in the breeze over Ankara's 50th Year Park; the city's prominent Kocatepe Mosque visible in the background. The keening of an eerie female voice presages the arrival of the villain, a well-dressed man with a trim beard and sunglasses. He walks towards the flagpole, pulls a crowbar from his mid-length jacket and breaks the lock to the flag's pulley system. Using the same tool, he destroys the pulley and, as the flag begins to fall, the unmistakable voice of (then) Prime Minister Erdoğan begins:

> My friend! Leave not my homeland to the hands of villainous men![4]
> Render your chest as armor and your body as bulwark! Halt this disgraceful assault!
> For soon shall come the joyous days of divine promise;
> Who knows? Perhaps tomorrow? Perhaps even sooner!

The flag's shadow starts to fall across the skyline of Istanbul's financial district, then across the face of a barber, a university classroom and citizens in a city street. While all citizens appear to be surprised, the reaction of a middle-class woman wearing a headscarf is the most pronounced, as it shifts

from astonishment to outrage. Farmers in a field are next, as they shield their eyes from the sun to trace the flag's falling shadow.

> Oh glorious God, the sole wish of my pain-stricken heart is that,
> No heathen's hand should ever touch the bosom of my sacred Temples.
> These adhans and their testimonies are the foundations of my religion,
> And may their noble sound prevail thunderously across my eternal homeland.

Citizens in Ankara's central Güven Park appear next, with particular focus on a businessman. A woman without a headscarf sheds a tear at the door of her apartment building, as others look on from apartment windows. An elderly male villager wearing *kefiye* (a male head wrapping common in the southeast of Turkey and also popular among Palestinians and those supporting their cause) and *şalvar* (baggy pants worn in village areas across Turkey) hears the *ezan* (call for prayer, translated above as 'adhan') just as Erdoğan's voice mentions it, and stops in his tracks to pray with hands uplifted.

> View not the soil you tread on as mere earth – recognise it!
> And think about the shroudless thousands who lie so nobly beneath you.
> You're the glorious son of a martyr – take shame, grieve not your ancestors!
> Unhand not, even when you're promised worlds, this heavenly homeland.

The various groups of citizens just shown begin to run towards what one can assume is the flag: city dwellers from screen left to screen right; villagers from screen right to screen left. A man is shown praying in a mosque as Erdoğan speaks of 'shroudless thousands'.

> Who would not sacrifice their life for this paradise of a country?
> Martyrs would burst forth should one simply squeeze the soil! Martyrs!
> May God take my life, my loved ones, and all possessions from me if He will,
> But let Him not deprive me of my one true homeland in the world.

More citizens from across Turkey begin to run in groups in varied screen directions. As Erdoğan says 'martyrs would burst forth', hundreds of citizens jump off a dock into the Bosphorus – the large body of water separating the eastern and western sides of Istanbul. An aerial shot shows the first Bosphorus

Bridge (renamed the '15 July Martyr's Bridge' after the 2016 coup attempt) filled with citizens running towards the Asian side, about 2,000 tiny dots in the water below them appear to be swimmers.

> I have been free since the beginning and forever shall be so.
> What madman shall put me in chains! I defy the very idea!
> I'm like the roaring flood; trampling my banks and overcoming my body,
> I'll tear apart mountains, exceed the Expanses and still gush out!

Citizens begin to converge on the park with the flag. As Erdoğan says 'overcoming my body', the first wave of citizens, males of varied costume, reach the flagpole and begin to form a scaffold of bodies. The next wave includes women of varied costume as well.

> For only then, shall my fatigued tombstone, if there is one, prostrate a thousand times in ecstasy,
> And tears of blood shall, oh Lord, spill out from my every wound,
> And my lifeless body shall burst forth from the earth like an eternal spirit,
> Perhaps only then, shall I peacefully ascend and at long last reach the heavens.

The mountain of bodies begins to grow with shots from every angle, including from high above the flagpole, where the bodies look like ants. As Erdoğan says 'arşa değer, belki, başım' (perhaps my head will be worthy of heaven),[5] the camera focuses on a young man climbing the pile of bodies.

> So ripple and wave like the bright dawning sky, oh thou glorious crescent,
> So that our every last drop of blood may finally be blessed and worthy!
> Neither you nor my kin shall ever be extinguished!
> For freedom is the absolute right of my ever-free flag;
> For independence is the absolute right of my God-worshipping nation!

The young man reaches the top and grabs the cable dangling just above his head. He pauses for a moment, looking around, and then, as Erdoğan says 'so that very last drop of blood may finally be blessed', he jumps, not to be seen again. The crimson flag leaps into place, to the cheers of those in the mountain of people. A long shot shows the flag waving proudly atop the pole, with the mountain of people still rising and growing beneath it. Erdoğan's image emerges on screen as the word 'absolute right' (*hakkıdır*) is voiced, and the

phrase 'The nation does not bow, Turkey will not be defeated' (*Millet eğilmez Türkiye yenilmez*) also appears on screen. In the original ad, this is followed by a one-second shot of the AKP logo: a light bulb with seven cone-shaped rays of light emanating outward.

Both the imagery and the text are striking for their evocation of sacrifice to the cause of the nation, but before approaching this point, context regarding two key issues is crucial: Erdoğan's past with poetry and politics, and the election atmosphere as charged by the struggle between the Gülen movement and the AKP.

Erdoğan and Poetry

Erdoğan is an immensely popular, charismatic politician with a resonant and immediately recognisable voice. He was also the unquestioned leader of the AKP by the time this ad first aired. Any of these factors could explain why his voice was used for the ad, but there is a further history as well. In 1997, when Erdoğan was mayor of Istanbul, he gave a speech in the town of Siirt in Turkey's largely Kurdish southeast that included the lines: 'Our minarets are our bayonets, our domes are our helmets, our mosques are our barracks.' That line allowed a prosecutor to file charges of 'inciting the people to enmity and hatred by focusing on religion and race' against Erdoğan under Article 312/2 of Turkey's Penal Code. Despite a defence claiming that the lines came from nationalist poet and icon Ziya Gökalp, Erdoğan was found guilty. In 1998, he was handed a hefty fine and a ten-month prison sentence of which he served four months. The provenance of the lines in question and, indeed, the poem from which they came, are the source of a variety of different stories. Far less in question is the fact that Erdoğan's reading of, and serving time for, the poem, coupled with his continued defence of Islam's role as a reference point in his political life, made him even more popular, cementing his reputation as a man of the people. Indeed, by attacking the poem and highlighting its potential religious overtones, the secular establishment helped to strengthen both the movement and the individual it sought to suppress.

AKP and Gülen

This was an early case in what became a series of struggles between Erdoğan and the secular establishment. In subsequent iterations of this strife, Erdoğan and his AKP found a key ally in Islamic cleric Fethullah Gülen,

whose nebulous community had, by the 2000s, made marked inroads into both the police force and the judiciary (Seufert 2014). While this relationship remained strong through the AKP's first and second terms (2002–7; 2007–11), the party's third term (2011–15) saw it souring. In 2012, the investigation of one of Erdoğan's top intelligence operatives, Hakan Fidan, by prosecutors presumed to be loyal to Gülen was an early sign of tension. During the Gezi Park protests that began in central Istanbul and spread to many parts of the country in the summer of 2013, the forces of Gülen's considerable media empire generally backed Erdoğan, though some voices did begin to question the wisdom of his violent and uncompromising approach to the protestors and their demands (Carney 2015). Such questioning was unusual in what had otherwise been a fully supportive stance.

It was the fall of 2013, however, that saw the relationship rupture. Erdoğan targeted the Gülen movement directly by championing educational reform to eliminate a system of test-preparation schools that were vital to both the financing and recruitment model for the movement. This move was overt, and it did not go unanswered. In December of 2013, a series of investigations into corruption at the highest levels of the AKP were made public. In January, gendarme forces presumed to be loyal to Gülen searched a series of trucks being driven to Syria by Turkish intelligence agents, raising many questions about the nature of Turkey's involvement in the Syrian Civil War and causing both domestic and international embarrassment for the AKP. The AKP countered by firing and reassigning police and prosecutors, and encouraging AKP loyalists within both forces to open counter-investigations against the Gülenists. This was answered with a series of highly embarrassing leaks to social media of taped conversations among AKP leaders, including one that purported to reveal Erdoğan telling his son to get rid of a great deal of on-hand foreign cash.

In addition to very strong evidence of rampant corruption among the AKP, as well as overt AKP collusion with media, the leaks revealed the incredible depth of the Gülen movement's surveillance machine. As the municipal election neared, the stakes rose. On 15 March, Turkey's High Council on Radio and Television (Radyo ve Televizyon Üst Kurulu, RTÜK) suspended twenty TV shows on Gülen-affiliated network Samanyolu TV's news channel, just one of numerous crackdowns on a Gülen media that fought back

with increased coverage of corruption allegations and reference to various leaks that could be found online.

This immediate backdrop, coupled with the continued unrest in the wake of the Gezi Park protests, overdetermined the significance of the municipal elections in March 2014. The local candidates running for office were of minor importance; the election was seen as a referendum on AKP rule generally and, in some ways, as a showdown between supporters of Erdoğan and Gülen.

Dawn of the Flag Pile

On 19 March, the AKP ad *Millet Eğilmez* was released to the Internet and began airing on TV channels. Its prominent use of the Turkish flag, the national anthem and scenes of prayer and mosques left no doubt that the ad was in violation of election law 298, which forbade use of the Turkish flag, national symbols and religious expressions in election propaganda. Predictably, pundits began to criticise the ad both in terms of legality and its message. In keeping with the brief history noted above, there was little question as to the identity of the enemy in the ad or the basic assertions: Turkish democracy was under direct threat from the Gülen movement, and citizens needed to mobilise immediately. The nature of the citizens and the type of mobilisation, however, were immediate fodder for discussion. Observers on social media pointed out that Erdoğan's voice took on the role of the Pied Piper of Hamlin, gathering followers who were powerless to resist, and that scenes of people jumping into the Bosphorus were reminiscent of lemmings leaping to their death.

Even more striking, the body pile in the ad seemed to quote directly the zombie film *World War Z*. Given that the film's trailer, which climaxes in a very similar body pile, had been watched over thirty million times on YouTube at that point, and that the film itself was among the most popular foreign films in Turkey in 2013, there is little doubt that the ad's creators were aware of the obvious parallels, despite the more positive portrayal of piling in the ad. While medium-shot visuals of the body pile in the election ad emphasise careful cooperation among citizens rather than frenzy, the cinematographic emphasis is on long shots, stressing sheer scale, and the strength of bodies driven towards a cause. There is a threat both *to* and *from* these bod-

ies. The threat *to* the bodies is perhaps most apparent from the lyrics of the national anthem and their rearrangement to accompany the ad: martyrdom and bodily sacrifice are evoked in almost every stanza.

The threat *from* the bodies, though implicit, was clear to observers in Turkey, and had been ever since the previous year when Erdoğan began to adopt rhetoric of crowd power in the midst of the Gezi Park protests. Rather than addressing protestor concerns at Gezi, Erdoğan had responded with the language of numbers, boasting, 'if they gather 100,000 we will gather 1,000,000' (Albayrak 2013). Shortly thereafter, he claimed that he had the support of 50 per cent of the country, and that it was only 'with difficulty' that he was holding these people back from the park, where they would presumably destroy the protestors (Milliyet Staff 2013). Both remarks posited an us/them approach to Turkey with a clear threat implied for 'them'.

Returning to the ad's initial reception, Turkey's YSK announced on the same day as the ad premiered that it violated election rules and was therefore banned. The council passed this information on to RTÜK and the Information and Communication Technologies Authority (Bilgi Teknolojileri ve İletişim Kurumu, BTK), charged with implementing the ban on television and the Internet. Erdoğan responded to the decision immediately, saying 'we will ban the ban' (T24 Staff 2014). Given both the content of the ad and Erdoğan's particular history with verse, religion and politics, it is likely that a ban was an anticipated and intentional aspect of the marketing strategy for the election; that its goal was to fuel a populism that turns both the law and standards of election decorum against themselves.

While the AKP triumphed in the 2014 municipal elections, the next two years saw a progressive ramping up of political tension across Turkey. Erdoğan was elected president in the fall of 2014 and, as an early sign of the 'New Turkey' promised in that campaign,[6] immediately changed the impartial and ceremonial character of the office to take a very hands-on approach to running the country. The Kurdish-rights oriented Peoples' Democratic Party (Halkların Demokratik Partisi, HDP) entered parliamentary elections for the first time in June of 2015, and eliminated the AKP's outright majority in the process. The AKP responded by calling for a snap election in November, turning its back on the Kurdish peace process and stoking tensions in the southeast in the intervening months.

This same period saw an increasing crackdown on all forms of political opposition. Journalists, academics and laypeople alike who challenged the AKP or criticised the president were investigated, fired and detained with increasing frequency. Numerous media outlets were shut down or taken over by the government. Though the Gülen movement and its financial, business and media outlets were prominent among those targeted in this crackdown, they were by no means the only victims. Academics and artists signing a call for peace in the southeast in January of 2016, for instance, were accused of being members of a terror organisation and put on trial.

Return of the Living Flag Pile

It was against this backdrop of increased social polarisation and rampant restriction on media that the coup attempt took place in July of 2016. While the precise nature of what happened will likely be debated for some time, four aspects of the coup are of direct relevance to the present discussion. First, there is little doubt that forces loyal to the Gülen movement were involved in the coup attempt. Though questions remain over the nature of Gülen's involvement – the reasons for the coup's failure, and the ways in which AKP loyalists responded to the coup, including when and how they became aware of the plot – no serious analyst doubts that the coordination of the coup involved Gülen loyalists (see, for example, Akkoyunlu and Öktem 2016; Çalışkan 2017; Yavuz and Balcı 2018). Thus, the alarmist message of the 2014 ad was retrospectively warranted.

Second, Erdoğan's role in both the ad and the coup attempt was similar. If the prime minister's scripted voice worked to call people to the street in the ad, it was the president's apparently unscripted call to the people to take back the streets, first shown via FaceTime on national broadcaster CNN Türk, that was credited with bringing thousands of citizens out to the streets in a showdown with military unlike any that had occurred in prior coup attempts.[7]

Third, and closely related to this, the people responded in similar fashion in both the ad and the coup. In both cases, huge groups of people answered Erdoğan's call and came out to the street at risk to their own safety. Indeed, over 200 people died as a result of the struggles that arose in the coup attempt, many of them civilians who had answered Erdoğan's call. The language of martyrs and bodily sacrifice from the anthem read by Erdoğan was made

literal on the night of the coup and in the days to follow, as those who died in defence of the nation were quickly classified as martyrs and heroes.

Finally, the ad's apparently predictive role was recognised and formalised as the AKP re-adopted the spot as part of the celebrations that followed the coup's thwarting. The ad was played repeatedly on public transportation in Istanbul, which was made free to all in the weeks following the coup attempt. This was part of the effort to encourage public participation in the so-called 'democracy watches' (*demokrasi nöbetleri*), which took place in public spaces for twenty-three days after the attempt, culminating in a massive rally with Erdoğan (see Carney 2019). The 'story' of the ad was thus told to those making their way towards the Istanbul rallies in a convergence of narrative, meaning and motion that evokes an observation by Michel de Certeau:

> In modern Athens, the vehicles of transportation are called *metaphorai*. To go to work or come home, one takes a 'metaphor' – a bus or a train. Stories could also take this noble name: every day, they traverse and organise places; they select and link them together; they make sentences and itineraries out of them. They are spatial trajectories. (de Certeau 1988, 115)[8]

The nature of this story, metaphor, itinerary and trajectory is what interests me in the remainder of this chapter. In particular, I pursue the intersection of metaphor and itinerary. I begin with the imagery of the ad, or metaphor, suggesting that the borrowing of zombie tropes is a meaningful political choice. I then turn to itinerary, focusing on the vector of time, rather than de Certeau's choice of space, to examine the predictive role of the ad in the Turkish political milieu – the way in which it set a pattern that was followed with alarming accuracy. This leads me, via the work of W. J. T. Mitchell, to the emergence of new image regimes and, as I move towards conclusion, to a discussion of the relationship between crowds and power.

Metaphor – Zombie

Given both the timing and the striking similarity of imagery between *World War Z* and the ad, I assume that the makers of the ad knowingly adopted and adapted the zombie visuals, which justifies a brief exploration of some tropes of horror (and, more specifically, zombie) film, particularly given the death-laden verbal imagery of the voice-over. My conceit here is not that the

ad's producers were thoroughly versed in zombie cinema, but, rather, that such borrowed imagery is infused with surplus meaning, some of which has relevance for the political situation in Turkey.

I begin with the basic formula for horror film set forth by Robin Wood: '[N]ormality is threatened by the Monster' (Wood 2003 [1986], 71). The AKP narrative codes normality in Turkey as a cross-section of society: rural/urban, male/female, young/old, as well as those who are overtly pious (that is, wearing headscarves or praying) and those who are not overtly pious. This normality is also defined by a variety of tasks, which are interrupted by the falling of the Turkish flag, and by a universal concern for the flag itself. The monster is, as made clear by the context above, a representative of the Gülen community, but there is no visible signal for this other than the vague, 'slick' appearance of the character in dark glasses and a pea coat. The threat is, of course, a threat to the nation, which is in turn embodied by the Turkish flag. It is noteworthy that the normality signalled by the ad contravened Turkish laws on election advertising on two fronts: the use of religious and national symbols.

Wood's analysis of horror explores the monster's threat to normality through the question of repression and oppression. As he notes, horror is based upon,

> the actual dramatization of the dual concept of the repressed/the Other, in the figure of the Monster. One might say that the true subject of the horror genre is the struggle for recognition of all that our civilization represses or oppresses, its reemergence dramatized, as in our nightmares, as an object of horror, a matter for terror, and the happy ending (when it exists) typically signifying the restoration of repression. (68)

While Wood's formula appears to suffer some slippage between the terms 'repression' and 'oppression', he is well aware of their distinction, as well as their potential fields of overlap:

> One needs here both to distinguish between the concepts of repression and oppression and to suggest the continuity between them. In psychoanalytic terms, what is repressed is not accessible to the conscious mind (except through analysis or, if one can penetrate their disguises, in dreams). We may also not be conscious of ways in which we are oppressed, but it is much easier

to become so: we are oppressed by something 'out there.' One might perhaps define repression as fully internalized oppression (while reminding ourselves that all the groundwork of repression is laid in infancy), thereby suggesting both the difference and the connection. (64)

This internal/external dynamic is helpful in understanding the complex relationship between oppression, repression and normalcy in the ad. In short, the AKP's political ascendance is generally (if simplistically) viewed as a 'return of the oppressed' (religious and, somewhat more tenuously, 'traditional') majority, which had been subjected to the modernist and secularising strictures of Kemalist reform projects from the dawn of the Turkish Republic. While the broad contours of this interpretation are accepted by secularists and Islamists alike, this is not the 'oppression' (and, hence, monster) signalled by the ad. Indeed, the ad's normality is a world in which this oppression has finally been overcome – hence the AKP's bold move of contravening secular election laws to depict religion so openly. Instead, the monster is the Gülen community, arguably a 'repressed' – that is, long hidden and often denied – element of the greater trend that led to the AKP's ascendance.

The scenario above has both repressed and oppressed, and this is why the acknowledged monster is not the same as the group that I am calling a zombie horde. In fact, the group that imagistically matches the behaviour of a zombie horde in various ways – growing exponentially and moving as a collective, jumping into water in wave upon wave and, ultimately, forming a massive body pile around the flagpole – is the very force of AKP normalcy. The fact that such clear zombie tropes are presented proudly points to a very particular view by some in the AKP of the collective that makes up its support base: they are a mass of bodies, present to serve the needs of the AKP, rather than individual citizens to be served by their government.[9]

The stakes of such representation – overt in its implication, regardless of whether the crowd is read as zombies or humans – are better revealed through some of the tropes of zombie cinema evoked by the ad. The first is the notion of familiars turned enemy, which, as Kyle Bishop notes, is closely linked to Freud's notion of the uncanny (Bishop 2006, 203). In zombie films, a friend at one moment can easily become a zombie in the next merely by being bitten. While this Jekyll/Hyde relationship is clearly signalled on one level by the Gülen figure, viewers who are not interpellated by the ad are also likely to

see the crowd in this way: former co-citizens turned into a dangerous mass. This is in part due to the visual history of such representations, both in terms of horror film and, more broadly, fascist political projects. The distinction between those interpellated by the ad and those who were, instead, horrified is important, as it speaks to the division sown both by the ad and the broader project of 'New Turkey'.

The second trope is the zombie controlled by the will of a leader. This emerged with the first zombie film, Victor Halperin's *White Zombie* (1932), and remained a common element of zombie films until the genre was re-codified by George Romero with *Night of the Living Dead* (1968) (Bishop 2006; Dendle 2001). In *White Zombie*, the zombies are not dead, but, rather, under a spell, and they remain under the control of the man who bewitched them until he is killed, at which point they regain their consciousness. This trope has obvious resonance with the ad insofar as citizens appear to be summoned to the streets by Erdoğan's voice, and are willing to follow its lead virtually anywhere. Indeed, as journalist Alexander Christie-Miller pointed out in a blog post that came out just days before the ad first emerged, the depths of this loyalty can be striking. As one fan noted: 'I support him until the end, until death' (Christie-Miller 2014). Erdoğan echoed this sentiment in his famous FaceTime announcement on the night of the coup, telling the audience: '[T]o the death, to the death' (*ölümüne, ölümüne*).

If the leader casts a spell with his voice, the other side of this command dynamic is cemented by a further trope – that of the non-speaking zombie. Aside from the man in the mosque, who appears to be mouthing a prayer, none of the characters in the ad speak. Bereft of this most human of traits, the subjects of the ad are little more than visualisations of Erdoğan's voice. As Bishop notes: '[Z]ombies do not think or speak – they simply act' (2006, 197). Indeed, he suggests that this non-speaking element is what makes the zombie uniquely suited among monsters to the medium of film. While it is difficult to read or listen to a compelling story about a speechless, thoughtless horde, watching it can be spectacular.

In his comparison of Romero's first two zombie films, *Night of the Living Dead* and *Dawn of the Dead* (1978), Robin Wood emphasises that a return to normality in the first film works against the liberatory potential of horror cinema, while the destruction of social order in the second is more optimistic

(Wood 2003 [1986], 101–8). The ad follows the more conservative trajectory of order restored, signalled by the re-hoisting of the flag. But the normalcy there shrouds an important shift that has taken place in the three-minute spot: a population going about its everyday activities has been transformed into a crowd of zombies – summoned by the voice of a leader, individuals have become speechless automatons who, if not yet dead, are at least willing to die at his whim.

Itinerary – Prediction

The fact that many did die in similar circumstances two years later brings us to the predictive power of the ad. I approach this through what W. J. T. Mitchell calls a biopicture, which he sees as a technologically (and, often, violently) enhanced extension of what he once dubbed the 'pictorial turn':

> [B]oth image-making and war-making have undergone a radical transformation in our time, a transformation that can be summarized in the phrase, 'cloning terror.' By this I mean, on the one hand, the reproduction or proliferation of terror, often in the very act of trying to destroy it, and, on the other hand, the terror or horror of cloning itself, both as a biotechnology and as a figure for the indefinite duplication of life forms, especially those life forms (such as cancers and viruses) that are seen as bearers of death or threats to identity. (Mitchell 2011, 57)

While Mitchell does not mention zombies, they are the nightmare synthesis of both aspects of cloning terror. The zombie represents, on the one hand, an uncanny form of cloning, insofar as it is an 'indefinite duplication' leading to both loss of identity and (un)death. On the other hand, the zombie, at least in this ad, and often in zombie films, demonstrates how unexpected terror may result from attempts to combat social threats. In films such as *28 Days Later* (2002) and *I Am Legend* (2007), for instance, it is medical research that leads to the zombie outbreak.[10] Similarly, it was the AKP's long dalliance with the Gülen community for political ends that made that group far more dangerous, leading to the summoning of what I am labelling a zombie response.

For Mitchell, the biopicture (or biodigital picture) is linked to Foucault's biopolitics (Foucault 2008 [2004]) insofar as it serves as a means for power to control the life of subjects. But it represents a further phase of this project,

as it takes advantage of new technologies of imaging and biology (Mitchell 2011, 70–2). These new faculties are thus linked up with the powers that images have always exercised. As Mitchell puts it: 'The biopicture, then, is the fusion of the older "spectral" life of images (the uncanny, the ghostly) with a new form of technical life, epitomized by the contemporary phenomenon of cloning and the development of digital imaging and animation' (73). Indeed, the ad does fuse the uncanny – the shift that overcomes citizens when exposed to Erdoğan's voice – with the powers of digital imaging, which are most pronounced when the bodies are put in positions that would normally signal danger: leaping into the Bosphorus and forming the body pile.

The crucial insight provided by Mitchell's biopicture, however, involves the evolving relationship between images, reality and politics – a shift that he explores with reference to the presidential tenure of George W. Bush. Citing the words of one Bush official who ridicules the 'reality-based community', claiming that 'we create our own reality', Mitchell suggests that iconoclastic revealing is no longer sufficient for the cultural critic. In the emerging world order, it is precisely the power of the image/metaphor to change the terms of reality that we must tackle:

> It is never enough to simply point out the error in a metaphor, or the lack of reality in an image. It is equally important to trace the process by which the metaphoric becomes literal, and the image becomes actual. This means a renunciation of the most facile and overused weapon in the iconologist's arsenal, the tactic of 'critical iconoclasm,' which wins easy victories by exposing the unreal and metaphoric character of an icon. Blunt, commonsense declarations about the illusory character of images will simply not do. We need instead a method that recognizes and embraces both the unreality of images and their operational reality. (Mitchell 2011, xviii)

It is this territory between unreality and operational reality that is most pertinent here – the span of time between the two iterations of the ad, and the shift in meaning revealed by this itinerary, to return to de Certeau. The 2014 version of the ad was a nightmare that came true in 2016, but the obvious monster was clear all along. What changed with the shift in time is the realisation of a mass of citizens called to death. Between its two lives, then, the ad mediates the transition from a political fantasy to reality.

Conclusion – Crowds, Democra-Z and Alternatives

When the ad emerged from its grave in 2016 to be reanimated for public celebration, it merely put the seal on a project of reality creation that had already been achieved. Mitchell does not provide a formula to describe this process, and that discussion is beyond the purview of this piece, but, at the most basic level, the ad presented an image of prescribed behaviour that served as a pattern in 2016. That pattern, particularly when reinforced by Erdoğan's call to the people on the night of the coup, had the strength of what Elias Canetti calls a command:

> A command addressed to a large number of people thus has a very special character. It is intended to make a crowd of them and, in as far as it succeeds in this, it does not arouse fear. The slogan of a demogogue [sic], impelling people in a certain direction, has exactly the same function; it can be regarded as a command addressed to large numbers. From the point of view of the crowd, which wants to come into existence quickly and to maintain itself as a unit, such slogans are useful and indeed indispensable. The art of a speaker consists in compressing all his aims into slogans. (Canetti 1962, 311)

This passage comes from Canetti's *Crowds and Power*, an eclectic foray into the human drive for belonging and its exploitation by leaders. This relationship is central to what I am here calling Democra-Z: the form of rule that emerges when leaders in authoritarian democracies harness the power of the crowd for political ends. Democra-Z arises in the media-saturated world of post-truth politics, a setting where consensus understandings of reality have begun to dissolve, and all political narratives are thrown into question. The drive of the crowd in Democra-Z is the need for belonging made salient when faith in institutions and master narratives is severely shaken. The catalyst is the leader with a slogan.

The 'zombies' in this system, the 'Z' of Democra-Z, are not dead, but they may be called upon to die, as in the case of the coup. Whether subjects are ultimately called to their deaths, they are seen as less than human. The essential aspect of the zombie image, then, is not its tie to death, but the way that it represents subjects as a crowd: a dehumanised force that functions in the collective.

Does the ad offer an alternative vision? If not in the text itself, perhaps in one of its inspirations. Activist collective Ztudyo responded to the ad on

the day it aired in 2014 with a form of culture jamming that highlighted and inverted its key dynamics.[11] Their version of the ad begins with the shadow of the flag falling and, like the original, shows the shock of citizens from across the country, followed by a move to action. But there are neither citizens leaping into water nor a body pile in this ad. Instead, the final image is a video of Taksim Square at the height of the Gezi Park protests. A giant Turkish flag is once again prominent, but the crowd is assembled horizontally rather than vertically around it, representing a very different vision of political participation. The soundtrack to this version is the Gezi Park chorus singing 'Do You Hear the Sound?' (*'Duyuyor Musun Sesi'*) to the tune of 'Do You Hear The People Sing?' from *Les Miserables*.[12] The message here is, once again, clear to observers in Turkey: authoritarian politics are a threat to the nation, and participatory efforts like Gezi are the answer.

Returning to Wood's formula for horror cinema, the restoration of normality in the conclusion is a conservative option, but the challenge to social order need not end this way. The Ztudyo ad signals an alternative: an assembly in which those drawn do not give up their cause (the flag and nation), but neither do they become zombies. Rather than a fantasy of Democra-Z, Ztudyo presents the image of a public.[13] This simplistic dichotomy – critique of the AKP and lauding of its opposition – is far from remarkable; what may raise eyebrows is the degree to which the AKP casts its supporters into the role of zombies and the rigour with which that script appears to have been followed. These are elements of fantasy that speak all too clearly to the vision of 'New Turkey', in which the zombie crowd is the ideal citizen assembly. Whether Gezi's publics offer hope for a different resolution is a question awaiting the sequel.

Notes

1. As of June 2021, a version with English subtitles (slightly different than the translation offered below) was available at <https://vimeo.com/89687376>.
2. I wrote a blog post about the ad at the time, and I was far from alone in seeing this resemblance: <http://wp.me/p2Ne8x-1e>.
3. This concept, which also involves a lopsided idealisation of the Ottoman past, is developed more fully in the introduction to this book.
4. This translation comes from the English language Wikipedia page for 'İstiklal Marşı', available at: https://en.wikipedia.org/wiki/%C4%B0stiklal_Mar%C5%

9F%C4%B1. It is unattributed, and periodic editing since 2016 suggests a collective effort. The version included here is from July of 2019.

5. My translation of this section.

6. While the rhetoric of 'New Turkey' was prominent in the 2014 municipal elections, the phrase took on a far more central role in the presidential campaign later that year, where it became Erdoğan's chief slogan.

7. Though Erdoğan's intervention is often credited for the public showing, Unver and Allassad (2016) present a compelling case based on analysis of digital data to suggest that this role has been overstated – in short, that people were using a variety of strategies to mobilise against the coup prior to Erdoğan's intervention.

8. My use of de Certeau here was spurred by a presentation by Zeynep Gürsel at the SCMS conference in Chicago in 2017. She made an insightful connection between public transportation, metaphors and the visual aftermath of the coup attempt in pursuit of a different, but related, topic.

9. This visual rhetoric is nearly the opposite of the rhetoric and subtext of earlier campaigns, which emphasised the service that the AKP provided to citizens, especially its own voters.

10. I extrapolate the source of the rage virus in the film *28 Days Later* based on the related graphic novel *28 Days Later: The Aftermath* (Niles 2007). There is debate among fan communities over whether *I Am Legend* is closer to a vampire or zombie film. I group it with the latter here because it employs the trope of a viral outbreak that radically alters its victim's consciousness and physical abilities, spreads rapidly and wreaks havoc on a massive scale.

11. As of June 2021, the ad could be viewed at: https://haber.sol.org.tr/devlet-ve-siyaset/akpnin-bayrakli-reklamini-bir-de-boyle-izleyin-haberi-89645.

12. While the song overtly speaks to any listener who might join the movement, it indirectly addresses Erdoğan with ironic reference to his labelling of Gezi protestors as '*çapulcular*' (looters).

13. For more on the construction of publics in Turkey, see Carney and Marcella (2017); Carney (2019).

Bibliography

Akkoyunlu, Karabekir and Kerem Öktem. 'Existential Insecurity and the Making of a Weak Authoritarian Regime in Turkey'. In *Southeast European and Black Sea Studies*, vol. 16, no. 4 (2016): 505–27.

Albayrak, Nafiz. 'Taksim, Erdoğan'ın Tahrir'i mi olacak?' ['Will Taksim be Erdoğan's Tahrir?']. In *Milliyet*, 2 June 2013, http://www.milliyet.com.tr/-

taksim-erdogan-in-tahrir-i-mi/dunya/detay/1717890/default.htm (last accessed on 19 November 2020).

Bishop, Kyle William. 'Raising the Dead'. In *Journal of Popular Film and Television*, vol. 33, no. 4 (2006): 196–205.

Çalışkan, Koray. 'Explaining the End of Military Tutelary Regime and the July 15 Coup Attempt in Turkey'. In *Journal of Cultural Economy*, vol. 10, no. 1 (2017): 97–111.

Canetti, Elias. *Crowds and Power*. Translated by C. Stewart. New York: Farrar, Straus and Giroux, 1962.

Carney, Josh. 'Shifting the Community Press: A Brief Examination of Gülen-Affiliated Papers'. In *The Gülen Media Empire*, edited by L. Nocera, 77–91. Rome: Arab Media Report, 2015.

Carney, Josh. 'Projecting "New Turkey" Deflecting the Coup: Squares, Screens, and Publics at Turkey's "Democracy Watches"'. In *Media, Culture & Society*, vol. 41, no. 1 (2019): 138–48.

Carney, Josh. and V. Marcella. 'Screens of Satire and Commons of Resistance: The Place and Role of Humor in the Gezi Park Protests of Turkey'. In *Ridiculosa*, vol. 24 (2017): 151–64.

Certeau, Michel de. *The Practice of Everyday Life*. Translated by S. Rendall. Berkeley: University of California Press, 1988.

Christie-Miller, Alexander. '"Seni bilen hayran, bilmeyen dü ş man" or, Why Erdogan Remains So Popular', 2014, https://turkeyetc.wordpress.com/2014/03/12/seni-bilen-hayran-bilmeyen-dusman-or-why-erdogan-remains-so-popular/de (last accessed on 19 November 2020).

Dendle, Peter. *The Zombie Movie Encyclopedia*. Jefferson and London: McFarland, 2001.

Foucault, Michel. *The Birth of Biopolitics: Lectures at the College de France, 1978–79*. Translated by G. Burchell. New York: Palgrave Macmillan, 2008 [2004].

Milliyet Staff. 'Erdoğan: "Tü rkiye'nin yü zde 50'sini zor tutuyoruz"' ['Erdoğan: "We're Holding Back 50 per cent of Turkey with Difficulty"']. In *Milliyet*, 3 June 2013, http://www.milliyet.com.tr/basbakan-4-gun-yok-siyaset-1717873/ (last accessed on 19 November 2020).

Mitchell, William John Thomas. *Cloning Terror: The War of Images, 9/11 to the Present*. Chicago: University of Chicago Press, 2011.

Niles, Steve. *28 Days Later: The Aftermath*. New York: Dey Street Books, 2007.

Seufert, Günter. 'Is the Fethullah Gülen Movement Overstretching Itself? A Turkish Religious Community as a National and International Player'. In *SWP Research Paper*, vol. 2 (2014): 1–31.

T24 Staff. 'YSK, AKP'nin reklamını yasakladı, Erdoğan "yasağı yasaklarız" dedi' ['High Voting Council Banned AKP's Ad, Erdoğan said "We Ban the Ban"']. In *T24*, 19 March 2014, http://t24.com.tr/haber/akpnin-turk-bayrakli-reklam-filmine-durdurma-karari/253820 (last accessed on 19 November 2020).

Ünver, Akın and Hassan Alassaad. 'How Turks Mobilized against the Coup'. In *Foreign Affairs*, 14 September 2016.

Wood, Robin. *Hollywood: From Vietnam to Reagan . . . and Beyond*. New York: Columbia University Press, 2003 [1986].

Yavuz, Hakan and Bayram Balcı, eds. *Turkey's July 15th Coup: What Happened and Why?* Salt Lake City: University of Utah Press, 2018.

Yeşil, Bilge. *Media in New Turkey: The Origins of an Authoritarian Neoliberal State*. Chicago: University of Illinois Press, 2016.

6

UNITED AGAINST THE REFEREE: COMPETITIVE AUTHORITARIANISM, SOCCER AND THE REMAKING OF NATIONALISM IN ERDOĞANIST TURKEY

Can Evren

One might say of sport something similar to what Fredric Jameson has said of the sphere of culture after the Second World War, namely that it has undergone a prodigious expansion, so that everything has come to seem, in a sense, 'cultural'. Sport has equivalently radiated and ramified to such a degree that, if everything has become cultural, then everything in that culture is tending to the condition of the sporting. The two meanings of performance – achievement and imposture – have come close together. (Connor 2011)

The constitutional referendum in April 2017 ultimately transformed Turkey from a parliamentary to an executive–presidential political system. In the run-up to the referendum, one Twitter user, a lawyer named Şenol Özçakıcı, summarised the proposed amendments in the following way:

Turkish style presidential system: Aziz Y [the president of Fenerbahçe Sports Club] will serve as the president of both FB [Fenerbahçe] and TFF [Turkish Football Federation] and will even appoint the MHK [Central Council of Referees], the PFDK [Disciplinary Committee for Professional Football], and the Arbitration Council. And, he can revoke the league if Fenerbahçe fails to win. (Özçakıcı 2017)

Throughout the months leading up to the referendum, the opposition frequently relied on football metaphors to underline issues around unfairness and partiality that, they feared, would inevitably arise under the proposed

new regime. According to the opposition, the idea of handing electoral 'champions' unrestricted power to shape non-executive branches of the state (especially the judiciary) was akin to a football team competing in the Turkish league while also governing the national football federation, appointing the referees and subtly penalising its rivals.

Those who supported the proposed changes had their own footballing narrative, however. A propaganda video for a 'yes' vote, commissioned by several pro-government agencies, depicted the Turkish national football team playing against a foreign national team in a game governed by a corrupt and anti-Turkish referee. In this footballing narrative, analysed in more detail below, the referees appear as insidious Western conspirators and antagonists who act against the national interest and cause the nation to lose. If the nation is to have a chance of defeating its foreign rivals and achieving national sovereignty, then, the video implies, it must show a red card to the referee. In 'New Turkey', this vision of a footballing struggle 'against the referee' enjoys considerable purchase. Political rhetoric is increasingly shaped by a constructed ideological opposition between, on the one hand, the executive discretion of an electoral majority and, on the other, the powers held by non-elected and ideally non-partisan organs.

To be sure, these two opposing narratives differ in the content of their message. Nonetheless, their co-existence in a public debate over Turkey's political future points to the crucial role of football, not only as a popular pastime or a cultural industry, but also as an accessible narrative repertoire for concocting rival imaginaries about the nexus between competition and politics. On the one hand, this repertoire can be used for fabricating a liberal–democratic imaginary of the state as an impartial umpire ensuring fair play among rival parties and candidates. Alternatively, it can be used as fuel for a majoritarian denunciation of referees as oppressors of the nation, and to depict an unruly nationalist telos which seizes 'sovereignty' from impartial officials. The first uses football to imagine state neutrality vis-à-vis intra-national political rivalries, the second to denounce what are deemed 'non-national' rules enforced by a minority. As the introduction to this volume has indicated, cultural representations function as sites of struggle, and they are open to ideological uses and abuses. In the same vein, what football comes to represent vis-à-vis the nation state is also up for grabs. The pliability of symbols and narratives

allows for the fabrication of rival footballing myths about the past and future of Turkey.

In this essay, I view recent political transformations in Turkey through the lens of sports. I suggest here that discursive repertoires of football partisanship both mirror and contribute to the establishment of a competitive authoritarian regime in contemporary Turkey. This political modus operandi actively cultivates polarisation, grounds legitimacy in victories scored on (competitive) electoral 'matchdays', records victories by pressuring the referee and stretching the rules and relies on the majoritarian incumbent's power to bend regulations with (authoritarian) impunity. Seen more widely, this signals a shift in the core modality of state power. At one time, this was rooted in non-partisan institutions, but these have come to be categorised as building blocks of a bygone tutelage. Now, the state operates through power and opposition, expressed in competitive and/or polarising repertoires most accessibly allegorised in the language of sports.

Competitive Authoritarianism as a Paradigm

In 2002, political scientists Steven Levitsky and Lucan Way published a seminal article entitled 'The Rise of Competitive Authoritarianism'. The authors questioned transitional frameworks of democracy and argued that, when electoral legitimation co-exists with undemocratic government, such regimes should not be treated as incomplete democracies or 'stuck' in their progress towards 'true' democracy. Instead, electoral authoritarianism should be viewed as a 'specific regime type' (2002, 51). Levitsky and Way thus indicate that the competitive organisation of multi-party elections and universal suffrage might have developed into a modern repertoire for consolidating a specific style of (authoritarian) rule. Rather than constituting deviations in a 'modernisation' process teleologically leading to democratic maturation in a field of fair political play, this style actually contributes to the maintenance and consolidation of fundamentally undemocratic regimes. Levitsky and Way's diagnosis could be read as an invitation to think of ways by which cultural repertoires of competition, partisanship and polarisation contribute to the consolidation of authoritarian regimes. The following chapter is an attempt to take up their invitation.

In competitive authoritarian regimes, 'formal democratic institutions are widely viewed as the principal means of obtaining and practising political

authority', even though incumbents 'violate these rules so often and to such extent' that the regime hardly qualifies as democratic (2002, 52). By contrast, in democracies, 'open, free and fair' elections determine executives and legislatures; voting rights are universal; 'political rights and civil liberties' are protected; and elected authority is not 'subject to tutelary control over military or clerical leaders' (53). Certainly, in the competitive–authoritarian style that Levitsky and Way delineate, elections are free of significant fraud. However, the winners of elections use their hard-won status and power to 'create an uneven playing field' and to defend their titles over successive cycles of elections. An ascendant and often charismatic leader, one legitimised through electoral triumphs, corrodes the 'tutelary' control of non-elected authorities. Elections gradually morph into the very mechanism preventing, rather than enabling, the alternation of power.

In this transition from non-electoral monopolies to the electoral consolidation of non-democracy, the chances of a change in government narrow significantly. The field of sociopolitical contestation contracts into a polarised electoral fight. Incumbents weaken the opposition not by banning them from the 'playing field' or rigging elections, but through more 'subtle forms of persecution' (53). These forms often involve the use of (ideally impartial and non-partisan) 'state agencies', such as tax authorities or 'compliant judiciaries'. The guardians of these regimes 'routinely manipulate formal democratic rules', but do not 'eliminate them or reduce them to a formal façade' (53). Central to the consolidation of this pattern is the corrosion of state neutrality and the partisan instrumentalisation of public bodies – actions which can be carried out with impunity thanks to partisan majoritarian support. Notably, political scientists have recently argued that this model of competitive authoritarianism can be instructively applied to the new Erdoğanist status quo in Turkey (Esen and Gümüşçü 2017), while the concept has also entered public debates in the media (Erdem 2017; Tezkan 2014; Yeldan 2017).

It is far from surprising if sporting analogies take centre stage in a public sphere increasingly focused on questions about the fairness of elections and the degree to which competition can help alternate or stabilise power. Sports have long been related to ideas of a political regime characterised by peacefully alternating governments and the erosion of ascribed hierarchies. In *The Quest for Excitement: Sport and Leisure in the Civilizing Process*,

historical sociologist Norbert Elias argued that the development of rule-governed sports in the eighteenth and nineteenth centuries was closely related to the changing norms and habitus of political and social elites and their internal agreements. In Elias' phrasing, 'the sportization' of elite pastimes served as the counterpart for 'the parliamentarization' of government and inter-elite conflict (qtd. in Dunning 1997, 480). This historical ideal type required the 'peaceful handing of government to an opponent' and a 'willingness on the part of a new government not to use its great power resources for the humiliation or destruction of hostile or oppositional predecessors'. Both of these tendencies require considerable self-restraint. Parliamentary government thus entails the 'smooth rotation of rival groups according to agreed rules' (1997, 480), a powerful simulation of which takes place in athletic competitions of the modern era.

Elias' conceptualisation of sports hints at their valuation as pedagogical antidotes to the possible slide of electoral regimes into authoritarianism, particularly due to their alleged power to permeate society with the idea that winning and losing are reversible moments in an ongoing competition. This is a sporting morality associated with elite education in British public schools of the late nineteenth century (Holt 2011, 24). Indeed, its roots lie in the elevation of 'competition' into a regulative idea for organising political, economic and cultural worlds since the eighteenth century (Collins 2013, 13). To be sure, sports do contribute to a popular cultural repertoire of alternating champions and status achieved by means of rule-based competition. After all, it is precisely the annual recycling of the position of the winner, which is newly emptied every summer, that sustains and reproduces the momentum of fandom. Footballing crowns are inherently seasonal and must be re-achieved anew as one league season follows the next. Viewed through this lens, an incumbent who visibly resents the possibility of handing power to an opponent, and who resists the neutralisation of advantage accumulated by wins in a previous cycle of elections, finds a natural cultural framework of objection in the rivalrous dynamics of sport.

This is precisely what Özçakıcı's Tweet accomplishes. It condemns Erdoğanist regime change by likening it to a sports club hegemonising the Turkish Football Federation and using its regulative powers to nullify the league when it cannot win. And in fact, in the annals of modern Turkish

history, there is no shortage of attempts to equate the monopolisation of political power by one party with a tyrannical soccer federation (Adil 1945), and democratic aspirations with a fair soccer league. The period after World War II was marked by a contentious transition from a single-party regime to a multi-party democratic state. At this time, sports journals frequently remarked that soccer could provide a model for a democratic nation state. As one columnist wrote in October 1945, 'the game of football is a miniature model of democratic society', and provided that referees are chosen democratically by the competing clubs, they would surely be 'chiefs of justice', compelling the competitors to respect the rules of competition ('*Üstad Diyor Ki*').

Such projective models that referenced football in order to make political claims were used to define a democratic multi-party future for the Turkish nation state. These models identified the key condition for democracy in the selection of referees by inter-club consensus, rather than their appointment by a single-party executive branch. Another telling example can be found in *Demirkırat* (1991), the classic documentary on Turkey's turbulent transition to a multi-party regime produced by the journalist Mehmet Ali Birand. In an interview for this documentary, Kasım Gülek, the General Secretary of the Republican People's Party (CHP) between 1950 and 1959, was asked about İsmet İnönü's initial response to electoral fraud and voter obstruction by the CHP cadres against the challenging Democrats in the first ever 1946 general elections. According to Gülek, İnönü's instinctive reaction was to think back to the first soccer competitions played in Turkey's military academies, in which sore losers would physically assault their opponents and cause disorder. However, as the general is said to have then observed, losers gradually learned the necessity of competitive self-restraint.

This story is wholly compatible with other examples from popular print media during the heated electoral races of the 1950s. Newspapers and journals frequently relied on a sporting imaginary to represent inter-party rivalries, sometimes analogising elections as a *şampiyona*, ('electoral championships' [Kaynar 2016, 33]). This resulted in a profound sportisation of political representation, a repertoire to dramatise and make sense of politics in sports terms.

Locating Statehood in the Terraces

However, the propaganda video for an affirmative vote to constitutional amendments in the April 2017 referendum relied on a very different football narrative. The video, titled *Evet! Şanımız Olsun* (*Yes! We Shall Be Glorious!*), was produced by the pro-Erdoğan think tank Bosphorus Centre for Global Affairs. During the referendum campaign, this think tank organised a social media campaign under the motto 'The System That is Best for Us', which endorsed a 'yes' vote, and thus effective regime change towards a presidential system. The video cites two other sponsors, the pro-government NGO Türkiye Gençlik Vakfı (Turkey Youth Foundation), and a district local government in Istanbul controlled by an Erdoğanist mayor, Üsküdar Belediyesi.

The footballing narrative staged in the video positions partisan fandom, rather than a well-refereed competition, as the central element in the projective model of the nation state. In the video, the Turkish national football team in red is playing against a foreign national team coached by a blonde-haired manager. We understand that this is a home game by the fact that the stands are replete with Turkish flags. Fans are worried, worn-down, passive, unhappy. The video zooms in on the rival manager's smile: the opponent is about to take a penalty. Then we watch a replay of the incident that led to the penalty, which shows that the opposition player dived to win it, but the referee still called it. After the decision, the diving player and the referee exchange conspiratorial smiles. The Turkish keeper nonetheless saves the penalty, but the referee continues to unfairly whistle in favour of Turkey's opponent. Finally, in a climactic moment, a young girl dressed in red and white and wreathed in a radiant light leaves the stands and walks onto the pitch. She accosts the referee and shows him a red card emblazoned with a star and crescent. The camera turns to the stands: all the fans are holding the same red cards as the young girl. Having sent off the ref, the girl gives the ball to Turkey: Turkish players suddenly turn into world-class athletes, artistically dribbling past their opponents and scoring with a fantastic bicycle kick.

The video dramatises the contours of regime change by pitting a solidarity between the national representatives (the team as the Erdoğanist 'yes' vote) and its cheering supporters (the pro-Erdoğan electorate) against the referee. Only by vanquishing the referee can the true potential of the nation be realised. The referee, who wears the respect badge of UEFA, embodies

two constitutive others of the ascendant Erdoğanist rhetoric. The first of these is the EU or, more generically, the West. The West is presented as a mistaken role model, towards which Kemalist modernisation misguidedly strove at the expense of cultural authenticity and sovereignty. The second is the so-called *Kemalist vesayet*, non-elected bodies like the military and judiciary, staffed by schooled functionaries who restrict the sovereignty of the civilian majority by using their veto powers against electoral champions. The Erdoğanist plebiscite becomes a red card against both of these others, but above all against the second, because the vote relates to an alteration in the distribution of power among the branches of government in favour of the elected executive.

The utilisation of an international football match to represent intra-national political rivalry is perhaps the critical feature of this allegory. Indeed, it elevates this allegory to an almost intentional illustration of competitive authoritarian projections towards the future. This displacement in effect translates domestic opposition into an international framework – a conspiratorial rhetoric which is gradually moving to centre stage in the 'New Turkey', where a suspicious 'foreign' hand lies behind every domestic conflict. This projection pre-empts possible future alternations of government by defining electoral losses as defeats against foreign enemies, and it delegitimises objections to the use of public resources by the incumbent in order to retain power. This is a partisan conception of the nation state which dissolves conceptions of statehood based on supra-partisan monopolies like the army.

However, by equating all non-elected and non-partisan institutions under a reductive category of tutelage, this discourse is imbued with authoritarian overtones. In short, it blurs critical distinctions between the judiciary and coercive functions of the state apparatus. By placing an electoral competitor (a party) at the highest echelon of the nation state, it hints at a ceaseless condition of partisanship as the condition of, and grounds for, the regime. This is best represented in an idiom associated with Erdoğanism, *taraf olmayan bertaraf olur* (those who won't take sides will be washed aside), a form of politics which relies on the formation of irreconcilable blocs.

In this modality of governance, sending off the referee and violating the space of play are possible and even acceptable tactics. The authority of non-partisan rule keepers is constantly weakened by the repeated transgression of

the formal parameters of the game, whether through mass booing, physical attacks like throwing projectiles onto the field or, as the mythic narrative of the video suggests, by an angelic representative of the national majority entering the pitch and dismissing the referee. In this way, a field of competition is structured in which all actors are partisan. This is the path to victory. To be sure, the narrative can be read as one political party using the power of audiovisual media to manipulate public opinion through the widely despised figure of the football referee to symbolise one's rivals. However, the red card adorned with a star and crescent directed at the referee conjures a strong dislocation of established articulations of football and nationhood. This is particularly evident in the use of an international football match to dramatise a deeply divisive plebiscite which produced an almost 50/50 split within the population.

This sporting representation of politics is rooted in a repertoire of referee bashing, and suspicions about referee neutrality,[1] which have their roots in public perceptions and memories around football fandom. First, the video superimposes a current political discussion against memories of international sporting controversy. Since Turkey's record in international football began to improve from the mid-1980s, such memories have become salient aspects of Turkish popular culture. The video deliberately depicts the political opponent in the colours of the Brazilian national team. This touches on memories of the 2002 FIFA World Cup, when Turkey's opening day defeat against Brazil became the stuff of a mass media campaign against the game's referee, after he sent off a Turkish player by misreading a deceptive dive by the Brazilian striker Rivaldo. By consciously staging a political myth according to a template provided by international soccer, the video treats Erdoğanist defiance as a correction against anti-Turkish refereeing in 'international sports competitions'. As Tanıl Bora has aptly pointed out, this gives rise to a particularly 'aggressive language of nationalism', one grounded in the concept of 'national causes' that demand unquestioned allegiance and unity from citizens (2003, 437).

The competitive achievements of Turkey's sporting representatives in international competitions, particularly in the 1990s, morphed sports into cultural rituals of nationalism on an industrial scale, driven by a mass media profiting from amplified indignation (Gökalp 2007). Significantly, many such competitions were against Western European rivals, and they came against the backdrop of a heated Turkey–EU integration process. Consequently, such sporting

events frequently became platforms for campaigns of anti-European mobilisation. The most remarkable example came in 1999, when a Galatasaray game against Juventus Turin overlapped with debates in Italy over the granting of political asylum to the PKK leader Abdullah Öcalan. The game itself became an anti-European spectacle.

Indeed, from the mid-1980s, sport media-led campaigns of national indignation were a regular occurrence, serving to popularise a conveniently anti-Western rhetoric that flowed both up and down between the media and the public. On one occasion, a month-long media campaign against UEFA to repeal what was perceived as an unfair penalty imposed on Galatasaray due to spectator misconduct during a match against Swiss rivals Neuchatel Xamax drew the following fan letter to *Milliyet*: 'Having seen this despicable UEFA decision, I am ashamed of myself for having admired Europe in my earlier life' ('*UEFA'ya lanet yağıyor*'). It is precisely within this anti-Western sportive repertoire that the nationalist epic of the propaganda video is located.

Notably, however, the figure of the football referee is closely related to conspiracies in domestic, as well as international, football. Indeed, the referee marks the constitutive other of the partisan masculine solidarity that is said to predominate on the terraces. The ambiguity of the ref's position, symbolised in FIFA rules by a non-coloured uniform, provides the basis for fan routines designed to alchemise affective self-affirmation out of the material of ordinary sporting controversies. Across stadia in Turkey, the sporting opposition of one team against another is often translated into a vulgar, gendered binary, with the non-heterosexual ambiguity reserved for the ref, who is often denounced with the F-word. Anthropologist Yağmur Nuhrat, in her ethnographic work on popular perceptions of fairness and refereeing in Turkish football, writes that the referee is 'the only fan-less actor in the entire social site of football [and] occupies the peculiar position where no one is on their side' (2013, 259). As Nuhrat ethnographically explores, swearing at the referee and collective chants attacking this lonely figure play a powerful role in the cultivation of collective identities in the stands (Nuhrat 2017).

The propaganda video presents a rampant nation which storms the pitch and overcomes a suspicious barrier standing between the uncertainties of competitive game-play and the inconvertible want of partisan fans to see their side emerge victorious by any means. In this way, the video draws on a *fait social*

which is ritualistically reproduced in the football terraces and in front of television screens. In fact, the video follows in the footsteps of a particular cultural–industrial pattern that has emerged in Turkey, especially in the last two decades. During this period, football became increasingly televised but live games were rarely free-to-air. Frequently the content with the highest ratings were not the matches themselves, but free-to-air post-match discussion and analysis shows. These slots filled broadcast hours with the inexpensive content of verbal debates about referee decisions, developing referee bashing and controversy into a mass cultural product (Özsoy 2014). Media scholar Margaret Morse has suggested that the televised production of matches has the power to tip the balance of sporting truth in favour of mass spectator certainty against the judgement of authorised umpires, because 'slow motion replays are treated as part of hermeneutic process of scientific discovery, which allows the viewer to outguess the referee and see what "really" happened' (Morse 2003, 381).

Referee bashing and partisanship are far from being recent phenomena in Turkey's football history. Indeed, such activities date back to the first ever leagues and tournaments in Istanbul, to the extent that, in the 1920s, they drew the attention of municipal governments and statesmen.[2] Only recently has this been co-opted as a repertoire of political mobilisation, however. In the past, the partisan modality of referee bashing was long scorned by the political establishment as a sociological nuisance or a form of mere hooliganism. Indeed, interwar nation-building elites, particularly the cadres of the General Directorate of Physical Education, held an explicitly negative evaluation of football fandom precisely because of its polarising effects – referee bashing, pitch-storming and partisan crowd behaviour – which ideologues likened to the 'primitive' atmosphere of underground cockfighting (Akın 2004, 104–11). For this reason, many doubted the efficacy of soccer for nation-building and development, and such discourses had a significant influence on Turkey's post-war centre left.

A testimony to the continuity of this discourse has recently come in the form of the discovery and wide circulation of a dismissive 1954 text by centre–left leader Bülent Ecevit about football. This text describes the culture of athletic competition as relying on misguided notions of national pride, and it categorises athletic achievements as inferior to those in science or the arts.[3] Erdoğanism, in contrast, projects a new regime and a constitution that

emerges from among cheering fans. This regime projects the will to victory of these fans; it locates the ideal constituency within the realms of indignant referee bashing crowds, in effect affirming partisanship as a mode of nation-building. That a repertoire of football partisanship has recently moved to the political mainstream as part of seismic shifts in Turkish politics is visible from a plethora of scenes. These include electoral candidates wearing partisan foot-ball scarves during pre-electoral rallies, and policing initiatives for stadium governance which involve prefect chiefs of police joining fan collectives in the *curva* wearing home-team insignia ('*Emniyet Müdürü*'). Moreover, the controversial 2011 Law on Sport Violence, still in effect, formally recognised fan associations as legal partners in stadium policing and thus eroded the formal – one might say 'elitist' – distances dividing the state from the terraces (Resmi Gazete Staff 2011).

All these processes are part and parcel of a new sense of democratisa-tion, in so far as democracy is narrowly defined as a bridging of the gap between statehood and popular culture. When sport analogies are used to voice demands for democracy, then statehood assumes the form of an impar-tial referee. Viewed in this way, the more recent nexus of football and politics does not simply fall short of democratic norms – it actively and proactively fabricates a notion of nationhood/statehood as located among cheering (most likely swearing) crowds in the *curva*. In propagandistically privileging the will of the terraces over referees, the video erodes the idea that political rivalries can benefit the whole by motivating collective improvements and bringing about fairer and more just governance.

Multi-party parliamentary imaginations, notions such as fair play, rule of law or horizontal accountability, are absent from this and other similar myths of 'New Turkey'. These polarised visions hint at a new regime based on the sublimation of electoral victories and the 'word of the ballot box': *sandık*. This has become the single, incontrovertible source of legitimacy, imbued with the power to trump regulatory and legal limitations and unite all capacities of the state.[4] Winning at all costs and the ritual scapegoating of the referee take centre stage. This implies the occupation of public space exclusively by irreconcilably partisan forces.

Recently, the role of footballing repertoires in corroding the rule of law has also entered the vocabulary of critical lawyers. In April 2018, lawyer and

co-president of the Society for Democratic Judiciary Orhan Gazi Ertekin wrote an essay entitled 'A State Won't Construct a Society by the Voice of Football Terraces'. The title referred to a Tweet in which the actress Berna Laçin criticised calls for the reinstitution of corporal punishment in the style of popular justice. In his article, Ertekin writes that, since the failed coup attempt of July 2016, a

> new political link is built between 'public indignation' and the 'function of judging.' This is new vis-à-vis the history and the tradition of Turkey's judiciary. 'Judging by indignation' has the effect of making the regime of law and rights a *teferruat* and violates the law's principal mission of protecting the minority. The principal quality of a judiciary should be to mark the difference between the 'voice and the indignation' of the masses and the general societal common sense, and thus give equilibrium to societal conflict. (Ertekin 2018)

These concerns are congruent with, and reminiscent of, the conclusions of a recent study of American politics and public culture entitled *Uncivil Agreement*. This book utilises a rich set of sporting anecdotes, metaphors and imagery to lay bare an intensification of partisan sorting and polarisation and the erosion of 'cross-cutting cleavages' (Mason 2018, 7), which enable a degree of societal 'equilibrium'.

Indeed, there is something inherently, or at least potentially, uncivil about sports – a basic uncivility (not to be confused with primitiveness) produced by the immanent logics of sporting opponency. In treating sports as a 'subtle deterrent' of unruliness and violence which contains a potential pedagogy for the peaceful 'rotation of power' among rivals, Norbert Elias' civilising process functioned with a rather limited conception of sports (Connor 2011, 200). As critic Steven Connor persuasively argues, there is something fundamentally erroneous about such notions of sports as restraining unruliness and violence by enclosing them in a universe of contrived rules, and as a grounding for the analogy of parliamentary rule of alternating governments. Against Elias' cathartic conception of sports, Connor writes that 'despite all claims that sport is a theatrical displacement of human desires, virtues, and values, sport in its essence is zealously nonsymbolic and unillusory . . . the tendency of all sports is always towards the reduction of the virtual to the actual' (2011, 175).

Connor's emphasis on non-illusory seriousness implies that sport is anything but a mere theatrical space reserved by society for the restrained and rule-based simulation of violence, one intended to keep violence within strict bounds. Instead, 'the field of play seems to act as a zone of legal exception where ordinary understandings of violent, aggressive and disorderly behaviour are suspended' (2011, 201). With this statement, Connor is suggesting that rule-based competitions should not be simply thought of as domesticating otherwise violent or unrestrained impulses toward the arbitrary exercise of power. On the contrary, they produce a specific kind of violence by the rules they contrive, a 'zone of exception' as much as a zone of rules. These spaces are shaped by abundant forms of cheating and violation, which are not simply rule-breaking or 'foul play', but exist as the condition for opponency, rooted in the sole rule that overrides all others: if the players are indeed playing, then they must play to win (2011, 146).

Similarly, elections are not simply formalised voting games designed to facilitate the peaceful alternation of government. Instead, they are exceptional, victory-oriented campaigns, in which rivals aim to exert as much effort as they can in order to win. This is the very problem tackled by theorists of competitive authoritarianism. Like sports, elections are also first and foremost ways of 'making decisions', 'of determining or getting to know . . . who wins'. Elections can be said to 'reduce the plenitude of the [political] world' and introduce a registry of scorekeeping (2011, 148). One could politically reframe a question posed by Connor with respect to the inexhaustible presence of unfair exertion and the inevitable centrality of winning in sports. As he observes, rules do not simply restrain violence and preclude their violation, and sports 'multiply and distribute the opportunities to participate in' (2011, 208) victories and the feeling of supremacy vis-à-vis opponents. If this is, indeed, the case, and if electoral regimes bring about a widespread impulse for pushing rules to their limits in seeking victory, then wouldn't elections essentially become another modality for multiplying and distributing unrestraint and violence?

If one were to apply Steven Connor's interpretation of rule-based sports competitions to elections, one could say that an election 'prolongs and even perhaps amplifies a violence that might otherwise be dissipated much more quickly, or not even arise' (2011, 206). After all, codified rules of formal equality among consenting rivals, the condition of elections as well as sports,

'is not principally to increase fairness, or reduce cruelty, but in order to make it possible to *win*' (2011, 187 (emphasis in original)). When definitions of democracy narrow into the partisan victories of elections, therefore, the race for votes could very well turn into the occasion for concentrated, participatory and amplified unfair play, as well as for violence. This is because winning 'creates losers and depletes [their] subjectivity' (2011, 187). Beyond the parameters of electoral gameplay, such circumstances might never arise.

That said, modern sports are fundamentally different from forms of absolute supremacy practised in, for example, the sport of hunting, because they involve a relative form of winning over nominally equal opponents. In much the same way, elections also prolong violence and domination in their procedural pretence and regular intervals, defining a form of decision making that does not involve killing. Seen from this perspective, the binary of coup d'états and elections, which signify *the* grand historical–political opposition between Kemalism and Erdoğanism in 'New Turkey', is more accurately defined as two different durations and expansions of violence and unfair political play. On the one hand are the military coup d'états, chronologically known and named in public discourse by the days of their coercive executions; our May 27ths, March 12ths, September 12ths, February 28ths and July 15ths. On the other hand are the electorally defined authoritarian 'eras' of executive stability, named after electoral champions, our Menderes or Erdoğan eras.

In 'New Turkey', debates over the limits of incumbent exertion throughout electoral durations – starting with the legal kick-off day for campaigning, continuing with voter registration and the actual casting of votes on the election day and ending with the counting process – have taken an unprecedented centrality. This itself is a symptom of an emergent gravitation of politics towards notions of competition which shape both authoritarian and democratic aspirations. The former are obsessed with the acceptable extent of rule violation in order to win, while the latter are determined to see fair play and courageous referees resist popular pressure. In this atmosphere, even the mere administration of elections is no longer a weekend nuisance for functionaries, who must work as voting station administrators as part of their obligations as state representatives. Alongside these paid functionaries, the energies and capacities of thousands of civilian volunteers from all walks of life are mobilised. An increasing percentage of citizens, myself included, have

taken part in the dramatic process of electoral oversight, as voting station observers, vote counters or in other roles. A new set of activities have very rapidly become part of Turkey's seasonal routines – from the mundane act of preparing and distributing lunch boxes for volunteering voting station observers, to the sophisticated creation of digital apps to conduct a parallel count to that of the Higher Institution of Elections, which involves the coordination of thousands of voting stations.

These oppositional mobilities emerge as responses to pre-empt anticipated fraud, but also as counter-demonstrations of oppositional electoral resilience against the instrumentalisation of public power by the incumbent. Such actions result in a highly unequal playing field. They range from the partisan deployment of police forces in order to intimidate voters and restrict freedoms of speech and assembly, the use of executive pressure on the judiciary to pacify or wrong-foot opponents and more territorial tactics, such as gerrymandering.[5]

Notes

1. Whether this suspicion is legitimate or purely illusory is beyond the scope of this paper, but it is an interesting question from a sporting angle. Allegorically posed, this would imply a question for historical inquiry. Did a non-partisan conception of the Turkish nation state ever exist? If yes, what enabled it? Or, what might have corroded its public credibility and authority? Or, was the league ever not rigged and fair? Was it always an unfair race, contributing to a common sense whereby the only viable strategy to succeed is to bend the rules for one's own gain?
2. Accounts of early Republican football history present ample evidence. See Yüce (2015).
3. For the original text, see Ecevit (1954). For an example of its contemporary circulation, see 'Ecevit Yazdı'.
4. For the precedents of this idea of 'majoritarian system' in the 1950s, see Bora (2016). The existence of a precedent to sporting populism is the 1950s Democrat Party, which should not be surprising to those familiar with patterns of political identification in Turkish history. An example can be found in the mass mediated indignation about defeats in the 1952 Olympics, as the Democrats created a sporting platform of national fandom to attack the Republicans for acquiescing to the rules of the International Olympic Committee (see Özsoy 2011).
5. For example, Aygül (2016).

Bibliography

Adil, Fikret. 'Türk Sporu: Yükselme için yeni veçhe verilmesi lazımdır'. In *Futbol*, no. 1 (17 September 1945): 1, 8.

Akın, Yiğit. *'Gürbüz ve Yavuz Evlatlar': Erken Cumhuriyette Beden Terbiyesi ve Spor*. Istanbul: İletişim, 2004.

Aygül, Cenk. 'Electoral Manipulation in March 30, 2014 Turkish Local Elections'. In *Turkish Studies*, vol. 17, no. 1 (2016): 181–201.

Birand, Mehmet Ali (1991). *Demirkırat: Bir Demokrasinin Doğuşu*. Available at 32. Gün Arşivi, 'Demirkırat Belgeseli Tüm Bölümler'. *Youtube*, 31 August 2017, https://www.youtube.com/playlist?list=PL19EshdPt3R80rux_vc-tC_8QjvI4JyCM (last accessed 19 November 2020).

Bora, Tanıl. 'Adnan Menderes'. In *Türkiye'nin 1950'li Yılları*, edited by Mete Kaan Kaynar, 331-47. Istanbul: İletişim, 2016.

Bora, Tanıl. 'Nationalist Discourses in Turkey'. In *South Atlantic Quarterly*, translated by Linda Stark, vol. 102, no. 2–3 (Spring/Summer 2003): 433–51.

Bursa Hakimiyet Staff. 'Emniyet Müdürü Ak, Teksas Tribününde'. In *Bursa Hakimiyet*, 18 November 2017, http://www.bursahakimiyet.com.tr/haber/emniyet-muduru-ak-teksas-tribununde-205416.html (last accessed 1 December 2018).

Collins, Tony. *Sport in Capitalist Society: A Short History*. London and New York: Routledge, 2013.

Connor, Steven. *A Philosophy of Sport*. London: Reaktion, 2011.

Dunning, Eric. 'Sport in the Quest for Excitement: Norbert Elias's Contributions to the Sociology of Sport'. In *Group Analysis*, vol. 30 (1997): 477–87.

Ecevit, Bülent. '7 Golde "Milli Felaket"'. In *Halkçı (Yeni Ulus)* (30 June 1954): 3, http://ecevityazilari.org/items/show/263 (last accessed 2 December 2018).

Erdem, Eren. 'Rekabetçi Otoriterlik, Popülizm ve Demokratik Hat'. In *ABC Gazetesi*, 26 Aralık 2017, https://www.abcgazetesi.com/eren-erdem/rekabetci-otoriterlik-populizm-ve-demokratik-hat-8229yy/haber-8229 (last accessed 30 November 2018).

Ertekin, Orhan Gazi. 'Devlet Tribün Sesleri ile Hukuk İnşa Eder mi?' In *Gazete Duvar*, 4 July 2018, https://www.gazeteduvar.com.tr/forum/2018/07/04/devlet-tribun-sesleri-ile-hukuk-insa-eder-mi (last accessed 07 May 2018).

Esen, Berk and Şebnem Gümüşçü. 'Rising Competitive Authoritarianism in Turkey'. In *Third World Quarterly*, vol. 37, no. 9 (2017): 1581–606.

Futbol Staff. 'Üstad Diyor Ki: İngiliz Futbolu Hikâyesi'. In *Futbol*, no. 2 (1 October 1945): 2.

Gökalp, Emre. 'Reconstruction of Turkish Nationalist Discourse(s) in the Sports Press (1990-2002)'. In *culture&communication*, vol. 10, no. 2 (Summer 2007): 9–62.

Holt, Richard. *Sport and the British: A Modern History*. Oxford and New York: Oxford University Press, 2011.

Kaynar, Mete Kaan. 'Türkiye'nin Ellili Yılları Üzerine Bazı Notlar'. In *Türkiye'nin 1950'li Yılları*, edited by Mete Kaan Kaynar, 15–38. Istanbul: İletişim, 2016.

Levitsky, Steven and Lucan Ahmad Way. 'Elections Without Democracy: The Rise of Competitive Authoritarianism'. In *Journal of Democracy*, vol. 13, no. 2 (2002): 51–65.

Mason, Lilliana. *Uncivil Agreement: How Politics Become Our Identity*. Chicago: University of Chicago Press, 2018.

Milliyet Staff. 'UEFA'ya lanet yağıyor'. In *Milliyet* (20 November 2018): 14.

Morse, Margaret. 'Sport and Television: Replay and Display'. In *Television: Critical Concepts in Media and Cultural Studies*, edited by Toby Miller, vol. 2. London and New York: Routledge, 2003.

Nuhrat, Yağmur. 'Fair to Swear? Gendered Formulations of Fairness in Football in Turkey'. In *Journal of Middle East Women's Studies*, vol. 13, no. 1 (2017): 25–46.

Nuhrat, Yağmur. *Fair Enough? Negotiating Ethics in Turkish Football*. PhD dissertation, Providence: Brown University, 2013.

Özçakıcı, Şenol (senolozcakici). 'Türk tipi başkanlık: 'Aziz Y hem Fb, hem Tff başkanı oluyor, Mhk, Pfdk ve Tahkimi atıyor, yine de Fb şampiyon olmazsa ligi iptal edebiliyor!' https://twitter.com/senolozcakici/status/818715233430700032'. 9 January 2017, 02:04 UTC. Tweet.

Özsoy, Selami. 'Basına Yansımalarıyla "1952 Amatörlük Olayı" ve Türk Sporunda Amatörlük'. In *Dokuz Eylül Üniversitesi Sosyal Bilimler Enstitüsü Dergisi*, vol. 13, no. 2 (2011): 97–119.

Özsoy, Selami. 'Futbolun Sözel Hali: Televizyon Programları'. In *Global Media Journal: TR Edition*, vol. 5, no. 9 (Fall 2014): 280–302.

Resmi Gazete Staff. 'Sporda Şiddet ve Düzensizliğin Önlenmesine Dair Kanun'. In *Resmi Gazete*, vol. 50, no. 27905, 14 April 2011, http://www.mevzuat.gov.tr/MevzuatMetin/1.5.6222.pdf (last accessed 1 December 2018).

Socrates Staff. 'Ecevit Yazdı: 7 Golde Millî Felâket!'. In *Socrates*, 28 May 2017, https://www.socratesdergi.com/bulent-ecevit-ve-futbol-turkiye-bati-almanya (last accessed 2 December 2018).

Tezkan, Mehmet. 'Rekabetçi Otoriterlik'. In *Milliyet*, 26 Haziran 2014, http://www.milliyet.com.tr/yazarlar/mehmet-tezkan/rekabetci-otoriterlik-1903219 (last accessed 30 November 2018).

Yeldan, Erinç. 'Asya krizinden rekabetçi otoriterliğe'. In *Cumhuriyet*, 2 August 2017, http://www.cumhuriyet.com.tr/koseyazisi/794246/Asya_krizinden_rekabetci_otoriterlige.html (last accessed 30 November 2018).

Yüce, Mehmet. *İdmancı Ruhlar: Futbol Tarihimizin Klasik Devreleri: 1923–1952*. Istanbul: İletişim, 2015.

7

BETWEEN RESISTANCE AND SURRENDER: COUNTER-HEGEMONIC DISCOURSES IN TURKISH SATIRICAL MAGAZINES

Valentina Marcella

Satirical magazines have historically had a strong presence in Turkey. Though their survival has often been troubled, they have nonetheless managed to establish a reputation among their readership as key voices of criticism against the misdeeds of the political class and the absurdities of certain sections of society. In the past, these publications have frequently exercised a counter-hegemonic function, especially at times of political crisis and during anti-democratic crackdowns. The growing authoritarianism of successive AKP governments has certainly provided fruitful material for satirical magazines, while also exposing these publications to the risk of becoming targets of repression.

This chapter investigates satirical magazines published during the so-called summer of Gezi (2013) and in the weeks following the military coup attempt of 15 July 2016. It aims to present an up-to-date reflection on their political potential. The focus is on major publications – namely, *Gırgır*, *Penguen*, *LeMan* and *Uykusuz*. The chapter draws on the tradition of British Cultural Studies to approach satire as a subdivision of culture – and thus as a site of struggle against political dominance. How do satirical magazines respond to political crises? Which tactics of resistance do they adopt? Which challenges do they pose to the hegemonic process? The author of this chapter argues that these magazines challenge hegemonic power at various levels, and discusses why, despite this fact, they seem to have lost their overall political potential.

Political Cartoons as Resistance

On 4 July 2018, Nuri Kurtcebe, one of Turkey's leading political cartoonists, was handed a one-year, two-month and fifteen-day prison sentence for insulting President Recep Tayyip Erdoğan. Kurtcebe boasts a five-decade long career and has worked for iconic satirical magazines like *Gırgır* and prominent newspapers such as *Hürriyet, Cumhuriyet* and *Aydınlık*. Nonetheless, he was sentenced for drawing and publishing several Erdoğan caricatures in 2015 (Diken Staff 2018). Two days after the verdict, the cartoonist was released on probation.

Kurtcebe's case turns the spotlight on the complicated relation between satire and power, and on the merits and limitations of satirical *representations*. This chapter embraces Stuart Hall's understanding of representation as an act of reconstruction. According to Hall, representation is an act of ideological recreation and, as such, it is never neutral, but rather subject to the interests of specific groups (1997, 32, 49, 51, 56, 61–2).

If this understanding is applied to the current political climate in Turkey, its most evident aspect is that power appears increasingly concerned with exerting control over representations of itself. Power offers considerable visibility to media, publications, artistic expressions and initiatives that suggest a positive representation of itself, while silencing those that question it. The spectrum of permitted representations is thus highly limited, rather than broad and diverse. In other words, in 'New Turkey', plurality is sacrificed for the sake of cultural hegemony.

Satirical representations – like any other representation – are ideologically charged. As such, satire that puts forth critical representations of power is not exempt from hegemonic intervention, as Kurtcebe's arrest indicates. At the same time, satire aims to strike a balance between farce and seriousness, entertainment and denunciation, fiction and reality. As such, it is the genre which, perhaps more than any other, has the power to negotiate the boundaries of what it is possible and not possible to say.

This chapter discusses satire's ability to challenge hegemonic representations of power. It argues that, even under the growing authoritarianism of the AKP, satire remains a critical and thought-provoking form of expression, able to develop counter-narratives that undermine official discourses. This study assesses the counter-hegemonic potential of anti-government

satire produced and circulated at two key moments of political tension: the so-called summer of Gezi in 2013, and the weeks following the military coup attempt of 15 July 2016. As Antonio Gramsci points out, ruling groups resort to force when their hegemony breaks down (1977, 311, 1603, 1638). This became most apparent at these two points in time – that is, when the AKP's hegemony was seriously questioned, though in different ways. On both occasions, Erdoğan took decisive action in order to retain power. Consequently, strategies of resistance became more culturally and politically important.

The following chapter offers a comparison of the political satire of summer 2013 and 2016. First, it analyses cartoons' counter-hegemonic representations in terms of portrayed actors, conveyed messages and adopted techniques. Second, the comparison explores the mechanisms that satire activates among the readership. And third, it addresses hegemonic responses to satire, and the implications of these responses. Previous studies have suggested that the mainstream is more revealing than the underground, because it is in the mainstream that struggle is engaged more openly and directly (Paton and Powell 1988; Fekl 1997; Marcella 2015; Gardes and Labar 2016). Therefore, this study focuses on Turkey's most popular satirical weeklies, specifically *Penguen*, *Uykusuz*, *Gırgır* and *LeMan*.[1]

Counter-hegemonic Representations of Power I: Gezi Cartoons

In late May 2013, a series of protests began in Turkey. These protests lasted throughout the whole summer, and changed shape several times during this period, encapsulating street marches, the occupation of parks, sit-ins, public forums and so on. The protests became a driving force for satire. The actors, spaces, political claims and strategies of the protests became sources of inspiration for cartoonists. Amidst the variegated satirical production of that summer, some general patterns emerged with respect to the figures portrayed, the messages conveyed and the techniques adopted.

In quantitative terms, Erdoğan appears as the undisputed central character of the cartoons. Other political figures who also actively contributed to the government's repressive machine and often appeared on the news were not featured in a comparable way. Equally visible is the police. Though Erdoğan is widely represented as the instigator of the attacks against the protestors, the

police are portrayed as perpetrators, and the relationship between the two is so intertwined that, on some occasions, it becomes symbiotic.

For instance, in an unsigned cartoon published in *Gırgır* on 12 June 2013, Erdoğan wears a full anti-riot police uniform. He holds a weapon in one hand and a tear-gas shotgun in the other. When asked about his intentions, his improbable answer is that he is going to establish a 'dialogue' with the protestors. Symmetrically, featured as *Penguen*'s cover cartoon of 13 June 2013, by Taner and Selçuk Erdem, two policemen escort Erdoğan as he reads some political slogans sprayed on a wall around Gezi Park. He wears a brown, checked suit like the one that the real Erdoğan wore during several public appearances. The uniform worn by the two policemen under their bullet-proof vests is exactly the same.

Erdoğan and the police often interact with a third actor – namely, the protestors. They may be particular protestors who became iconic, like the *kırmızılı kadın* ('woman in red')[2] and *duran adam* ('standing man').[3] More often than not, however, they are anonymous. Indeed, the representations of anonymous protestors tends to converge on two general trends. First, they are used to depict the disproportionate repressive measures of which they are victims, and second, their intelligence, humour and moral superiority to both the police and Erdoğan is praised. While the first trend opposes the stigmatisation of protestors perpetrated by power and pro-government media, the second challenges the ruling class on moral grounds.

The messages expressed by this satire may be grouped according to three main categories. These include Erdoğan's almost irrepressible hostility toward the protestors, the brutality of police violence and the press and media coverage of the events, which is either biased or totally absent. The techniques through which these denunciations are expressed are as multifaceted as the cartoons themselves. Here, too, some general patterns emerge.

Mocking power through imagined scenes is one of these patterns. In a cartoon by Fatih Nadir for *Gırgır* (12 June 2013), Erdoğan addresses a tree in a challenging way: 'Just lay down that hand, first! Lay that hand down!', he angrily orders to a 'hand', which is, in fact, a tree branch. Through the lens of Roland Barthes's concepts of *denotation* and *connotation* (1986), we might say that, at a denotative level, power is ridiculed by showing its highest representative expecting to have a conversation with a tree, failing to

understand the difference between a tree branch and a human arm, and pretending to assert his power over the plant. Connotatively, the cartoon plays with what seemed to be one of Erdoğan's main obsessions: the trees of Gezi Park being held in higher respect than the construction project he had endorsed for the area.

The second technique may be deemed to some extent the opposite of the first, as it is based on specific real-life events rather than imagined scenes. An example is a *LeMan* cartoon by Sefer Selvi published on 12 June 2013 (Figure 7.1). Erdoğan is depicted here watching some footage of the protests on a screen – specifically, a first aid scene broadcasted from an indoor environment that resembles a mosque more than a hospital. The reader familiar with the daily record of Gezi will immediately recognise Istanbul's Dolmabahçe Mosque, where dozens of protestors sought refuge from heavy police attacks on the night of 1 June 2013, helping each other recover from tear gas and pepper spray inhalation. This fact was largely exploited for anti-Gezi propaganda by Erdoğan, who accused the protestors of desecrating a holy place by drinking alcohol, smoking, wearing shoes in the mosque and writing slogans on its walls.

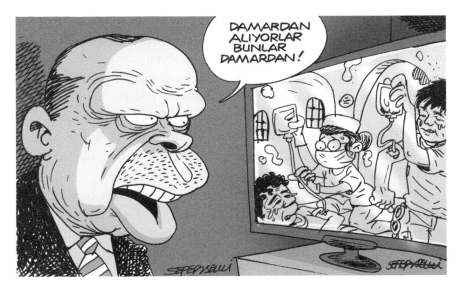

Figure 7.1 Erdoğan watches footage of first aid scenes at Istanbul's Dolmabahçe Mosque (Source: *LeMan* 2013/24)

While it is true that protestors entered the mosque without removing their shoes, the accusations neglected to acknowledge the emergency nature of the event, and the fact that the imam and muezzin had allowed the protestors in precisely to assist them (Bianet Staff 2013). Inspired by Erdoğan's false accusations, the cartoon has his fictional counterpart comment: 'They take it directly into their veins, in the veins!', as if the protestors were administering some sort of drug to each other, despite the easily recognisable intravenous drip featured in the cartoon. The counter-narrative is thus constructed by simply exaggerating the hegemonic version of the event. At a connotational level, the latter is absurd enough to make any further satirical device unnecessary.

Another technique that emerges from the 'Gezi cartoons' consists of paradoxical reversals of logic. A *Penguen* illustration by Mustafa Satıcı dated 4 July 2013 portrays, at denotational level, a collapsed man with copious blood streaming out of his mouth and two policemen standing next to him. One of the policemen is armed with a truncheon; he comments: 'How should we know, you were standing there like a person . . .'. It thus becomes clear that he beat the man and is now hesitantly defending his act, or rather justifying it. Several elements of the picture (the first part of his comment, the puzzled expression of the victim) suggest that he had no reason to exercise violence in this circumstance.

At connotational level, a political denunciation is built here around the concept of violence, its randomness and self-justification. In this way, a counter-narrative to the myth of the heroic police is offered. Yet the illustration goes further, revealing its most powerful meaning in the second part of the comment. For these words imply that simply looking like an ordinary person is enough to be perceived as someone dangerous and, therefore, to attract police violence. In this sense, the cartoon comments both on the banality of evil and, more specifically, on the irony of the fact that this evil emerges from the very same agency charged with protecting the people. Ultimately, this means that the police and their instigators fear ordinary people, in general, as a threat to their hegemony.

The fourth recurrent technique is a combination of the second and third. On the one hand, and like the cartoon just mentioned, it revolves around the concept of the banality of evil; on the other, it expresses this banality

through real-life situations such as the previous one. For instance, on 6 June 2013, *Uykusuz* published a cartoon by Cihan Ceylan in which, denotatively, a riot policeman is shown breaking through the window of an apartment and finding himself face-to-face with a resident who is sitting in his living room searching through the TV channels looking for a news bulletin (Figure 7.2). This latter detail can be deduced from the resident's comment: 'Hah! I was looking for you, where are you? WTF, I can't find you on any TV channel!'.

Figure 7.2 A riot policeman breaks through the window of an apartment for no actual reason (Source: *Uykusuz* 2013/23)

Here the connotation unfolds in four steps: first, it is hard to find news reportage involving the police (because of the low media coverage of the protests); second, the police resort to drastic measures, including violating private property; third, they do so even when the protestors are not violent or are not protestors at all; and fourth, this practice has become so widespread that the resident appears surprised but not scared. In order to fully appreciate the effectiveness of this illustration, it has to be remembered that, during Gezi, tear gas canisters were shot into people's apartments. The persecution of anti-government protestors further included raiding the houses of people who had voiced their disapproval by sharing political content on social media (Ergin 2013; Harding and Letsch 2013). Overall, this scene offers a critique of the official narrative of the infallible media, dangerous protestors and trustworthy police.

Counter-hegemonic Representations of Power II: The 15 July Cartoons

From the point of view of satire, the summer of 2016 also proved to be highly productive. The night of the coup attempt and its aftermath emerged as a rich source of inspiration. A common feature in the cartoons of both periods is Erdoğan's visibility. At the same time, this is also the main difference, because the 2016 cartoons are focused almost exclusively on him. By contrast, other dominant actors, such as the army, the police and the mass of anti-coup demonstrators who took to the streets at the behest of the president, are only rarely visible.

The political messages of the coup cartoons are less easy to define than in the case of Gezi. This difference is perhaps rooted in the fact that the failed coup took place on a single night, whereas the Gezi Park protests lasted throughout the whole summer, and the forms they took, though reshaped several times, always maintained an exceptional character. Crucial developments following the failed coup, such as persecutions, mass imprisonments and dismissals, were denounced in these cartoons. This, however, should not be considered simply as a result of the coup attempt. The subsequent state of emergency simply intensified the scale of repressive measures that were already in force, and which were thus already a subject of political satire. It is certainly difficult to generalise about the political denunciations of post-15 July cartoons. Nonetheless, some recurring themes include the unusual

responses to, and management of, the events of that night, the subsequent witch-hunt for actual and alleged government opposers and the resulting new order of relations among the government, police, armed forces, intellectuals and civil society.

As in the Gezi cartoons, numerous satirical devices can also be detected in those cartoons which emerged after the coup attempt. In the July 2016 context, those discussed in the previous section translate in the following ways: the technique of ridiculing power through imagined scenes is well exemplified by an unsigned cartoon published in the 17 August 2016 issue of *Gırgır*. Denotatively, Erdoğan is furtively posting a 'pilot wanted' advertisement on the outer wall of an airport building, when a man approaches him and expresses interest in the job: 'My president, can I give it a try? I have experience with tanks!'. Connotatively, the job advertisement plays with the sudden shortage of fighter pilots in connection with mass arrests and purges of military personnel in the aftermath of the coup attempt. The Turkish flag draped over the shoulders of Erdoğan's interlocutor evokes the hundreds who took to the streets on the night of 15 July in response to Erdoğan's call, which came in defiance of a military-imposed curfew.

The figure in the cartoon clearly played an active role in preventing the success of the coup. This is further confirmed by his reference to driving tanks, which hints at scenes of Erdoğan's supporters parading on the military vehicles seized from the defeated coup perpetrators. The counter-hegemonic strength of this scene lies in portraying Erdoğan as lonely and resigned, and his supporters as ignorant. In fact, power is mocked, first, through the menial action of looking for new pilots via an advertisement; second, through the fact that Erdoğan is personally dealing with this task; and third, through the excessive self-confidence of his supporter, who would do anything to please his leader, even if he does not have the required skills.

Cartoons that are based on specific real-life events rather than totally imagined scenes are also common. An iconic moment of the night of the coup was Erdoğan's video call interview on CNN Türk. The poor technical arrangements of the interview were striking: it was broadcasted through the screen of a smartphone that the anchorwoman held in her hand and turned to the TV camera. Indeed, the phone in question actually received two calls during the live broadcast, showing the names of the callers and

covering Erdoğan's video (but not the audio) until the anchorwoman dismissed them. These unusual, and to some extent comical, broadcasting conditions contrasted with Erdoğan's serious speech. They helped to ease the tension of the night, at least briefly.

Faruk Kaya and Bahadır Baruter from *Penguen* reversed the perspective, focusing on Erdoğan's point of view (18 August 2016). Erdoğan is depicted holding the phone and addressing the smartphone camera, while he downplays the protests and reassures the audience that the situation is under control. His language is informal, and his tone friendly. This so closely resembles a conversation between friends to the extent that Erdoğan says: 'I just thought I'd call and see how you're doing . . .' At the same time, a thought balloon reveals that he is proud of himself for carrying out the video interview with no technical difficulties. The cartoon could have easily pushed its satire to a greater extent, especially through dialogue. Instead, it essentially allows the informal nature of the real video call to turn the latter into a self-parody, which discredits the image of the charismatic leader.

The third satirical technique that emerged from the Gezi cartoons comprised paradoxical reversals of logic. This finds an eloquent counterpart in 2016 in an unsigned cartoon published in *Gırgır* (17 August 2016). At the level of denotation, a judge asks a man on trial whether he is an FETÖ member. This is a reference to the Fethullah Gülen movement, a formerly close ally of the AKP, which was blamed by the government for organising the coup attempt and is now widely referred to as FETÖ (Fethullahçı Terör Örgütü, Fethullahist Terror Organisation). The man reveals that he is, in fact, a member of the Islamic State of Iraq and Syria (ISIS), prompting the judge to reply: 'Acquitted! Don't waste the court's time, dear!'.

At connotation level, the scene points the finger at the witch-hunt against people suspected of ties with Gülen through a juxtaposition between FETÖ and ISIS. The author of the cartoon thereby challenges the government's official discourses on the war on terror. The insinuation is that an internationally outlawed terror organisation is tolerated by the Turkish state, while a formerly close ally of the government is being persecuted. This juxtaposition is no coincidence, but rather grounded in Turkey's (at least) temporary indulgence of ISIS (Callimachi 2016). Ultimately, the denunciation is two-fold.

Figure 7.3 A woman is prevented from returning home due to a reversed curfew
(Source: *LeMan* 2016/32)

As far as the fourth satirical technique is concerned, an example of paradoxical reversals of logic set in real-life situations comes in the form of a Ronî Battê cartoon for *LeMan* (17 August 2016). This image depicts a man preventing a young woman from returning home by invoking a 'ban on leaving the streets' (Figure 7.3). This hints at the Democracy and Martyrs' Rally held in Istanbul on 7 August 2016 (Bianet Staff 2016). The character justifies this reversed curfew by referring to a 'democracy meeting' that is taking place as they speak, implying that everyone should be attending it. The woman appears floored at his logic, which provokes him to ask whether she is an FETÖ member. The idea of a reversed curfew could be comical. However,

the real implication here is that any failure to attend events promoted by the government implies a link to an organisation that, after 15 July, was labelled as terrorist. This effectively conveys the sense of polarisation and suspicion that was created in the aftermath of the failed coup.[4]

What emerges from this brief exploration is that, in the summers of 2013 and 2016, satire responded to political tension with representations of power that called into question its highest representatives and highlighted the most critical aspects of their management of the political crises. Various narrative strategies were commonly used during both periods, including aesthetic and linguistic devices that are not analysed here due to restrictions of space. But in both cases, political cartoons developed counter-hegemonic alternatives to predominant official discourses.

The next section discusses other counter-hegemonic strategies and moves from cartoon analysis to the realm of author–reader relations.

Author–Reader Relations as Counter-hegemonic Strategies

The previous sections of this chapter have revealed the general anti-government sentiment that characterises the satirical representations in *Gırgır*, *Penguen*, *LeMan* and *Uykusuz*. In addition to promoting critical representations of power through cartoons, all four magazines developed further counter-hegemonic strategies.

In summer 2013, for instance, they expressed solidarity with the protestors in multiple ways. As soon as the Gezi Park protest developed into a nationwide anti-government mobilisation, *Penguen* and *LeMan* endorsed the protestors by adjusting their cover pages. *Penguen*'s logo – a clumsy penguin who attempts to fly with the aid of artificial wings – became a protesting penguin modelled on Banksy's iconic stencil known as *The Flower Thrower*. *LeMan* added the epithet *kronik çapulcunuz* ('your obstinate looter') to its name. This was a reference to the protestors' ironic appropriation of the term *çapulcu* ('looter'), which was initially appended to them by Erdoğan in order to discredit them.[5] Both *Penguen*'s protesting penguin and *LeMan*'s self-declared *çapulcu* identity remained on the covers of the respective magazines throughout the whole summer.

Gırgır and *Uykusuz* did not alter their names or logos. Nonetheless, on several occasions, they explicitly referred to the active participation of their

staff in the protests. An unsigned *Gırgır* cartoon of 12 June 2013 portrays a group of protestors holding copies of the magazine (the actual cover of the 5 June 2013 issue is visible), while a caption explains that some of *Gırgır*'s authors went to the places of the protests to distribute the magazine for free. And the fact that joining the protests, either as cartoonist or citizen, also meant sharing the risk of being exposed to repressive measures was clear from a note in the 12 June 2013 issue of *LeMan*. This note revealed that cartoonist Suat Özkan was not able to design his illustrations for this issue because he had been severely affected by exposure to tear gas. The physical participation of cartoonists in the protests thus reiterated the anti-government position they were simultaneously expressing in the magazines.

One of the protestors' major weapons was irony. Indeed, this earned them the expression *orantısız zeka* ('extraordinary intelligence'). Their clever and ironic responses to the government's hostility and to police violence achieved wide visibility thanks to both substantial participation in the protests and the wide dissemination of photos and videos through the Internet. This 'extraordinary intelligence' did not go unnoticed by satirical magazine authors, who repeatedly paid homage to the protestors' wit.

For example, a short piece of writing by Alper Ocak in *Gırgır* on 12 June 2013 congratulates the protestors on their 'bright intelligence' and 'understanding of humour', which he describes as the essence of a 'brilliant and cheerful resistance'. The author encourages the protestors to keep following this path, for 'the subtler your wit, the more your opponents foam at the mouth'. Similarly, in a written message in *Uykusuz* (6 June 2013), Barış Uygur directly addressed the protestors to admit that he did not prepare his weekly editorial because: 'you wrote history, what else could I write? . . . you also wrote on the Internet, in the streets, on banners and even on the door of my building! This week I read you . . .'. A piece in *LeMan* by Bahadır Boysal (12 June 2013) went as far as stating that 'it seems that wall writing has outdone satirical magazines'. Finally, on 6 June 2013, a weekly column entitled *Sokaklardan orantısız zeka* ('Extraordinary Intelligence from the Streets') began to appear in *Peguen*, which aimed to curate a selection of photos of smart street slogans.

Professional cartoonists' proximity to the protests was marked also in material terms, through Gezi-related gadgets that were distributed for free

with the magazines. In June and July 2013, *Uykusuz* gifted its readers cardboard cut-outs of some of the most well-known figures of Gezi, like the already mentioned 'woman in red' and 'standing man'. Similarly, *Penguen* distributed posters of its Banksy-style protesting penguin.

Even though the marketing aspect of these operations cannot be neglected, it is interesting to observe that some of these gadgets prompted active responses from readers. In particular, *Penguen* readers revised the penguin poster by adding Gezi-themed written and graphic details and sending photos of their own versions to the magazine. *Penguen* dedicated a column to these revised versions and reproduced some of them along with the names of their authors. According to a short text introducing this column on 20 June 2013, this was a spontaneous initiative. The text also explained that the posters reproduced in the magazine comprised only a small proportion of the many that had been sent. Consequently, an online page was created to pay homage to all of them.

The multiple strategies through which the four magazines manifested their proximity to the protests paved the way for a virtual common space, or what Michael Warner (2002) calls 'a public'. Warner defines this public as 'an ongoing space of encounter for discourse', wherein it is the interaction of discourses, rather than a single text, that creates a public (2002, 90–2). In this case, the public was created first out of cartoonists' identification with the protestors through editorial initiatives that conveyed the message 'we are with you', and even 'we are you'.

However, a similar narrative was hardly evident in summer 2016. Although post-15 July cartoons do not refrain from counter-hegemonic representations of power, editorial initiatives similar to the ones outlined above were not promoted. I argue here that this key distinction can be explained by the absence of a strong collective identity in 2016. In 2013, satire could easily address a defined readership represented by Gezi protestors and supporters (no matter how diverse and inclusive of different political ideologies). In 2016, however, anti-government sentiment was shared by individuals and groups that did not converge on a single community. The absence of a collectively framed opposition prevented the development of 'we are with you' and 'we are you' initiatives that could have reinforced the political stand expressed in the cartoons.

However, this absence does not imply that, in 2016, satirical magazines simply abandoned the dialogue with the readership *tout court*. In addition to the cartoons created by their staff, they regularly published amateur cartoons sent in by readers. *Gırgır*, *Penguen*, *LeMan* and *Uykusuz* hosted these cartoons in specific columns – such as *Çiçeği Burnundalar* ('Cub Cartoonists'), *Yumurtalar* ('Eggs'), *LeMan 2023* and *Gelen Kutusu* ('Inbox'). These had already existed in 2013.[6]

The amateur columns are relevant to our analysis because they contributed to the formation of a public in a related but different way to cartoonists' solidarity initiatives during Gezi. In both cases, an identification occurs. But the difference is that, in 2016, it was not cartoonists who manifested closeness to the readers, but, on the contrary, readers who approached the magazines as temporary cartoonists. From the magazines' point of view, accepting amateur cartoons for publication implied a 'you are us' message, in contrast to the 'we are with you' or 'we are you' messages of 2013.

But the importance of the amateur columns is not limited to the identification they established between professional and non-professional cartoonists. By involving amateurs in the making of the magazines, the latter provided potentially anyone with a chance to express themselves, and thus to exert power. Indeed, the fact that these cartoons were not published anonymously is significant. As such, the amateur corners were politically charged in the light of their very nature and structure.

Overall, the analysis of author–reader relations shows that the boundaries between cartoonists and readers were often intentionally blurred. In both periods under study here, the aforementioned satirical magazines developed and maintained various editorial policies that led to an identification between authors and readers. In the case of summer 2013, this even evolved into an identification between the magazines' authors and protestors who were not necessarily regular readers. This cohesion strengthened the counter-hegemonic function of satire as performed chiefly through cartoons.

The Government's Hegemonic Reaction

The contents and policies of these magazines thus exhibit the emergence of a clear counter-hegemonic stance at various levels. However, the lack of any strong reaction of power to their satire is striking. In summer 2013, for

example, there was no evidence of any repressive measures addressed specifically to these magazines. Similarly, in summer 2016, the only example of censorship involved *LeMan*, whose printing was hampered right after the coup attempt due to a cover cartoon. The incriminated cartoon referred to the events of the night of 15 July, as did the cover cartoons of *Gırgır*, *Penguen* and *Uykusuz*. *LeMan*'s publication was resumed the following week and, like the other three magazines, it did not face any other significant obstacles throughout the summer.

Although the relative freedom enjoyed by these magazines could suggest a certain degree of tolerance, the larger picture shows that this interpretation is too optimistic. The very same episode that involved *LeMan* in July 2016 proves that censorship did not necessarily spare satirical representations. The hampering of a Gezi-themed cartoon exhibition in summer 2013 provides another example.[7] Moreover, beyond the realm of cartoons, persecutions came to affect artists and intellectuals who expressed critical views through their work in both 2013 and 2016. Others affected included civilians who merely exercised their fundamental rights and freedoms – of expression or assembly, for example – as well as those who attended to their duties – such as doctors and nurses who looked after injured protestors during Gezi, or lawyers who assisted the people detained on political grounds (Amnesty International 2013, 2017).

A presumed tolerance thus cannot explain the government's lack of a strong reaction towards *Gırgır*, *Penguen*, *LeMan* and *Uykusuz*. Instead, arbitrariness seems to be a more realistic cause. In fact, broadening the scope to the whole period of AKP rule (2002 to present), it becomes clear that these magazines have been consistently persecuted. Lawsuits filed by Erdoğan and other AKP representatives targeted *Penguen* in 2005 and 2015 (Bianet Staff 2005; Diken Staff 2015); *LeMan* in 2006, 2008 and 2014 (Önderoğlu 2006; 2008; Gazeteciler Staff 2014); *Uykusuz* and *Gırgır* in 2013 (Cumhuriyet Staff 2013; Aydos and Konca 2014).

Some cartoonists insist that 'if there is no lawsuit against you, you are not a satirical magazine' (Aydos and Konca 2014). Nonetheless, the fact that satire always has the potential to be subject to repression inevitably triggers a precarious scenario. Lawsuits appear to be a strategy of the ruling class to intimidate satirical authors, as well as intellectuals and journalists, among

others. Moreover, the arbitrariness with which this strategy is applied undermines satire at its very roots. Lawsuits are highly unpredictable in terms of which cartoons are targeted – but so too is their timing. Kurtcebe, for example, was arrested for cartoons published three years earlier.

Over the long-term, then, it seems clear that lawsuits and their arbitrariness can be effective as strategies of containment. To be sure, the editorial policies and political stands of *Gırgır*, *Penguen*, *LeMan* and *Uykusuz* remained essentially unchanged after each lawsuit, thus reiterating their counter-hegemonic position. And yet recent years have witnessed the decline of these magazines. In particular, in February 2017, the editorial group of *Gırgır* ceased the publication of the magazine following the publication of a religious-themed cartoon that sparked strong controversy (Cumhuriyet Staff 2017). Three months later, *Penguen* published its final issue. In this case, the decision was taken by its own staff, who identified the general crisis of print media and the related loss of readers as their main reason. But they also invoked the gradual restriction of civil liberties in Turkey (Penguen Staff 2017). *Gırgır* and *Penguen* were not closed down by direct government intervention, but the general climate of intimidation and distress hastened their demise.

Conclusions

This analysis of the issues of *Gırgır*, *Penguen*, *LeMan* and *Uykusuz* published during the summer of Gezi and in the weeks following the coup attempt of 15 July indicates that, during both of these political crises, satirical magazines were able to formulate successful counter-hegemonic responses. These responses can be judged as successful according to two main criteria. First, the cartoons proposed representations that challenged official discourses, thus providing valuable counter-narratives. Second, these responses were successful since the editorial policies of these magazines encouraged a two-way dialogue with the readership. This contributed to the formation of a dissenting public and thus performed a counter-hegemonic function which extended beyond the boundaries of representation.

These outcomes prove that satire has the capacity to negotiate the boundaries of political discourse, even when authoritarian power appears especially concerned with self-assertion and hegemony. They also show the ability of satirical magazines to become cohesive spaces for anti-government

groups and individuals. These features make satire a crucial site of ideological struggle.

This study also pondered how it was possible that, given its political weight, satire could survive in the repressive context that characterised both periods. The only exception to this trend was a single censored edition of *LeMan* in 2016. Such relative freedom has been explained here as a result of the arbitrariness with which power interferes with satire. To be sure, satirical magazines were generally able to escape direct hegemonic intervention in the summers of 2013 and 2016. But the broader picture reveals that they may be persecuted at any time. The genre thus finds itself in a state of permanent low-level tension. *Gırgır* and *Penguen* closed down in 2017, leaving *LeMan* and *Uykusuz* as the only two counter-hegemonic satirical strongholds. As such, they are confronted with the challenges implied by this uncertain scenario on a daily basis.

Notes

1. This choice is in no way meant to belittle newspapers' editorial cartoons, whose political potential is equally worthy of attention, as Kurtcebe's case suggests.
2. In the first days of the protests, a woman wearing a red dress stood for a few seconds in front of a policeman shooting pepper spray in her face. Photos and videos revealed that before the attack the woman was standing peacefully, and also that the policeman kept spraying her as she moved away. The 'woman in red' became a symbol both of protestors' bravery and unjustified police violence.
3. Performer Erdem Gündüz became known as the 'standing man' for his peaceful protest, which consisted of standing still in the middle of Taksim Square (adjacent to Gezi Park), facing the Atatürk Cultural Centre. The latter had once been a symbol of Turkey's modernisation, until it closed down in 2008. In summer 2013 it became crucial as protestors covered its façade with banners and slogans. During the same period, Erdoğan announced its demolition in favour of an opera house.
4. The association between opposition and terrorism emerges prominently in hegemonic discourses. In speeches preceding the local elections of 31 March 2019, for instance, Erdoğan explicitly linked opposition parties to terrorism by asserting that the AKP, 'unlike the CHP, does not campaign to fill the municipalities with the extensions of terrorist organisations, but for you, for our nation' (AK Parti 2019).

5. On the widespread use of satirical reversal of words and images during Gezi, including the protesting penguin and the term *çapulcu*, see Carney and Marcella (2017).
6. On the origins of the amateur cartoons that date back to the early 1970s, see Marcella (2015, 58–67).
7. In early September 2013, the opening of a cartoon exhibition dedicated to the Gezi resistance, organised in the framework of the 18th Peace Festival of Didim, Aydın Province, was prevented by AKP local authorities because it allegedly insulted Erdoğan. The decision was taken as exhibition posters featuring some of the cartoons appeared on advertising billboards. The cartoons were confiscated and an investigation was launched against five people connected to the exhibition, including a member of the billboard company (Bianet Staff 2013).

Bibliography

AK Parti. 'Cumhurbaşkanımız Erdoğan, Siirt Mitingi'nde konuştu'. *YouTube*, uploaded by AK Parti, 7 March 2019, http://www.youtube.com/watch?v=xc__U1C8QMQ (last accessed 19 November 2020).

Amnesty International. *Gezi Park Protests: Brutal Denial of the Right to Peaceful Assembly in Turkey*. London: Amnesty International Ltd, 2013.

Amnesty International. *Amnesty International Report 2016/17: The State of the World's Human Rights*. London: Amnesty International Ltd, 2017.

Aydos, Özgen and Semih Konca. 'Gırgır Dergisi Ekibi Çok Keyifli!'. In *CNN Türk*, 20 July 2014, http://www.cnnturk.com/fotogaleri/kultur-sanat/diger/girgir-dergisi-ekibi-cok-keyifli?page=1 (last accessed 5 August 2018).

Barthes, Roland. *Elements of Semiology*. New York: Hill and Wang, 1986.

Bianet Staff. 'Tayyipler Aleminden Penguen Dergisine Dava'. In *Bianet*, 23 March 2005, http://m.bianet.org/bianet/medya/57049-tayyipler-aleminden-penguen-dergisine-dava (last accessed 10 December 2009).

Bianet Staff. 'Dolmabahçe'deki Caminin Müezzinine İnceleme!'. In *Bianet*, 10 June 2013, http://bianet.org/bianet/insan-haklari/147442-dolmabahce-deki-caminin-muezzinine-inceleme (last accessed 3 December 2018).

Bianet Staff. 'Didim'de Gezi Karikatürlerine Soruşturma'. In *Bianet*, 4 September 2013, http://m.bianet.org/bianet/medya/149658-didim-de-gezi-karikaturlerine-sorusturma (last accessed 5 August 2018).

Bianet Staff. 'Yenikapı'da "Demokrasi ve Şehitler Mitingi"'. In *Bianet*, 7 August 2016, http://bianet.org/bianet/toplum/177586-yenikapi-da-demokrasi-ve-sehitler-mitingi (last accessed 10 October 2018).

Callimachi, Rukmini. 'Turkey, a Conduit for Fighters Joining ISIS, Begins to Feel its Wrath'. In *New York Times*, 29 June 2016, http://www.nytimes. com/2016/06/30/world/middleeast/turkey-a-conduit-for-fighters-joining-isis-begins-to-feel-its-wrath.html (last accessed 10 October 2018).

Carney, Josh and Valentina Marcella. 'Screens of Satire and Commons of Resistance: The Place and Role of Humor in the Gezi Park Protests of Turkey'. In *Ridiculosa*, no. 24 (2017): 151–64.

Cumhuriyet Staff. 'Adana Valisi, Uykusuz'a dava açmış'. In *Cumhuriyet*, 14 November 2013, http://www.cumhuriyet.com.tr/haber/turkiye/9337/Adana_Valisi__Uykusuz_a_dava_acmis.html (last accessed 6 September 2015).

Cumhuriyet Staff. 'Gırgır Dergisi kapatıldı . . . Tüm çalışanları işten çıkarılacak'. In *Cumhuriyet*, 17 February 2017, https://www.cumhuriyet.com.tr/haber/girgir-dergisi-kapatildi-tum-calisanlari-isten-cikarilacak-677907 (last accessed 19 November 2020).

Diken Staff. 'Penguen'in Erdoğan'a 'top işareti' yaptığı iddiası ciddiye alınıp dava açıldı'. In *Diken*, 20 March 2015, http://www.diken.com.tr/penguenin-erdogana-top-isareti-yaptigi-iddiasi-ciddiye-alinip-dava-acildi/ (last accessed 6 September 2015).

Diken Staff. 'Erdoğan'a hakaret'te bugün: 69 yaşındaki karikatürist Nuri Kurtcebe hapiste'. In *Diken*, 4 June 2018, http://www.diken.com.tr/erdogana-hakarette-bugun-69-yasindaki-karikaturist-nuri-kurtcebe-tutuklandi (last accessed 5 June 2018).

Ergin, Sedat. 'Yatak odanızdan içeri biber gazı fişeği girerse'. In *Hürriyet*, 25 June 2013, http://www.hurriyet.com.tr/yatak-odanizdan-iceri-biber-gazi-fisegi-girerse-23578038 (last accessed 10 October 2018).

Fekl, Walther, ed. 'Tyrannie, dictature et caricature'. In *Ridiculosa*, no. 4, 1997.

Gardes, Jean-Claude and Morgan Labar, eds. 'Caricature et liberté d'expression'. In *Ridiculosa*, no. 23, 2016.

Gazeteciler Staff. 'Bingöl belediye başkanından Leman'a dava'. In *Gazeteciler*, 13 November 2014, http://www.gazeteciler.com/haber/bingl-belediye-bakanndan-lemana-dava/238840 (last accessed 6 September 2015).

Gırgır, selected issues of May–September 2013 and July–September 2016.

Gramsci, Antonio. *Quaderni del carcere*, edited by Valentino Gerratana. Torino: Einaudi, 1977.

Hall, Stuart. 'The Work of Representation'. In *Representation: Cultural Representations and Signifying Practices*, edited by Stuart Hall, 13–74. London, Thousand Oaks, New Delhi and Walton Hall: Sage Publications, 1997.

Harding, Luke and Constanze Letsch. 'Turkish Police Arrest 25 People for Using Social Media to Call for Protest'. In *The Guardian*, 5 June 2013, http://www.theguardian.com/world/2013/jun/05/turkish-police-arrests-social-media-protest (last accessed 4 August 2018).

LeMan, selected issues of May–September 2013 and July–September 2016.

Marcella, Valentina. *Laughing Matters: Mainstream Political Cartoons under the Military Regime of the Early 1980s in Turkey*. PhD dissertation, European University Institute, 2015.

Önderoğlu, Erol. 'Başbakanın Dava Açtığı Leman Dergisine Küfür ve Tehdit'. In *Bianet*, 20 February 2008, http://m.bianet.org/bianet/ifade-ozgurlugu/105021-basbakanin-dava-actigi-leman-dergisine-kufur-ve-tehdit (last accessed 10 December 2009).

Önderoğlu, Erol. 'Leman Dergisine Başbakan Davası Başladı'. In *Bianet*, 2 November 2006, http://m.bianet.org/bianet/medya/87213-leman-dergisine-basbakan-davasi-basladi (last accessed 10 December 2009).

Paton, George E. C. and Chris Powell, eds. *Humour in Society. Resistance and Control*. Basingstoke and London: Palgrave Macmillan, 1988.

Penguen, selected issues of May–September 2013 and July–September 2016.

Penguen Staff. 'Veda Yazısı'. In *Penguen*, http://www.penguen.com/vedayazisi (last accessed 29 April 2017).

Uykusuz, selected issues of May–September 2013 and July–September 2016.

Warner, Michael. *Publics and Counterpublics*. New York: Zone Books, 2002.

PART III

CIVIL SOCIETY AND THE POLITICS OF GENDER

8

THE BOUNDARIES OF WOMANHOOD IN 'NEW TURKEY': THE CASE OF KADEM

Gülşen Çakıl-Dinçer

Since the 1970s, women who define themselves as pious conservative have successfully increased their visibility in Turkey's public sphere. These women have positioned themselves vis-a-vis a range of 'others' – such as secular Western feminists, secular Kemalist women and, finally, pious conservative men. In this way, most of these women have developed their own anti-feminist women's rights discourse that prioritises 'justice over equality'.

The AK Party positions Sunni Islam as the principal value system behind the process of creating a new/revitalised nation. The party has aimed to set the boundaries of what it means to be an 'acceptable woman'. This mindset drives the government's official policies on women. It has been institutionalised through KADEM, a pro-government women's rights association founded in 2013. This organisation has shaped public discourse around 'new womanhood' in 'New Turkey'.

This discourse is positioned principally in opposition to egalitarian feminism. It encourages women to be religious and to actively participate in the public sphere and in politics. Yet, on the one hand, KADEM's agenda encourages women's participation in business and the public sphere, while, on the other, constantly promoting women's traditional role as wife and mother. Above all, this agenda identifies Islam as the ultimate source for gender-related questions.

KADEM's strategy resonates with the AK Party's leadership. The number of female candidates for parliament has been bolstered – though without

'feminist' issues making it onto the agenda. The advocates of this approach claim to promote a women's human rights discourse that is not related to feminism. They argue that women's rights should be addressed through an Islam-based 'justice over equality' approach.

This chapter is based on empirical data obtained as a participant observer within KADEM between December 2014 and January 2017. It enquires into the impact of the 'justice over equality' discourse on women's identities. It further explores how the idea of the 'acceptable woman' has contributed to establishing a new cultural hegemony in Turkey. During the fieldwork conducted for this chapter, the author spoke with key figures within the association and was afforded the opportunity to participate in KADEM's activities in various cities and provinces. These locations included Malatya, Bursa and Sakarya.

Equality or Justice?

Islamism's positioning, both against 'the West' and against Kemalism as an agent of Western thought, has always been crucial in the construction of Muslim women's identity in Turkey.[1] The attempt to construct a corresponding discourse on women vis-à-vis Western models was particularly evident in Islamist women's magazines such as *Kadın ve Aile*, *Mektup* or *Bizim Aile* (Acar 1995). Since the 1980s in particular, Islamist women have been positioning themselves in opposition to feminism. They have carefully countered feminist discourses on each and every aspect of women's politics. This occurred despite the fact that various Islamist women's groups did indeed engage with, and occasionally utilised, feminism for their own purposes.

A closer look at the AK Party's women's policies underlines the importance of the distinction between feminism and the ruling elite's official discourse. Sociologist Büke Koyuncu (2014) has evaluated the AK Party's policies between 2002 and 2013 to show how the party has evolved from simply being a conventional government to effectively taking over and representing the state itself. During this transformation, Koyuncu argues, a new process of national identity construction took place in which Islamism occupied a central position (Koyuncu 2014, 77). Policies relating to the situation of women were not immune to this transformation. In this process of reshaping Turkish national identity along the lines of religion, a new women's association

appeared on the scene: the Women and Democracy Association, or KADEM (Kadın ve Demokrasi Derneği).

In Turkey, women's sections within political parties commonly help to canvass for new members, strengthen political cohesion and, first and foremost, raise awareness of and shape the party's perspective on women's issues. Usually, however, they do not engage in cooperation across party lines. This has to be taken into account when studying gender issues on a political level. The AK Party's Women's Section (AK Parti Kadın Kolları) was initially established as a subsidiary. But it has played an important role in the party's repeated electoral successes since 2002. The key to this was the section's wide network of neighbourhood organisations. The tremendous success and effectiveness of the AK Party's Women's Section raises the question of why, with KADEM, an additional pro-government women's association was established in the first place.

KADEM was founded in 2013 as an association to publicly embrace pious ideals, while simultaneously crafting strategies to advocate for a more active presence of women in public and a stronger role within the family. The fact that KADEM's strategies coincide with the AK Party's women's policies distinguishes it from other women's associations, such as Mor Çatı (Women's Shelter), Kadın Dayanışma Vakfı (Women's Solidarity Foundation), KA.DER, Uçan Süpürge (Flying Broom) or Kadının İnsan Hakları ve Yeni Çözümler Derneği (Women for Women's Human Rights and New Ways). All of these organisations were established long before KADEM and represent the feminist faction of Turkey's women's rights discourse. Accordingly, they did not address women's problems in the context of their role in the family, but rather worked to ensure gender equality in every aspect of life (Timisi and Ağduk Gevrek 2007; Kardam and Ecevit 2007; Bora A. 2007; Bora T. 2017, 813–14). KADEM, however, differs not only from feminist women's rights organisations but also from the AK Party's Women's Section insofar as it appeals to young and educated women, especially students, who are trying to cope with the problems that confront women in 'New Turkey'. The party's official women's wing apparently fails to reach and address the everyday problems of this particular target group.

This chapter argues that KADEM's discourse on women stands in direct contrast with Turkey's feminist movement. KADEM claims that the feminist movement's call for equality has made no impact whatsoever in Turkey. The

association thus calls for 'justice' instead of equality. The theoretical framework of this demand appears in a series of panels and symposia, such as the biannual 'International Woman and Justice Summit' and the annual 'Gender Justice Congress'. Both of these events aim at spreading the idea of 'justice over equality' to a wider audience.

Indeed, the first event that brought KADEM's name to a broader public was the First International Woman and Justice Summit. Organised in partnership with the Ministry of Family and Social Policy, it was held on 24–5 November 2014. President Erdoğan, who also attended the summit, gave a speech which included the following, famously controversial statement: 'You cannot equate man and woman. Because they are different by creation, by nature, by physical characteristics'. As can clearly be seen in the summit's final declaration, as well as in a series of follow-up events organised by KADEM (congresses, conferences, written and oral statements), the word 'creation' was not chosen at random. On the contrary, it appears to be a key word, one determinative of KADEM's policy agenda. The first article of the summit's final declaration explains the event's purpose as follows:

> Regarding the relationship between men and women, an approach is needed that considers equality [eşitlik] in terms of rights, but also [the issue of] justice as related to the distribution of social roles and responsibilities. [Any form of] equality, which draws on dominant values without acknowledging the differences [between men and women] might, under certain circumstances, work to the detriment of disadvantaged groups. Even though present-day politics favour equality, it is a reality that women are not treated equally as far as politics, decision-making processes and the realm of economic life are concerned. Therefore, a justice-based approach, which takes into account the multi-faceted victimisation of women, is highly important. (KADEM 2014)

This quote illustrates the point from which KADEM begins its discussion of women's rights: demanding equality is insufficient for women and needs to be replaced by a demand for justice. This change of paradigm is justified through a highlighting of the biological differences between men and women. Only from an ontological perspective are men and women accepted as equal.

As mentioned above, this call for a paradigm shift from equality to justice was discussed in theoretical terms in a workshop series entitled 'Studies on Discourse'. These gatherings were initially small-scale activities in which a

group of members met with guest speakers in an informal and conversational format. Due to the association's expanding number of members, however, such gatherings no longer take place. While defining the framework of the debate around the concept of justice, these discussions also reflected on the idea of equality between men and women from an Islamic perspective.

In one of these meetings, Şaban Ali Düzgün, a professor of Islamic theology, responded to a question raised by the then-president of the association, Sare Aydın Yılmaz. The question was simple: 'Are women and men equal in Islam?' Düzgün's response was also simple: 'All human beings are ontologically equal'. He tried to support his argument by providing verses from the Holy Koran. In response to questions about the kind of things women and men do, he added:

> Was it imaginable to have a female pilot? No. Based on certain characteristics of women, it was argued that they were unable to do so. Can we say a woman cannot become a pilot today? No. We can't. There is no such point from a religious point of view either. What kind of jobs women can or can't perform depends on the era they live in.[2]

When some audience members argued that women and men are not equal, and also based their arguments on particular hadiths, Düzgün said:

> Start these sentences with 'according to hearsay'. One of Islam's aims at the time was to improve the lives of women. Why would it want to assign a secondary role to women today? These are just interpretations. You have reason and evaluate these accordingly.

Şaban Ali Düzgün is a professor at the Faculty of Theology of Ankara University, which is known for aiming to set the Koran in a historical perspective. In other words, many representatives of the so-called Ankara school of theology address the Koran by considering its place in relation to particular social and historical conditions. The influence of the school's theological approach was also perceptible in the first meetings of KADEM. On the whole, however, this influence has declined. Indeed, one of the senior administrators of the association recently observed:

> I think the interpretations of the Ankara School are a little bit non-religious. Therefore, we mostly prefer the ideas of the scholars from the Faculty of Theology at Marmara University.[3]

This preference appears to be based on KADEM's stance against a feminist approach towards women's issues. Hidayet Şefkatli Tuksal is one of the best known scholars from the Ankara School who is working on women's issues. She describes herself as Muslim–Feminist (Yılmaz 2015, 153). However, even though KADEM uses concepts from feminist literature without explicitly referring to them as feminism, it does not accept the idea of 'Muslim feminism'. It even labels feminists as 'the others'. In conducting the research for this chapter, the author asked one of KADEM's media executives[4] about their campaign mottos: 'If you're a man, keep your temper!', and 'Be a man first'. The executive brusquely replied that:

> We were criticised for reproducing patriarchic language with these campaigns. Do you really think so? Of course, those feminists think they know everything and that we are not aware of such things, right?

She further stated that the aforementioned slogans were used to add a sense of irony to the campaign.

The opposition to the feminist idea of equality derives from the fact that it is considered a Western idea. In 1999, Merve Kavakçı was elected to parliament, but she was not allowed to be sworn in because of her headscarf. She thus became a symbol of political Islam in Turkey. Indeed, in her keynote speech at KADEM's second 'Gender Justice Congress' held on 3 March 2015, she stated that:

> The understanding of equality in the West, which we imported, is Eurocentric, European-centred, ethnocentric, ethnicity-wise white, culturally secular and, at the same time, Orientalist . . . The system behind this curtain of equality that we oppose is an Orientalist system. Because, in an Orientalist system the woman who veils her head does not have a voice . . . A woman who covers her head won't be accepted as a normal woman, just in the same way as the state in Turkey has looked at women with headscarves for many years. Because she is an inferior human being; this is what the Orientalist system tells us . . . In this Eurocentric and ethnocentric perception, in which the West and the East are diametrically opposed, in this understanding, in this dichotomy, which is sacrificed [?!] by the representatives of a feminist movement that actually defends equality, the Westerner represents what is right, mature, and the normative standard, whereas the Easterner is immature,

childish, and in need of guidance . . . I am not talking about a geographical demarcation here, I am talking about a mentality. You know, my point is not a blatant anti-Westernism. In fact, I cannot simply be anti-Western because I owe so much to the West, unfortunately. Right? I am talking about a mentality. There is a West inside the East. It does not make any difference you know. (Kavakçı 2015)

KADEM's discourse of 'justice over equality', which is set in opposition to equality, seeks distance from the feminist discourse and invokes 'women's human rights' as a starting point. Appropriating a women's human rights discourse does not mean that there is no entanglement with feminism. The struggle for women's rights is essential, but it is fought beyond the scope of feminist literature. From a 'justice over equality' perspective, feminism is not only seen as a struggle over equal rights for men and women, but as the religiously inappropriate attempt to erase all differences between men and women. For this reason, KADEM emphasises differences to feminism, rather than addressing feminism as a whole. It thereby stresses those aspects that support its own discourse, which is also where the critique of modernism comes into play.

Western feminism is criticised for being imposed as a norm upon women in other countries. Conversely, criticism of Turkey's feminist movement draws on voices from the 'Third World' and 'Black Feminism'. The advocates of this approach favour the idea of various types of womanhood, instead of the 'one woman' doctrine allegedly imposed by (Western) feminism on all women. Proponents of this idea do not hesitate to declare that, even though they make use of feminist literature, they have no relationship whatsoever with feminists, that they are different from feminists and that they use women's human rights as their starting point. But what does their appropriation of this discourse really mean?

Especially since the 1990s, the Islamist segments of Turkish society aspired to reverse their own exclusion through readings of post-colonial theory. Criticising the universalist language of Western modernism facilitated the Islamist movement's entry into the public sphere. Subalternity and hybridity were concepts of choice for carving up public space. Conceptual couplings such as Islam and modernism, Islam and human rights, Islam and democracy, Islam and women's rights were instrumental in forming hybridities to counter 'the

West's' monopoly on these concepts, and to claim Islam's unique perspective vis-à-vis 'the West'. The concept of subalternity in post-colonial literature was adopted as a form of victimisation by identity-based movements, and it became a point of reference in the fight for recognition.

> Therefore, subaltern is seen as 'those who are mistreated' or it is defined as oppressed or victimised. These subjects, within the framework of 'multiculturalist' politics, aspire to overcome their oppressed-ness with such identity reference points. (Yılmaz 2015, 44)

These concepts, which were utilised extensively by Islamist men, were also used by Islamist women. At this juncture, 'women's human rights' became important, insofar as an initially Western concept merged into an Islamist discourse – albeit after heavy modification. According to its use in this novel context, women's human rights takes Islam as a point of reference. The conceptual point of reference here is justice. Therefore, the motto is 'justice not equality' or, to put it slightly differently, 'justice over equality'.

From an Islamic perspective, the differences between men and women require them to be 'equivalent' rather than equal. The concept of 'equivalence' (*eşdeğerlik*) considers men and women to have the same value as human beings. And yet different roles, rights and responsibilities are ascribed to them. The real emphasis here is on a recurring claim in KADEM's activities, which suggests that men and women complement each other. In fact, this was uttered during KADEM's First International Woman and Justice Summit by Sare Aydın Yılmaz, who described man and woman as one. This discourse is justified through references to family, moral values, tradition, culture and religion.

Similar claims are evident in President Erdoğan's speeches. In his talk at the same conference, he said: 'What women need is not being equal but equivalent'. KADEM justifies this with references to religion. According to this approach, women and men bear no ontological superiority or weakness with respect to each other. They are created as ontological equals. Social life comes with a division of labour. But it does not impose a hierarchy, because it maintains equivalence (Aydın Yılmaz 2014b). KADEM proposes equivalence as a solution to demanding equality, which falls short of achieving the goals of solving women's problems (Aydın Yılmaz 2015a).

Replacing equality with equivalence is considered the first step to the establishment of 'gender justice'. This attributes justice to the biology or nature of women, and thus to the division of labour. Because of this division of labour, wherein social structures are determined according to men's needs, women find themselves in a disadvantageous position, because laws demanding equality fall short. This is why justice and law are intended to replace the demand for equality.

> Opening equality up for discussion does not imply retreat. On the contrary, it is a step forward, since it calls attention to victimization, resulting from traditional values and modernity. This approach calls for justice to attain healthy presence in public life without conflicting with women's nature. (Aydın Yılmaz 2014b)

KADEM and the Public Sphere

Despite all efforts to distance itself from feminism, KADEM aims to show that women's presence in public is not in conflict with Islam. Women's integration into the realms of work and politics are among KADEM's most prominent demands. Such positioning is not coincidental for an organisation that works for greater female visibility in public life. A closer look reveals that many prominent figures who took active roles in the establishment and maintenance of KADEM are, in fact, AK Party politicians, or are directly linked with the party.[5] The reason for such high rates of participation in politics among KADEM's founders seems a clear result of various programmes which encourage women's participation in political life. KADEM's vision is reflected in the effort to push for women's active presence, not only in family life, but also in the social, cultural, political and economic sphere.

Along with being a women's association, KADEM has also sought for ways to show that it is an advocate for 'democracy'. In addition to internally organised training programmes, KADEM is also involved in projects on a national and an international scale, in order to shed light on the connection between democracy and women's participation in political life. From a political perspective, it is an undisputed fact that civil society organisations are not independent from the political structures of the countries in which they operate. KADEM is no exception. Focusing on KADEM's activities with respect to 'democracy', a clear tendency to support President Erdoğan's AK Party can be

observed. It can be also observed that KADEM enjoys the support of President Erdoğan, the Ministry of Family and Social Policy, as well as influential figures within the AK Party. Taken together, these factors promote an environment in which KADEM and the AK Party can be evaluated in tandem.

KADEM's position vis-à-vis feminist movements, and the organisation's views on women in Islam, are reminiscent of debates around the issue of women in Turkey that have been ongoing since the Tanzimat era. Islam was always a major component of this struggle among the leading, well-educated, multilingual women of the movement. Fatma Aliye, who is considered by many as the most important thinker of Ottoman feminism, used her knowledge of Islam to elevate women's status. Ottoman women's rights advocates always took Islam as a major point of reference in their struggle for demanding education for women and improving their everyday lives. They also defined women's rights from this perspective (Zihnioğlu 2003, 45–56). As the present author's observations at various KADEM meetings reveal, issues regarding women's rights or practices of everyday life are consistently framed in an Islamic perspective.

During a public panel discussion on the topic 'The Other Side of 28 February: The Changing Manhood Perception of Islamist Men',[6] Sultan Işık addressed the question of greetings customs used by men and women in the public sphere. The attitudes of men on this subject were criticised. The reasons for the very different behaviour of Islamist men towards women with and without headscarf in the public sphere were questioned. Their behaviour towards headscarf-wearing women were also defined as distracting. A teacher with headscarf stated that the Islamist men at her school greet women without headscarf in the morning by saying 'Good morning', but that they do not behave in the same way towards teachers with headscarf. In fact, they refuse to greet them. Sultan Işık considered this to be offensive.

Similarly, this behaviour did not find approval among those women who take the view that the exchange of greetings between men and women does not contradict an Islamic way of life. That said, Sümeyye Erdoğan Bayraktar, one of the founders of KADEM and President Erdoğan's daughter, shared an experience of one of her 'male' friends and stated that, when men greet women, they sometimes get negative responses from them.

According to well-known writer Cihan Aktaş, this new situation between men and women is indicative of the transition of Islamist women from *bacı* (literally 'sister') to *bayan* ('woman' in the formal use) in the eyes of men. Aktaş employs this duality to explain Islamist women's appearance in the public sphere. In the first stage, men consider women in public as *bacı*. Even though these women could exist in the public sphere, their essential separateness was acknowledged with the use of this term. This move secured presence for women in the public sphere, but primarily for the purpose of celebrating their religious beliefs. *Bayan*, on the other hand, has become the new identity of empowered Islamist women. The wish of Islamist women to benefit from opportunities present in the public sphere is one of the main reasons behind this change. The fact that covered women can find themselves placed in public prompts a redefinition of 'privacy' among both men and women (Aktaş 2005, 32–3).

KADEM advocates counter-discourses which assign a secondary status to women by giving examples from the Holy Koran and the lifetime of the Prophet Mohammed. According to the proponents of KADEM, seizing opportunities presented by modern life is by no means contrary to Islam. During the lifetime of the Prophet, they argue, women worked, were literate and played an active role in social life and in the dissemination of Islam. According to this position, what appears to be religious today is, in fact, traditional and subject to change. During a seminar the author of this chapter participated in, Salime Leyla Gürkan gave a talk entitled 'The Image of Women in Jewish and Christian Traditions'.[7] In this talk, the speaker argued that discourses which assign secondary status to women stem from Arab, rather than strictly religious, traditions. She also argued for women's reinterpretation of these traditions based on the teachings of the Holy Koran.

For women at KADEM, being in public is of great importance and a major goal. For some time, and even as recently as the 1990s, women in Turkey were systematically excluded from major fields of public life due to the headscarf ban. This included universities and public institutions. Many women were forced to pursue higher education abroad, returning to Turkey only in the 2000s.

There is still an appreciable anger among women in their forties who have vivid memories of '28 February'. In 1997, the Welfare Party, which won the 1995 general elections, was the ruling party. However, some of its actions

were perceived as contrary to the secular foundations of the Turkish state, which resulted in an extraordinary meeting of the National Security Council on 28 February 1997. At this meeting, a decision to proceed against reactionary (that is, supposedly anti-secular) activities was arrived at. This decision has been described as a 'postmodern coup'. Subsequently, the reputedly 'Islamist' Welfare Party (Refah Partisi) was closed down, and a series of measures was taken to protect secularism. One such measure involved the banning of girls from entering universities wearing a headscarf. Girls were forced to take off their headscarves, and some who refused to do so left higher education altogether. The February 28th process is thus a cause of considerable anger for Islamic women.

However, the younger generation seems less interested in – if not completely oblivious to – these events. Consequently, this period – which has come to be known as '28 February' – is increasingly historicised as a struggle for existence among women for wearing headscarves in the public sphere. As a senior KADEM official stated:

> '28 February' is very important for us, but current university students with headscarves are not even aware of its existence. They do not know what it means. Of course, they can go to school as they wish and act like this was never a problem before. We couldn't explain this to the new generation. We have to do that.[8]

These comments clearly indicate the target group of KADEM's policies.

Criticisms

Within the first five years of its existence, KADEM built a strong reputation for itself in Turkey. The organisation focused exclusively on pious conservative women's sensitivities. But its policies have not escaped significant criticism. A closer look at KADEM's activities reveals a conscious effort to promote a new discourse on women centred on the concept of gender justice. KADEM advocates gender justice by replacing equality (*eşitlik*) with equivalence (*eşdeğerlik*). This position has caused significant discomfort among secular feminists who fight for gender equality.

Pınar İlkkaracan (2015), the founding president of Turkey's Women's Human Rights Association, criticised KADEM for simply re-promoting an

idea originally proposed by the Vatican at the United Nations' Fourth World Women Congress in Beijing in 1995. At this event, İlkkaracan argues, the Vatican, in association with a few Catholic charities and Muslim countries, proposed replacing gender equality with gender justice and called for a broad coalition to promote this idea. İlkkaracan's reference to the mid-1990s resonates with Josephine Donovan. She argues that 'the fundamental divergence within feminist theory continues to be between those who assert that women form a separate cultural group with its own values and practices and, on the other hand, those who resist this assumption' (2012, 183–4).

Another main axiom of critique centres on the close affinity and institutional connection between KADEM and the government. Many commentators consider KADEM's organic contact with the governing AK Party, and thus the parallels between KADEM and state policies, to be highly disturbing. Government participation in KADEM may be linked with the high profile of the organisation's events which, in turn, may have helped to enhance its visibility even further. That said, these ties do not render KADEM's position insignificant. On the contrary, we have to consider KADEM's efforts to redefine women's position in contemporary Turkish society as part of the AK Party's efforts to redefine national identity.

A nation state which combines the concept of citizenship with the principle of equality facilitates a merging of the idea of modern citizenship with liberalism. The universal character of modern citizenship, which includes individual, social and political rights, points to the necessity that the nation state treats all citizens equally. The question of who benefits from the rights rendered by the nation state is important from the point of view of practical application. From a women's perspective, the reform efforts of the early Turkish Republic created a new type of woman by means of adopting new legal regulations. This new type of woman became a Turkish citizen. As Ayşe Durakbaşa states, this identity of a new woman was proposed as a solution to the newly established citizen.

> The idea of 'modern femininity' prescribed by Kemalist reforms proposes a constellation of various images including well-educated professional women, socially active women in clubs and associations, well-educated mothers and wives, good dancers who can dance in balls, and feminine women who follow fashion. 'The image of Kemalist woman' was key in the process of

socialization of new citizens compatible with new institutional arrangements and was a cultural solution to establish congruent relations between men and women in the process of nation building. (Durakbaşa 1998, 46)

This description of women implies the abandonment of the traditional burden stemming from religion or religious sources. At the very least, it implies a partial reduction of this burden for the purpose of improving women's lives. This was a key component of modernisation in Turkey. Women's visibility in the public sphere meant the enablement of a life beyond the boundaries imposed by traditional Islam through the adoption of Western values. A depiction of the headscarf as a symbol of backwardness became pre-eminent. Under the influence of Orientalist views, the headscarf became widely accepted as a symbol of backwardness. However, the increased visibility of women in the public sphere, and the recognition of many citizenship rights through the introduction of a comprehensive Civil Code in 1926, did not stop criticism about society's failure to treat women as equal citizens.

The Civil Law of 1926 rendered considerable rights to women, including improved citizenship status. The essence of this criticism was that Kemalist reforms did not entail any provisions altering the sharp divide between the private and the public sphere. Çağla Kubilay (2010) has argued that Kemalist reforms did not challenge the modernisation project of patriarchy, but merely replaced the Islamic patriarchal order with a Western-oriented variant. The net result was little more than supposedly saving women from their veils. Another line of criticism of this vision of women has come from Islamists who challenged the criteria of visibility in the public sphere. According to this criticism, Western values and standards, which were taken as a point of reference, were simply not applicable to the lives of those living according to Islam (Şişman 2015, 44).

Since the inception of the AK Party's rule, debates about women with headscarves and their rights have generally focused on the image of women established by Kemalism and its shortcomings. In order to draw public support, the government introduced the slogan 'my nation' ('*benim milletim*'). This slogan was meant to mark a return to 'the roots' of the Turkish nation and to represent the AK Party's new discourse. This discourse apparently sought to create a new national identity that emphasises Islam in everyday

life. The 'my nation' discourse was also used as a tool to turn the spotlight on those who remained beyond the parameters of the AK Party's policies, and thus who represents the 'true' nation (Koyuncu 2015).

In his opening speech at the First International Women and Justice Summit, President Erdoğan stated:

> Our religion endowed woman with the status of being a mother. Mothers are endowed with another status. Heaven is set under their feet. Mothers are something else. This status is beyond reach. Some understand this, some don't. You can't tell this to feminists for instance. They don't accept motherhood. But we say those who comprehend this are enough for us. We will continue on our path with them. (Erdoğan 2014)

As this quotation reveals, 'acceptable women' are those who 'comprehend' motherhood as conceived by Erdogan. In other words, once again, the state defines the boundaries of who is to be considered the new women of 'New Turkey'. KADEM's discourse is highly effective and influential in defining these boundaries.

Conclusion

Feminist movements in Turkey, especially those which have flourished since 1980, have contributed much to the attainment of certain gains for women. The keyword for these gains is equality. Since 2014, however, another discourse has come forwards. This new discourse views struggles for equality as futile and calls for their replacement with the concept of 'justice'. This has significant repercussions, to the point where it may impact Turkey's legal order. KADEM is busily engaged in promoting an agenda for justice. To do this, it proclaims the innate differences between man and woman, not just biologically but also religiously. However, despite this agenda, KADEM cannot completely turn its back on struggles for equality. This forces the organisation to advance the following slogan: 'justice *over* equality'.

On the other hand, arguments for justice often embody policies which maintain women's secondary status. According to Berktay (2017, 16), this reflects an old understanding of justice that can be traced back to Plato, who suggested that justice means to give what is due. In other words,

everybody benefits from proportional justice. Changes in laws that are supposedly protective of women (such as getting a full day's pay for a half day of work, subsidies for children, paying salary for grandmothers for child-rearing) are in fact laws which strip women of their rights to exist in public. Fırat Mollaer, who refers to Turkey's policies of conservatism as 'techno-conservatism', makes a similar point on inequality. Mollaer (2016, 234) argues that the core of conservativism in every historical era is a basic belief in inequality, as opposed to ideologies which favour equality.

KADEM implements an intensive academic programme in order to spread this idea and proclaim to its followers that asking for equality will not be to the benefit of women. In addition to its academic activities, KADEM also works hard to influence policy-making and shape public opinion. For instance, instead of fighting for day care as a right, it advocates for flexible work hours and a salary for grandmothers taking responsibility in child-rearing. KADEM also supported a law which granted religious officials the right to perform marriage ceremonies, in the hope that this would increase the number of legal marriages in the country. On the other hand, feminist movements view the entrustment of this kind of legal authority to religious officials as a retreat from rights obtained through civil marriages. Moreover, KADEM successfully blocked a bill about sexual abuse, which showed its effectiveness in policy-making processes.

The extended participation of members of the AK Party's Women's Section in KADEM events is another indication of the scope of acceptable women. At a KADEM-organised event in Malatya,[9] at which I was also a participant, I came across a female AK Party member who found KADEM women to be too academic, and thus distant from the party base of pious Muslim women. Conversely, members of KADEM consider the AK Party's base to be too traditional.

It is obvious that 'New Turkey's' new women do not demand equality. But the idea of 'acceptable women' seems to be caught between two worldviews. Time will tell whether or not this idea can bring any possibility of freedom. To sum up, KADEM is in a volatile position, negotiating between traditionalist Islamic factions within the AK Party establishment and well-educated young women who are fighting for women's rights from a non-feminist, non-secularist perspective.

Notes

1. Considering that some women might disagree about the combined usage of Islam and feminism, I prefer using the expression 'Muslim women'; 'Islamist' is used when emphasising a political dimension.
2. The seminar 'Gender Justice' was held on 11 February 2015.
3. Quoted from a discussion during the author's visit of a KADEM meeting on 6 August 2016.
4. The conversation took place after a conference on 'The Other Side of February 28', held on 5 December 2015.
5. Sare Aydın Yılmaz, the founder and first president of the association, Özlem Zengin, one of the co-founders of the association, and Rümeysa Kadak, Young KADEM project coordinator, were all elected as MPs at the June 2018 general elections. KADEM's Ankara chief, Zehra Zümrüt Selçuk, was appointed Minister of Family, Labor and Social Services in July 2018.
6. Held on 5 December 2015.
7. Held on 28 March 2015.
8. Personal conversation with the author during a coffee break at the seminar titled 'The Image of Women in Jewish and Christian Traditions' on 28 March 2015.
9. Held on 17–18 January 2016.

Bibliography

Acar, Feride. 'Türkiye'de İslamcı Hareket ve Kadın'. In *1980'ler Türkiye'sinde Kadın Bakış Açısından Kadınlar*, edited by Şirin Tekeli, 73–90. Istanbul: İletişim, 1995.

Aktaş, Cihan. *Bacı'dan Bayan'a: İslamcı Kadınların Kamusal Alan Tecrübesi*, 3rd edition. Istanbul: Kapı Yayınları, 2005.

Aydın Yılmaz, Emine Sare. 'Kadın Ve Demokrasi Derneği Başkanı Sayın Sare Aydın'ın Açılış Konuşması'. 2014a, http://kadem.org.tr/kadem-kadin-ve-demokrasi-dernegi-baskani-sayin-sare-aydinin-acilis-konusmasi/ (last accessed 11 July 2018).

Aydın Yılmaz, Emine Sare. 'Eşitlik Üstü Adalet'. 2014b, https://kadem.org.tr/sare-aydin-yilmazin-esitlik-ustu-adalet-baslikli-makalesi-starda-yayinlandi/ (last accessed 11 July 2018).

Aydın Yılmaz, Emine Sare. 'A New Momentum: Gender Justice in the Women's Movement'. In *Turkish Policy Quarterly*, vol. 13, no. 4 (2015a): 104–15.

Aydın Yılmaz, Emine Sare. 'Kadın Hareketinde Yeni Bir İvme: Toplumsal Cinsiyet Adaleti', March 2015, https://kadem.org.tr/sare-aydin-turkish-foreign-quarteriy-dergisine-kadin-hareketinde-yeni-bir-ivme-toplumsal-cinsiyet-adaleti-ni-yazdi/ (last accessed 11 July 2018).

Berktay, Fatmagül. 'Dinsel İdeoloji, Toplumsal Cinsiyet ve İslam Motifli Muhafazakarlaşma'. In *Felsefelogos*, vol. 67 (2017): 7–16.

Bora, Aksu. 'Bir Yapabilirlik Olarak Ka.Der'. In *1990'larda Türkiye'de Feminizm*, edited by A. Bora and A. Günal, 109–24. Istanbul: İletişim, 2007.

Bora, Tanıl. *Cereyanlar Türkiye'de Siyasi İdeolojiler*. Istanbul: İletişim, 2017.

Doğan, Sevinç. *Mahalledeki AKP*. Istanbul: İletişim, 2017.

Donovan, Josephine. *Feminist Theory*. New York: Continuum, 2012.

Durakbaşa, Ayşe. 'Cumhuriyet Döneminde Modern Kadın ve Erkek Kimliklerinin Oluşumu: Kemalist Kadın Kimliği ve "Münevver Erkekler"'. In *75 Yılda Kadınlar ve Erkekler*, edited by Ayşe Berktay Hacımirzaoğlu, 29–50. Istanbul: İş Bankası Yayınları, 1998.

Erdoğan, Recep Tayyip. 'Türkiye Cumhurbaşkanı Sayın Recep Tayyip Erdoğan'ın Açılış Konuşması'. 24 November 2014, https://www.kadem.org.tr/turkiye-cumhurbaskani-sayin-recep-tayyip-erdoganin-acilis-konusmasi-tr/ (last accessed 15 July 2018).

Göle, Nilüfer. '80 Sonrası Politik Kültür: Yükselen Değerler'. In *Melez Desenler İslam ve Modernlik Üzerine*, edited by Nilüfer Göle, 37–48. Istanbul: Metis Yayınları, 2011.

İlkkaracan, Pınar. 'Vatikan'dan Kopya: Toplumsal Cinsiyet Adaleti'. 2 January 2015, http://kazete.com.tr/makale/vatikandan-kopya-gundemsal-cinsiyet-adaleti_1013 (last accessed 15 July 2018).

KADEM. 'Uluslararası Kadın Ve Adalet Zirvesi Sonuç Bildirisi'. 24 November 2014, https://kadem.org.tr/uluslararasi-kadin-ve-adalet-zirvesi-sonuc-bildirisi/ (last accessed 11 July 2018).

Kardam, Filiz and Yıldız Ecevit. '1990'ların Sonunda Bir Kadın İletişim Kuruluşu: Uçan Süpürge'. In *1990'larda Türkiye'de Feminizm*, edited by A. Bora and A. Günal, 87–108. Istanbul: İletişim, 2007.

Kavakçı, Merve. *Toplumsal Cinsiyet Adaleti Kongresi-Merve Kavakçı*. 2015, https://www.youtube.com/watch?v=xWIjIMLqs9g (last accessed 15 July 2018).

Koyuncu, Büke. *Benim Milletim . . . Ak Parti İktidarı, Din ve Ulusal Kimlik*. Istanbul: İletişim Yayınları, 2014.

Koyuncu, Büke. '2002'den 2015 Seçimleri'ne AK Parti'nin Ulusçuluğu ve Bir Projeksiyon'. In *Birikim*, Sayı 313, Mayıs 2015: 37–45.

Kubilay, Çağla. 'Türban Sorunu Bağlamında Siyasal İslamcı Söylemin "Alternatif" Yurttaşlık Tasarımı'. In *Anadolu Üniversitesi Sosyal Bilimler Dergisi*, vol. 10, no. 2 (2010): 135–64.

Mollaer, Fırat. *Tekno-Muhafazakarlığın Eleştirisi*. Istanbul: İletişim, 2016.

Şişman, Nazife. *Küreselleşmenin Pençesi İslam'ın Peçesi*. Istanbul: İnsan Yayınları, 2015.

Timisi, Nilüfer and Meltem Ağduk Gevrek. '1980'ler Türkiye'sinde Feminist Hareket: Ankara Çevresi'. In *1990'larda Türkiye'de Feminizm*, edited by A. Bora and A. Günal, 13–39. Istanbul: İletişim, 2007.

Yılmaz, Zehra. *Dişil Dindarlık*. Istanbul: İletişim, 2015.

Zihnioğlu, Yaprak. *Kadınsız İnkılap*. Istanbul: Metis, 2003.

9

NEVER WALK ALONE: THE POLITICS OF UNVEILING IN 'NEW TURKEY'

Ayşe Çavdar

As the madness of the #10yearschallenge neared its peak, a group of women in Turkey shared photos of themselves with and without the Islamic headscarf. They declared their decision to abandon it and briefly expressed their feelings about this choice. Their statements were apparently formulated with great care, bearing little resemblance to the usual anti-Islamic, anti-headscarf sentiment. They revealed that they had worn headscarves as a result of encouragement or pressure from their families or schools. Consequently, they considered their abandonment of the headscarf to be a matter of emancipation, motivated by the desire to uncover their authentic selves.

There were two types of reaction to these Tweets. First, a secular reaction, happily supportive of these decisions. Second, an Islamist objection, approving of neither their choice nor their announcement. Both categories of responses signified that, merely by abandoning their headscarves and declaring this on social media, these young women had recast and upended a discussion first initiated some thirty years ago. This earlier discussion was begun in the 1980s by other young women who had claimed public space and politics in their Islamic veils.

This chapter does not aim at a comparison of the secular and religious reactions to these Tweets, or the hegemonic imaginations regarding the public sphere and contemporary politics in Turkey that they are based on. Instead, it

seeks to analyse the responses of Islamist men in order to examine the meaning which the headscarf of religious women has for them.[1] This analysis draws on the work of psychiatrists Elisabeth Kübler-Ross and David Kessler (2005) on the 'stages of grief' in order to explain how the decision of religious women to abandon their headscarves feels like a rupture in the masculine hegemonic project of Islamism. Before doing this, however, I will summarise the background to the transformative role of the headscarf regarding the struggle that has played out between Islamist men and women since the 1980s.

The Counter-hegemonic Agenda of the Modern Veil

Many commentators have suggested that the struggle of women in headscarf to engage in the public sphere emerged as a counter-hegemonic movement (Göle 1991; Özdalga 1998; Çakır 2000; Cindoğlu and Zencirci 2008). Especially in the 1980s, the veil in Turkey was a symbol indicating the existence of young Muslim women who dared to challenge the ideal female typology created by the secularist state. Increasingly, the headscarf was worn on the street by young university students – that is, by people 'intelligent' and 'educated' enough to grasp the possibilities and opportunities provided by the modern state. In this way, wearing the headscarf constituted a contestation of the state's hegemony over the female body. It meant a rejection on the part of these women of their status as would-be carriers of the hegemonic dream of the state bureaucracy. This dream entailed Turkey becoming integrated into modern/secular Western civilisation.

According to Alev Çınar (2005), the female body was one of the agencies which helped 'to reset the boundaries of the public and the private, which in turn served the creation and institutionalisation of a sense of secular, modern nationhood' (63). Thus, in parallel to stark official prohibitions, the veil became a key counter-hegemonic symbol challenging the modern secular state in Turkey. However, after the Justice and Development Party (AKP) came to power, the headscarf eventually became a symbol of state hegemony in 'New Turkey'. Of course, the AKP have never made the headscarf compulsory for women. However, the way they have used, defended and promoted both the headscarf and veiled women has elevated these to symbols of the new hegemonic status quo. They constitute a kind of border between the 'old/secular Turkey' and the 'new/religious Turkey'.

However, there is another, rarely mentioned dimension to the veiled women's movement in Turkey, and one that is intrinsic to their claim to visibility in the public sphere. While attempting to go to university, pious young women also claimed their emancipation from the home. Wearing the headscarf enabled many young girls to attend university because their traditional religious families believed this item of clothing would protect their daughters from the damages of the modern secular world. Political Islam played a significant role in this development through its support to veiled young women to appear in the public sphere. But this support always remained conditional. And in turn, political Islam in Turkey gained immense visibility by siding with the veiled female university students.

Political scientist Zehra Yılmaz argues that, especially by the 1990s, the headscarf was transformed into a 'potentiality for public life':

> Being re-defined on the basis of emancipation, the headscarf transforms into an element increasing female mobility. It does not squeeze the women into (their) bodies but emancipates them by marking the border over the body. It is reinterpreted by women (as a vehicle) to overcome the boundaries. (Yılmaz 2015, 190)[2]

By going to university in their headscarves, these young women multiplied their possibilities for, and imaginations of, the future. They challenged not only the hegemony of the secular state in the public sphere, but also the religiously prescribed hegemony of men in the private sphere. Even though it happened fast, this transformation has not yet come to an end. Paradoxically, the controversy surrounding young women who abandon their headscarf reveals that, in 'New Turkey', this transformation has picked up pace. And yet, through a conservative political discourse, masculine hegemony has become more and more potent.

She is Leaving Home

When worn by women in their homes, neighbourhoods and villages, the Islamic headscarf did not pose any problems – provided that these women did not ask for positions in the state bureaucracy (Atasoy 2009, 139). However, when university students began to wear the headscarf, the state showed considerable confusion. Even though these young, veiled women were not

asking for positions in the state bureaucracy, it was clear that they eventually would. Moreover, the university was one of the secular state's most valued symbolic spaces. The wearing of the headscarf here was thus seen as a challenge to the secular nature of the Turkish state. Consequently, as early as the 1960s, a series of repressive and prohibitive measures were imposed against the headscarf.

The struggle of veiled young women to go to university and their demands to actively participate in the public sphere gradually created a rift between Islamist men and women. The former demanded that these women disobey the secular state, while at the same time remaining obedient to the domestic hierarchy as defined within the Islamist patriarchy. One of the harshest debates about this cleavage took place in the newspaper *Zaman* in 1987. Ali Bulaç, a famous Islamist writer, published an article titled 'The Short-Minded Feminist Women' (1987), in which he targeted a group of young female writers of the same newspaper. Due to the negative influence of feminism, Bulaç argued, these young writers were unable to grasp the supreme dignity granted to women by Islam. He further accused them of misleading pious young females.

In their responses to Bulaç, the writers Tuba Tuncer, Yıldız Kavuncu-Ramazanoğlu, Mualla Gülnaz and Halime Toros established a bridge between pious women and feminism. Each of them argued that feminism is not a blasphemy, but a call for an uprising against male domination. They also called on Muslim men to desist from stereotyping Muslim women, and to question their privileges in everyday life (Bora 2017, 803).

Shield and Sword

During the early years of the AKP government, the appearance of headscarf-wearing spouses of AKP politicians in symbolically Republican places and rituals led to an intensive public discussion. This discussion resulted in further restrictions on the headscarf at universities, partly because the state bureaucracy was still acutely sensitive to the demands of the secular army. Thanks to the Democratisation Package initiated in the process of harmonisation with the EU in 2013, women were allowed to wear the Islamic headscarf in public offices, except in the military, police and judicial bureaucracy. Over time, members of the security forces and soldiers also came to benefit from this freedom.

Meanwhile, the AKP altered its political discourse by reinventing the headscarf as one of the elements of polarisation between the religious and secular segments of society. For that reason, Erdoğan frightened his supporters at every opportunity, insinuating that the headscarf ban would return if his party should lose power.[3] Nevertheless, the AKP administration did not fulfil all the demands of veiled women. Before the 2011 general elections, for example, headscarved women initiated a campaign with the slogan 'no headscarved candidate, no votes' (*Başörtülü aday yoksa, oy da yok!*). They wanted to be represented in parliament by headscarved women like themselves (see also Chapter 8 by Gülşen Çakıl-Dinçer).

The AKP did not favour this idea. Another significant challenge to the still secularist military and bureaucratic establishment was not on the agenda at this point in time. Many AKP politicians and writers advised women in headscarf that the time for such a move was not right (Yılmaz 2015, 200–7). It was only after the Democratisation Package in 2013 that female deputies were allowed to wear the headscarf in parliament. The AKP and Erdoğan presented this development as their personal gift to Muslim women and a victory against the Gezi Park protests.[4]

Indeed, according to Erdoğan, the Gezi protesters were attacking veiled women. During the protests, the headscarf issue once more came to occupy the centre of political discussion. News emerged that protesters had allegedly harassed an AKP district mayor's daughter-in-law, a young women in veil. According to the story disseminated by pro-government media, a mob of young men had insulted the young lady and her baby. Erdoğan cited this incident several times to support his claim that, without him, the future of religious people in Turkey would be dark. Pro-AKP journalists even claimed there was video evidence of the attack. Two years later, security camera footage did indeed emerge, but there was no substantive evidence to confirm the story (Oruçoğlu 2015).

'What Am I To You?'

In a small field survey conducted in 2001, I interviewed women who experienced the consequences of the headscarf ban. As a fresh graduate student who had newly abandoned the headscarf, I aimed to show how the restrictions and prohibitions on the headscarf had also changed religious women's private

lives. I also asked them whether Islamist men and families had developed a solidarity with veiled women in order to ease the consequences of the ban in everyday life. According to the interviewees, men wanted women to challenge the secular state in the public sphere, but they *also* expected them to continue to obey the Islamic codes of masculine dominance in their private lives. From the perspective of Islamist men, it was acceptable for women to become politicised by opposing the hegemony of the secular state. However, it was not acceptable to extend this politicisation to the private lives or the semi-private sphere of Islamist organisations.

Havva, a 43-year-old doctor working for the Istanbul Metropolitan Municipality, recalls that she was forbidden to practice medicine because of her veil.

> When I confronted my male colleagues about their mistakes at work, they wanted me to keep silent. They wanted me to obey them (only) because we believed in the same faith. Religious men are surprised when a veiled woman raises her voice. Because it is beyond their expectation.

I asked her if she received any support from men when she encountered problems because of the headscarf. Her reply:

> No, they did not (support me). They cannot. And why should they help us? This problem is ours. It is difficult for them to feel, understand and act like us. Everybody has their own lives. It is our struggle, not theirs.

Dilek (35), another woman I spoke to during the same research, got married when she was still in high school. Her family was conservative, but her fiancée had promised to let her go to university. Immediately after their marriage, she began to study for the university admission exam. Meanwhile, however, the headscarf ban was tightened. She explains:

> I told my husband that I would continue my education even if I had to abandon my headscarf . . . I think he got a shock. It was painful. I questioned the headscarf, but never God. Now, I am thinking about taking the exams wearing a wig . . . That sounds like hypocrisy to me. I cannot tell people I will go to university even if the price is to give up my headscarf. They raise their eyebrows. They act as if I no longer believe in our religion. I even stopped seeing some of my friends to avoid their questions about this matter.

Hanife (20) was planning to run away from home and abandon the headscarf in order to be able to go to university:

> I want to go to university. My family wants me to marry and establish a good family. But this will make me unhappy. I can't go to university with a headscarf . . . I'm studying now. I'll take the university admission exam. If I pass, I will run away. I will study and work. I will always feel the absence of my family's love.

In 2010–11, I conducted extensive field research for my PhD thesis in Başakşehir, a district of Istanbul which since the mid-1990s has been planned, built and privileged by Erdoğan for the emerging religious middle classes. While here, I also saw how the 'headscarf issue' worked against the welfare of pious women in an urban setting formed by conservative middle-class AKP supporters. The level of education among the female population of Başakşehir is higher than in many other areas of Istanbul. The women I spoke to often argued that it is not worth working because the wages for veiled women are very low. In many cases, Islamist bosses were forcing women in headscarf to accept lower positions and salaries, because these women could not find better jobs due to their veils. In the public sphere of Başakşehir, veiled women undertake voluntary charity work, such as caring for children, the poor or the protection of the environment. Civil participation in the district was organised within the framework of a civil society platform established by the male representatives of local NGOs (Çavdar 2014).

Should I Stay or Should I Go?

It thus seems that the struggle of women in headscarf has two dimensions: they have resisted secular hegemony in the public sphere, and its religious rival in their private lives. In both cases, however, this resistance was against a masculine hegemony designed to shape and restrict women's clothing, behaviour and choices. The signs of the desire to give up the headscarf were thus already inherent in the struggle of university students in headscarf.

There have been many women who abandoned the headscarf and declared it publicly. One example comes from an interview conducted by Ayşe Arman, a journalist who works for *Hurriyet* daily, with Reyhan Gürtuna, the wife of Ali Müfit Gürtuna, Erdoğan's successor as mayor of Istanbul from 1998 to 2004. Reyhan Gürtuna abandoned her veil after many years.

I recognised that wearing the headscarf automatically puts me into a particular category of people. And I realised that wherever I go and whatever I tell, people listen to me with a constant prejudice due to that category. I wanted to be neutral. If you wear the headscarf, they don't see you but that piece of fabric. I decided to get away from it.[5]

Fadime Özkan, a journalist for *Star*, a pro-AKP daily, had worn the headscarf for seventeen years when she decided to abandon it. As she was a public personality, her decision became a matter of curiosity. In February 2005, she was also interviewed by Arman. Özkan said that she regrets neither her years in veil nor her decision to abandon it. She also added that she did not receive any negative response from her colleagues after leaving the veil.[6]

As the AKP strengthened in power, the headscarf's status as a neutral expression of religious belief began to recede. More importantly, as the AKP turned the veil into one of the central symbols of its cultural hegemony, the likelihood of headscarved women disagreeing with the AKP dissolved. This dilemma also explains why the decision of young women to abandon the headscarf at a time when the AKP adopted a more authoritative tone was interpreted as a matter of self-esteem, emancipation and as search for inner peace. This is evident from their statements while sharing and declaring their decision on social media.

Hard Out Here

In this section, I present examples of how women who give up their headscarves express themselves and their decision on social media. Most of the Tweets quoted here were published under the #10yearschallenge hashtag. Without exception, they attracted derogatory reactions from Islamist men. In the next section, I will also discuss these reactions.

A woman with the nickname Mother Ant, who wrote on Twitter under the #10yearschallenge, said:

After 11 years, despite the pressures (I took off the headscarf). I am happier, more peaceful, more free and more myself. You'll find yourself as soon as you stop bowing to the pressures.

Busranur: No matter what they say, WE ARE EMANCIPATED. And it has nothing to do with the family, the environment, whatsoever. Our thoughts about what we can do become free. We are free of all the norms that religion

imposes on women. We did not play the role that others put on us. We became ourselves.

Latife Ünal: You will learn to respect and accept women as they want to be, not as you want them to be.

Nurş: I am not trying to prove anything for anyone. But I am so happy. There are people unable to respect others, but they will learn it. I will never be the one stepping back.

The first thing that is apparent from these concise expressions is the claim that these young women have gained control over their lives. The headscarf functions to represent the status quo in an environment built by a political party that has governed Turkey for seventeen years. In this context, the claim for individuality raised by these young women also means a bold rejection of being the vehicle/transmitter/representative of cultural hegemony, the status quo as structured and defined by this government. This is why the reactions of Islamist men are far from unimportant.

God's Away on Business

In December 2018, the webpage named yalnizyurumeyeceksin.com ('you will never walk alone') emerged. At this time, many independent media outlets in Turkey were intensively discussing a single question: would the younger generation effectively be giving up their religion if they choose deism instead of a faith, which failed to practically implement its moral premises? Given that one of Erdoğan's most ambitious promises was the creation of a 'pious generation' (*dindar nesil*), the AKP representatives could not remain silent in this debate.

For Necdet Subaşı, a theologian and senior bureaucrat at the Directorate of Religious Affairs, the arrival of this discussion constituted a new stage of 'religious fatigue' (see also Chapter 4 by Pierre Hecker). Subaşı has argued that religion (Islam) is becoming increasingly strained as it has been converted into a brand within popular culture, one used to attract religious people to commodities and services within the market economy. Ayşe Böhürler, an Islamist journalist and one of the founding members of the AKP, reinterpreted this concept as the fatigue experienced by a younger generation that is completely surrounded by religious symbols and discourses (2017). The

common point of both Subaşı's and Böhürler's arguments was that the potential for Islam to produce meaning for young people had somehow become exhausted. The stories told by young women (in yalnizyurumeyeceksin.com) challenging their family and social environment to be able to leave the headscarf could be taken as proof that 'religious fatigue', according to both Subasi's and Bolurler's definition, is indeed a serious issue.[7]

The narratives of the young women who left the headscarf behind reveals that it no longer functions as a means of emancipation for pious women. Patriarchal religious discourse has infiltrated both the home and the public sphere, limiting the opportunities for women to express themselves. Under these circumstances, mobility is still possible, but somehow less meaningful. These young women explain how the headscarf makes them dependent on their families or religious communities, because they could never gain anonymity through their veils. In other words, these young women complain that, wherever they go, there is no chance for them to express themselves independently, because the headscarf makes them into vehicles for the religious and political choices of their families. The headscarf also prevents them from getting to know different lives and people because of its heavy historical and political symbolism.

In May 2017, Erdoğan stated that 'holding political power is something. But the social and cultural hegemony is something else. We have been in power for 14 years, but we have problems establishing our social and cultural hegemony (kültürel iktidar)'.[8] He stressed the necessity for Imam-Hatip schools and Koran courses to raise a 'pious generation'. In one of the stories published anonymously on yalnizyurumeyeceksin.com, a young woman describes how she experiences this 'problem'.

> I want to share the traumatic state of being veiled. I experienced my youth under a government which imposes the headscarf. I would be blessed if I could keep it. But, it was not possible anymore. I went to imam-hatip schools. There were only four girls not wearing the headscarf. All the rest were veiled. However, the ones who were free were those girls without the headscarf. We would try to make them accept us; they would not have to explain why they do not wear the headscarf. This situation becomes even more obvious in the street. Whatever you do, the street belongs to the women without the headscarf. You become the exception. You need to explain and defend your clothing. Wearing the headscarf is a trauma, which sometimes becomes

very unfair. Interestingly enough, being in the majority does not empower the women in headscarf. Even if you work for the most religious companies, the ones without the headscarf are freer than the ones with it. A woman without a veil does not have to explain anything. I have always been aware of that, and it makes me angry, resentful and rebellious.[9]

This narrative shows two aspects of the headscarf debate: the headscarf has been provided with significant legal freedoms, and even positive discrimination to allow veiled women to have visible power positions (such as the Ministry of Family, chairs and jobs in parliament, universities, financially strong charitable foundations, the bureaucracy and so on). And yet this apparently does not find an echo in the life of the young woman who wrote the above paragraph. The reason for her discontent must be that the slogan 'freedom for the headscarf' did not really mean freedom for headscarved women, even after the AKP came to power. The visibility of the headscarf was the sign of the success of Islamism, but the liberation of headscarved women meant violating the traditional family structure. Such a move would be in contradiction with the conservative agenda of both Islamism and AKP.

For the writer of this paragraph, a young woman who grew up in a conservative family, the headscarf still provides an opportunity to leave home and to be active in the public sphere. Nevertheless, the public sphere is apparently no different from the home, as the Islamist patriarchal hierarchy also determines the code of conduct in the public sphere. Even more unfavourably, she cannot fight against this hierarchy, as she is assigned to be its flag under her headscarf. Another anonymous narrator explains how this process works:

> I have been a woman in headscarf for fifteen years. I grew up in a conservative family. Years have passed, college is over. I found a job and began to question myself. When I am on the bus going to work, most of the women wear the headscarf. Sometimes a woman without headscarf gets on the bus, and I try to imagine whether she feels disturbed being the only one without the headscarf. Then, I think it is not my right to make her feel that way. I think the headscarf segregates us. It may sound illogical to you, but I think the headscarf segregates us and I feel sorry for having been utilized for this for many years.[10]

These narratives also explain why abandoning the headscarf is a crucial matter in the public and political discussion. These women evidently want to

discover themselves and live their own lives instead of bearing the political/ symbolic baggage attached to the headscarf. The question of how much this sentiment is related to religious belief is a separate and much broader discussion. Instead, I will focus on how their quest for subjectivity resonates with Islamist men.

Precious Illusions

Although it was written about six decades ago and has been criticised by many authors, the 'stages of grief' model of psychiatrists Elisabeth Kübler-Ross and David Kessler (2005) is still considered an essential source in the literature on mourning. According to this model, grief comprises five stages: denial, anger, bargaining, depression and acceptance. These stages do not define grief as a process with a precise beginning and end, but function to frame and identify the person's reactions to loss (2005, 7). In this section, I will use Kübler-Ross and Kessler's model as a metaphor, examining the masculine expression of the responses of Islamist men, not on a personal level but as a collective, hegemonic reaction consolidated via Islamism. In other words, with the stages of grief metaphor, I will describe how Islamism as a hegemonic project reveals itself in these masculine reactions.

In the stages of denial, 'the world becomes meaningless and overwhelming' (10). Anger covers an underlying pain and signals that the individual 'feel(s) deserted and abandoned' (15). The third stage is bargaining – an attempt to make life return to what it was (17). This is followed by depression, wherein 'the person in grief withdraws from life, left in a fog of intense sadness' (20). The final stage is acceptance. Kübler-Ross and Kessler insist that acceptance does not consist of a feeling that everything is now fine. It is just the expression of learning how to survive after a significant loss (24).

The following male responses to women abandoning the headscarf were written on Twitter by individual men with their own subjectivities. Of course, the present analysis does not attempt to reduce these subjectivities to a collective voice. However, these responses come from those men who perceive themselves as a sort of authority or, at least, as spokespeople for a shared 'cause' or 'religion'. In the virtual space of social media, their individual voices merge into a collective masculine voice which responds to a group of women who designate themselves as liberated from the headscarf and its symbolic

hegemonic sphere. This setting on Twitter is nothing more than an illusion. Nonetheless, it still generates a sort of atmosphere wherein everybody talks not only in their own names, but also represents the demands of anonymous parties countering each other in a public space.

The sample expressions were selected for analysis in several steps. First, the expressions of men who reacted to the women sharing their photos with/ without headscarf under the #10yearschallenge hashtag were selected. Then, the copy-and-pasted reactions and some accounts reacting to multiple cases were dismissed. After this trimming, the trolls (recently created accounts following or followed by nobody, Tweeting about nothing else and so on) were eliminated. After this process, a reasonable number of accounts and responses remained.

While categorising the responses, it became clear that the categories that were formulated via the keywords used by the responding Tweets were evocative of the stages of grief described by Kübler-Ross and Kessler. To be sure, the present case is not about an individual's feelings over the death of a loved one. The men responding to the women who abandoned the headscarf have not lost a real person, but rather a precious – and even 'sacred' – idea represented by these women. The only meaningful connection between these men and women is the headscarf, which signifies what is considered sacred by the former, and which was once also considered sacred by the latter. In this relationship, there is a critical problem creating anxiety for these men: what will happen to the idea and cause represented by the headscarf?

In such a relationship, the headscarf turns into an idea which obscures the women who carry it. By abandoning the veil, a woman clarifies her image both with and without a headscarf. Disturbed by this apparent clarity, Islamist men try to protect the idea represented by the headscarf from the women. Thus, for Islamist men, the headscarf turns into a flag without an ensign – a flag that men are unable to carry.

The responses of Islamist men lead to the seemingly paradoxical conclusion that these men are trying to protect the idea represented by the headscarf from the very people assigned to carry that idea – from women. Indeed, the first observation with respect to these Twitter responses is that Islamism, as a hegemonic project, is infused with a masculine tone. Mansplaining was inherent in all of the reactions. Without exception, in all their responses,

Islamist men seem to assume that they know better than those young women who abandoned the headscarf. This sense of rectitude extends to what is right and what is wrong for a Muslim woman, what a Muslim woman should do for herself and for society, and how they will be punished in the afterlife for such a decision.

Denial: The Tweets responding at this level deny the connection between the women and the veil. For the Islamist men, unveiled women do not represent the value of the headscarf, which is why the headscarf is better without them. In this way, they designate the act of abandoning the headscarf as meaningless and in no way representative of any decline in the value and authenticity of veiling. After all, with their act, these women have seemingly indicated that they are not true believers of Islam.

> I don't like those women wearing headscarves and tight-jeans together. You should either take off the headscarf or wear something decent on your ass. She did the right thing. The scarf does not work with such a jean. (Senol Bolat)

> Instead of damaging real veiled women by having sex with men in parks under your veil, leave the headscarf. Live where you want in a free state. (Talha Dayı)

> In recent days, Twitter is full of the shabby women saying they got their freedom by leaving the veil. You did not flee the headscarf; the headscarf has escaped and emancipated from you. (HestBehist)

Anger: Anger emerges with a bitter sarcasm and pejorative language, designed to hit the unveiled women below the belt. Curses, insulting expressions and short sentences abound, humiliating the women for abandoning the idea they shared with the men about the 'cause': the headscarf.

> It is effortless to buy the character of such prostitutes. You know, character is essential. (Mur4t)

> [Now] We see which community is disgusting more, you lefties with pink asses. [They] Fuck each other in the alleys. Take also the veiled ones, [they] do prostitution in the parks. They already belong to your community! (Sayın Hazretleri)

I can respect women with and without headscarf. But, I don't respect you. Because you are doing more than just uncovering your head. You are spreading your evil in society. (Salim Engin)

Bargaining: The subject matter of bargaining is the public visibility of the act of women abandoning the headscarf. The Islamist men urge women to keep their decision to themselves and not to be a model for other veiled women.

Do not humiliate people's beliefs here. Do not expose your impertinence and shamelessness to benefit from our religion. If you want to be famous, try other ways. (Fazlı Öztürk)

Look how she looks like a cliché posing as if she fled from ISIS. As if the society gathers every month to decide who should or should not wear the headscarf. Why do you selfishly publicise your own family business here? (FTHGLC)

Ms. Busranur, headscarf is not only covering your head and body but also closing your mind and heart to ugliness and abundance. Real freedom occurs when submitting yourself to God. (Mehmet Emin Parlaktürk)

Depression: At first glance, these Tweets are unlikely to be characterised as depressive in tone/nature. With clear mansplaining, they tell women exactly what to do. However, they still hit a sad tone of withdrawal with words like 'sorry', 'heart' and 'wisdom'. Others end with a sort of wish or sense of longing. The reason I attach the definition of 'depressive' to this category of reactions is that they convey a more emotional tone compared to other masculine responses in this discussion; they sound depressed where other responses are full of rage.

Mawlana says that if a Muslim is proud of her/his sins, then s/he surrenders her/his heart to Satan. That is it. (Mahir)

It is not so important to cover your head as long as you do not have a love of wisdom in your heart. Congratulations. (Mahsun Süpertitiz)

I am sorry, but you were not in Islamic headscarf anyway my sister. You were at the beginning of a beautiful road, but you chose to get another cycle. I wish God bestows guidance to all of us. (Drokoli)

Acceptance: These responses indicate an acceptance of the loss and a decision to move forwards via ironic wishes and greetings towards those women who abandoned the headscarf. They also create a projection for the future. Of course, this acceptance without approval is in no way humble. It is an acceptance that states 'do whatever you like. Who cares?' It is an expression of acceptance which punishes the other with indifference.

> You were not different when you were veiled. It is better for you to uncover your head. Those women who veil in your style are the signs of doomsday. (Ahmed)

> I see you are one of those abandoning the headscarf. I do not condemn, I just feel sorry. The road was never easy. I hope you understand the truth before the last regret. A note to myself: You will know somebody's sin but not repentance. (Sadık Yılmaz)

> Unveil, my daughter; then they will call you civilised. Walk in the market with your bra. Then, Kemalists will celebrate you as you gain your individuality. Be republican women altogether. Swear on your days in veil saying 'how backward I was'. (Mustafa)

Conclusion

In Turkey since the 1980s, women in headscarf have left their private sphere to go to university, find jobs and participate in politics. These developments have been challenged not only by the modern nation state's secular definition of the public sphere, but also by the Islamist patriarchy. Islamist men understood this challenge, but they also benefited from the fact that the headscarf gave them and their cause an immense visibility and legitimacy in the political sphere. The headscarved women in universities, hospitals, courts and so on were representative of the existence not only of Islam, but also of Islamism as an advancing hegemonic project. The reaction of Islamist men to the women who abandoned the headscarf confirms this hegemonic representation. For Islamist/religious men, women's declarations about why they abandoned the headscarf constitute a retreat from the territory they had gained, and an extremely visible defeat.

The characteristic feature of the men who wrote the above Tweets is the implicit relationship they establish or construct between themselves and

veiled women – and, in fact, the veil without women. These Tweets reveal how, in the Islamist/religious masculine discourse, the veil as an idea actually replaces women. These men claim authority for themselves to explain the shape, meaning and importance of the headscarf, as if they were the owners and rulers of the headscarf idea. This idealistic conception of the veil explains not only the separation anxiety these men experience, but also the extent of the mansplaining in their expressions. For these men, the true headscarf represents the women who are sexless, dedicated to the cause, living as a marker in a space defined by Muslim men, educating the children of the nation and religion appropriately, free from any worldly desires. When these young women abandon the headscarf and share their stories on social media, this image of the perfect Muslim woman is also brought into question. The resulting grief, then, is not over these women abandoning the headscarf, but over the dream of an ideal Muslim woman.

Interestingly, these Tweets show how women leaving the headscarf suddenly turn into beings that can be subjected to sexual insults from Islamist/religious men. This raises the question of the self-imagination of Islamist masculinity in relation to the headscarf. Most probably, for the responding men, the perfect Muslim woman appears as a saviour who rescues the Muslim man from the hellish state of the profane world. When she abandons the headscarf, the Muslim man loses not only the ideal spouse, but also his saviour. This is merely a hypothesis, however; one needful of further study.

Notes

1. In this article, the term Islamist as an adjective refers mostly to men, while the term religious is used for women. This is because the word Islamism refers to a (or any) hegemonic project which claims Islam (religion) as the basis of their legitimacy discourse. In Islamist discourse, both Islam and religiosity serve as empty signifiers to consolidate the claims of Muslims under the Islamist hegemonic project. From this perspective, the headscarf issue is one of the typical problems to analyse this hegemonic relationship between Islamism and Muslim religiosity. As this article is about the women abandoning the headscarf mostly because of the way it is used within the Islamist hegemonic project, it was necessary to distinguish Islamism and religiosity based on this hegemonic play. However, although these women declare that they abandon the headscarf, in private conversations, a

few of them express their doubts, disbelief and disappointments about their religiosity. But this is not a part of their public declaration regarding their decision to abandon the veil. Thus, by their act of leaving the headscarf, they distinguish piety and Islamism. For this reason, the word religious is used to refer to the women who used to be veiled and later leave the headscarf in this chapter.

2. Translated into English by the author.

3. 'My brothers, remember! CHP means oppression and cruelty. CHP means to ban the headscarf, Imam-Hatip schools . . . [and] to prevent the teaching of the Koran. CHP means to support [military] coups . . .', quoted and translated from a speech of Recep Tayyip Erdoğan, "Basbakan Hatay'da Konusuyor", in *Sabah*, 22 March 2014.

4. For example, he thanked the parliament for accepting the Democratisation Package in the name of the 'nation and himself'. *"Erdoğan'dan başörtülü vekil açıklaması"*, in *Internethaber*, 1 November 2013.

5. "Nasıl kapandım? Nasıl açıldım?", Ayşe Arman-Reyhan Gürtuna interview, in *Hürriyet*, 1 June 2008.

6. "Saçımı açmadan tam dört yıl düşündüm, pişman değilim", Ayşe Arman-Fadime Özkan interview, in *Hürriyet*, 27 February 2005.

7. The website still functions as a solidarity platform. Similar discussions also arose in a blog named recel.org.

8. "Cumhurbaşkanı Erdoğan: Sosyal ve kültürel iktidarimiz konusunda sıkıntılarımız var", in *Hürriyet*, 28 May 2017.

9. "Kafası karışık olanlar hep çocuklar olmuyor, anne babaların içinde de bir şeyleri sorgulayanlar var", available at https://www.yalnizyurumeyeceksin.com/2019/01/11/kafasi-karisik-olanlar-hep-cocuklar-olmuyor-anne-babalarin-icinde-de-bir-seyleri-sorgulayanlar-var/ (last accessed 25 November 2020).

10. "Yüzleşemediğim şeylerle artık yüzleştim", available at https://www.yalnizyurumeyeceksin.com/2018/12/18/yuzlesmedigim-seylerle-artik-yuzlestim/ (last accessed 25 November 2020).

Bibliography

Atasoy, Yıldız. *Islam's Marriage with Neo-Liberalism*. New York: Palgrave Macmillan, 2009.

Bora, Tanıl. *Cereyanlar*. Istanbul: İletişim Yayınları, 2017.

Böhürler, Ayse. 'Din Yorgunu Gençler'. In *Yeni Şafak*, 30 September 2017.

Bulaç, Ali. 'Feminist Bayanların Kısa Aklı'. In *Zaman Gazetesi*, 17 March 1987.

Çakır, Ruşen. *Direniş ve İtaat*. Istanbul: Metis Kitap, 2000.

Çavdar, Ayşe. *Loss of Modesty, the Adventure of Muslim Family from Mahalle to the Gated Community*. Frankfurt Oder: European University of Viadrina, 2014.

Çınar, Alev. *Modernity, Islam, and Secularism in Turkey: Bodies, Places, and Time*. Minneapolis: University of Minnesota Press, 2005.

Göle, Nilüfer. *Modern Mahrem: Medeniyet ve Örtünme*. Istanbul: Metis Kitap, 1991.

Kübler-Ross, Elisabeth and David Kessler. *On Grief and Grieving: Finding the Meaning of Grief Through the Five Stages of Loss*. New York: Scribner, 2005.

Oruçoğlu, Berivan. 'Turks, Lies, and Videotape'. In *Foreign Policy*, 13 March 2015.

Özdalga, Elisabeth. *The Veiling Issue, Official Secularism, and Popular Islam in Modern Turkey*. London: Curzon, 1998.

Subaşı, Necdet. 'Din Yorgunluğu'. 2013, http://www.necdetsubasi.com/calisma/makale/251-din-yorgunlugu (last accessed 30 November 2019).

Yılmaz, Zehra. *Dişil Dindarlık*. Istanbul: İletisim Yayınları, 2015.

10

WELCOME TO DYSTOPIA. A VIEW INTO THE COUNTER-HEGEMONIC DISCOURSE(S) OF ECOLOGICAL ACTIVISM IN ISTANBUL

Julia Lazarus

And one day, the human, one of the guests of this hidden heaven, fell under the illusion that he could be the master of all creatures. He fattened as he consumed; he consumed as he fattened. As the monuments of arrogance he constructed mushroomed in cities, cities sprawled and started occupying hither and thither.

(From the picnic of NFD at Istanbul's third airport construction site)[1]

This chapter presents the work of Julia Lazarus, an artist, film-maker and curator. It is based on two scenes from her documentary film *Northern Forests*. This film aims to establish a counter-hegemonic discourse on the impact of gigantic construction and infrastructure projects in the Greater Istanbul Area. It focuses primarily on the activities of the Northern Forests Defense (NFD), an ecological activist group. The chapter confronts the reader about both the practical and theoretical means and possibilities of resistance. Ultimately, it poses two questions: how is this group using language to build a counter-hegemonic discourse? And how is this reflected in the documentary film?

One of the film's key scenes focuses on the collective effort to establish this counter-hegemonic discourse on a grass-roots level. This is an essential precondition for forging an alliance against the continuing process of ecological destruction. In another scene, we follow a group of men who seem to be lost in a foggy forest and are looking at flowers sprouting from the earth.

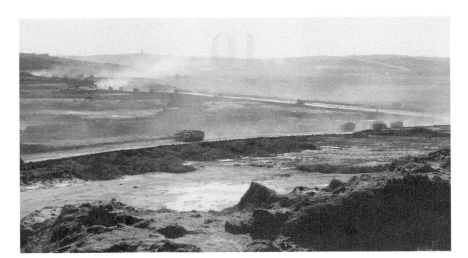

Figure 10.1 Construction site, Istanbul 3rd airport (Source: Still frame, *Northern Forests*, TR/D 2020, HD, 86min, Julia Lazarus)

Aesthetically and in terms of content, these two scenes are very different. But this chapter argues that both scenes are relevant to the film's overall objective – the promotion of a new momentum for resistance.

Welcome to 'New Istanbul'

With its almost sixteen million inhabitants, the Greater Istanbul Area ranks among the largest metropolitan conglomerations in the world, and it continues to grow. Concrete stretches over kilometres on the European, as well as Asian, side of the Bosphorus and along the coasts of the Marmara Sea. Istanbul, built on seven hills, is devouring entire coasts, mountains and forests.

Located north of Istanbul, the Belgrade Forest has been under protection since the sixteenth century due to its importance in supplying water and fresh air to the city. However, the forested area has shrunk from its peak of 13,000 to 5,500 hectares today. In recent years, it was further divided by the construction of a third beltway connecting Istanbul's third Bosphorus Bridge to the city's new airport hub on the shores of the Black Sea. Both projects have been the subject of public controversy. Critics have impugned the imponderable financial liabilities the state assumed through these projects, as well as the massive environmental destruction caused by the government's gigantomania.

Some observers even contested the populist discourse surrounding Erdoğan's mega-projects, which have, indeed, become an integral part of the ruling elite's politics. These projects are intended to represent mythical greatness. They serve to support and symbolise not only Erdoğan's personal claim to power, but also 'New Turkey's' rise to global prominence.

The authoritarian populism represented by these projects is also operative in the realm of memory politics. Istanbul's third bridge over the Bosphorus, for instance, was named in honour of Yavuz Sultan Selim. This sultan is known primarily for winning the Battle of Çaldıran against the expansionist armies of the Safavid Empire in 1514, but he is also remembered for his merciless persecution of the Ottoman Empire's Alevi community in Anatolia. His honouring thus constitutes a clear message of disrespect, denial and depreciation to Turkey's present-day Alevi population.

The next mega-project is Kanal Istanbul, an artificial waterway between the Black Sea and the Sea of Marmara. This is already in the planning stage. Much like the AKP's other gigantic infrastructure projects, Kanal Istanbul will not only destroy the natural habitats of many plants and animals, it will also endanger the metropolis' water supply.

To openly articulate resistance against the government's populist gigantomania has become increasingly difficult, if not dangerous. But there are still ecological activists who persist in organising public actions against the destruction of the livelihood of many for the profit of a few. Their numbers are growing.

In 2016, I lived in Istanbul for half a year. Whilst there, I heard about a group of ecological activists who were organising resistance against the government's huge infrastructure projects to the north of the city. The most important of these projects was intended to be Istanbul's third, gigantic, highly prestigious airport, which was opened to the public in 2019. The new aviation hub is part of a masterplan for greater Istanbul. It entails the intended relocation of large parts of the population from the inner city districts to newly built satellite towns.[2] Out of curiosity, I watched some of the group's self-produced videos online and immediately found myself enthused. I wrote to them and asked if they might allow me to shoot a documentary film about their work. After some time, they responded, inviting me to introduce myself at one of their public forums.

From that moment, I accompanied *Kuzey Ormanları Savunması* (Northern Forests Defense) everywhere they went. I became their friendly embedded journalist, sitting in the backseat of their car, driving with them through the forests of northern Turkey. Sometimes, they asked me to be silent, in order not to betray my German origins. At other points, I was asked to turn off the camera. But most of the time, I filmed, and I filmed, and I filmed. In the end, I returned to Germany with over forty hours of video material.

At the time of writing, the film is still being produced. The idea is to make it into a documentary. But it will not necessarily be the kind of documentary one might expect – that is, a film that merely aims to confront people with facts, to inform and educate them. To be sure, the film will, indeed, aim to look at the facts, to explore reality. But by doing so, it will attempt to 're-create the reality, because reality runs away; because reality denies reality', to be a 'film more beautiful than realism, and therefore composed to give it another sense', as Georges Franju once put it (Levin 1971, 121).[3]

According to the German film-maker Alexander Kluge, a documentary is always shot with three cameras: (1) the camera in the technical sense, (2) the film-maker's mind, and (3) the generic patterns associated with the documentary film which exist in the audience's expectations (Kluge 1988, 4).[4] In this chapter, I will write about the first two of these cameras – in the technical sense and in the film-maker's mind. But the third I leave to you, the reader.

The camera in this documentary looks at the activities of a Turkish ecological activist group. The artist holding this camera has a particular viewpoint, has had particular experiences with this group, has participated in collective activities with them. Indeed, in the light of this empirically acquired knowledge, the artist openly admires the continuous solidarity and humour of this group. This group showed itself capable of agitating tirelessly against an enormous construction project on the coast of the Black Sea.

The film seeks to fully capture how this group manages to generate the energy necessary for taking on a superior power. How do they try to stop, or at least to hinder and delay, the destruction of the common good for the limited wealth of the few? Indeed, this is symptomatic of a broader development towards violent growth, a key aspect in a pattern of global capitalism that is currently manifesting not only in Turkey, but across the world.

The film focuses on developments in Turkey. But by doing so, it also asks a very fundamental question, a question which is relevant to everybody: what kind of world do we want to live in? The kind of world currently being cast in concrete out on the shores of the Black Sea? Yes, this movie is a piece of political agitation. It aims to incite those who answer the above question with a resounding 'NO' to become active, rather than to merely sit back despondently. It calls on them to get moving, even if only for the experience of solidarity.

This is intended to be an optimistic film. This optimism is despite (or perhaps precisely because of) the fact that the present situation does not seem particularly promising. But then, as literary theorist and film-maker Trinh T. Minh-Ha once wrote, 'reality is more fabulous, more maddening, more strangely manipulative than fiction' (Minh-Ha 1990, 88).

Northern Forests Defense

> To feel is to rebel. The insatiable appetite of neoliberalism surrounds us, our very existence, the whole planet. We have become a simple *homo economicus* who calculates everything and anything according to its exchange value. 'Rational man' has already declared his triumph over nature and the world has already been disenchanted. Never in the history of our species has the disruption of the ties that bind us to the whole planet been so severe as today. Towers of arrogance are rising over demolished neighbourhoods, leaving thousands displaced. From Mumbai to the north of Istanbul, machines of destruction are relentlessly working to wipe out water and earth, to construct mega projects. Consumption frenzies are fuelling the enlargement of an energy sector which is conducive to the violation of ecological thresholds and the exacerbation of the climate crisis. In this age of madness, as Saskia Sassen puts it, we are ruthlessly creating 'dead land, dead water', where life is completely consumed on a scale we have not encountered before. A deep ecologist would have added the clause 'dead spirit' to Sassen's definition. The destruction of nature is draining our own energy, damaging human nature, which is indistinguishable from the whole.[5]

Since 2013, the Turkish activist group Northern Forests Defense (NFD) has been organising resistance to the deforestation and colonisation of protected forest and water areas in northern Istanbul. The group was

initially founded in direct response to the Gezi Park protests. Today, the NFD holds public, wholly peaceful protests against the government's plans to urbanise broad rural areas on the Black Sea coast. The aim is to inform the residents of Istanbul and its environs about the negative impact of these large-scale infrastructure projects. Such projects include the third airport, the third bridge, the canal which is intended to connect the Black Sea with the Sea of Marmara, and the various new highways and satellite towns that will emerge as a result of all these developments. These large-scale projects are currently making considerable profits in the portfolios of those supplying the capital. But they are also dispossessing and displacing the populations of rural regions, and they entail devastating effects on Istanbul's free air and drinking water supplies, as well as on the ecological balance and biodiversity of the region. Some even claim that the global climate could be affected.

NFD aims to contribute to the survival of plants, animals and humanity. Some activists and opponents of the government's plans have already left Turkey. But despite all the setbacks, Northern Forests Defense remains and continues to openly oppose government plans. State repression has made it considerably harder to call for demonstrations. Consequently, the NFD invites members of the public to take walks through the threatened landscapes. Members of the group claim to be more fearful of falling into despondency and despair than they are of state repression. They also claim that the solidarity and community within the group protects them from any sense of isolation. Ali Yıldırım, who founded the NFD alongside a few of his friends, says:

> Before the Gezi movement started, I had already joined the demonstrations against the 3rd bridge. The fact that we will lose the forests was disturbing me very much. And I used to wake up at night, upset that I could not do anything about it. But then during the Gezi movement we learned something. We learned that we can fight for the values we believe in. We discovered that there are alternative ways of doing this and we started to mobilise. We knew that there was a sizable investment there. A huge investment which is backed by the government. We knew that we as a group of activists cannot go and stop this. But Istanbul residents can save their own forest if they want to. We took it as our duty to tell Istanbul residents about this.[6]

NFD has succeeded in bringing people together across party and educational boundaries. The group targets its message not only at the inhabitants of Istanbul, but also at the inhabitants of the surrounding towns and villages. The group actively seeks to defuse the burgeoning conflict between the expanding city and the surrounding rural areas. It aims to involve the rural population in its campaigns, with the intention of building resilient structures in precisely those areas most affected.

Rüya Kurtuluş, a female member of NFD who participates loudly and actively in the protests, stated:

> One of the most important things we do at NFD is the villages work. Of course, during our initial visits, we didn't have the kind of relationships that we do now. It was really a mutual learning process. When we go there, we tell villagers about the destruction which the airport, the bridge, the canal project and mines will cause. We explain their adverse environmental impacts and negative impacts on village life. But we also learn lots of things from the villagers. Because they are the best to describe the place, where they live and define the problem there. There are new experiences each time we visit. We are forming very beautiful friendships there.[7]

The group is organised as a direct democracy. The core comprises perhaps twenty to thirty people. Every Friday, they hold an open forum. Ali Yıldırım describes this grass-roots democratic process as follows:

> Our first forums were crowded. Usually fifty to sixty people would attend. And we set up some basic rules. One of these rules was that everyone has equal right to speak and everyone's speech is equally important. And everyone has equal voting rights. And even moderators don't vote, so that he/she doesn't influence others. It was hard to organize this. We faced difficulties again and again. But we built a nice system after a long period by resisting these difficulties. An organization without a leader. An organization whose leader is the forum.[8]

NFD activities are totally peaceful and focus on quick initiatives:

> We continued to protest like the wind. We protested very often, once or twice a week. All were peaceful protests. We often came face to face with the police and each time we took the same approach: 'This forest is yours as well as ours.' What we defend isn't our own garden. This place belongs to all of us.[9]

Film and Language

Making a documentary film about an activist group poses a number of challenges. First, it is important to remain aware that my concerns as a film-maker are not identical with those of the group. Even if I sympathise with the group, the film has to tell its own story. Ideally, this story should be timeless. It should deliver a message that transcends history, and continues to be valid even if the political situation changes.

In this film, I decided to tell a David versus Goliath story. Furthermore, the aim was to show how much work – and how much fun – are involved in collective activism, in defending against damaging developments. Of course, all of this relates to political events. But the ultimate focus is on the strong sense of community. It is important for the film that the protagonists are sympathetic and that the viewer is ready to follow them on their adventures.

A scene from *Northern Forests* observes how the group works intensively to develop some kind of common ground with the residents who are most affected by the infrastructure projects. This dimension is essential for the group's political work. We see a gathering of men and a few women in a tearoom in the village of Durusu, north of Istanbul. The room is dimly lit. The men sit in a circle in the foremost section of a large hall. Some sit with

Figure 10.2 NFD village forum at the teahouse in Durusu (Source: Still frame, *Northern Forests*, TR/D 2020, HD, 86min, Julia Lazarus)

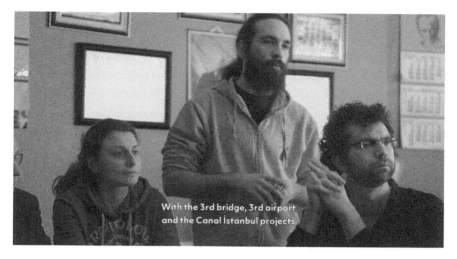

Figure 10.3 NFD village forum at the teahouse in Durusu – NFD members (Source: Still frame, *Northern Forests*, TR/D 2020, HD, 86min, Julia Lazarus)

Figure 10.4 NFD village forum at the teahouse in Durusu – local residents (Source: Still frame, *Northern Forests*, TR/D 2020, HD, 86min, Julia Lazarus)

their backs to the window, through which one can see a sun-drenched village street. The meeting was obviously announced with some publicity; some attendants travelled from other towns and villages, while some of the village's inhabitants went to some lengths to make it. Others seem to be present by

accident, however. A group at the back of the hall indifferently continue their game of backgammon.

A young man with a beard starts to speak and invites everyone present to participate in the discussion. A young woman explains that the aim of the meeting should be to find common ground between urban and rural residents, in order to work together against the destruction of the environment. An older man stands up and states that he almost got lost on his way to Durusu because the landscape has been so profoundly altered by the myriad construction sites. Another elderly man interrupts and, with some vehemence, denounces the local administration for allowing a hotel to be built in the middle of a water conservation area. The meeting grows louder, more unruly. It becomes increasingly clear that the interests of city dwellers and those of the rural population diverge markedly. The attempt to reach some kind of agreement is postponed until the next meeting.

In another scene of the film, the camera follows three Turkish men as they drive through a misty forest in a car. The men talk about the coming spring, and that soon the storks will return to the area. They speak of a sea of flowers that will spread over the forest floor. The driver stops the car and they get out to scour the forest floor for the first messengers of spring. The conversation

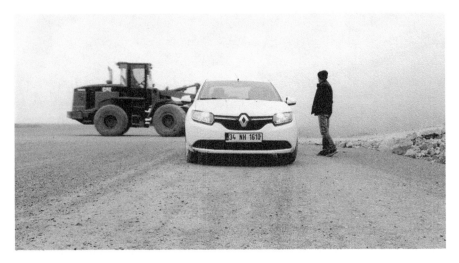

Figure 10.5 Road construction works on the coast of the Black Sea (Source: Still frame, *Northern Forests*, TR/D 2020, HD, 86min, Julia Lazarus)

revolves around primroses and violets, and around the age of the trees. One man says that he cannot really believe that these trees are so old, because their trunks are not wide enough. Another observes in response that oak trees grow very slowly.

The group leaves the forest and continues the journey. Suddenly, a fog closes around the car, forming a white wall of smoke to the right and left. From this fog, the contours of a huge mechanical excavator gradually appear. The car stops, allowing the excavator to circle us and drive up a steep embankment. One of the three men descends the embankment with a long, loping step. He begins a narrative on nature and language.

At first glance, there is nothing to connect these two scenes. And yet, together, they create a coherent portrait of the group. While the first offers us a glimpse into the work and activism of the organisation, the second shows some of them in a relaxed setting, enjoying the very forest they want to preserve.

In order to promote their concerns, the NFD also experiments with the use of language and concepts. They aim to develop an inclusive language that can allow broad sections of society to overcome their speechlessness. The NFD use terms and words that are close to the lived experiences of ordinary

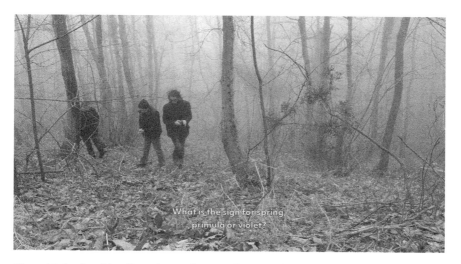

Figure 10.6 Searching for endemic plants on the coast of the Black Sea (Source: Still frame, *Northern Forests*, TR/D 2020, HD, 86min, Julia Lazarus)

people in order to create a new and strong connection between the people of the city and those in the countryside. Onur Akgün, an NFD activist who joined the group in the early stages of its development, put it as follows:

> NFD generates a discourse which tries to use its own position for its purposes, keeps giving hope, showers people with nice feelings. For example, we don't say 'this system is bad', but instead we say 'this system will change'. Of course, we want to change everything, but we build our movement based on the principle of 'defending life'. Because defending life means defending the right of trees and birds to live, it means defending the ecosystem's rights as a whole. It doesn't matter if it's the AKP or another government in power. While we are showing the will to change in practice, we also avoid the ordinary and homogeneous. In my opinion (we have) consumed anti-government discourses in our way of communication, and in texts which results from our relationship with local people. Thus NFD is forming a discourse on a more inclusive base, while using the discourse and terminology of flowers and beetles is more about life. I see it as a discourse which hasn't been consumed yet.[10]

To underline the importance the group attaches to these terms, I want to relate an anecdote here. In 2017, I invited the group to an event at Depo Istanbul, a self-governing arts and cultural centre in the heart of the city. While we were jointly preparing the invitation text, we suddenly found ourselves in the midst of a heated discussion over a single word in the text's title. NFD had used the word '*yaşam*' ('*Ortak geleceğimiz icin yaşamı ve doğayı savunmak*'). In English, this translates as 'defence of life and nature, love of our common future'. But the curator of the exhibition wanted to have the word '*yaşam*' replaced with '*hayat*'. Both words mean 'life', but, according to the curator, '*hayat*' would be more appropriate in the context of an exhibition, while '*yaşam*' sounded a little too pedestrian. The NFD, however, argued that they deliberately chose to use the more pedestrian term '*yasam*'. Its unpretentious simplicity, they insisted, made it better able to touch the hearts of rural people. This was wholly in keeping with the group's constant efforts to include local villagers – the very people who would be most severely affected by the government's plans – in their discourse of resistance. In the end, the term '*yaşam*' was also used in the invitation for the evening at Depo Istanbul.

NFD has always opted for speech rather than silence. They use the language of resistance in times of oppression. They develop their own terminology of

hope. By using only positive terms, the group specifically targets the emotions and memories of the population, thus taking the complex counter-hegemonic discourse to the remotest areas.

The film seeks to capture this particular sensitivity to terminology. To illustrate what the activists are doing, emotionally loaded and striking landscapes are contrasted with images of destruction. After all, in order to continue the fight, you have to know what you are fighting for. With this in mind, I hope to facilitate the work of the group through this documentary film. Indeed, by portraying them and their struggle, my aim is to inspire others to join and imitate them.

Throughout the process of making the film, I invited the members of the group to a few test screenings, each time asking for their permission to use and incorporate particular scenes into the documentary. Not all members of the group were enamoured by the essayistic approach of the film. I suspect that some of them would have preferred more of a reportage format. Certainly, such a film could have been produced more quickly. Still, they agreed that I had managed to capture the spirit of NFD, and they were evidently looking forwards to the official premiere of the film. Hopefully, this will take place in Turkey, before it travels to international film festivals. A double screen

Figure 10.7 Vive la Solidarité – La Z.A.D. est partout! (Source: Still frame, *Northern Forests*, TR/D 2020, HD, 86min, Julia Lazarus)

video installation, using the early footage, was already presented in Istanbul in 2019. It sparked the interest of TRT News, Tele1 and the German public broadcaster ARD, who invited me to talk about the making of the film, as well as the issues depicted in it.

In the years I spent working on the film, the situation in Turkey did not improve. After the third bridge and the airport were opened to the public, an economic crisis hit the country. For a moment, it also sparked the hope that Turkey's dire financial situation might prevent the realisation of more, even bigger infrastructure projects, such as the Kanal Istanbul. But these hopes were quickly extinguished. The Turkish state continues to foster giganto-manic projects that are of interest mainly to the portfolios of their investors. One can only hope that these investors, as well as the public, soon grasp the vital relevance of water and air.

Up to the present day, NFD has remained very active in publishing infor-mation on the recent developments in the Black Sea area and nationwide. Given the current situation, however, they do not plan to organise bigger protests. Still, one could argue that, by developing a new, counter-hege-monic discourse, NFD has laid the ground for an ecological mass movement in Turkey.

Notes

1. Available at https://kuzeyormanlari.org/2016/10/24/welcome-to-the-dystopia-the-new-istanbul/ (last accessed 25 November 2020).
2. Kuzey Ormanları Savunması, ed. The Third Airport Project Vis-à-vis Life, Nature, Environment, People and Law. Istanbul: Northern Forests Defense, 2015.
3. Levin, G. Roy. Documentary Explorations: 15 Interviews with Film-Makers. Garden City, NY: Anchor Press, 1971.
4. Kluge, Alexander. A Retrospective. New York: The Goethe Institutes of North America, 1988.
5. Kuzey Ormanları Savunması. 'Welcome to the Dystopia: "The New Istanbul"', available at https://kuzeyormanlari.org/2016/10/24/welcome-to-the-dystopia-the-new-istanbul/ (last accessed 25 November 2020).
6. Ali Yıldırım Transcript translated from Turkish, Istanbul, 2016.
7. Rüya Kurtuluş Transcript translated from Turkish, Istanbul, 2016.
8. Ali Yıldırım Transcript translated from Turkish, Istanbul, 2016.

9. Ibid.

10. Onur Akgün Transcript translated from Turkish, Istanbul, 2016.

Bibliography

Kluge, Alexander. *A Retrospective*. New York: The Goethe Institutes of North America, 1988.

Levin, G. Roy. *Documentary Explorations: 15 Interviews with Film-Makers*. Garden City, New York: Anchor Press, 1971.

Kuzey Ormanları Savunması, ed. *The Third Airport Project Vis-à-vis Life, Nature, Environment, People and Law*. Istanbul: Northern Forests Defense, 2015.

Minh-Ha, Trinh T. 'Documentary Is/Not a Name'. In *October*, vol. 52 (Spring 1990), 76–98.

PART IV

MEDIATING NEO-OTTOMANISM
IN POPULAR CULTURE

11

NEW HISTORIES FOR A NEW TURKEY: THE FIRST BATTLE OF KUT (1916) AND THE RESHAPING OF THE OTTOMAN PAST

Burak Onaran

'New Turkey' has become the label for the AKP's political vision. But as we might expect of any claim to 'newness' – that is, of a radical political rupture – this new Turkey is based upon an existing, if remapped, historical foundation. This chapter investigates the connections between 'New Turkey' and its imagined Ottoman past. In doing so, it also identifies and analyses the major mechanisms which allow the current ruling elite to reshape history according to the needs of its own political agenda. In recent years, the government has been using all possible means of according a new prominence to the First Battle of Kut (hereafter FBoK) in national memory. This battle was a long forgotten victory over the British Army in World War I. But over the last decade, it was first promoted by Islamist historians, and then persistently recalled by Recep Tayyip Erdoğan, his government and pro-AKP columnists. In 2018, national public broadcaster TRT launched a historical drama series called *Mehmetçik Kut'ül-Amare* which centred around the events of the battle. This chapter treats *Mehmetçik Kûtulamâre* as a case study for exploring the relationship between politics and truth in 'New Turkey'. It enquires into the reasons for a growing popular indifference toward manipulations of history. In this way, the analysis relies on Myriam Revault-d'Allonnes' reflections on 'the age of post-truth' and François Hartog's concept of the 'reign of presentism'.

'New Turkey' Rediscovers the First Battle of Kut

The FBoK was a siege fought between the Ottoman and British forces as part of the Mesopotamian campaign launched in late 1914. It was one of the rare major Ottoman successes in the Great War, 'the most abject British capitulation', and one of the worst defeats in British military history (Erickson 1978, 61–89; Morris 1978, 171). In late 1915, the British Army advanced toward Baghdad. After a stalemate battle with the Ottoman forces at the end of November, the British took up a defensive position in the town of Kut al-Amara, about 170km southeast of Baghdad. In December, the Ottoman Army surrounded the town. The siege lasted until the end of April 1916, when the British garrison officially capitulated. More than 13,000 British and Indian soldiers were taken prisoner.

Turkish history textbooks had always referenced the FBoK as a notable military achievement. On the whole, however, it has traditionally been accorded a fairly limited place in the official memory of the Great War. Indeed, until 2015–16, the FBoK remained almost completely unknown to the Turkish public. When it was rediscovered under the auspices of 'New Turkey', the government and pro-ruling party publications equated its importance with that of the Gallipoli Battle. They further claimed that its memory had been *deliberately* neglected. According to this widely propagated conspiracy theory, the 'Old Turkey' had glossed over the battle at British insistence. In the 'New Turkey', however, the battle took on a different moniker – 'The victory which was made forgotten' ('*unutturulmuş / unutturulan zafer*').

There are obvious reasons why national history has attributed considerably greater importance to Gallipoli. If the Allies had succeeded at Gallipoli, they would have occupied Istanbul and knocked the Ottoman Empire out of the war at a stroke. A sea route to the allied Russian Empire would have opened before them. Gallipoli was certainly a much larger, more significant battle. The popular mobilisation it triggered by far exceeded anything that occurred during the FBoK. Moreover, the zone of conflict was close to Istanbul, home to the majority of the literate population and the national press. It was thus virtually inevitable that the battle would leave much greater and more decisive traces in public memory.

But there is another reason for the importance attributed to the Battle of Gallipoli: the significant place it occupies in the biography of Mustafa

Kemal, the founder of the Republic. Kemal participated in this battle as a commander. There is little doubt that Gallipoli has been highlighted in order to emphasise Kemal's historical role in the defence of Turkey. Moreover, Gallipoli remained within Turkey's national borders after the First World War – in contrast to Kut. Any attempt to accord a vital importance to the FBoK in national history would have implied an irredentist intention. This might have had problematic international ramifications.

'New Turkey' rediscovered the FBoK at the precise moment when these two political concerns ceased to be priorities. Pro-government historians and journalists began to pay attention to the battle during the First World War Centennial Commemorations. In February 2016, President Erdoğan gave the task of coordinating the centennial commemoration activities for the FBoK to Deputy Prime Minister Tuğrul Türkeş. In a widely issued circular, Tuğrul Türkeş ordered several ministries and institutions to celebrate the forthcoming anniversary in a 'grandiose' and 'exuberant' manner.

In parallel with the official efforts of the state, a competition developed between various public institutions, national and local media over who could most 'exuberantly' celebrate the victory. The office of the presidency, the government with its various ministries, the ruling party's municipalities and right-wing, nationalist–Islamist publishers organised numerous meetings and panels and published several books and special issues. The anniversary of the victory was marked in national education calendars and celebrated in schools. Moreover, the students in religious vocational Imam-Hatip schools were expected to recite the entire Koran on behalf of the martyrs of Kut, and to lead Islamic memorial services (*mawlid*) in mosques.

This extraordinary level of attention also resulted in the creation of some remarkable works of propaganda. The TV series *Mehmetçik: Kut'ül-Amare*[1] is among the most notable of these. Since 2013–14, an increasing number of historical dramas – for example, *Diriliş Ertuğrul* (2014), *Filinta* (2014) and *Payitaht: Abdülhamid* (2017) – have been aired on the national public broadcaster TRT (see also Chapter 12 by Caner Tekin). This wave of historical dramas was triggered by Erdoğan's harsh criticism of *Magnificent Century*, a *Tudors*-style historical soap opera. In late 2012, Erdoğan publicly condemned *Magnificent Century*, its director and the owners of the TV station for insulting the values and memories of the nation.

These TV dramas narrate a power struggle in a universe riven with conspiracies and characterised by a stark dichotomy of good and evil. This dichotomy consists in Muslim/religious versus non-Muslim/secular, or national versus non-national/universal/Western binaries.[2] The fictional scenarios produce a pseudo-historical background in support of the government's political agenda. This feeds nationalist populism, militarism and Islamic identity politics. Ottoman history functions here as a herald to 'New Turkey's' 'imminent' achievements. The first of these is a claim to leadership of the Muslim world. In this vein, *Mehmetçik: Kut'ül-Amare* aims to provide historical evidence of the great potential inherent in the idea of Muslim unity under Turkish leadership. The series narrates a heroic Ottoman/Turkish victory over a great Christian–European power. In so doing, it evokes images of Muslim solidarity between Ottoman troops, the local Arab population and Muslim soldiers in the British Indian Army.

The perfect symmetry with the government's agenda is not surprising. We need only consider Erdoğan's explicit advice to Turkish youths that they should watch these dramas in order to learn about 'their history'. Indeed, from the beginning of its run, the president enthusiastically embraced *Mehmetçik: Kut'ül-Amâre*. The series was even premiered in the conference hall of his new presidential complex.

The opening episode closes with a scene showing a battalion of Ottoman volunteers reciting a patriotic poem. This poem is known to the Turkish public as 'The Soldier's Prayer'. It was originally written by prominent nationalist Ziya Gökalp (1876–1924) during the Balkan Wars of 1913. The piece places strong emphasis on religion and is therefore very suitable for Islamist–nationalist propaganda. However, the last verse read in the episode was not part of the original poem as composed by Gökalp. It reads:

The minarets our bayonets, the domes our helmets
The mosques are our barracks and the faithful our soldiers
Allah is [the] greatest, Allah is [the] greatest.

These lines originate not from 'The Soldier's Prayer', but from another poem: 'The Holy Army', published by Cevat Örnek (d. 1981) in 1966. Since it was first written, this second poem has been popular within the Islamist milieu.[3] In the 1990s, the two pieces were published together (Bozkurt 1994;

Bardakçı 2002). But for the last twenty years, this patchwork poem has owed its popularity almost entirely to Erdoğan. On 28 February 1997, Erdoğan recited the poem in a public rally in the aftermath of a military memorandum. As a result, he was sentenced to ten months imprisonment (of which he served three months), and he was banned from politics for five years on the charge of inciting religious hatred.

The poem thus enabled Erdoğan to construct an image of himself as a defiant leader victimised by the Kemalist regime for his religious beliefs. He was also present during the gala of the historical drama. After the closing scene, the cameras turned to President Erdoğan, who could be seen wiping tears from his eyes. This is one of the stunning instances of the government's use of historical fiction in order to support its political agenda. Moreover, it constitutes a contribution to the construction of Erdoğan's own cult of personality.

'Remembering the Glorious Victory': Political Instrumentalisation of the First Battle of Kut

The subtitle of this section is lifted directly from the title of an article on the FBoK. The title might lead us to think that we are dealing here with a critical text on the instrumentalisation of history. Nothing could be further from the truth, however. In fact, the article in question aims to show how this history is suitable for supporting the political objectives of 'New Turkey' (Kılıçarslan 2018). We may dismiss a non-academic article published by a young historian in an insignificant nationalist–Islamist periodical. In fact, however, the article perfectly demonstrates the extent to which the instrumentalisation of selective histories has been normalised in Turkey's political and academic milieus.

The history of the FBoK has been instrumentalised in order to convey five principal political messages. Firstly, it serves to produce a historical justification for the Turkish government's foreign policy in the Middle East. During the period of AKP rule, the status quo in the region has been radically transformed. This period has been defined by the 2003 war in Iraq, as well as a wave of revolutions, uprisings and civil wars since 2010. In accordance with the neo-Ottomanist/pan-Islamist aspirations of the AKP elite, Turkish foreign policy has repeatedly stressed the country's religious and historical ties with

the Middle East. In short, Turkey has sought to enlarge its sphere of influence (Yanık 2016; Balta 2018). It was in this foreign policy context that Erdoğan's 'New Turkey' began to 'remember' the FBoK. Ultimately, however, the priority has been to convince the Turkish public that there exists a solid historical basis for the government's foreign policy, cross-border military operations and irredentist aspirations.

Secondly, the history of the FBoK serves as evidence for Turkey's fraternal ties with the Muslim and particularly Arab world. Official Turkish historiography had generally considered the rise of Arab nationalism in the Ottoman lands during the First World War as a betrayal of the Empire (that is, of 'us') (Copeaux 1997, 269–74; Çiçek 2012). The FBoK is used to modify this widely propagated judgement. An exaggerated highlighting of the FBoK in the general history of the war helps to define Muslim solidarity under the Ottoman/Turkish flag as a general Arab tendency. It thus serves to glorify the Pax Ottomana, and to marginalise the rise of Arab nationalism as a Christian–Western plot. To be sure, this narration still condemns Arab nationalism as a betrayal. This time, however, it is Muslim unity that is being betrayed – and still, indirectly, the Turks/Ottomans. Continuity between the 'Old Turkey' and the 'New Turkey' is much more conspicuous here than any kind of rupture. Indeed, this is true of most of the nationalist discourses that comprise the concept of 'New Turkey' (Christofis 2018).

Thirdly, reinvented histories of the FBoK draw exact parallels between the victory of the Turks and the success of Islam. This serves to strengthen the nationalist imaginary with an imperial historical background, and with an imperial neo-Ottomanist/pan-Islamist agenda. It feeds nationalism's need for grandiosity. The following sentence quoted from a popular history book about the FBoK perfectly illustrates the privileged and paternalistic position attributed to Turks among other Muslims:

> The people of the Middle East stood by us in Gallipoli while we were united against the Western world, just like we stood by them while we were defending our motherland. (Bilgi 2018, 196)

Fourthly, the government has rediscovered the FBoK in the context of a deterioration in the Kurdish–Turkish peace process. In this conflict, there has been a marked return to military methods. In the wake of the general election

of June 2015, the government has stigmatised any objection to the military operations as a national betrayal. It has drawn on a range of discursive tactics in order to silence any public reaction against the high casualties that have resulted from the radical turn towards a more hawkish policy. A major role has been played here by the glorification of militarism and martyrdom with religious and nationalist motives. In such a political climate, the FBoK has been instrumentalised in order to foster the cult of martyrdom and a spirit of popular militarism.

Fifthly, and finally, the AKP's turn towards ultra-nationalistic politics has also influenced the construction of a popular historical narrative of the last twenty years of the Ottoman Empire. In this narrative, the key difference has been accorded to the Committee of Union and Progress (CUP). Until 2014–15, leading figures in the party and the pro-AKP media largely condemned the Unionists for dethroning Abdülhamid II. As Edhem Eldem (2018) has suggested, the 'Hamidophilia' of the Islamist–conservative milieus was largely transformed into a 'Hamidomania' under AKP rule. This began to change with the AKP's turn toward a more hawkish brand of politics, however. The government now shows a willingness to embrace the CUP's legacy by highlighting its militarist, Turanist, pan-Islamist aspirations, as well as its devoted nationalism (Bora 2018). The rediscovery of the FBoK and the glorification of its Unionist commandants Süleyman Askerî and Halil Paşa as national heroes have been key aspects of this process. And yet recent histories of the FBoK have not diminished the tone of 'Hamidomania'. On the contrary, they have persisted in redundantly referring to Abülhamid II while narrating 'the glorious heroic victory' at Kut, which actually occurred seven years after his dethronement.

The ideological abuse of 'the glorious victory' is also clearly apparent in the speeches of various AKP protagonists and in pro-government publications. Indeed, several actors who participate enthusiastically in the formation of new histories make no secret of the fact that their principal motive lies in the necessities of the current political context. The president himself invoked these political messages in his speech during the centenary commemoration of the FBoK.[4] In other words, no one and nothing is being 'exposed' through this denouncement of the extremely selective nature of historiography in 'New Turkey'. It is being openly practised.

Instead, the following questions seem worth asking. First, how is it possible that history still holds a crucial legitimising role in Turkish politics, given that the instrumentalisation of the past is so obvious and normalised? Second, what mechanisms inure or render the public indifferent to these flagrant manipulations – and even fabrications – of the past?

Historical Fabrication and Legitimacy

During the period when the FBoK was implanted in the national memory, the AKP had already established control over broad sections of the Turkish media. State-owned radio and television broadcaster TRT had been transformed into a party media organ, while private broadcasters had been sold off to companies with strong ties to the ruling party. The AKP thus encounters little difficulty in radically modifying existing narrations about the recent and distant past. Well-known historical facts are easily distorted or dismissed, even if an obvious historical fabrication is being perpetrated.

For instance, during a talk broadcast live in October 2018, Erdoğan displayed a photo of İsmet İnönü (1884–1973), a former leader of Turkey's main opposition party, proudly holding an American flag. In this way, Erdoğan implicitly condemned Turkey's main opposition party as treasonous. But the photo was actually taken during the visit of the US Vice-President in 1962. İnönü was holding the flag as a gesture of hospitality. Moreover, it is visible in the photo held by Erdoğan that İnönü was actually holding two flag sticks in his hand. Several other photos taken during the same event clearly show that this second stick was emblazoned with a Turkish flag.

Within minutes of the conclusion of Erdoğan's speech, these other, more revealing photos, as well as abundant information about the context in which they were taken, were available on social media and dissident news portals. It is more than probable that the president and his advisers envisaged how quickly and readily the truth on this specific historical document would come to light. And yet they did not consider this to be a relevant risk. Erdoğan and his government subsequently did not even bother to respond to the criticism that they were manipulating the past for political purposes.

This nonchalance with respect to the construction and use of historical falsehoods is a decisive characteristic of the AKP's politics of history. It is partly related to the party's control over the state and the media. To be sure,

the trivialisation of the distinction between historical facts and distortions is not a phenomenon peculiar to 'New Turkey'. History has long been a tool for inventing traditions and national symbols based on selective historical facts, factoids and myths (Hobsbawm and Ranger 1983; Anderson 1983). The political history of the twentieth century is full of falsifications deliberately propagated by governments, especially under totalitarian regimes. Furthermore, as Hannah Arendt pointed out: '[N]o one has ever doubted that truth and politics are on rather bad terms with each other and no one . . . has ever counted truthfulness among the political virtues' (2006 [1968], 223).

But even with this in mind, can we still consider the prevalence of the concept of post-truth to be an indicator of a new framework for the relationship between politics and truth? Myriam Revault-d'Allonnes, in her recent book *The Weakness of Truth* (2018), attempts to define the special characteristics of the 'age of post-truth'. She first points out that the prefix 'post' does not imply that this *comes after* an era of impeccably truth-based politics. But still, according to Revault-d'Allonnes, the erosion of the status and legitimacy of truth in politics is the main characteristic of the current historical era.

To be sure, in the past, totalitarian regimes systematically replaced reality with a set of false but coherent ideas. But the main distinction of the 'post-truth' era is the generalised relativism which blurs the line between facts and opinions. Consequently, the post-truth era gives rise to 'a policy that makes the truth itself inessential or meaningless, a policy that delegitimises the value of the truth' (Revault-d'Allonnes 2018, 13–16, 23). It thus renders unnecessary the distinction between true and false. However, this nuance does not mean that the 'post-truth' experience is completely distinct from the experience of totalitarianism. Indeed, the commonalities seem particularly pertinent in the light of the rise of populist authoritarian politicians. Like their totalitarian forbearers, these regimes also aim to silence their opponents and to hijack the truth.

With respect to this apparent popular indifference to historical falsehood, I would suggest that a key determining factor is the dominant manner in which time itself is experienced. To borrow the words of François Hartog, we are 'living in a world governed solely by an omnipresent and omnipotent present, in which immediacy alone has value' (2015, xvii). This is the condition that Hartog calls 'presentism'. It has become particularly prevalent since

the end of the Cold War. This 'presentist' mode of perception and experience of time is characterised by the supremacy of the present over two other temporal categories – namely, the past and future. In a presentist regime of historicity, the present constitutes the only possible horizon of our universe. Conversely, the future is no longer perceived as a time of utopia, but rather of imminent danger. The past, meanwhile, is transformed by the supremacy of the present into a form of memory 'in furtherance of the present's immediate self-historicisation' (Hartog 2015, 124). Hartog explores multiple reasons for 'this increasingly distended and bloated "now"'. Three of these are directly related to political change. First, the globalisation of the market economy imbues life with a rapid rhythm and an orientation toward 'real time' (Hartog 2015, 6). In Enzo Traverso's words, this time of neo-liberalism is 'a time of permanent acceleration . . . without a "prognostic structure"' under 'the dictatorship of the stock-exchange' (2016, 8). Secondly, the expansion of consumer society transforms time itself into 'a consumer product'. Finally, opinion polls as a strategic political tool are able to produce and manage popular judgements about the past and future 'without moving an inch from the present' (Hartog 2015, 6, 123, 115).

Two further important factors in the maintenance of presentism are media and the rapidly developing communication technologies. On the one hand, the capacity of 'produc[ing], consum[ing]and recycl[ing] an increasing number of images and words in an ever shorter time' (Hartog 2015, 113) compresses the longer periods of the past into mere minutes.[5] On the other hand, the accelerated rhythm of communication details and enlarges the present yet further. Consequently, as stated by Hartog, this invasive and immense present 'daily fabricates the past and future it requires, while privileging the immediate' (2015, 113, 185).

In the context of such a regime of historicity, the main concern of politics is not the facts of the past, but the opinions and judgements which are propagated with respect to it. It is politically useless to make a distinction between historical facts and fabrications, provided that either or both can successfully carry the message which is supposed to orient already existing opinions, beliefs and emotions according to present requirements. Politics thus adapts its rhythm to the tyranny of the immediate and strengthens it further (Hartog 2015, xiv). This prioritising of the immediate is certainly not

specific to political power, and is certainly not restricted to Turkey. However, given its extended propaganda capacities and control over the state, the AKP has an upper hand in directing public opinion. It has significant scope to choose or merely invent facts for new histories in accordance with its changing needs in the present.

On the other hand, this dominance of the present and its political agenda over the historical past is not limitless. Of course, history is always open to reformulation, and our invasive present seems to be more presentist than ever before. However, the past still remains as an essential temporal reference which has the capacity to corroborate and even to justify current political discourses and decisions. Any historical narration and investigation is an inevitable product of interwoven elements derived from three major temporal positions: the time of the target-event; the present in which the historical narration is written/shaped; and the intervening past – that is, the events which fall between the target-event and the present (Ricœur 2000, 453).

This third temporal position is also the period during which the opinions, beliefs, clichéd interpretations, judgements and emotions concerning the targeted historical fact or period develop. For the political instrumentalisation of history, this elapsed, intervening past is arguably even more important than the actual target-event itself. After all, the major aim of politics is to influence and reorient the opinions and emotions developed between the time of the target-event and the present. That explains, at least partially, how history can still be a useful source of legitimacy for politics. It also helps to explain why, from a political point of view, the distinction between historical facts and fabrications is largely meaningless. In other words, what makes history indispensable for politics in our presentist context are the pivotal memories, related opinions and emotions which carry the past into the present.

Accordingly, in lieu of a conclusion, I shall point out the main characteristics that the new history of the FBoK has adopted from the elapsed past.

In Lieu of a Conclusion: The Past of the New Histories

Until 2016, the history of the FBoK was largely unknown to the public. Since then, however, it has become very familiar. This newly reinvented history and the patriotic emotions it gives rise to are in perfect harmony with several universal clichés about the nature of national myths. It is capable of

remobilising established feelings and judgements in Turkish public opinion according to the needs of the current political agenda.

The reinvented narration of the FBoK is based on a schema of heroic national history. Firstly, it strengthens the nation's sense of uniqueness, the belief in the nation's historical–world mission and the assumed presence of eternal external enemies (Bouchard 2013, 277). It is essentially about a victory won against a superior army, thanks to sacrifices made on the basis of patriotic feelings and religious beliefs. These clichés serve to underline the priority given to the survival of the nation above any political principles or socio-economic issues. It also feeds nationalism through the sentiments of pride and revenge; two emotions which are indispensable for any nationalist historiography aiming to tap into the public spirit. After all, 'revenge/vengefulness' is a particularly strong general characteristic of the neo-Ottomanist policies of the AKP (Tokdoğan 2018; Yılmaz 2017).

Even the unintended emotional outcomes of the FBoK are very familiar. Like many other heroic national histories, the reinvented history of the FBoK interweaves with an acute inferiority complex. In order to demonstrate the historical and ontological superiority of the Turks, this narrative unwittingly emphasises the greatness of the enemy (the Britain), the invincibility of its army and the rarity of such a defeat in the enemy's history (Güneş 2017; Özdamarlar 1978; Bilgin 2018).

The harmony of such a narrative with the feelings and judgements inherent to Turkish public opinion is widely related to a growing interest in Ottoman history. This has been visible since the 1950s. It first developed among the Islamist and nationalist milieus (Çetinsaya 2003). In the 1960s, it began to gain a certain official importance. This was largely due to the propagation of an ideology of Turkish–Islamic synthesis, which was in keeping with the anti-communist priorities of the state. Since then, eulogies to the Ottoman legacy have gained an increasing influence in the political and cultural sphere. In the 1960s and 1970s, an explosion of popular cultural products, especially movies on Ottoman/Turkish history, enabled the masses to imbibe the clichés and slogans of this ideology. Finally, the coup d'état of 1980 contributed to this process by fixing the official interpretation of Kemalism up to the Turkish–Islamic synthesis (Copeaux 1997, 75–101; Çetinsaya 1999; Aytürk 2014; Tokdoğan 2018, 49–94).

In the 1980s, towards the end of the Cold War, Turkey was able to grasp the opportunity to assume the status of regional power. At this time, eulogies to the Ottoman legacy and the Islamic character of Turkish national identity began to acquire a new political utility. They thus found more echoes in the political sphere, in textbooks and popular culture (Çetinsaya 2003; Yavuz 2016; Ongur 2015). This has been reflected in heroic narrations of the glorious Ottoman past, and in the growing ubiquity of Ottoman power symbols (such as the Ottoman coat of arms, maps, the *tuğras* of the sultans and so on). Together, these have served to feed the irredentist–expansionist imagination, as well as the imperial ambitions of Turkish nationalism.

From the 1990s, the Ottoman Empire has also been perceived as an idealised historical model of a pluralistic society. This interpretation has been especially marked among liberal public intellectuals in their critiques of the nation state. Through the glorification of the Pax Ottomana, the AKP's neo-Ottomanist project has managed to incorporate the ideal of diversity and appeal to the liberal critics of the Kemalist nation state, while simultaneously feeding the nationalist imagination through an illusion of Turkish–Islamic imperial sovereignty. The idea of Pax Ottomana has also helped to extend the notion of homeland beyond the borders of the nation state, to relate all associated patriotic–nationalist emotions to the large territory of the Ottoman Empire and to defend Muslim unity as a national project. In the same way, the history of the FBoK aims to provide an historical justification for the necessity of Muslim unity and Turkish–Islamic sovereignty, while continuing to feed the belief in national superiority.

The history of the FBoK certainly belongs to the AKP's historiographical attempt to create a rupture and reinvent a new state tradition (Christofis 2018). When selected and recalled in the 'New Turkey', this battle is reinvented according to the requirements of the AKP's political agenda. And yet this new history is not only about the past of the target-event, nor is it entirely a product of present political concerns. It follows and revises the official Turkish nationalist historical schema. Since the 1950s, the rise of Turkish–Islamic ideology has resulted in this schema becoming progressively modified.

The emotions, ideas and judgements developed and preconceived between the time of the target-event and the present are deeply inscribed in the reinvented narration of the battle. These are, indeed, the most indispensable

historical references, even more so than the 'raw material' of the target-event itself. Their strong presence in the reinvented narrations helps to completely trivialise the issue of historical accuracy and reorient the past of the target-event according to the political needs of the present. This is the main characteristic of the process which has transformed the FBoK, an important but not decisive Turkish victory from the First World War, into one of the crucial events in the national history.

Notes

1. *Little Mehmet: The Battle of Kut*. Mehmetçik is the Turkish equivalent of 'digger' or 'tommy'.
2. This schema is not peculiar to the TRT's historical dramas. It, in fact, determines the everyday allegoric renderings of melodramas on Turkish television (Sirman and Akınerdem 2019).
3. The verse was quoted in the brochure prepared for the staging of a late Ottoman patriotic play (*Ya Şehid Ya Gazi*) by the students of the Istanbul religious vocational high school in 1967. Three years later, an Islamist–nationalist publishing house republished the script of the play, together with the aforementioned brochure. The annex of the book demonstrates that the same verse was also quoted in several laudatory news articles, which appeared in the Islamist–conservative press about the staging of this play ([Manastırlı] Mehmet Rifat 1970, 6, 46, 53, 60, 68).
4. Interestingly enough, a large part of this talk is included verbatim in a popular history book on the FBoK without mentioning and citing Erdoğan, as if they were the author's own words (Bilgi 2018, 200–5).

Bibliography

Anderson, Benedict. *Imagined Communities*. London and New York: Verso, 1983.
Arendt, Hannah. 'Truth and Politics'. In *Between Past and Future*. New York and Toronto: Penguin Books, 2006 [1968].
Aytürk, İlker. 'Nationalism and Islam in Cold War Turkey 1944–69'. In *Middle Eastern Studies*, vol. 50, no. 5 (2014): 693–719.
Balta, Evren. 'AKP's Foreign Policy as Populist Governance'. In *Middle East Report*, vol. 288 (Fall 2018): 14–18.
Bardakçı, Murat. 'Erdoğan'ı yakan mısralar Örnek'in'. In *Hürriyet*, 23 September 2002.
Bilgi, Zafer. *Kut'ül Amare*. Istanbul: Mihrabad, 2018.

Bilgin, İsmail. *Kûtü'l Amâre: Osmanlının Son Tokadı.* Istanbul: Timaş, 2018.

Bora, Tanıl. 'Ebed-Müdded İttihatçılık'. In *Birikim Güncel,* 7 November 2018, www.birikimdergisi.com/haftalik/9184/ebed-mudded-ittihatcilik (last accessed 5 May 2021).

Bouchard, Gérard. 'National Myths: An Overview'. In *National Myths, Constructed Past Contested Presents,* edited by Gérard Bouchard, 276–97. London and New York: Routledge, 2013.

Bozkurt, Ömer Naci. *Türk ve Türklük.* Ankara: TSE, 1994.

Christofis, Nikos. 'The AKP's "Yeni Turkiye": Challenging the Kemalist Narrative?' In *Mediterranean Quarterly,* vol. 29, no. 3 (2018): 11–32.

Copeaux, Étienne. *Espaces et temps de la nation turque.* Paris: CNRS, 1997.

Çetinsaya, Gökhan. 'Rethinking Nationalism and Islam'. In *The Muslim World,* vol. 89, no. 3–4 (1999): 350–75.

Çetinsaya, Gökhan. 'Cumhuriyet Turkiye'sinde "Osmanlıcılık"'. In *Modern Türkiye'de Siyasi Düşünce: Muhafazakarlık,* edited by Ahmet Çiğdem, 361–80. Istanbul: İletişim, 2003.

Çiçek, Talha. 'Erken Cumhuriyet Dönemi Ders Kitapları Çerçevesinde Türk Ulus Kimliği İnşası ve "Arap İhaneti"'. In *Dîvân,* vol. 17, no. 32 (2012): 169–88.

Eldem, Edhem. 'Sultan Abdülhamid II: Founding Father of the Turkish State?' In *Journal of the Ottoman and Turkish Studies Association,* vol. 5, no. 2 (2018): 25–46.

Erickson, Edward J. *Ottoman Army Effectiveness in World War I.* London and New York: Routledge, 1978.

Güneş, Mehmet. *Kûtü'l-Amâre Zaferi.* Ankara: Akçağ, 2017.

Hartog, François. *Regimes of Historicity.* New York: Columbia University Press, 2015.

Hobsbawm, Eric and Terence Ranger, eds. *The Invention of Tradition.* Cambridge: Cambridge University Press, 1983.

Kılıçarslan, Hacer. 'Tarihin Keşfi Yahut İnşası: Şanlı ve Kullanışlı Kûtü'l Amâre Savaşını Hatırlamak'. In *Sungur Türk Fikir Mecmuası,* vol. 4 (2018): 9–12.

Koselleck, Reinhart. *Futures Past,* translated by Keith Tribe. New York: Columbia University Press, 2004.

Morris, Jan. *Farewell the Trumpets.* London: Faber and Faber, 1978.

Ongur, Hakan Övünç. 'Identifying Ottomanisms'. In *Middle Eastern Studies,* vol. 51, no. 3 (2015): 416–32.

Özdamarlar, Metin. *Kûtü'l Amâre.* Istanbul: Eğlenceli Bilgi, 1978.

Revault d'Allonnes, Myriam. *La Faiblesse du Vrai.* Paris: Seuil, 2018.

Ricœur, Paul. *Mémoire, histoire, oubli.* Paris: Seuil, 2000.

Rifat, [Manastırlı] Mehmet. *Ya Şehid Ya Gazi*. Istanbul: Yağmur, 1970.

Sirman, Nükhet and Feyza Akınerdem. 'From Seekers of Truth to Masters of Power: Televised Stories in a Post-Truth World'. In *The South Atlantic Quarterly*, vol. 118, no. 1 (Jan. 2019): 129–44.

Tokdoğan, Nagehan. *Yeni Osmanlıcılık*. Istanbul: İletişim, 2018.

Traverso, Enzo. *Left-Wing Melancholia*. New York: Columbia University Press, 2016.

Yanık, Lerna K. 'Bringing the Empire Back In: The Gradual Discovery of the Ottoman Empire in Turkish Foreign Policy'. In *Die Welt des Islams*, vol. 56, no. 3–4 (2016): 466–88.

Yavuz, M. Hakan 'Social and Intellectual Origins of Neo-Ottomanism'. In *Die Welt des Islams*, vol. 56, no. 3–4 (2016): 438–65.

Yılmaz, Zafer. 'The AKP and the Spirit of the "New" Turkey'. In *Turkish Studies*, vol. 18, no. 3 (2017): 482–513.

12

BETWEEN INVENTION AND AUTHENTICITY: REPRESENTATIONS OF ABDÜLHAMID II IN THE TV SERIES *PAYITAHT*

Caner Tekin

This is the war between God and superstition, and the victory of superstition never existed. Let the war begin.
　　　– Abdülhamid, having seen a British-designed map partitioning the
　　　　　　　　　　Ottoman Empire (*Payitaht*, Season 1, Episode 1)

Over the past decade, the government of Turkey has gradually popular-ised a specific historical narrative. According to this narrative, Ottoman (that is, Turkish) conservative elites have been battling 'internal and external enemies' in order to defend 'Turkish–Islamic civilisation' throughout history. This narrative concludes with the emergence of the Justice and Development Party (AKP) led by Recep Tayyip Erdoğan as the final (and ultimate) defender of Islam and the Turkish nation. The AKP thus takes its place within a cel-ebrated genealogy of historical predecessors. The government, in its attempts to promote and popularise this historical narrative, has relied extensively on popular culture and more specifically on television series.

This chapter discusses how representations in the popular TV drama series *Payitaht: Abdülhamid* are instrumentalised in order to make an implicit connection between the historical travails of Sultan Abdülhamid II and the present-day challenges facing President Erdoğan.[1] This connection, it is argued here, has been intentionally constructed. It reflects changing representations of Sultan Abdülhamid II in educational materials (history curricula and textbooks) during the AKP era. The chapter then turns to

how the state-commissioned TV drama series follows the official narrative on Abdülhamid as outlined in school textbooks and curricula. However, the series goes further by actively fabricating certain aspects of history, including, for instance, the sultan's encounters with British ambassadors, the nascent Zionist movement and members of the reformist Committee for Union and Progress (CUP).

From 'Red Sultan' to 'Glorious Saviour': The Mythical Metamorphosis of Abdülhamid II

Biographical accounts of Abdülhamid's life and reign as the 34th sultan of the Ottoman Empire have been controversial and subject to manipulation by numerous political groups. The Sultan famously ruled with absolute power from his Yıldız Palace, but he also promulgated two versions of the first Ottoman Constitution, one at the beginning and one at the end of his era. He systematically used his Caliph title in international diplomacy. Moreover, in the face of losing vast territories in the Balkans and North Africa, he instrumentalised Islam as the common foundation of Ottoman society in an attempt to prevent the secession of the Empire's remaining minorities.

Owing to his iron rule and his secret police, as well as conflicts with secessionist minorities in the Balkans, Western media and literature have generally depicted Abdülhamid as an infamous figure. He has been referred to as the 'Red Sultan' due to the massacres of Armenian and Assyrian Christians under his rule (Ward et al. 1910, 418). In 1908, he re-enacted the constitution under immense pressure from the CUP, a constitutional–Republican political group organised within parts of the civil and military bureaucracy. The following year, however, he was overthrown by the same group in response to loyalist riots.

In modern Turkish historiography, Abdülhamid's reign signifies the tension between conservative, Islamist and secular interpretations of national history and identity. During the first years of the Turkish Republic, secular historians created an image of a disintegrating Ottoman Empire and held the last sultans responsible for its eventual collapse. Abdülhamid was perhaps the principal bogeyman in this version of late Ottoman history. He was extensively demonised and, indeed, ridiculed. For instance, the first history book for secondary education published by the Turkish History Society in

1931 held the Sultan and his regime directly responsible for the rapid disintegration of the Empire. This textbook, which was the standard history textbook in Turkish high school education for a period of ten years, portrayed Abdülhamid as 'arbitrary, unsuccessful, inglorious and boring', while its 1966 edition described him as 'an anxious coward' (Türk Tarihi Tetkik Cemiyeti 1931; Oktay 1966).

Over time, such flagrant denunciations receded. Nonetheless, up until 2015, school textbooks almost always linked him to the keyword *istibdad* or autocracy, in reference to his tyrannical rule. From the annulment of the constitution until its re-enactment, the Sultan exerted an iron grip over politics and society. Fearful of losing power and of further territorial losses, Abdülhamid employed a vast secret police network, and his regime was commonly referred to as *istibdad*.

The history textbook of 1966 depicts the Sultan's regime with the following words: 'his rule of *istibdat* continued for 33 years. During this period, the intellectuals who aspired to set the country free of his autocracy and cruelty began to work together secretly to establish the parliamentarian monarchy once again' (Oktay 1966, 239–40). The word *istibdat* was used a final time in the official Ministry of Education textbook between the years of 2012 and 2016. This included special references to a number of keywords that were banned in the written press under Abdülhamid: '*İhtilal* (revolution), *istibdat* (autocracy), *inkilap* (reform), *oligarşi* (oligarchy), *cumhur* (halk), *cumhuriyet* (republic), *demokrasi* (democracy), *demokrat* (democrat), *diktator* (dictator), *sansür* (censor), *avam* (people), *meclis-i ayan* (senate), *meclis-i umumi* (parliament), *mutlakiyet* (absolute regime)' (Turan et al. 2014, 184).

Strikingly, however, textbooks published after 2016 discarded all critical references to Abdülhamid's autocracy (Tüysüz 2017; Okur et al. 2016). Instead, there is abundant mention of his contributions to Ottoman modernisation, the foundation of state-established schools and his attempt to start a welfare state with social aid institutions and a retirement system. Although the new educational materials rightfully refer to Abdülhamid's pioneering role in the modernisation of the Ottoman state, the conspicuous removal of criticism regarding the *istibdad* regime is entirely new and warrants further attention.

The official practice of glorifying Abdülhamid II has its antecedent in the publications of Necip Fazıl Kısakürek (1904–83), a seminal poet and

author who was influential amongst Turkey's conservative public. President Erdoğan, who personally met Necip Fazıl in his youth, admits the poet's influence over his ideology and view of Turkish history. Kısakürek was one of the first authors to reinterpret Abdülhamid as a hero fighting for the salvation of Islamic civilisation against the Young Turk movement, which was allegedly controlled by British and Jewish Freemasonry. Kısakürek ended his book *Great Khan Sultan Abdülhamid II* (2014, 644) with these words:

> The crucial personality of Turkish history and (the key to understanding) the mystery of pseudo reforms, the victim of the rootless movement controlled by Jews and Young Turks, Great Khan Sultan Abdülhamid awaits, (lying) next to his grandfather Mahmud II, generations that will solve this mystery. Understanding Abdülhamid means understanding everything.

It is worth noting that the producers of *Payitaht* use the last sentence in this paragraph on the official Twitter page of the series, making an explicit and intentional connection to Necip Fazıl Kısakürek.

Commentators in the pro-government mass media have been quick to seize upon the parallels between Abdülhamid and President Recep Tayyip Erdoğan. They have focused particularly on their respective power struggles with sections of the civil and military bureaucracy. Burhanettin Duran, for example, wrote in the *Daily Sabah* that both leaders strived for order and faced fundamentally similar challenges. Abdülhamid II was fighting to 'keep the Ottoman Empire in one piece at a time when the great powers were fighting over world domination'. He thus had no choice but to suspend the Kanun-i Esasi, the first constitution in Ottoman history, and modernise the country along authoritarian lines. Duran contends that, a century later, the president of Turkey is dedicated to a similar cause:

> Erdoğan, in turn, consolidated his power through democratic elections and spends most of his time dealing with the challenges presented by a troublesome neighbourhood, where the post-World War I order is disintegrating and national borders are shifting . . . Luckily, the July 15 resistance made it clear that Erdoğan, unlike Abdülhamid, isn't fighting the good fight by himself. (Duran 2016)

Duran argues that the current conflicts in the Middle East are a continuation of those which began during the time of Sultan Abdülhamid. These conflicts,

Duran argues, place the survival of the Turkish state in jeopardy. The president is thus called upon to enact radical measures, much like Abdülhamid a century ago. For Duran, the civil resistance mounted against the coup attempt on 15 July 2016 signifies popular support for Erdoğan. This was not afforded to Abdülhamid when he was deposed from power in 1909. The president himself asked his supporters during an election campaign if they were following *Payitaht* and added: '[T]o know your history, watch *Payitaht* . . . Foreign enemies are still looking for concessions (from our land)' (Yeni Şafak Staff 2018, 11). Moreover, a well-known motto voiced by the popular media and the AKP supporters is: '[W]e will never abandon you to the solitude of Abdülhamid'. This signifies the belief that Erdoğan and the erstwhile Sultan share a common struggle (Alanoğlu 2016).

Abdülhamid's portrayals thus loom large over contemporary depictions of Erdoğan. This is partly because the politicised history narrative detailed above inevitably creates parallels between the enemies that both leaders are confronted by. In other words, glorifications of Abdülhamid II serve not only to deconstruct earlier Republican historical narratives; they also furnish the political propaganda necessary in order to legitimise 'New Turkey's' authoritarianism.

Allegorical Enemies of the Last Emperor

Analysing a drama series that is full of political symbolism, as in the case of *Payitaht*, calls for a semiotic approach. Roland Barthes famously pointed to the ruling class's ideological abuse of modern-day myths for the purpose of manipulating public opinion (see the introductory chapter of this volume). According to Barthes, symbols can hold both denotative ('literal') and connotative ('abstract') meanings. Connotative meanings are frequently used to infuse 'ordinary' symbols with political messages. From a Barthean perspective, *Payitaht* can be conceptualised as a modern-day myth that aims to persuade the Turkish public into accepting Recep Tayyip Erdoğan's rule.

A dominant feature of the series is its reliance on allegory in order to allude to current political events in Turkey. Enemies portrayed in the series frequently have some sort of a connection to imagined or real opponents of the AKP. In the series, the internal and external foes of Abdülhamid II include sections of the civil and military bureaucracy associated with the Young Turk movement, as well as members of the Zionist movement and

the Freemasonry. However, although Russian aggression against the Ottoman Empire posed a near-constant threat during Abdülhamid's era, Russia is hardly mentioned throughout the series. This might be attributed to contemporary policies of de-escalation between Turkey and Russia. Instead, the point of having allegorical enemies in the series is to justify the need for a permanent state of vigilance, and the necessity of autocratic rule in order to hold society together. Given the nature of the enemies faced by the Sultan in the television series, *istibdad* thus appears justified.

In the series, the foremost threat stems from Britain's aspirations to dominate the territories ruled by the Ottoman Empire. At the beginning of Abdülhamid's reign, the Ottoman Empire's relationship with Britain changed from strategic alliance to rivalry. Britain annexed Cyprus in 1875 and allowed for large parts of Ottoman territory to secede from the Empire after the 1877–8 war between Russia and the Ottomans. These strained relations provide the historical backdrop to the storyline of *Payitaht*. In the series, the British aim to create a 'New World Order' centred on Jerusalem and based on the hegemony of financial elites and Freemasons (Episode 4 and 17). In Episode 17, the Sultan states that only he and the Ottoman nation have the strength to foil these plans.

This purported New World Order is used to describe an amalgamation of different factions and interests. These include former Ottoman territories annexed by European powers, the hegemony of bankers over the disintegrating Ottoman Empire and the Zionist state of Israel. As the Empire's archnemesis, Britain backs this New World Order with its diplomacy and spies. The latter include Gertrude Bell, who works to mobilise the Ottoman Empire's Arab population against the Sultan, and Sara Hedaya, who collaborates with members of the World Zionist Congress.

Alongside the British, the Sultan is also confronted by the Zionist movement and the Freemasons. These shadowy groups seek to establish a Jewish state within the Ottoman territories, and they are key actors in the above-mentioned New World Order. Two characters appear to be particularly significant in the series. One is Theodor Herzl, the first president of the World Zionist Congress and a key ideologue of the Jewish state in Jerusalem. He joins forces with the enemies of Abdülhamid and with British intelligence. In the third episode of the series, the first World Zionist Congress convenes

under Herzl's leadership. In response to Sara Hedaya's insistence that Jewish territories be defined once and for all, Herzl draws the Star of David and adds two stripes symbolising the Nile and Euphrates. After this meeting, a plot to overthrow the Sultan is hatched between Herzl, the British ambassador to Istanbul and some within Abdülhamid's own inner circle. Ultimately, it is Abdülhamid's status as the Caliph which makes him the number one opponent of the Zionist drive to establish a Jewish state.

The other key antagonist in the series is Parvus Efendi, an arms dealer and Freemason working for the New World Order. In the 18th episode, Efendi visits the Vatican and insists to the Pope that only he can defeat Abdülhamid. Yet in the 48th episode, the Sultan vanquishes Parvus. Before sending the arms dealer to his death, Abdülhamid states that: 'We believe in God. You cannot buy us with money'.

The conspiratorial partnership between members of the World Zionist Congress, Freemasons, British spies, Ottoman diplomats and some members of the Ottoman royal family to overthrow the Sultan bears an uncanny resemblance to the 'FETÖ/PDY organisation'. Turkey's current government holds this organisation responsible for the 15 July coup attempt. Such parallels are evident in, for example, Episode 2, which depicts an attempt on Abdülhamid's life. During this attempt, the soldiers involved communicate by using a coin engraved with the Star of David. This is a direct allusion to the one dollar banknotes which members of the FETÖ/PDY organisation supposedly used to exchange information prior to their own alleged coup.

In the series, this coin was found on Hiram, an assassin working for Mahmud Pasha, as well as Theodor Herzl and the Vatican. In Episode 18, Parvus Efendi throws the same coin in front of the Pope before asking him to pledge himself to the New World Order. As the Star of David is a symbol associated with Jewry, the coin connotes a connection between Semitism, the FETÖ/PDY organisation and the conspiratorial network plotting against the Sultan. In the 48th episode, in an event which parallels recent political developments, the shadowy network attempts a coup. They do so after members of the Masonry, Parvus Efendi, Emannuel Karasu and Prince Sabahaddin, are foiled in their attempt to depose the Sultan, due to support from the public and the Ottoman Army.

Despite their failure, however, members of the Zionist movement and British intelligence are more effective at manipulating the attitudes of young bureaucrats and liberal journalists. Ultimately, then, the series chooses to portray reformist, anti-monarchist sentiment within the Ottoman Empire as the result of foreign manipulation. In Episode 5, for instance, a journalist allegedly shot by the secret police seeks refuge in Herzl's house and writes a tirade against Abdülhamid, who he refers to as the 'Red Sultan'. Later, it is revealed that he was in fact shot by Abdülhamid's rivals, who were seeking to provoke street protests against the monarchy. When the article is published, university students gather outside Yıldız Palace chanting 'liberty will come, the Sultan will go'. In this scene, however, Abdülhamid appears personally to make a rousing speech, which concludes with the following words:

> They want to use unrest (on the streets) to end our 600-year state. . . . Do not forget, if any of these four principles comes apart, the state comes apart: the religion of Islam, *Hanedani Saltanati seniyye* (the dynasty of the Ottoman Empire), the government of Turkey, the *Payitaht* of Istanbul.

'The Last Emperor is New Turkey's First Leader'

In the television series *Payitaht*, the character of Abdülhamid bears striking affinities with President Erdoğan's perceived personality. For example, a key element of Abdülhamid's character is his Muslim identity. To be sure, some biographies portray Abdülhamid as a devout Muslim who prayed five times a day (Sırma 2006; Osmanoğlu 2009) and used his status as Caliph to prevent Arabs from engaging in British-promoted secessionist movements. However, the series greatly exaggerate these aspects of his character. The Sultan is presented as a sworn fighter for the unity and prosperity of Islamic lands and societies. He constitutes a pragmatic juxtaposition between the Turkish nation and the territories dominated by the Islamic faith. The series represents Abdülhamid and the Ottoman government in Istanbul as responsible for the entire Ummah. Abdülhamid almost always reminds the audience of his dedication to Islam and the connection between his deeds and Islamic doctrine. In Episodes 29, 42 and 60, he repeatedly claims that Istanbul is the city of Islam and that the Ottomans are the defenders and leaders of Islamic civilisation.

A key metaphor used numerous times to build an association between Islam and Istanbul is Hagia Sophia. As the well-known story goes, upon seizing

the city, Mehmet the Conqueror turned the Byzantine cathedral into a mosque. In 1934, this mosque was converted into a secular museum by Republican authorities. But this conversion proved controversial. In recent years, the pro-government press has called for the Hagia Sophia to be turned back into a mosque. The claim is made that the museum symbolises the defeat and retreat of Islam in the face of its enemies. *Payitaht* repeatedly alludes to this claim. In Episode 10, for example, there is an attempt by the Orthodox minority to erect a cross in Hagia Sophia, which the Sultan personally prevents. When asked why he had to fight off the Christians without the help of the Ottoman Army, the Sultan replies that

> the state, nation and the Muslims own the mosque . . . it is the Sultan's duty to defend it. If the crescent's shadow disappears from Hagia Sophia and this nation puts no effort to re-establish it, woe to this nation.

The series thus implies a fundamental unity between Islamic communities on Ottoman territory and constructs a 'City of God' that is continuously under attack by Western powers. The final and opening scenes of Episodes 10 and 11, when Abdülhamid beats back the Christians in Hagia Sophia, are intended to emphasise the Islamic character of the Ottoman realm and nation. At this point, it is useful to introduce the second key aspect of Abdülhamid's personality: his unwavering commitment to the Turkish nation. In the series, he continuously refers to the 'nation' as one harmonious community of Islam. But he also refers to the Turkish nation in order to justify the ethnic aspect of the Ottoman family and state. In the 24th episode, he contends that any offence against his person is, in fact, a crime carried out against 'the state, the Turkish people and the Caliph'. In Episode 42, he accuses a British diplomat of escalating conflicts in Syria, and warns that: 'if you dare to divide Turks and Arabs, tomorrow they will unite to topple you . . . Turkey is a fire and this one flame is enough to set the world alight'. As well as praising Turkish ethnicity, the Sultan also asserts the natural unity between Turkish and Arabic societies and the Turks' responsibility in Syria. This, of course, directly parallels Turkey's involvement in the present-day civil war unfolding in Syria.

The third most notable feature of the Sultan's personality in the television series is his use of his mind to outwit the enemies of the realm. Sultan Abdülhamid II is portrayed as a bold and crafty leader who dedicated his

life and sultanate to the salvation of the Ottoman state and Islam in the face of Western imperialism. This aspect of the Sultan's character seems to be mostly fabricated in an attempt to depict him as a lone sentinel against British imperialism. In Episode 12, for example, Abdülhamid uses his perfect memory to draw a map of Buckingham Palace, which is then used by a spy to infiltrate Buckingham Palace and poison Queen Victoria. The Sultan proceeds to inform the British delegation that he will provide an antidote only if they agree to his conditions. In the next episode, the British ambassador in Istanbul admits to Abdülhamid's brilliance with the following words: '[W]e have to go to the palace (the Porte), England orders us to do what Abdülhamid wants . . . He captured the entire British people in one single move'. The pro-government media celebrates this and other similar scenes, thereby connecting them to contemporary diplomatic crises with the West and touching on a climate of nationalist fervour (Erdemir and Tahiroğlu 2018, 64).

The final striking feature of the Sultan's personality is the state of profound isolation that befalls him – or is inflicted on him. Despite his genius, Abdülhamid is portrayed as an almost wholly independent actor in his patriotic cause. His inner circle and cabinet consists of a few bureaucrats loyal to him, the most important being Fehim Pasha, the head of the Sultan's intelligence agency, and Tahsin Pasha, his executive assistant. Most of the other bureaucrats, however, collaborate with the British Empire and Zionists in an attempt to break the Sultan's resolve. Most of the plotlines revolve around how Ottoman bureaucrats and even Abdülhamid's relatives aimed to manipulate political groups, university students and ethnic/religious minorities in order to usurp his power.[2]

Among these rivals is Mahmud Pasha, the Minister of Justice. Mahmud Pasha was married to Abdülhamid's sister and became one of the pioneers of the Young Turk movement. Mahmud Pasha is the number-one villain in the series; he continuously hatches plots against the Sultan. Prince Sabahaddin is Mahmud's son and part of the Ottoman dynasty. But he is opposed to the Sultan's policy of trying to keep the Ottoman realm unified. He leads the Young Turk movement with the assistance of Emanuel Karasu (Carasso), an influential member of the Zionist movement. Overall, however, the effect is to once again impart the message that the Sultan alone bore the burden of managing the Empire.

Contrary to their portrayal in the series, the Young Ottomans and Young Turks were intellectual movements which desired democratic reform in the Empire. These movements began within the civil bureaucracy and culminated in the first Young Turk Congress of 1900. This was convened under the leadership of Mahmud Pasha and Prince Sabahaddin. The resulting CUP movement was built on the same constitutionalist–parliamentarian ideology and was strongly connected to Young Turk intellectuals. However, it also included elements of the Ottoman military, mostly officers based in the Balkans. CUP officers were preoccupied with the possible secession of the strategic region of Macedonia. In 1908, they thus staged an uprising and managed to force Abdülhamid into accepting a parliamentary monarchy. The following year, however, a loyalist counter-riot induced the CUP to enter Istanbul and overthrow Abdülhamid. Until the end of the First World War, members of the CUP had substantial influence over Ottoman governments. Even in contemporary historical debates, the movement remains highly controversial. Some of its members played decisive roles in the collapse of the Empire, while others joined the Kemalist movement.

In *Payitaht*, however, the CUP is portrayed much more unambiguously as a group of collaborators. Similarly, Prince Sabahaddin and his father Mahmud Pasha are portrayed as traitors who stirred up the Ottoman public. In Episode 4, both characters agitate a young group of students by calling for liberty in the face of Abdülhamid's *istibdad*, and by making repeated references to Bakuninist anarchism. The series thus characterises anti-government protests as one of the key methods used to weaken Ottoman rule. In this way, it cautions against such protests. In Episode 11, Theodor Herzl himself notes that street protests would define the fate of the New World Order. With regard to overthrowing Abdülhamid and founding Israel on former Ottoman territories, *Payitaht* consistently misrepresents Emanuel Karasu (Carasso) as a prominent member of the World Zionist Congress. Karasu is often shown provoking social unrest in collaboration with Prince Sabahaddin. In Episode 12, Karasu utters the following words:

> We will raise an excited, ambitious and enthusiastic new generation. We will start with schools. This will be a revolution without armament. We will have men in each bureaucratic position. Then with a signal a new Ottoman, a new people, even a new religion.

Karasu's speech clearly alludes to speeches made by Fetullah Gülen, a Muslim cleric who is the alleged leader of the FETÖ/PDY organisation. And yet, because this phrase is uttered by Karasu, it creates the connotation that the FETÖ/PDY organisation is somehow tied to Zionism. In Episode 10, Sabahaddin argues similarly that Ottoman youth will grow to become 'a flood to raze the wall of *Istibdad*', while Karasu makes a remark that only a small spark is required to ignite the youth to a 'fire of liberty on the streets'. In the series, Sabahaddin and Karasu systematically use forced disappearances and the murder of journalists to provoke university students. In the 11th episode, for example, a protesting student yells: '[T]he dissident journalist Samir was murdered. Our Greek brothers were massacred inside the state's police station. We will be next. Death to the Sultan!'.

Payitaht thus very systematically alleges that the CUP, Zionists and British spies manipulated the media and disseminated false ideas of freedom in order to provoke the masses against the Sultan. The series goes so far as to suggest that the enemies of the Ottoman Empire were behind all street protests. The connotation here, of course, is that social movements such as the Gezi Park protests were the product of an international conspiracy. Samir the journalist, whose kidnapping was fabricated by the media to cause social unrest against Abdülhamid, realises the conspiracy and writes the following words in a letter to his sister:

> They have deceived me, my sister. They gave me liberty, and in return I sold them my country, religion, belief. Do never let them fool you, my sister. I am Samir, a deluded journalist.

The series equates liberty with treason and suggests that those who wished for a parliamentary monarchy contributed to the downfall of the Ottoman Empire. One particularly dramatic example comes in Episode 28, which features a conversation between the Sultan and a university student protest outside the Yıldız Palace. The students chant for 'fraternity, freedom, equality', the overarching principles of the French Revolution, and also those engraved in the coat of arms of the CUP (Hanioglu 2001, 218). But Abdülhamid responds: 'These are what the French told you. They promise you a garden of roses but in fact give flames. You will bring these flames of plague to your country'.

Conclusion

This chapter has approached the TV drama series *Payitaht: Abdülhamid* from a semiotic perspective. It has examined the allegorical devices used to create affinities between the regime of Abdülhamid II and contemporary Turkey. This parallels the removal of references to Abdülhamid's autocratic regime in official history textbooks. *Payitaht*, much like other TV shows broadcast on official Turkish state television, needs to be imagined as an attempt by the government to instrumentalise and rewrite history in order to justify an increasingly authoritarian regime.

In a nutshell, the series not only praises Abdülhamid, but also fabricates history in order to legitimate the idea of *istibdad*. Such a regime was, it is claimed, of necessity to the Sultan in order that he might overcome his rivals. The series misrepresents Abdülhamid's struggles with the British Empire, the Zionist movement, the so-called New World Order and the Union and Progress movement in order to create parallels between history and current enmities and even to demonise civil demonstrations such as the Gezi Park protests. As such, the framing and fabrications of the series contributes, in the cultural field, to justifying authoritarian politics in Turkey under Erdoğan's leadership.

Notes

1. *Payitaht: Abdülhamid*, also known as the *The Last Emperor* in English, is a TV drama series written by Osman Bodur and Uğur Uzunok and directed by Serdar Akar for the government-owned TV channel TRT. It dramatises the reign of Abdülhamid II and his struggles with various foes for the survival of the Ottoman Empire. The filming of the first season began in 2016 with an (estimated) budget of twelve million dollars. Ever since its official launch in May 2017, the series has attracted a firm following among Turkish viewers, particularly those with strong ethnic–religious nationalist beliefs.

2. One may argue that some of the villains of the series are allusions to the burgeoning opposition within Erdoğan's AKP. While most of the allusions are subtle, others are more direct. For instance, in the 85th episode, the Sultan targets the growing opposition within his administration by uttering the following phrase: '[W]e water the rose tree of rose, but water feeds both the rose and the thorn together. If what we water becomes thorns in our side, we will certainly cut them off'. This phrase is a direct allusion to former President Abdullah Gül (whose surname translates to rose), an AKP member directly involved in opposition efforts against Erdoğan.

Bibliography

Alanoğlu, Harun. 'Seni Abdülhamid'in Yalnızlığına Bırakmayacağız'. In *Diriliş Postası*, 11 December 2016.

Barthes, Roland. *Mythologies*. New York: Hill and Wang, 1972.

Bignell, Jonathan. *Media Semiotics: An Introduction*. Manchester: Manchester University Press, 2002.

Chandler, David. *Semiotics: The Basics*. Abingdon and New York: Routledge, 2002.

Duran, Burhanettin. 'Comparing Erdoğan with Mustafa Kemal and Sultan Abdülhamid'. In *Daily Sabah*, 7 December 2016.

Erdemir, Aykan and Merve Tahiroglu. 'The Islamist Takeover of Turkish Media'. In *Digital Dictators: Media, Authoritarianism, and America's New Challenge*, edited by Ilan Berman, 53–76. Lanham: Rowman & Littlefield, 2018.

Hanioglu, M. Sukru. *Preparation for a Revolution: The Young Turks, 1902–1908*. New York: Oxford University Press, 2001.

Kısakürek, Necip Fazıl. *Ulu Hakan İkinci Abdülhamid Han*. Istanbul: Büyük Doğu Yayınları, 1965.

Oktay, Emin. *Liseler için Tarih II*. Istanbul: Atlas Yayınevi, 1966.

Okur, Yasemin, Mehmet Aksoy, Hakan Kızıltan, Akın Sever, Mehmet Öztürk and Mülver Karaman. *Ortaöğretim Tarih 11*. Ankara: Milli Eğitim Bakanlığı Yayınları, 2016.

Palabıyık, Mustafa Serdar. 'Politicization of Recent Turkish History: (Ab)use of History as a Political Discourse in Turkey'. In *Turkish Studies*, vol. 19, no. 2 (2017): 240–63.

Sırma, İhsan Süreyya. *II. Abdülhamid'in İslâm Birliği Siyaseti*. İstanbul: Beyan Yayınları, 2006.

Turan, Vicdan, İlhan Genç and Mehmet Çelik. *Ortaöğretim Tarih 10*. Istanbul: Devlet Kitapları, 2014.

Türk Tarihi Tetkik Cemiyeti. *Tarih I*. Istanbul: Devlet Matbaasi İstanbul, 1931.

Tüysüz, Sami. *Ortaöğretim Tarih 10*. Ankara: Tuna Matbaacılık, 2017.

Ward, Adolphus William, George Walter Prothero and Stanley Leathes. *The Cambridge Modern History: The Latest Age*. Cambridge: University Press, 1910.

Yeni Şafak Staff. 'En Güçlü Savunma Taarruzdur'. In *Yeni Şafak*, 1 January 2018, 11.

Zürcher, Erik J. *The Young Turk Legacy and Nation Building: From the Ottoman Empire to Ataturk's Turkey*. New York: Tauris, 2010.

13

WRITING A VISUAL HISTORY OF TURKEY: 'GLORIOUS HISTORY' IN MAINSTREAM CINEMA VERSUS 'COMPLICATED HISTORY' IN ART HOUSE FILMS

Diliara Brileva

Modern Turkish cinema is a space in which different versions of national history coexist. Mainstream cinematography produced during the period of AKP rule is a field for broadcasting Turkey's 'glorious history', both within and beyond the country. In mainstream historical films, neo-Ottomanism is brought to the fore. The heroisation of the Ottoman past is conducted through the depiction of Turkish military glory. At the same time, acute ethno-confessional issues are ignored, and Turkey is represented as a homeland of many peoples. Religious myths are used to support the idea of Turkey as the legal successor to the Ottoman Empire and the Caliphate. Conversely, Turkish art house films focus on complicated moments in the history of the Ottoman Empire and the Republic of Turkey (such as the Greek, Armenian and Kurdish questions). Niche films are a forum for expressing critical attitudes to the 'traditional' vision of Turkish history. Overall, this disagreement between Turkey's creative intelligentsia and the ruling elite over the interpretation of history is part of a wider discourse on cultural hegemony and resistance. In contrast to mainstream films, art house cinematography details history by focusing on the lives of individuals and telling their (often tragic) stories. This chapter is devoted to exploring the formation of 'different histories' of Turkey in modern Turkish cinema as a discourse of hegemony and resistance.

Introduction

Mehmet has a dream. He is trapped between high stone walls, unable to find a way out. He hears a voice from above, calling him by name. Suddenly, Mehmet finds himself face to face with Osman I, who informs him of his mission:

> Mehmet, I am your ancestor Osman. I founded our *beylik* [principality]. Those who were after me: your grandfathers, your father, turned this *beylik* into a great state. And you are the man who will turn this state into a strong empire, Mehmet. You deserve this ring more than others. You are that beautiful commander whom our Prophet foreshadowed, Mehmet. May your conquest be blessed![1]

Mehmet awakens, filled with determination to conquer Constantinople. The subsequent scenes tell of a long and difficult battle for the city, during which Mehmet loses heart. Toward the end of the film, there is another dream in which Mehmet's teacher sees Abu Ayub al-Ansari, a companion of the Prophet who allegedly died during the first Arab siege of Constantinople (674–8). The dream inspires Mehmet once more. Mehmet takes out his dead father's prayer beads, kisses it and says: 'I will not return until I conquer this city, father!'.

Gottfried Hagen (2012, 356) argues that 'typical dreams in historiographical contexts have two dimensions, one motivating, the other interpretive'. Motivational dreams in the film *Fetih 1453* appear at key moments in this narrative about the conquest of Constantinople. In one such dream, the founder of the first *beylik*, whose name provided the basis for the Ottoman state, comes to support Mehmet. He convinces Mehmet of his impending success, referring to the authority of the Prophet Mohammed. Ottomanism and Islam are shown as the basis, the foundation, upon which the key conquest in Turkey's history became possible.

In contemporary Turkey, the prevalence and popularity of television formats of information dissemination can be explained by the fact that 'audiovisual culture took a historical revenge in the twentieth century, first with film and radio, then with television, overwhelming the influence of written communication in the hearts and souls of most people' (Yanardağoğlu 2013, 566). Films and TV series thus remain the most common format for obtaining information, including ideological information. For domestic audiences

in particular, historical films allow for a shift in focus from modern problems to the glory of the Ottoman past. Mainstream cinema productions released during the AKP era serve to popularise the idea that modern Turkey is the successor to the Ottoman Empire – in a cultural, if not territorial sense. Moreover, Turkish cinema and television are very popular abroad, primarily in the regions that were formerly part of the Ottoman Empire. The popularity of Turkish television in Arab countries is also due to their cultural proximity to Turkey. Despite this popularity, however, 'a survey of Arab public discourse reveals a critique of these Turkish TV series, viewing them as an attempt to influence Arab culture and "sell" Turkey as a cultural and political model' (2013, 562). Turkish TV series are also often criticised by a religious Arab audience for supposedly contradicting Islamic values.

The 'Inglorious History' of Turkish Art House Cinema

In connection with the study of Turkish cinema, the problem of defining the terms 'mainstream cinema' and 'art house films' must be addressed.[2] As Annette Kuhn (1982, 22) puts it: '[I]t is in the historically specific relationship between the economic and ideological – in the "cinematic apparatus" – that dominant cinema takes its concrete forms'. In other words, mainstream cinema is economically and ideologically conditioned. This chapter uses the concept of 'mainstream cinema' in relation to films whose main message does not contradict the ideology of 'New Turkey', and can thus be considered part of the ideological 'mainstream'. In this sense, 'mainstream cinema' has to be seen as an instrument in the hands of the ruling elite for controlling the public narrative, and thus for establishing its vision of cultural hegemony over state and society.

By contrast, art house films are often understood as the opposite of mainstream cinema. These films belong to a political economy of cinema which does not primarily depend on (a) making profit, or (b) remaining within the ideological boundaries set by those wielding hegemonic power. As such, the genre has often been instrumentalised throughout the cinematic history of Turkey to convey counter-hegemonic narratives. As a medium, cinema is a particularly apt choice for such narratives, because it allows for the construction of a 'soft' collective memory (Etkind 2013). Soft memory is expressed in the form of novels, films and debates about the past. Hard memory, on the other hand, is

mainly represented in the form of monuments. It is possible only when there exists a consensus in society around the event or figure being commemorated (2013, 175–9). When we talk about the victims of conflicts on ethnic and religious grounds within the Turkish context, memory can only exist in a soft form. As A. Etkind has observed, this is because monuments are too visible and thus cast a shadow over the glorious history of the state: 'Monuments are monological; they usually stand on their sites with no rivals to challenge them; they do not debate and compete' (2013, 194). Furthermore, the state usually controls the resources needed to create monuments. It is thus easier to talk about pogroms, genocides and conflicts on ethno-religious grounds in a soft form. Examples of this tendency come in the form of films which address these bloody events and their victims.

We thus need to theorise art house films not just as independent cinema, but rather as political films aiming to insert certain experiences or narratives into the soft collective consciousness of Turkish society. Murat Akser (2009, 142), speaking of the problem of the definition of political cinema in Turkey, notes that 'cinema in Turkey from its start has had a difficult relationship with the state'. He argues that, until the 1970s, Turkish cinema did include films with elements of politics, but these films can hardly be considered political. The first truly political Turkish films appear with Yılmaz Güney. The emergence of this director is often connected to the burgeoning division of popular and political cinema in Turkey. It is important to note that the focus on 'political' cinema tends to shift in accordance with changes within Turkey's hegemonic power structures.

A key trope within the context of political cinema is the notion of ethnicity, especially Kurdish ethnicity. This began to establish itself in the late 1970s, in keeping with a broader push for the wider recognition of cultural rights for minorities. To be sure, Kurdish cinema is by no means restricted to the films of Kurdish film-makers in Turkey. It also includes works made by film-makers living in other countries with a native or diaspora Kurdish community (Akin 2010, 112). Nonetheless, almost all films belonging to this genre can be considered art house or political cinema (Aktaş 2009, 68).

During the AKP years, a dominant theme of political cinema has consisted in the insertion of the Kurdish experience into the collective memory of the Turkish Republic. For instance, the film *Babamın Sesi* (*Dengê Bavê*

Min/ Voice of My Father) by Orhan Eskiköy and Zeynel Doğan (2012) reflects the story of a Kurdish Alevi family who suffered during the so-called Maraş Massacre in December 1978. The film is centred around the pogroms against Alevi Kurds. The main character of the film, Mehmet, lives with his wife. While moving to a new apartment due to the impending birth of his child, Mehmet finds a tape recording of his and his mother's voice. The recording was intended to be sent to his father, who worked abroad. In search of tapes with a recording of his father's voice in his mother's house, he finds old newspapers with information about the Maraş Massacre. From his mother's stories, Mehmet learns that his parents survived the pogrom: 'These are Alevis too! Let's kill them and earn a *savap* (religious reward), they said'. It emerges that Mehmet's father insisted on keeping his children ignorant of these events. The film shows how such events can give rise to post-traumatic stress.

Themes of collective memory, acknowledgement and trauma are also salient within art house films that grapple with the issue of Armenian ethnic identity in Republican Turkey. In 2015, two films were released in connection with the 100th anniversary of the Armenian genocide. One of these is *Kesik* (*The Cut*), a much-publicised film by Fatih Akın, a German director of Turkish origin. Another is *Rüzgârın Hatıraları* (*Memories of the Wind*) by Turkish–Armenian director Özcan Alper. This second film is built around the memories of Aram, an Armenian who escaped the massacres. Throughout the film, Aram tries to remember his mother's face, which has been erased from his memory. During the Second World War, while on the run somewhere on the Russian border, Aram carves out images of his family on wooden planks.

Alper's film was made 'in memory of the strangled, escaped and unburied'. This is a 'study' of collective trauma based on the experience of a single family. It is important that the 'researcher' is an insider, an internal investigator. Dominick LaCapra (2014) identifies two ways to deal with trauma. It can be lived through again and again, which offers no freedom from the post-traumatic condition. Or the trauma can be worked through in order to overcome its negative effects. LaCapra defines the first option as 'acting-out', the second as 'working-through'. The film is aimed at identifying and declaring the existence of trauma, at breaking the silence. In his interview, film director Özcan Alper emphasises the importance of recognising the past, initially with the aim of preventing new tragedies: 'Today, there is a Kurdish question,

because Turkey cannot talk about 1915'.[3] The film details history, focuses on the destinies of individuals and ultimately composes a tragic microhistory.

A similar note is struck by the 2009 film *Güz sancısı* (*Pains of Autumn*) by Tomris Giritlioğlu. Based on the novel of the same name by Yılmaz Kara-koyunlu,[4] the film describes the events of the Istanbul pogrom of September 1955. These riots took place between 6 and 7 September 1955 and were aimed at the Greek minority of Istanbul. The film describes the relationship between Behçet, a young Turk and the son of an influential man, and Elena, a Greek prostitute. The narrative unfolds in the Greek quarter of Istanbul against the background of the preparation and implementation of the pogrom. These tragic events occurred during a period of tense relations between Greece and Turkey due to the Cyprus crisis. The situation was aggravated by the fake news that Atatürk's house in Salonica had been bombed by the Greeks. *Güz sancısı* begins with a scene in which a man carries a bucket of blood-red paint and marks Greek houses with a red cross. On a stone-paved street, we see a newspaper with the headline: 'America is supporting Turkey in Cyprus war'.

The film *Güz sancısı* strives to show how historical events create hard and often traumatic boundaries between the nation (*millet*)[5] and the internal 'other'. The film examines the otherness and the oppression of otherness on the basis of ethno-religious principles. In other words, this film is about the alienation of the other from the nation. This is best illustrated by the crowd's screamed slogan: 'Get rid of the Greeks and the problem will be solved!'.

The interests of the nation and the methods of its defence become the subject of disagreement among the people, justifying violence against opponents of Turkish foreign policy in Cyprus, and also against the party condemning this policy. The dialogue between the father, who considers everything done 'in the name of the nation' to be justified, and his daughter, reveals this confrontation:

– When it comes to the interests of the nation, the rest is details.
 – Even if it is a crime? Dad, who organised the crime
 in the interests of the nation!

The main message of the film lies in the words of the protagonist, Behçet. When asked by his wife about preventing the murder of their mutual friend,

an opposition journalist, he merely replies: 'I couldn't do anything, I just watched'.

The image of Elena in the film carries a significant meaning. Elena is a metonymy. She represents the Istanbul Greeks. At the same time, Elena is an oxymoron, an innocent prostitute, the most innocent figure in the film. The younger generation of Turks represented by Behçet and his wife are the conscience of the nation. They condemn their criminal parents.

Fetih 1453 – A 'Glorious' Interpretation of Turkish History

Political art house cinema thus aims to include Kurdish, Armenian and Greek experiences in the collective memory of present-day Turkey. Within the framework of what might be described as the 'glorious history' of Turkish mainstream cinema during the AKP period, however, these experiences are rejected. This 'glorious history' consists of great conquests, wise rulers and the dedication of loyal subjects. As such, the film *Fetih 1453* is one of the most blatant portrayals of Turkey's 'glorious history'.[6]

It might be argued that this portrayal is based on two main nationalist tenets: an ethnic identity structured around the notion of Turkishness, and religious beliefs based on Sunni Islam with a Sufi tone. Part of this narrative is also based on a deep tradition of statehood, which imagines a perfect genealogical continuity between contemporary Turkey and the sixteen Turkic states, the first of which was the Great Hun Empire (220 BC to 216 AD). The seamlessness of this narrative of Turkish statehood constitutes the creation of a myth which establishes the Ottoman Sultan and the Turkish nation as the legitimate successors to the Islamic Caliphate founded by God's own messenger, Mohammed. 'New Turkey' is thus conceptualised as the leader of the Islamic world and Ummah.

In this regard, 'New Turkey' becomes a key instance in this glorious history. According to the myth, a seamless genealogy links the Turkish and Sunni–Islamic foundations of the state. In other words, as a result of this myth-making, the main message of the film *Fetih 1453* is constructed: Turkish nationalism and Islam are also characteristic of modern Turkey, which has inherited these characteristics from the Ottoman Empire – along with that empire's glory. In recent years, this representation of the Turkish past has become part of the cultural hegemony of 'New Turkey'.

It is important that the Turkish nation is not portrayed as a victim. This is valorisation, not mourning. Significantly, in mainstream historical films, instances of shame are conspicuous by their absence. According to Mithat Sancar (2006, 18), 'as individuals, society also prefers to remember the periods which they can look at proudly without experiencing any feelings of guilt or shame'.

By focusing on the film *Fetih 1453*, this section has sought to reveal how mainstream films (in contrast to art house cinema) construct the 'glorious history' of Turkey. The construction of the 'glorious history' of Turkey is thus presented here as a modern-day myth. What are the tropes and components that make up this 'glorious history'? What connotations do these tropes have? What makes this myth seem 'natural' to a Turkish audience? How is the myth of neo-Ottomanism and the Caliphate constructed?

The film *Fetih 1453* is one of the most expensive Turkish films ever made. Even before its appearance on screen, it managed to attract considerable attention. In an interview for the newspaper *Bugün*, film director Faruk Aksoy claimed that he had been carrying the idea of the film around with him for ten years. But lack of funds and adequate technology prevented him from implementing his ideas. According to the director, the main financing of the film came from his own funds. The producers also had to take out a loan, which was embellished with sponsorship from an unspecified source.[7] Though it is difficult to talk explicitly or specifically about the AKP's support for the project, the media has pointed to the close ties between Faruk Aksoy and İbrahim Melih Gökçek, a leading member of the AKP and, before 2017, the mayor of Ankara. Moreover, the media has alluded to the film-maker's 'close relations with the government'.[8] According to the newspaper *Sabah*, the day before the film was released, it was watched and 'liked' by Prime Minister Erdoğan.[9] This at least testifies to the congruence of the film's ideas with the ideology that currently predominates in Turkey.

The film *Fetih 1453* begins with a scene that takes place during the time of the Prophet Mohammed in Medina in 627. One of the Prophet's companions, Abu Ayub al-Ansari, quotes the famous hadith (that is a saying of the Prophet Mohammed) that a 'truly magnificent commander' of an equally 'magnificent army' will one day conquer Constantinople. The action then

switches to the fifteenth century, the year of birth of Mehmet II the Conqueror (1432). Mehmet II ascended the throne at the age of twelve, but his father soon returned to the throne. After the death of his father, Mehmet once again becomes sultan. He sees his goal as the conquest of Constantinople.

Meanwhile, the Byzantine Emperor Constantine XI Palaeologus seeks to enthrone another son of the late sultan, Orhan, who he holds in captivity. Having overcome numerous difficulties, Mehmet gathers an army and besieges Constantinople, but fails. In this moment of despair, Mehmet is visited by his teacher Akshemseddin. Akshemseddin tells Mehmet about Abu Ayub al-Ansari, who appears to him in a dream and shows him the site of his grave. Inspired by the conversation with the sheikh, Mehmet looks for Abu Ayub al-Ansari's grave in the vicinity of Constantinople. Ultimately, he decides to drag the Ottoman fleet overland to the Golden Horn and smash the unfortified walls.

The scene of collective prayer (*namaz*) before the final battle is particularly important. The scene creates a sense of naturalness around religiosity, a myth about the overarchingly religious character of the Ottoman Empire. The film ends with a meeting between the Greek population and Mehmet II the Conqueror, who promises his new subjects a life of peace and harmony.

The story told in this film is not only the history of the Ottoman Empire as a state. It constitutes the creation of a myth which establishes the Ottoman Sultan and the Turkish nation as the legitimate successors to the Islamic Caliphate. Turkic and Islamic identities are presented in a strong bond with the state. In other words, the film dramatises Turkic–Islamic statehood.

The film opens with a scene which presents the Prophet Mohammed's prophecy about the capture of Constantinople by Muslims. This appeal to one of the four sources of *fiqh* (Islamic jurisprudence) imbues the conquest of Constantinople with theological substantiation. The cinematic depiction of the year of Mehmet the Conqueror's birth is also replete with symbolism. The film mentions a series of miracles (*mucize*) allegedly related to the year of Mehmet's birth: mares giving birth to twins, four harvests, fruit trees sagging with the weight of their bounty, a comet flying over Constantinople, foreshadowing the fall of the city's invulnerable walls. In honour of the Prophet, the baby boy was named Mehmet (in the Arabic tradition – Mohammed).

By laying such emphasis on this historical fact, the film once again highlights the connection between Mehmet II and the Prophet Mohammed.

Because it is embedded in the history of the Ottoman Empire, continuity is also demonstrated by Mehmet's dream scene. In this scene, Mehmet receives a prophecy about the conquest of Constantinople from Osman I Gazi, the founder of the Ottoman Empire. His appearance and support for Mehmet II elevate the latter as the putative successor to the traditions of *gazavat* (religious war).

Another example of religious symbolism in the film can be found in the conversation between a desperate Mehmet and his teacher Akshemseddin. Mehmet relates to his teacher that Abu Ayub al-Ansari, who had once fought for Constantinople, appeared to him in a dream. The grave of Abu Ayub al-Ansari, which Mehmet finds, inspires him to continue the work of the Companion of the Prophet. Thus, in the film, Mehmet II is presented to the viewer as a successor of two great figures: his ancestor Osman I, and the Companion of the Prophet Mohammed, Abu Ayub al-Ansari. Mehmet is thus embedded in the continuity of the Ottoman and Islamic, while the history of the Turks is embedded in the history of Islam.

Mehmet serves here as a metonymy; he represents the Turkish nation. He is the main symbol in the structure of the myth of Turkey's glorious history. The correct, proper relationship of the Turkish nation to the state is symbolised by Mehmet's love and devotion to his father, who was first and foremost the sultan, and his awe at Osman. This warmth of the son to his father and his grandfather is extremely apparent to the viewer. This ensures the perception of myth as reality. The film also shows the relationship between Mehmet and the Sheikh. Mehmet II listens to the advice and exhortations of the Sheikh, and the Sheikh supports him with difficult decisions. In the film, the Sheikh symbolises Islam. He is depicted as a strong and respected teacher. In general, the greatness and glory of Mehmet II become the greatness and glory of the Turkish nation.

The director signally avoids questions around the diversity of the religious identity of the representatives of the Turkish nation. There is also an attempt to create a religious justification for the conquest of Constantinople. The film presents the conquest of Constantinople as the restoration of historical justice in retaliation for the Crusaders, in particular for the destruction of mosques.

This again returns us to the religious plane, giving the capture of Constantinople the appearance of a historically and religiously just war.

Islam is manifested not only in numerous symbols. It can also be seen in the way these symbols are presented. For example, in the first scene of the film, the Prophet Muhammed is not depicted and his voice is not audible. Thus, the (Sunni) tradition of the non-depiction of prophets is preserved. During the production process, Islamic traditions were also enacted on set. According to the film's director, before filming the first and last scenes, the director's mother read a prayer into a megaphone.[10]

Excessive enthusiasm for religious symbolism in the film indicates an attempt to construct a myth about religiosity as an integral feature of the Ottoman Empire. In the film, a profound religiosity is characteristic of all segments of the population, from soldiers to the sultan.

Conclusion: It's Complicated

In 'New Turkey', modern cinema can be viewed as a space in which the struggle over collective memory plays out, a site of collision of two contending narratives of history. One of these narratives reflects the hegemonic version – a glorious history of the motherland and the nation in which there is no place for shame. This constructed history represents 'New Turkey' as the successor to the Ottoman Empire, thus legitimising the right to (at least) cultural hegemony over former Ottoman territories. Within this narrative, ethno-religious diversity briefly appears only so that gratitude might be expressed toward a benevolent master. In this way, the legitimacy of 'New Turkey's' glorious history is acknowledged. This is perhaps best portrayed in the final scene of *Fetih 1453*, in which Sultan Mehmet stands at the entrance of Hagia Sophia and promises to protect the population of Constantinople, just as the first Muslims did when conquering cities: 'Do not be afraid. From now on, we are one, our goods are common, our destiny is common. You are free to live your faith as you wish'. Upon hearing these words of reassurance, the gathered crowds rejoice, while Sultan Mehmet holds up a blond baby girl into the rays of sunlight flooding inside the church.

This hierarchical but magnanimous relationship, in which the vanquished express gratitude towards Sultan Mehmet, seems to resonate even today among those involved in the production of the film. In an interview for the

pro-government newspaper *Yeni Şafak*, the film's screenwriter, İrfan Saruhan, articulated his assessment of the film within the framework of the Orthodox question:

> This story is also very valuable in terms of the Orthodox in Turkey. We met them during the film writing process. We do not want to offend anyone. We visited the patriarchate. We talked to a professor at the University of Athens. The Orthodox believe that they survived thanks to Fatih Sultan Mehmet. They do not see Fatih Sultan Mehmet as an enemy.[11]

In contrast, art house films debunk the myth of Turkey's 'glorious history'. They point instead to tragic events from the history of Turkey's ethno-religious minorities which are ignored in mainstream cinematography. Portraying the collective traumas of the Greeks, Armenians and Kurds, these films need to be understood as a counter-hegemonic stratagem against the hegemonic historical narratives set forth by the ideological mandarins of 'New Turkey'. By appealing to collective soft memory, the art house cinematic experience becomes a vehicle for questioning the glorious history of 'New Turkey'. In doing so, they perhaps point towards the formulation of a common historiography that is neither glorious nor inglorious but simply complicated.

Notes

1. Quoted from the film *Fetih 1453* (*The Conquest 1453*).
2. In addition, the meaning of the term 'Turkish' used in this chapter should also be specified. As Zahit Atam states: '[T]he word Turkish "Türk" in this definition [New Turkish Cinema] sounds like something that is allied to Turkey, that is done in the Republic of Turkey and that is culturally related to Turkishness' (Atam 2009, 203). It is important that, when this term was first used, some Turkish writers suggested the term 'New Cinema of Turkey' instead of the term 'New Turkish Cinema', in order to avoid nationalistic connotations. However, this term has not taken root in the literature (203). Therefore, in this chapter, the term 'Turkish Cinema' will be used, even if it is about films created by Turkish directors of Kurdish or Armenian origin.
3. Alper, Özcan. Interview by Maral Dink. *Childhood Remained in a Train to Eternity*, 12 November 2015, available at http://www.agos.com.tr/en/article/13678/childhood-remained-in-a-train-to-eternity (last accessed 17 November 2020).
4. Yılmaz Karakoyunlu (b. 1936) is a Turkish writer.

5. Interestingly, from the nineteenth century (according to another theory from the fifteenth century) in the Ottoman Empire, the term *millet/Rum milleti* began to be used in reference to the Greek population (Konortas 1999, 172–3).

6. Studies suggest that the film attempts to convey an official version of Ottoman history to a cinematic audience (Koçak and Koçak 2014), while evoking nostalgia for the Ottoman era (Carney 2014).

7. Aksoy, Faruk. Interview by Şebnem Özcan. *Faruk Aksoy, Fetih 1453'le yakaladığı başarıyı anlattı*, 1 April 2012, available at https://t24.com.tr/haber/faruk-aksoy-fetih-1453le-yakaldigi-basariyi-anlatti,200738 (last accessed 17 November 2020).

8. "İstanbul'u fethettiler hazineyi paylaşamadılar", 12 December 2011, available at https://odatv.com/istanbulu-fethettiler-hazineyi-dagitmadilar-1212111200.html (last accessed 17 November 2020).

9. "Fetih 1453'ü izleyen Erdoğan'ın yorumu!", 17 Şubat 2012, available at https://www.sabah.com.tr/kultur-sanat/2012/02/17/fetih-1453u-izleyen-erdoganin-yorumu (last accessed 17 November 2020).

10. Aksoy, Faruk. Interview by Şebnem Özcan. *Faruk Aksoy, Fetih 1453'le yakaladığı başarıyı anlattı*, 1 April 2012, available at https://t24.com.tr/haber/faruk-aksoy-fetih-1453le-yakaldigi-basariyi-anlatti,200738 (last accessed 17 November 2020).

11. Saruhan, İrfan. Interview by Emeti Saruhan. *Fetih 1453'ü Recep İvedik'e borçluyuz*, 12 June 2011, available at https://www.yenisafak.com/yenisafakpazar/fetih-1453u-recep-ivedike-borcluyuz-324011 (last accessed 17 November 2020).

Bibliography

Akin, Salih. 'Language and Cultural Contact: Vive la mariée . . . et la libérarion du Kurdistan'. In *Polyglot Cinema: Migration and Transcultural Narration in France, Italy, Portugal and Spain*, edited by Verena Berger and Miya Komori, 111–24. Münster: LIT Verlag, 2010.

Akser, Murat. 'Yılmaz Güney's Beautiful Losers: Idiom and Performance in Turkish Political Film'. In *Cinema and Politics: Turkish Cinema and The New Europe*, edited by Deniz Bayrakdar, 142–53. Cambridge: Cambridge Scholars Publishing, 2009.

Aksoy, Faruk. *Faruk Aksoy, Fetih 1453'le yakaladığı başarıyı anlattı*, interview by Şebnem Özcan. 1 April 2012, https://t24.com.tr/haber/faruk-aksoy-fetih-1453le-yakaldigi-basariyi-anlatti,200738 (last accessed 9 April 2019).

Aktaş, Mehmet. 'Kürt Sineması: Artık Bir Gerçek'. In *Kürt Sineması: Yurtsuzluk, Ölüm ve Sınır*, edited by Müjde Arslan, 56–68. Istanbul: Agora Kitaplığı, 2009.

Alper, Özcan. *Childhood Remained in a Train to Eternity*, interview by Maral Dink. 12 November 2015, http://www.agos.com.tr/en/article/13678/childhood-remained-in-a-train-to-eternity (last accessed 9 April 2019).

Atam, Zahit. 'Critical Thoughts on the New Turkish Cinema'. In *Cinema and Politics: Turkish Cinema and The New Europe*, edited by Deniz Bayrakdar, 202–21. Cambridge: Cambridge Scholars Publishing, 2009.

Carney, Josh. 'Re-Creating History and Recreating Publics: The Success and Failure of Recent Ottoman Costume Dramas in Turkish Media'. In *European Journal of Turkish Studies* (online), vol. 19 (2014), http://ejts.revues.org/5050 (last accessed 9 April 2019).

Castels, Manuel. *The Rise of the Network Society. 2nd edition with a new preface*. Malden and Oxford: Wiley-Blackwell, 2010.

Etkind, Alexander. *Warped Mourning: Stories of the Undead in the Land of the Unburied*. Stanford: Stanford University Press, 2013.

Hagen, Gottfried. 'Dreaming Osmans: Of History and Meaning'. In *Dreams and Visions in Islamic Societies*, edited by Özgen Felek and Alexander D. Knysh, 99–121. Albany, NY: SUNY Press, 2012.

Koçak, Dilek Özha and Orhan Kemal Koçak. 'Geçmişe Methiye: Fetih 1453'. In *Birikim*, vol. 305 (2014): 53–65.

Konortas, Paraskevas. 'From Taife to Millet: Ottoman Terms for the Ottoman Greek Orthodox Community'. In *Ottoman Greeks in the Age of Nationalism. Politics, Economy and Society in the Nineteenth Century*, edited by Dimitri Gondicas and Charles Issawi, 169–79. Sevenoaks: The Darwin Press, 1999.

Kuhn, Annette. *Women's Pictures: Feminism and Cinema*. London and New York: Routledge and K. Paul, 1982.

LaCapra, Dominick. *Writing History, Writing Trauma*. Baltimore: Johns Hopkins University Press, 2014.

Sancar, Mithat. 'Geçmişle Yüzleşme: Bir Adalet ve Özgürleşme Sorunu'. In *Birikim*, vol. 211 (2006): 18–26.

Saruhan, İrfan. *Fetih 1453'ü Recep İvedik'e borçluyuz*, interview by Emeti Saruhan. 12 June 2011, https://www.yenisafak.com/yenisafakpazar/fetih-1453u-recep-ivedike-borcluyuz-324011 (last accessed 9 April 2019).

Yanardağoğlu, Eylem and Imad N Karam. 'The Fever that Hit Arab Satellite Television: Audience Perceptions of Turkish TV Series'. In *Identities*, vol. 20, no. 5 (2013): 561–79.

14

THE POLITICS OF NOSTALGIA: THE NEW URBAN CULTURE IN ANKARA'S HISTORIC NEIGHBOURHOODS

Petek Onur

In recent years, the historical centre of Ankara has undergone remarkable processes of restoration and renovation. New shops, cafés, restaurants, hotels and museums have been opened, while the city's historic neighbourhoods are being (re)discovered by tourists and local residents alike. These new tourist sites are characterised by neo-Ottomanist cultural practices, neoliberal economic activities and Turco-Islamic connotations. This stands them in stark contrast to the Ankara Citadel quarter, which for the past thirty years has undergone only a partial process of restoration and transformation. The new tourist sites constitute a spatial embodiment of the ruling elite's cultural politics, with all their accompanying social and cultural networks of power. The representations of Ottoman heritage are intended to signify the ruling elite's power, as well as a new notion of public memory. They are profoundly influenced by Turkish popular culture, and especially by popular TV series on different periods of Ottoman history. In this way, however, the authenticity of these new historic sites is implicitly called into question. Ankara's new urban culture appears as the perfect example of restorative nostalgia, which Svetlana Boym has defined as a nostalgia that promises to rebuild a lost past and fill gaps in the popular memory with new constructions. By inventing traditions, it serves nationalist and religious politics. This chapter is based on field research which investigates the (re)created nostalgia culture of Ankara's historic Hamamönü and Hamamarkası neighbourhoods.[1] It examines the

cultural outcomes of this urban transformation, and further discusses the role of the politics of memory, which deeply influences modern day myths embodied in these urban spaces. The process of urban transformation and regeneration will be analysed through the lens of Svetlana Boym's concept of nostalgia in relation to the concept of authenticity.

Introduction

The Citadel is the oldest quarter of Ankara. It is surrounded by a number of historic neighbourhoods – Hamamönü, Hamamarkası, Hacı Bayram, Hacettepe, İsmetpaşa, Atıf Bey, Hıdırlıktepe and Ulucanlar. The Citadel's history dates back to the Galatian, Roman and Byzantine eras, and most of it is officially designated by the Ministry of Culture as a protected area. The Hamamönü and Hamamarkası neighbourhoods are named after one of the oldest Ottoman bathhouses in Ankara, Karacabey Hamamı, which was built in 1427 and is still active. The neighbourhood facing the *hamam* is Hamamönü, and behind it is Hamamarkası.[2]

There are several mosques and historic buildings in the area which were built during the Ottoman Empire and date back to the fifteenth to nineteenth centuries. However, a devastating earthquake in 1892 and the great fire in 1917 destroyed much of the quarter's architectural heritage. Consequently, many of the historic mansions and housing structures date back to the nineteenth and early twentieth centuries (Gültekin 2014; Atauz 2004). One of the most important religious complexes and buildings in Hamamönü is the dervish convent, mosque and tomb of Taceddin-i Veli, *Taceddin Dergâhı*, which was built in the seventeenth century. Other than this, however, the religious structures in the area are not particularly prominent, as they were designed only to serve the relatively small local population.

Historically, and especially from the fifteenth century, Ankara was an important Ottoman trade city which lay at the intersection of multiple trade routes, including the Silk Road. Angora wool and *sof*, a very precious textile made of angora, were the main goods around which the city's economic activity was organised. They made Ankara a wealthy and cosmopolitan host to many non-Muslim traders, including Greek, Armenian and European merchants. In the eighteenth century, however, this trade city began to lose its wealth and cultural diversity, as the trade routes and modes of production in

Europe began to change (Ergenç 1980, 1982). By the nineteenth century, many of the non-Muslim merchants had left Ankara, which became culturally much more homogenous (Aktüre 2004).

However, with the disintegration of the Ottoman Empire after the First World War, Ankara gained a new status during the Turkish War of Independence (1919–22). It became the headquarters of the Turkish military, and the site of Turkey's first parliament in 1920. After the foundation of the Turkish Republic in 1923, Ankara became the capital city. Before new neighbourhoods were built, the existing old quarters of the city were the only option for providing accommodation to bureaucrats. In the early Republican years, the city began to expand around the Citadel and Ulus, and the old dwellers of the historic city centre moved to these new modern areas of settlement. Meanwhile, due to increasing rural–urban migration, the population of Ankara was growing rapidly. The first migrant groups arriving in Ankara settled in the historic neighbourhoods, mainly because of the cheaper rents. Consequently, the part of the city which is currently protected by the Ministry of Culture was once a lower-class neighbourhood.

This made the deterioration of the historic and cultural texture of the city all but inevitable. The existing city development plan of Hermann Jansen, which was drawn up in 1928, did not contain any measures for conservation. At the same time, the new inhabitants were making necessary structural changes to their houses. The first historic conservation plan for Ankara was developed in 1987, but it could not be implemented due to a number of structural, political and legal reasons. Nonetheless, the first restaurants, hotels, cafes, souvenir and traditional handcrafts shops in the Citadel opened in the 1990s.

Until 1994, local governance of Ankara was largely in the hands of Republican, social democratic mayors. But in this year, the Islamist Refah Partisi (Welfare Party) achieved an important success in local elections in Istanbul, Ankara and many other large cities. Ever since, the conservative Islamist rule of Ankara's metropolitan municipality has proceeded apace, with the Islamist political movement enjoying notable successes in both general and local elections. This initially took the form of victories for the Fazilet Partisi (Virtue Party), and more recently for the Adalet ve Kalkınma Partisi, the AKP (Justice and Development Party). This party's political standpoint, as well as

its neo-liberal economic policies, have put down firm roots, especially among the rural–urban migrant population. The ramifications of this fact are very much reflected in local politics and urban culture.

In 2006 – and after a long period of neglect of historic Ankara – renovations began in the Hamamönü district. These took the form of an urban regeneration and rehabilitation project designed by Altındağ Municipality. The outer facades of many buildings were restored, some buildings were rebuilt, the streets were re-laid and significant historic buildings were restored. The restoration and conservation process in the Citadel remains very limited, partial and lacking a comprehensive sense of direction. In Hamamönü, however, this transformation has comprised a holistic structural and social reorientation of the entire neighbourhood. New shops, cafés, restaurants, museums and art institutions have been opened, while the municipality began to organise social activities which were inspired almost exclusively by the Turco-Ottoman past. As the Hamamönü project and the resulting transformation gained enormous popularity and success, Ankara's Altındağ Municipality initiated the Hamamarkası Regeneration Project. Today, together with the Citadel, these two neighbourhoods comprise key sightseeing and recreation locations for tourists and locals alike.

In recent years, Turkey has been experiencing radical transformations, whereby social ties have been both broken and re-established through the implementation of nationalist and Islamist politics. References to the Ottoman era lie at the heart of these changes. Such references have grown in frequency and intensity, both in the conservative politics of the ruling AKP and through TV series which reach millions of homes. Since 2007, neo-Ottomanism as an ideology, an aesthetic programme and a vision of social inclusion and exclusion has constituted the ideological basis of AKP politics. This ideology envisions a glorious Ottoman imperial past in modern society on an Islamist basis, and it has proven an effective tool for the creation of social cohesion.

Accordingly, and in parallel with neo-Ottomanism's dominance in the Turkish cultural and political context, scholarly interest in this area has been growing. One of the first and most important works here is Esra Özyürek's *Nostalgia for the Modern* (2006), which points to the uses of nostalgia in the Kemalism–Islamism polarisation. Özyürek argues that Kemalist modernity

aimed to protect and reinforce the regime by using personalised nostalgia as a tool to privatise a public past (Özyürek 2006, 19). This past relates to the beginnings of the Westernisation process in the Ottoman Empire in the seventeenth century, a process which was perceivably interrupted by the contemporary rise of Islamism (2006, 10).

Building on Özyürek's contribution, several more recent studies have focused on the political and social aspects of the central role of neo-Ottomanism in Turkish Islamism. These include Jenny B. White's (2012) analysis of the place of Ottomanism in the formation of the new nationalist/Islamist politics, Bakıner's (2013) discussion of the links between majoritarian conservatism and the political uses of memory in neo-Ottomanism, and Gianotta's (2017) discussion of how history and historical heritage have become political tools in Turkey. The emotional power of this ideology in terms of the resentment, nostalgia and the narcissism it generates in its followers is eloquently illustrated by Nagehan Tokdoğan (2018). Tokdoğan shows that the ruling AKP strategically creates cultural and spatial symbols in order to nourish these feelings and perpetuate its political power. Her perspective intersects with Bülent Batuman's work on the urban and spatial politics of the new Islamist nation building. This contribution provides a wide range of architectural examples that reflect the radical shift from Kemalist modernisation project to a neo-Ottomanist, post-nationalist modernism (2018).

The AKP articulates this neo-Ottoman vision in combination with a particular claim to authenticity and Islamic principle. It does so in order to legitimise the party's authoritarianism, transmit its messages, mobilise the masses and redefine Turkish identity. Istanbul, the historic capital of the Ottoman Empire, has become the centre of Ottoman nostalgia. This owes not only to its historical heritage, but also to the AKP's cultural strategy of building new ideological symbols.

Several scholarly contributions focus on Istanbul as a principal site of neo-Ottoman memory. Öncü (2010) and Walton (2016) analyse the MiniaTurk Museum, while Ergin and Karakaya (2017) focus on the Panaroma 1453 conquest museum. The grandiose celebrations of the Ottoman conquest of the city (Ergin and Karakaya 2017) and the Ramadan fests (Karaosmanoğlu 2010) constitute further prominent nostalgic symbols created by the AKP. Meanwhile, in Ankara, the urban regeneration projects in Hamamönü and

Hamamarkası emerge as key embodiments of neo-Ottomanist nostalgia in the city culture.

The contemporary cityscape of historic Ankara reflects the fact that nostalgia has assumed a leading role in urban culture. However, the nostalgia culture in Hamamönü and Hamamarkası is infused with neo-Ottomanist cultural practices, neo-liberal economic activities and Turco-Islamic connotations, all of which reflect the political standpoint of the current governors of Altındağ Municipality. The structural and social changes in Hamamönü and Hamamarkası constitute a spatial embodiment of the ruling elite's cultural politics with all their social and cultural networks of power. This places them in stark contrast with the culture of the relatively untouched Citadel.

By taking nostalgia as the essential conceptual key, this chapter aims to explain how ties with the past are established in the region through historical and cultural references, and to discuss how politics and culture become intertwined in the creation of an urban culture. This new urban culture appears as the perfect example of restorative nostalgia. This is defined by Svetlana Boym as a nostalgia that promises the rebuilding of the lost past and the filling of spaces in memory with new constructions. By means of inventing traditions, it serves nationalist and religious politics.

Reading Urban Transformation through Nostalgia and Authenticity

The origins of the word nostalgia date back to two words in ancient Greek: *nostos*, which refers to returning home, and *algia*, which means longing. As Svetlana Boym puts it in *The Future of Nostalgia*, this is 'a longing for a home that no longer exists or has never existed. Nostalgia is a sentiment of loss and displacement, but it is also a romance with one's own fantasy' (Boym 2001, *Introduction*, para. 4). Feelings of nostalgia thus arise out of a sense of longing, a romantic desire to return to a lost home, which is either imagined or actually existed in the past. In the twentieth century, this nostalgic sense of home became an abstraction for a pre-modern past. Such feelings have become 'an incurable modern condition' arising from the rapid pace of globalisation, progress and modernisation (*Introduction*, para. 5). Furthermore, for Boym, nostalgia lies beyond individual psychology; it is a 'yearning for a different time – the time of our childhood, the slower rhythms of our dreams. In a broader sense, nostalgia is rebellion against the modern idea of time, the time of history and progress' (*Introduction*, para. 11).

At this point in her analysis, Boym introduces two conceptualisations of nostalgia: reflective and restorative. Reflective nostalgia dwells on *algia*; it focuses on 'longing and loss, the imperfect process of remembrance' (*Chapter 4*, para. 2). Those possessed by reflective nostalgia are very much aware that time is irreversible, that their home is lost. They harbour uncertainties around this feeling of belonging to a home, and they reject dogmatic truth claims about history. Instead, reflective nostalgia focuses on details from the past, pieces of memory, 'longing and loss, the imperfect process of remembrance' (*Chapter 4*, para. 2) and conserving the ruins of a lost home.

By contrast, restorative nostalgia emphasises *nostos*, returning home. It comprises a desire to reconstruct the home which was lost in the past. Boym recognises that, when nostalgia becomes part of the political sphere, romance becomes connected to nation building. On this basis, she argues that this reconstruction requires the claims of absolute truth and revitalisation, or the invention of traditions and symbols. It is thus a highly functional approach to the past as a repertoire for the formation of national identities, nationalist movements and religious revivalism (*Introduction*, para. 21–2).

Boym stresses that, in restorative nostalgia, 'the past is not supposed to reveal any signs of decay; it has to be "freshly painted" in its "original image" and remain eternally young' (*Chapter 5*, para. 1). Thus, restorative nostalgia manifests itself in attempts to rebuild the past and history in order to create a common national, religious collective identity. This results from a desire to preserve the past in its original image as an integral part of modern society. An essential point that differentiates restorative nostalgia from reflective nostalgia is that the former is crystallised in national memory and official accounts of history, whereas the latter is associated with a fragmented social memory.

Restorative nostalgia necessarily comprises a power dimension, which is translated into concrete symbols of power. In *Simulacra and Simulations*, Jean Baudrillard suggests a strong link between the decline of power and the increase in the collective demand for signs of resemblance to power.

> When it has totally disappeared, we will logically be under the total hallucination of power – a haunting memory that is already in evidence everywhere, expressing at once the compulsion to get rid of it (no one wants it anymore, everyone unloads it on everyone else) and the panicked nostalgia over its loss. The melancholy of societies without power: this has already stirred up

fascism, that overdose of a strong referential in a society that cannot terminate its mourning. (Baudrillard 2006, 23)

Baudrillard argues that the simulation of power is what remains when actual power no longer exists. It is at this point that the demand for signs of power emerges. In the political sphere, the signs of power are now mass-produced and -consumed, much like commodities (2006, 26). Baudrillard's argument relates to restorative nostalgia in the sense that invented traditions, constructed symbols and nationalist accounts of history reflect a desire for the revitalisation of a glorious past, the real or imagined victorious history of previous political formations. Mourning for lost political power creates a dynamic similar to the economic principles of supply and demand which structure neo-liberal capitalism. This process is central to understanding the contemporary culture of restorative nostalgia in countries with an imperial past.

The issue of authenticity, particularly in relation to tourism, is also crucial to understanding the nostalgia culture created in the historic quarters of modern cities. Dell Upton notes that scholars of heritage and tradition take authenticity as an unchallenged notion, as 'a testable and desirable quality of tradition. Implicitly or explicitly they assume the defence of tradition and authenticity against modernity and artificiality' (Upton 2001, 300). This assumption is an objective one; it can be associated with 'museum authenticity', in which the role of the expert in determining the value and the authenticity of objects is critical (Laite and Graburn 2009, 43). But the postmodern critique offers another perspective from which to understand the issue. It depicts authenticity not as an essential trait, but merely the result of:

> an invention of tradition (Hobsbawm and Ranger 1983), or constructed through mediated meaning making, interpretation and agreement (Bruner 1994; Hughes 1995). In this case, authenticity becomes a projection of tourists beliefs, expectations, preferences and stereotypes projected onto toured objects. (Wang 1999, quoted in Zhu 2012)

This constructivist approach also highlights the question of power embedded in the authentication process (Appadurai 1986) – that is, in claims of authenticity in touristic settings. The existentialist approach criticises structuralism by posing the question: '[W]ho has the power to authenticate?' It thereby shifts the focus to the agency of the actors, which becomes

manifest in existentialism to imply the existence of an 'authentic self' that is linked with intrapersonal and interpersonal authenticities. The former emerge from 'engaging in non-ordinary activities, free from constraints of daily life', giving rise to feelings of relaxation and pleasure. The latter offers a dynamic perspective, which focuses on the interaction between the agency of the individual and the external world through performativity (Knudsen and Waade 2010, in Zhu 2012). Then there is a process of becoming which renders authenticity a transformative state rather than a fixed category. This approach can help us understand the experience of 'becoming authentic' through various cultural activities, such as visits to historic sites and spaces.

Nostalgia and authenticity in the context of Ankara's historic sites has always been deeply influenced by the dynamics of politics, neo-liberal economics and cultural heritage. In Hamamönü and Hamamarkası, these dynamics are entangled with nationalist Islamism, Ottoman cultural heritage and its representations in the popular media.

Politics in Restoration: Hamamönü

Hamamönü restoration and regeneration project is one of the most famous urban transformations in Turkey (Figure 14.1). This low-income neighbourhood was once known as a dangerous, crime-ridden area. But through the rehabilitation project of Altındağ Municipality, it has been transformed into a tourist district. AKP mayor Veysel Tiryaki placed considerable emphasis on this project, as well as on the many other urban regeneration projects in Altındağ's *gecekondu* (slum) neighbourhoods. The project began in 2006; it comprised street rehabilitations, reconstructions and the restoration of certain historic structures, including several mosques, and the creation of a range of parks (Gültekin 2014). The regeneration brought many new cafés, patisseries and restaurants, as well as several right-wing NGO offices to the district. Most of its previous inhabitants, however, were required to move to other (relatively cheap) quarters of the city due to the increasing rents. The regeneration has thus largely turned out to be a process of exclusion for the lower classes, as well as a process of aestheticisation and social, moral and cultural cleansing. Just as the older, more garish facades of the buildings were painted over almost entirely in white,[3] so the social profile of the area

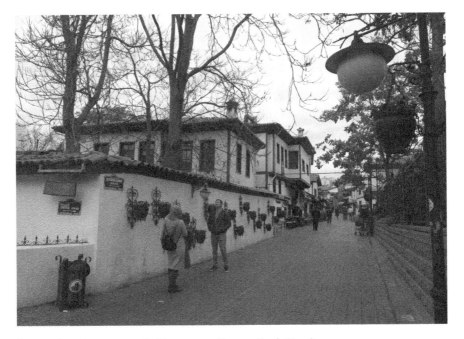

Figure 14.1 A street view in Hamamönü (Source: Petek Onur)

was cleared from its unwanted moral and cultural pollutants: lower-class life-styles, crime, alcohol and drugs.

The largest faculty of medicine in Turkey, Hacettepe University Faculty of Medicine, Faculty of Dentistry and Hospital and their dormitories, are also located directly next to Hamamönü. Thus, since the 1950s, the students as well as the academic and administrative staff of the faculty, the patients and their companions have been the customers of the small cafés, stores and teahouses of the neighbourhood. In the new Hamamönü, they continue to be the customers of both old and new enterprises.

Hamamönü project is not merely a social and architectural project; it is also cultural. It takes the Ottoman history and Turco-Islamist cultural heritage of the region as its reference points. The existence and historical significance of *Taceddin Dergâhı* (Taceddin Dervish Convent) and Mehmet Akif Ersoy House has a central place in restoring an Ottoman nostalgia. This complex and museum was also restored as part of the rehabilitation and regeneration project. Taceddin-i Veli (1590–1680), who is also known as Taceddin

Sultan, was a highly respected religious leader in the seventeenth century. During the years when he lived in the dervish convent, he was so admired that the residents of the neighbourhood were exempt from taxes, and when he died, he was buried there. His community and followers continue to visit this place up until the present day, among them the poet Mehmet Akif Ersoy, who wrote the Turkish national anthem in this place.[4]

The dervish convent is also the final resting place of Muhsin Yazıcıoğlu, another significant nationalist–Islamist political figure. Yazıcıoğlu was buried here in accordance with his will, and with a special decree of the Council of Ministers, after he died in a suspicious helicopter accident in 2009. Gönüllerde Birlik Vakfı (Unity in Hearts Association), the NGO founded in the name of Yazıcıoğlu, is located in a restored mansion in Hamamönü.

Indeed, the historical, religious and political importance of the *dergâh* has attracted visitors from across the country. During my visit, I encountered groups of primary school children on school trips. Several interviewees also mentioned that they came here to pray and visit the tombs, and that they now have customers who come to Hamamönü for Taceddin-i Veli.

> Let me tell you, we have three groups of customers: the ones who want to sit at a café and chat in Ankara, the ones who come from outside the city and as they come visit Taceddin Dergahı, the mosques here, there's Muhsin Yazıcıoğlu's *kabir-i şerif*[5], visit there and as they come they want to see here, and three, the foreigners. (Arif,[6] henna house and café owner, Hamamarkası)[7]

> I use to come [here], I use to come sometimes, because it was neglected, I used to come to Taceddin Dergahı a lot, its surroundings were very neglected, we couldn't walk around but now its better . . . Taceddin Sultan is the foundation of this neighbourhood . . . (Ayşe, book café owner, Hamamarkası)[8]

Another interviewee, who is one of the art tutors at a traditional Turkish arts course in Hamamönü, also mentioned that she met her business partners through their husbands, who go to Gönüllerde Birlik Vakfı. Clearly, then, the historic and Islamic ties of the *dergâh* have provided the basis for a social network of visitors, entrepreneurs and the municipality. This network is central to the new urban nostalgia culture of the region.

The municipality not only planned an architectural change; it also aimed to create a nostalgia which would revitalise an imagined Ottoman,

Turco-Islamist history. This was very much on the AKP's agenda. Clearly related to this aim is the organisation of Ramadan fests, Hamamönü Talks, handcrafts, traditional art and music courses and the henna house of the municipality. These activities nourish the restorative nostalgia culture and implicitly or openly support the cultural hegemony of AKP politics.

During Ramadan, all the streets of Hamamönü and the main square of Hamamarkası become festival venues. Local products and handcrafts from various Turkish cities are sold, while visitors can have their photographs taken in Ottoman Sultan costumes. After *iftar* (fast breaking), traditional Turkish and Sufi music and Turkish folk theatre are performed on the stage in the main square. The festival is a conscious attempt to revitalise the Ramadan festivals of the Ottoman era. Almost all the tables at cafés and restaurants are booked throughout Ramadan, and the streets are crowded with people from all around Ankara, especially immediately before and after *iftar*. Yet, when asked about the public interest in handcrafts and artworks during these festivals, the artists state that the people who come to the festival do not appreciate their value, occasionally damage them and instead seek cheap accessories and souvenirs. These reactions indicate that the festival visitors have a low socio-economic profile and cultural capital.

Another significant public event of the municipality is *Hamamönü Sohbetleri* (Hamamönü Talks), which takes place at a restored mansion, Kabakçı Konağı. The talks take place six days a week. Each day, a speaker invited by an NGO with a nationalist–Islamist political stance makes a presentation. They usually discuss a particular political, historical or cultural subject. Restorative nostalgia is also generated in the Kültür ve Sanat Evi (Culture and Art House) of the municipality in Hamamönü. The place is allocated to a *ney*[9] course and is decorated by the tutor himself in an authentic style with many objects of Turkish and Islamic art. It is open to all, whether interested in learning how to play *ney* or just listening to its music. The tutor, who is also a university lecturer, expresses that he is a pious believer with his manners and words, and aims to create a spiritual, peaceful atmosphere. Lastly, the henna house of the municipality is a restored mansion rented out to families who want to organise their henna nights[10] in an authentic and nostalgic atmosphere.

More subtle means of changing the urban culture of the neighbourhood can be observed in the processes by which the restored buildings were

allocated to their new owners or tenants. A considerable number had personal ties with Altındağ Mayor Tiryaki and harboured a similarly conservative worldview. One example is a book café located in the Art Street, a reconstructed building complex for art studios, directly opposite the historic Sarı Kadı Mosque. This is owned by three pious women, one of whom is an Islamist writer and publisher and personally knows the mayor. The second partner, Nevin, who is a retired chemistry teacher, explained that they had dreamt of opening their place while taking Islamic art courses in a studio in the Citadel. The café was the bookstore of a publishing house before they rented it, allowing them to add their own books to the existing library. Nevin explained that they began with simple homemade salads and pastries brought from home, before eventually hiring a cook. The name of the café is the term for the education institute of the Ottoman palace, signifying both a nostalgia for the Ottoman period and an atmosphere of intellectualism. The owners and waitresses welcome the customers as if they were guests arriving at their houses. Prices are moderate and affordable for students. Consequently, the café is busy throughout the day, and is frequented especially by pious women students who go to the mosque for *namaz*, the imam of the mosque and patients of Hacettepe. The owners of the café and some of the workers also go to *namaz*. Nevin participates in Arabic classes given in the NGO next to the mosque. The café is closed during Ramadan. Nevin highlighted the 'safe' family atmosphere which they strive to create and which pleases the students, especially those from other cities. She also mentioned that parents of these students frequently come to the café to thank them.

Despite the municipality's claims to authenticity and tradition, it is difficult to find services or goods that reflect Ankara's local culture. Most of the cafés offer a standard menu which one could find in any ordinary café in the city. A seemingly authentic item on the menu is Turkish coffee cooked on a semi-traditional brazier designed by a café owner in 2006. This became so popular that all other cafés and restaurants imitated the same brazier (Figure 14.2). Handcraft and souvenir shops are few in number, and only one of them sells a local handcraft: *telkâri*, the silverwork of Beypazarı, a small historic district of Ankara. Seyit, the first master and owner, stated that during the heyday of tourism in Beypazarı, he had sixty-five masters working at his atelier. But when the town's popularity began to decline, he closed his shop

Figure 14.2 A coffee brazier in Hamamönü (Source: Petek Onur)

and moved to a shopping mall in Ankara. When the Hamamönü project began, however, he believed that it would be an appropriate place to open a second store, because 'Hamamönü was a warm place like Beypazarı, again the old houses were stored, it looked warmer to us'.[11] Both traditional/authentic and modern works catch the attention of customers, including accessories designed with Ottoman *tuğras*, sultan's calligraphic signs, symbols of Turkish nationalism and Arabic letters. The ambience of authenticity is further enhanced by the presence of a mannequin dressed in traditional henna night clothes.

Reconstructions of the Past: Hamamarkası

After the Hamamönü project was successfully completed, the municipality commenced a second rehabilitation project in Hamamarkası in 2015–16. Before the project, the neighbourhood mainly housed low-income families and, like Hamamönü, was known as a dangerous place. This time, however, the municipality implemented a radically different rehabilitation in terms of

completely reconstructing the old houses and mansions in a similar historic architecture. Savaş Zafer Şahin, an urban sociologist and a city planner who had also worked on the Hamamönü project, commented that 'this time, the Municipality overstepped the limit',[12] and he described the new historical sites as a 'model history of Ankara'.[13] Among the new institutions and enterprises are henna houses, museums, cafés, offices of Islamist politicians and NGOs, a few shops and Islamic art studios and the wedding hall of the municipality.

The henna houses in this quarter became the first of their kind in Turkey. In Turkish culture, henna ceremonies symbolise the bride's willingness to sacrifice herself for her husband and children.[14] The tradition became obsolete during Turkey's rapid modernisation, and came to be despised as a sign of rural backwardness, especially among urban families. During the 2000s, however, the rise of conservatism and the growing wedding market with all its goods and services resulted in a revival of henna ceremonies in hotels and restaurants. For some brides, these ceremonies even resemble hen parties. Lale, a wedding organiser and a henna house owner in Hamamarakası, states that their business has become highly popular and even attracts brides from upper-middle class, elite neighbourhoods. She says that, throughout the wedding season, the main square of Hamamarkası is very crowded and lively, 'like Kızılay, the city centre'.[15]

The atmosphere and style in these henna houses is deeply influenced by the harem decorations featured in the popular TV series *Magnificent Century*, a drama about the reign of Süleyman the Magnificent. Lale enthusiastically explained to me how she was impressed by the series and decorated the henna house just like this harem. Arif, another henna house owner, proudly showed the golden replicas of the war helmets of Süleyman the Magnificent as part of the highly glamorous decoration (Figures 14.3 and 14.4). In both houses, there is a splendid throne for the bride and, instead of the traditional *bindallı*,[16] Ottoman kaftans in various colours and designs are offered. Lale designs the kaftans herself, taking yet more inspiration from the TV series. Arif's henna house differs from Lale's with its Islamic style and customer profile. The walls are decorated with various Islamic ornaments and calligraphic art, and there is a small *mescit*, a prayer room, on the upper floor. His customers have included the minister of the interior and the daughter of a high-ranking bureaucrat from the president's office.

Figure 14.3 A replica of the helmet of Süleyman the Magnificent (Source: Petek Onur)

Figure 14.4 A henna house in Hamamarkası (Source: Petek Onur)

In this small district, the reinvention of the henna tradition became possible through an intersection of political, religious and cultural manifestations of neo-Ottomanism. Moreover, the tradition essentially normalises and perpetuates gender inequality, and this new form in particular popularises women's submission to an authoritative masculinity for the sake of displaying glamour and extravagance.

There are three museums in Hamamarkası: the Intangible Cultural Heritage Museum, Poets and Authors House and Gökyay Foundation Chess Museum. These have been a significant component of the area's urban culture. The first two deserve special attention in terms of how they contribute to the atmosphere of restorative nostalgia in the district.

The Intangible Cultural Heritage Museum was founded by Gazi University's Department of Folklore, and it is voluntarily administered by the students of the department. The museum is spatially organised to depict everyday life in a traditional Ankara house. The guides accompany each visitor to explain in detail the culture vitalised in the museum, demonstrate traditional Turkish arts and handcrafts and then let the visitors try them out. The museum regularly receives groups of schoolchildren from Ankara and other nearby cities. Hasan, the director of the museum and a graduate student, underlined the centrality of an academic approach to the museum, which conducts extensive research about the intangible cultural heritage of Ankara and its surroundings. The museum's activities are not limited to the space within its walls, however; it also organises traditional Hıdırellez[17] festivals in Hamamönü each year in cooperation with the Altındağ Municipality to celebrate the arrival of summer. Even though an objectivist approach to authenticity is more than evident, various traditions are reinterpreted and popularised by the organisers (Teke 2016). They also invite their visitors to experience performative authenticity, both through the traditional handcrafts workshop and children's playroom at the museum, and at their festivals.

The Poets and Authors House was founded by a former AKP deputy and the poet Mehmet Atilla Maraş.[18] Maraş is an agricultural engineer who worked as a teacher, a civil servant and a bureaucrat for many years while simultaneously engaging in poetry and literature. He was also a former director of the Writers Union of Turkey. In 2015, upon learning that Altındağ's mayor was a fan of his poetry, Maraş asked his support for the foundation

of a literature museum. One of the rebuilt mansions in Hamamarkası was allocated to this purpose. Biographies, books and some personal belongings of the authors and poets who lived in Ankara during the Republican period are exhibited in the museum.

Furthermore, Maraş organises public poetry talks on Saturday afternoons in the museum, between the afternoon and evening prayers. The participants are mainly university students and high school literature teachers. In the two meetings that I attended as a listener, Maraş introduced two well-known Islamist poets. He deeply admires Sezai Karakoç, one of the most significant Turkish Islamist poets, and he is also personally acquainted with several other famous Islamist poets. He thus embellishes the ideas aired in the talks with accounts from his personal life. The scope of the talks extends to theology and sermon-like lectures, while listeners also participate with questions and comments about Islamic beliefs. Maraş explained that he designed the room in a way to resemble the classrooms of the Ottoman period, where listeners' stools are placed beside the walls, while the teacher's desk is placed at the front of the room. In this way, a literature museum gains an Islamist character, which is imbued with its own sense of nostalgia. There is a prevalent longing for the Golden Age of Islam at a time in Turkey's political history when Islamist movements have gained considerable momentum.

Several other buildings are located close to the Poets and Authors House, including the legal office of Bülent Arınç, one of the founders and former minister of the AKP, the central office of an Islamist literature journal and the offices of another AKP minister. This clustering is not a coincidence. As Maraş also states, the inhabitants of these buildings are in frequent communication with each other. They form a social network which embodies the underlying political forces currently acting on urban culture.

A new and potential influencer of the restorative nostalgia in Hamamarkası will be the Mevlevihane. This religious structure was the only heritage of Sinan the Architect in Ankara, but it was demolished in the 1950s. The municipality rebuilt it within the scope of the regeneration project and opened it as a culture and art house in 2017. The building is decorated with calligraphic works by twenty Turkish artists, and it is expected to host cultural activities of NGOs and universities.[19]

History, Culture and Politics

Hamamönü and Hamamarkası present their visitors with a freshly painted past, depicted with a nostalgia replete with the symbols of power. This past can be consumed in the form of various goods, services and social activities. People seeking a return to their lost homes encounter the glamour and power of the Ottoman Empire, the Golden Age of Islam, a past to be proud of. This nostalgic experience is architecturally, socially and culturally planned by neo-Ottomanist politics; it is realised through the invention of tradition. In Hamamönü and Hamamarkası, the (re)imagined past also conceals the heterogeneity of the previous social life. It essentially sacrifices the search for the authenticity of cultural practices, and leads to the social exclusion of the lower classes – especially non-Muslims, given the specific sense of belonging it mandates. All these processes of building and rebuilding identities and social ties are popularised through the means of a romantic restorative nostalgia culture. While the Altındağ Municipality and the mayor seem to be the principal leaders and planners of this transformation, it is also an outcome of the involvement of various actors who share in this collective Turco-Islamist spirit.

Notes

1. This chapter is based on a research project entitled 'Re-Creating Nostalgia in Citadel and Hamamönü Neighbourhoods of Ankara', which studies the cultural outcomes of the conservation, restoration, urban transformation and regeneration processes in Ankara's Hamamönü and Hamamarkası neighbourhoods as embodiments and reflections of different nostalgia cultures. The research project is supported by the Yüksel Erimtan Culture and Art Foundation. Within the scope of my fieldwork, I conducted thirty-two in-depth interviews and thirty semi-structured surveys with the workers and owners of cafes, restaurants, boutique hotels, shops and museums, and made observations during public events from October 2017 to February 2018. Ten interviews were conducted in Hamamönü and seven in Hamamarkası. I also photographed all the places where the fieldwork took place and included the relevant texts from the websites and social media accounts of these institutions and enterprises, as well as the online customer reviews as secondary data.
2. Hamamönü literally means in front of the *hamam* and Hamamarkası literally means behind the *hamam*.

3. White not only symbolises purity, but also an intentional choice to create a similarity with the architectural texture of Beypazarı, a small historic and touristic district of Ankara province. The same choice is also made for the restorations in the Citadel region. However, it does not make sense considering the dominant way of heating, as the use of coal stoves rapidly pollute the facades of the buildings.

4. The anthem was written in an era of nationalism strengthened with Islam. Mehmet Akif Ersoy was a pioneering figure of this ideology. The influence of this standpoint has been dominant in conservative–nationalist politics in Turkey since the 1940s (Çetinsaya 1999).

5. The words are used to denote the grave of a religiously significant person.

6. Names of the interviewees are pseudonyms.

7. Personal interview, Ankara, 7 December 2017.

8. Personal interview, Ankara, 4 December 2017.

9. *ney*: a type of flute used in traditional Sufi and Middle Eastern music.

10. Henna night is a part of wedding ceremonies and usually takes place the day before the wedding. The bride and the female relatives and friends are invited to the henna night. Henna customs and their meanings show variations across geographies and time, but in all of them the bride's palms are tinted with henna, which is also offered to guests.

11. Personal interview, Ankara, 25 February 2018.

12. Personal interview, Ankara, 8 January 2018.

13. Şahin, Z. S. 'Ankara'nın Maket Tarih Devri ve UNESCO', available at https://sehrekustu.blogspot.com.tr/2016/06/ankaranin-maket-tarih-devri-ve-unesco.html (last accessed on 25 January 2018).

14. The reddish colour of henna resembles blood and symbolises sacrifice. In Turkish culture there are two other occasions where henna is used: on the animal to be sacrificed for Islamic reasons, and on the palms of young men before they are sent to their military service.

15. Personal interview, Ankara, 9 February 2018.

16. The long, colourful jacket inlaid with silver or golden threads worn by the bride during the henna night.

17. *Hıdırellez* is widely celebrated across Anatolia. The word comes from the names of Hızır, who is believed to help the people in need on the land, and Ilyas, who is believed to be the sovereign of the seas and to help the people in the sea. It is believed that Hızır and Ilyas get together every year on the night of 5 May under a rose tree. With a set of rituals which change from one region to another, people make wishes and ask Hızır to make them come true on this night (Teke 2016).

18. The real name is used because of his public identity.
19. Retrieved from Altındağ Municipality, available at https://www.altindag.bel. tr/#!haberler/ankaranin-tek-mevlevihanesi-kultur-sanat-evi-olarak-yasatilacak (last accessed on 11 November 2018).

Bibliography

Aktüre, Sevgi. '1830'dan 1930'a kadar Ankara'da gündelik yaşam'. In *Şehrin zulası: Ankara Kalesi*, edited by Güven Tunç, Figen Özbay, Ahmet Faruk Keçeli, Gürsel Korat, Mithat Sancar, Necdet Teymur, Asuman Türkün Erendil, Zuhal Ulusoy, 35–74. Istanbul: İletişim, 2004.

Appadurai, Arjun. *The Social Life of Things*. Cambridge: Cambridge University Press, 1986.

Atauz, Akın. 'Kale ve Sur: Ankara'nın Kal'ası'. In *Şehrin zulası: Ankara Kalesi*, edited by Güven Tunç, Figen Özbay, Ahmet Faruk Keçeli, Gürsel Korat, Mithat Sancar, Necdet Teymur, Asuman Türkün Erendil, Zuhal Ulusoy, 61–22. Istanbul: İletişim, 2004.

Bakiner, Onur. 'Is Turkey Coming to Terms with its Past? Politics of Memory and Majoritarian Conservatism'. In *Nationalities Papers*, vol. 41, no. 5, (2013): 691–708.

Batuman, Bülent. *New Islamist Architecture and Urbanism: Negotiating Nation and Islam through Built Environment in Turkey*. London: Routledge, 2018.

Baudrillard, Jean. *Simulacra and Simulation*. Ann Arbor: University of Michigan Press, 2006.

Boym, Svetlana. *The Future of Nostalgia*. E-book edition. New York: Basic Books, 2001.

Çetinsaya, Gökhan. 'Rethinking Nationalism and Islam: Some Preliminary Thoughts on the Roots of Turkish Islamic Synthesis in Modern Turkish Political Thought'. In *The Muslim World*, vol. 89, no. 3–4 (1999): 350–76.

Ergenç, Özer. 'XVII. Yüzyılın başlarında Ankara'nın yerleşim durumu üzerine bazı bilgiler'. In *Osmanlı Araştırmaları*, vol. 1, no. 1 (1980): 85–108.

Ergenç, Özer. 'Osmanlı klasik dönemindeki' eşraf ve ayan' üzerine bazı bilgiler'. In *Osmanlı Araştırmaları*, vol. 3, no. 3 (1982): 105–13.

Ergin, Murat and Yağmur Karakaya. 'Between Neo-Ottomanism and Ottomania: Navigating State-Led and Popular Cultural Representations of the Past'. In *New Perspectives on Turkey*, vol. 56 (2017): 33–59.

Giannotta, Valeria. 'Narratives of the Past and Cultural Heritage in Turkish Party Politics: From Republican Political Myth to Conservative Counter-Revolution'. In *Contested Memories and the Demands of the Past*, edited by Catharina Raudvere, 107–26. London: Palgrave Macmillan, 2017.

Goonewardena, Kanishka. 'The Urban Sensorium: Space, Ideology and the Aestheticization of Politics'. In *Antipode*, vol. 37, no. 1 (2005): 46–71.

Gültekin, Nevin. 'Urban Conservation Policy – The Case of Hamamönü-Ankara-Turkey'. Conference paper held at the *54th Congress of the European Regional Science Association: Regional Development & Globalisation: Best Practices*. 26–9 August 2014, St. Petersburg, Russia.

Karaosmanoglu, Defne. 'Nostalgia Spaces of Consumption and Heterotopia'. In *Culture Unbound*, vol. 2 (2010): 283–302.

Öncü, Ayşe. 'Narratives of Istanbul's Ottoman Heritage and Competing Political Claims to its Present'. In *Spatial Conceptions of the Nation: Modernizing Geographies in Greece and Turkey*, edited by Nikiforos Diamandouros, Caglar Keyder and Thalia Dragonas, 205–28. London and New York: I. B. Tauris, 2010.

Özyürek, Esra. *Nostalgia for the Modern*. Durham, NC and London: Duke University Press, 2006.

Şahin, Zafer Savaş. 'Ankara'nın Maket Tarih Devri ve UNESCO'. In *Şehreküstü*, https://sehrekustu.blogspot.com.tr/2016/06/ankaranin-maket-tarih-devri-ve-unesco.html (last accessed 17 November 2020).

Tokdoğan, Nagehan. *Yeni Osmanlıcılık: Hınç, Nostalji, Narsizm*. Istanbul: İletişim, 2018.

Upton, Dell. 'Authentic Anxieties'. In *Consuming Tradition, Manufacturing Heritage: Global Norms and Urban Forms in the Age of Tourism*, edited by Nezar Al Sayyad, 298–306. London: Routledge, 2001.

Walton, Jeremy F. 'Geographies of Revival and Erasure: Neo-Ottoman Sites of Memory in Istanbul, Thessaloniki, and Budapest'. In *Die Welt des Islams* , vol. 56, no. 3–4, (2016): 511–33.

Wang, Ning. 'Rethinking Authenticity in Tourism Experience'. In *Annals of Tourism Research*, vol. 26, no. 2 (1999): 349–70.

White, Jenny B. *Muslim Nationalism and the New Turks*. New Jersey: Princeton University Press, 2012.

Zhu, Yujie. 'Performing Heritage: Rethinking Authenticity in Tourism'. In *Annals of Tourism Research*, vol. 39, no. 3 (2012): 1495–513.

Zukin, Sharon. 'Urban Lifestyles: Diversity and Standardisation in Spaces of Consumption'. In *Urban Studies*, vol. 35, no. 5–6 (1998): 825–39.

PART V

'NEW TURKEY'S'
ETHNO-RELIGIOUS OTHERS

15

THE AFFIRMATION OF SUNNI SUPREMACISM IN ERDOĞAN'S 'NEW TURKEY'

Kaya Akyıldız

By (re)affirming Turkish nationalism and the country's Ottoman past as well as championing the country's pious majority, President Recep Tayyip Erdoğan and the ruling AKP claim to have put an end to the degeneration of the nation. A relentless discourse of unity, religious and national purity, authenticity, resoluteness and irredentist dreams of a revived (Ottoman) empire through the creation of a new pious community represents the cornerstone of today's 'New Turkey'. One may argue that more than mere rhetoric, 'New Turkey' is a hegemonic project insofar as it aims to create a 'new' Turkish citizen and establish the views of the ruling elite as the commonly accepted norm. In their attempt to operationalise the hegemonic project of 'New Turkey', Erdoğan and the AKP have created an atmosphere of social polarisation, effectively mobilising a siege mentality of 'us versus them' within the electorate. As part of this strategy, the ruling elite consistently utilises (and exploits) secular–religious, sectarian (Sunni–Alevi), as well as ethnic (Turkish–Kurdish) tensions in Turkish society.

On a discursive level, the language of 'New Turkey' emphasises a populist–majoritarian, plebeian/right-wing, anti-elitist 'indigenous and national' (*'yerli ve milli'*) worldview. As such, it constantly reiterates the differences that separate the pious, ethnically Turkish majority from the rest of society. For instance, it is implied that secularism (*laiklik*) is the product of Western imperialism and therefore foreign to the nation's indigenous Sunni Muslim essence.[1] Ottoman–

Turkish modernisation and especially the early Republican experience from the 1920s to the 1940s should be thought as a process of mental, economic and cultural self-colonisation (*mankurtlaşma*) that has to be revoked. Within such a discourse, anyone who remains beyond the parameters of acceptability in 'New Turkey' is labelled as enemy and traitor.

On a personal level, participating in the hegemonic project of 'New Turkey' extends a number of benefits to the ordinary citizen, including a sense of belonging to the majority as well as a sense of entitlement. Furthermore, the ontological security of being within the discursive construct of 'New Turkey' creates an enabling effect wherein the participant feels encouraged to mobilise discriminatory and exclusionary attitudes towards social others, particularly within the realm of ethnicity and religion. As such, one may argue that as a hegemonic project, 'New Turkey' allows the participating subject to simultaneously 'enjoy' the unspoken privileges and advantages associated with being pious, Sunni and Turkish, while also normalising antagonistic attitudes and behaviours normally considered to be morally or socially condemnable. While much of the critical commentary has focused on the ethnic dimension to the hegemonic project of 'New Turkey', academic commentaries on the religious dimension are few.

Much of the literature on the religious dimension of 'New Turkey' focuses on the politicisation of institutions such as the Ministry of Education or the Directorate of Religious Affairs (Özgür 2012; Lord 2018; Gençkal Eroler 2019). This chapter argues that the valorisation of Sunniness as an indispensable element of the new Turkish identity subjectivises participants in a certain way and generates agency within social life. In other words, the valorisation of Sunniness within the discourse of 'New Turkey' encourages participants to believe certain things and act in certain ways. The culmination of these beliefs and behaviours can broadly be described as Sunni supremacism. This chapter sheds light on the logic of Sunni supremacism. Despite the overall failure of 'New Turkey' in the field of (high) culture and education, one can argue that Sunniness is one realm wherein the hegemonic project of 'New Turkey' has succeeded.

'New Turkey' Rising

If a particular worldview is adopted by the masses and transformed into a 'toolbox' that is then used to perceive and understand the world, then

the hegemonic project has proved successful. Cultural power means that the vision for the future as set out by the hegemonic project is commonly favoured and shared by much of the public. Erdoğan's 'New Turkey' has these qualities. Undoubtedly, the vision of 'New Turkey' has not been there from the very beginning. It obviously developed in a considerably long process. Consequently, the question of when and how 'New Turkey' emerged needs to be answered first.

The early years of the AKP government are often described as a success story in various respects. The economic framework that was originally laid out by the former Minister of Economic Affairs, Kemal Derviş, in response to the 2001 economic crisis, proved to be successful by adhering to Turkey's agreement with the IMF (Gürkaynak and Böke 2013). The democratic reforms implemented in line with the EU accession negotiations in the early and mid-2000s were furthermore portrayed as the reformist years of the AKP (Göle 2012; Heper 2013; Kuru 2009; Özbudun 2006; Yavuz 2009). Towards the end of these early years, the AKP faced the threat of a 'secularist counter-attack' and the closure of the party by the constitutional court. The AKP did, however, win this challenge that initially began with the general staff's e-memorandum on 27 April 2007. Abdullah Gül's success in the presidential election in August 2007 and the so-called Ergenekon (Sledgehammer) trials that were launched against an alleged ultra-nationalist, secularist conspiracy with the help of prosecutors aligned with the Gülen movement were followed by the 2010 constitutional referendum that formally ended the decade-long military tutelage over the civil government. All these steps combined finally liquidated the challenges posed by the remnants of the old Kemalist establishment. Subsequently, a power struggle with the Gülen movement began. Erdoğan emerged victorious from this struggle that approximately lasted from 2011 to 2016, culminating in the coup attempt of 15 July of the same year. In the 2010s, Turkey's political opposition not only comprised nationalist and Gülenist circles; both Kurdish and secularist masses also objected on various occasions.

However, especially after the Gezi Park protests in 2013 and the coup attempt on 15 July 2016, Erdoğan became more authoritarian, thereby incorporating the Turkish nationalist right into his vision of 'New Turkey'. This time, he sought to actively transform the political order in his favour by

establishing an authoritarian presidential system that resulted in a system of one-man rule. This new wave of authoritarianism is also frequently referred to as Turkey's 'authoritarian turn'.

The question of how the AKP came to and remained in power for such a long time has been a perplexing one. Generally speaking, Turkey's long and chaotic 1990s that were characterised by the quick succession of short-lived coalition governments, corruption and mismanagement translated into three severe economic crises, the devaluation of the Turkish lira and an enormous public debt. The AKP that was founded by former cadres of the Islamist Welfare Party (Refah Partisi) came to power in 2002 with the promise of delivering political and economic stability. The party was considered to have abandoned the lines of Necmettin Erbakan's Welfare Party and was celebrated for allegedly reconciling Islam with the principles of democracy and global capitalism. Erdoğan's undisputed leadership and the steps taken towards the EU in this process seemed to herald the emergence of the so-called 'Turkish Model' that was assumed to set an example for the Islamic world. After the collapse of Turkey's centre–right and centre–left governments, whose incompetence had caused the political and economic crisis of the 1990s and early 2000s, the AKP was thought to represent a brand-new conservative movement ready to make peace with the establishment and liberal democracy at a local and global level (Barkey and Çongar 2007; Cizre 2008; Kalaycıoğlu 2007; Özbudun 2006; Somer 2007; Yavuz 2009).

Some authors explain the AKP's success with the party's ability to form 'cross-class electoral alliances' (Öniş 2006, 207). There are also those who associate the strong support for the AKP in central Anatolian provinces with the harsh neo-liberal regulations imposed by previous governments, as well as with the support granted by the AKP to the agricultural sector; the peasant's ballot appears to be an important bargaining chip in the fight for power (Gürel et al. 2019). But the question of how the party has been able to stay in power after turning towards more authoritarian politics (especially during and after the Gezi Park protests) remains in question.

The AKP succeeded in reviving Şerif Mardin's centre–periphery dichotomy (1973) by describing the political conflict as an eternal struggle between the Kemalist establishment/tutelary regime (*vesayetçi güçler*) and the 'true' representatives of the people – namely, the AKP itself. The AKP also successfully

acted as a mediator between the Istanbul-based secularist bourgeois and the pious conservative 'Anatolian tigers' by introducing neo-liberal reforms. As some sort of catch-all party, the AKP furthermore offered a certain degree of social security for the working class, urban poor and provincial voters. In this sense, the AKP cannot be conceived as an 'ordinary' right-wing or centre–right party. Centre–right governments that dominated Turkish political life in the past conflated the Sunni character of the state with the principles of Western secularism without any problems. In this regard, the AKP and the AKP's hegemonic project are different from what we have seen in the past. Some authors emphasise that the authoritarian, neo-liberal character of AKP must be kept in mind (Bozkurt-Güngen 2018), while some claimed AKP's pious conservatism and cultural codes produced authoritarianism in the end (White 2014).

It is also necessary to mention that some claims are quite biased but popular among the Turkish public. After the general election of 7 June 2015, popular conspiracist narratives asserted that 'deep state elements', secular Turkish nationalists (*ulusalcı*) and more pious Turkish nationalist (*milliyetçi*) forces had infiltrated into the AKP and thus corrupted Erdoğan's mind. In this sinister scenario, Erdoğan is almost portrayed as an incarnation of Frankenstein. Another popular and biased narrative depicts Erdoğan as the moderate, open-minded arbiter of democracy who has been constantly harassed, humiliated, and misunderstood by society's secular–Kemalist 'White Turks'. After being constantly attacked (the e-memorandum, the Gezi Park protests, the Gülen-related corruption scandals and so on), Erdoğan finally gave up and changed his path towards a more authoritarian system. The whole story resembles the classical plot of an old Turkish drama from the Yeşilçam era. But except for some AKP supporters, this simplistic and apologetic narrative apparently holds no popular appeal.

Did Erdoğan Fail?

Yet despite his political success, President Recep Tayyip Erdoğan has often lamented about the AKP's failure to attain cultural hegemony (*kültürel iktidar*) in Turkish society.[2] He continuously reiterates that during his tenure a great leap towards building a robust and flourishing economy has been made, and that it was his government that finally succeeded in bringing an end to

military tutelage. He also emphasises the AKP's role in advancing democratic standards in both Turkey and abroad. Yet when it comes to cultural hegemony, the picture remains bleak, and for Erdoğan, there is nothing he can claim as a success. During a welcoming ceremony at Ibn Khaldun University on 19 October 2020, Erdoğan admitted again: 'We know very well that the real power is the cultural one. We have a young population, but we cannot materialise our imagination of civilisation, and I believe that we are still far from establishing our cultural hegemony'.[3]

Reading these lines, one would naturally think that President Erdoğan acknowledges his party's failure in imposing cultural hegemony on Turkish society. Erdoğan is convinced that he won great political victories against the once-powerful secularist bloc, which he believes to be Western-oriented (batıcı), Orientalist, apathetic and have a strong distaste for Islam and the 'Islamic civilisation'. In his view, the secular and Western-oriented *ancien regime* had never dared to challenge the 'Western-imposed' world order, which he considers to be unfair and Islamophobic. Yet under his direction, Turkey has emerged as a strong and independent player on the international stage that is praised by the oppressed nations of the world – Muslim and non-Muslim alike. However, when it comes to the question of what kind of a world the younger generation imagines and wants to live in, he acknowledges the persistence of Western concepts and secular values.

Despite his extraordinary political achievements, Erdoğan remains clearly frustrated due to the lack of enthusiasm that the Turkish masses have shown for his vision of a new Turkey. However, it would be a mistake to assume that the hegemonic project of Erdoğan and the AKP is an utter and total failure. Turkey's political opposition jubilantly hailed Erdoğan's alleged confession of failure to establish his vision of 'New Turkey'. Critics affirmed his defeat in the field of cultural hegemony by pointing out that not a single outstanding artist, writer or thinker has emerged from the AKP's Islamist circles since coming to power in 2002. Over and over again, the opposition indulges in the assertion that there is nothing to worry about in terms of cultural hegemony and the indoctrination of the younger generation. Simply speaking, the opposition confuses high culture (literary products, opera, ballet, painting and the arts) with cultural hegemony in terms of 'naturalising' particular values, norms, ideas and dreams, expectations, interpretations of the world

and the materialisation of particular, normative forms of conduct and behaviour, as framed by Erdoğan's new ruling elite.

In fact, 'New Turkey' successfully reproduces itself through what I prefer to call Sunni supremacism, as posited by Erdoğan and the AKP. In other words, Turkey's new ruling elite successfully asserts cultural hegemony by establishing a particular worldview (values, discourses, visions of the future) stemming from Sunniness and Sunni supremacism.

The Significance of Sunni Supremacism

In 'New Turkey', Sunniness can be thought of as some sort of contract that reinforces a set of advantages and privileges. Through Sunniness, certain ways of seeing (or not seeing), thinking (or not thinking), feeling (or not feeling) and reasoning are being exerted. As a contract, Sunniness also demands the 'signatories' of the contract to remain silent about certain issues. At the same time, it requires participants to react when the material or symbolic dominance of Sunniness in contemporary Turkey is endangered.

What is and defines Sunniness? Is it a single coherent concept? And more importantly, how can we figure out if Sunniness – in terms of providing social, cultural or political capital – is applied in a particular situation? Moreover, when can we talk about Sunni supremacism? I think these questions need to be addressed for a better understanding of how 'New Turkey' is built on Sunniness. The basic assumption of this chapter is that there cannot be a single and encompassing form of Sunniness.

Within the realm of mass media, Sunniness can function as a prohibitory frame for news reporting. According to Erving Goffman, frames function as a 'schemata of interpretation' that allow individuals or groups 'to locate, perceive, identify and label' events and occurrences, thus rendering meaning, organising experiences and guiding actions (Goffman 1974). Much like a parent berating their kids for an act of naughtiness, prohibitory frames are designed pedagogically to demonstrate the rules of good social conduct to the majority. For example, it is quite common to come across reports on, for instance, Alevi houses (repeatedly) being marked with red crosses. The 'red cross' here is actually meant to signify the unbeliever and represents a well-known reference to the past, telling the inhabitants of the so-marked houses to get ready for an imminent pogrom against them. Local news reports on

Alevi, Christian or Jewish citizens being insulted by, for instance, schoolteachers or academics are also quite common. Another typical news story within this category would be reports about verbal and physical abuse encountered by those not fasting during the holy month of Ramadan. Although these news stories portray Sunni Muslims in a negative light, they still interpellate news audiences as not as secular but as Sunni subjects, thereby eliciting the formation of Sunni subjectivities and identities. Yet as Stuart Hall eloquently points out, the question of identity is a 'strategic and positional one' (Hall 1996, 3). Identities 'are constructed within, not outside, discourse' (1996, 4), hence the process of identity formation is non-linear and can result in several different outcomes.

The interpellative effect of Sunniness not only functions in a prohibitory manner, it also teaches the subject about issues they need to feel sensitive about. For instance, the Turkish public is informed that the Head of Parliament rejects the use of the word 'massacre' in the opposition's motion to investigate the 1978 'Maraş Massacre', in which the houses and shops of Alevi citizens were attacked by pious ultra-nationalist supporters of the Nationalist Movement Party (Milliyetçi Hareket Partisi, MHP). Because, in the view of this AKP official, the word 'massacre' is deemed to be vulgar somehow, and therefore has a harmful effect on public values. Yet on another day, people can be seen being prevented from publicly commemorating the 'Sivas Massacre' (also known as 'Madımak Katliamı'), in which thirty-three Alevi intellectuals and artists were burned to death by an Islamist mob in 1993. As an explanation, local AKP authorities declared that the ceremony would stigmatise the pious people of Sivas, and that any commemoration of the 'Sivas Massacre' is Islamophobic because it implies a connection between being Sunni and massacring Alevis.

In public education, Sunniness shows up in religion classes (Din Kültürü ve Ahlak Bilgisi) that are mandatory for all, regardless of faith. Although on the outside these classes seem to be learning about different religions from around the world, they are in effect an education on the official doctrine of Sunni Islam as sanctioned by the Turkish state. As such, one can read religion classes in public education as a ham-fisted attempt by the state to impose Sunni religious culture and moral values on society. Naturally, the official interpretation of what Sunni Islam means shifts alongside changes in the state

elite. Yet, nevertheless, one can argue that Turkey's ruling class actively exerts a 'Sunni hegemony' over Turkish society's subordinate groups (such as Alevis, Jews or Christians) through these lessons.

What all these examples demonstrate is that despite their differing contexts, various forms of Sunni supremacism have similar discursive strategies. At their core, all these discursive strategies have a set of rigid claims and uncompromising, doctrinal views. Actors such as teachers, politicians and media spokespeople work as 'ideologists' who articulate and vernacularise Sunni supremacism within different institutions and arenas of Turkish public life. These actors may have very different (or even contending) interpretations of what Sunniness means. In its most extreme examples, the Sunni supremacist hegemonic order finds its expression, for instance, when representatives of the Sunni state elite refer to the believers of other religions as infidels. Yet not every form of Sunniness supports supremacist ideas of *millet-i hâkime* (Sunnis as the 'ruling class' of the Ottoman Empire) or a belligerent mindset of fighting the 'infidels' (*gavurlar*) and protecting the righteous Sunni belief. A person who either performs Sunniness implicitly or has unconsciously internalised Sunniness through a process of (life-long) socialisation can hardly be compared with a self-professed Sunni supremacist. However, both of them never actually reflect to what degree the world they live in is dominated by Sunnism.

This firm belief in the superiority and privilege of being Sunni equally discredits alternative interpretations of Islam and other religious beliefs. Alternative views and narratives of subordinate groups in Turkish society are either disqualified, made invisible or considered degenerate or misguided. For instance, a well-known tactic of the Sunni state elite (in terms of paternalising and incapacitating the Alevi community) is to call on Alevis to live in compliance with their religious roots or, in other words, to 'live like Hazrat Ali' and thus acknowledge the supremacy of the Sunni way of Islam. Another tactic is to criticise Alevis for not praying and fasting and not leading a religious life according to the standards of a good Sunni worshipper. Reducing Alevi beliefs to the 'love of Hazrat Ali' would alone suffice to illustrate the dominance of Sunni supremacism in Turkey. The ruling class's insistence on describing the Alevi faith only through 'syncretism' (Karakaya-Stump 2016; Dressler 2016) has never been publicly problematised or made subject of critical political debate.

During a meeting of the Istanbul Municipality Council on 16 January 2020, the AKP and MHP jointly rejected a motion that would have granted legal status to Alevi houses of worship (*cemevi*). This example demonstrates how the Sunni supremacist mentality works in everyday Turkish politics. The reasons brought forward by the ruling class to remove Alevi demands for acknowledging the cemevi as a legitimate house of worship from the political agenda are equally revealing: since Alevis are to be considered Muslims, they should pray in mosques.

A striking example for the demonisation of Turkish deists and atheists is the following: in the context of recent debates on the alleged rise of deism among Turkey's younger generation, the head of the Directorate of Religious Affairs, Ali Erbaş, publicly stated on TV that no member of the Turkish nation would ever accept such a 'perverted' belief: 'Let no one slander our nation, our youth. I do not think any member of this nation would respect these perverted thoughts'. Erbaş's words are the norm and not the exception in 'New Turkey'. Similar statements by government representatives, pro-government media outlets and intellectuals and other representatives of the ruling elite can be observed in Turkey on a regular basis.

As one can see, the strategy common to all of these approaches is based upon drawing boundaries between the Sunni majority and 'subordinate' minority groups. This process of constructing boundaries comprises the following steps:

- paternalise and thus incapacitate the Alevi religious community by claiming the prerogative of interpreting the Alevi faith; this includes trying to impose an Alevi belief that corresponds to Sunni interpretations of Islam;
- reject Alevi demands of equality and recognition as related to the right to the freedom of religion and worship (for instance, the recognition of cemevis or the demand to abolish compulsory religious classes);
- demonise non-Sunni Islam;
- dehumanise deists and atheists (see Chapter 4 by Pierre Hecker);
- reject the demands of Christian and Jewish citizens for equality;
- gradually weaken and cripple secular institutions and governmental structures; and
- 'bash' secular lifestyles by portraying them as a non-genuine but foreign and destructive way of life that is a deviation and anomaly.

The Road to Victory

'New Turkey's' hegemonic order is also closely linked to the new political order as it emerged after Erdoğan's victory against the 'old' secularist establishment and the supporters of Islamic cleric Fethullah Gülen. The call for an 'advanced democracy' (*ileri demokrasi*) was only the harbinger of a subversion of Turkey's political system. It was intertwined with popular Turkish right-wing mottos such as the call to 'end the tutelary regime!' (*vesayete son!*), to listen to the 'national will' (*milli irade*) or to bring down the secular cultural hegemony of the 'White Turks' (*Beyaz Türkler*). These slogans were in use around the time when the AKP began to liquidate its political rivals within the state. 'New Turkey' was an expression for the ideal society, for the ideal citizen the AKP wanted to create. Erdoğan often expressed what his 'New Turkey' should look like: a new, religiously devout youth rejecting the principle of equality between men and women; a new type of woman whose dream it is to be a mother and keep the family together (see Chapter 8 by Gülşen Çakıl-Dinçer); an education system in which Ottoman Turkish will be taught; and a new biopolitical agenda that is compatible with the ideals of the Muslim family. Erdoğan echoed old-school anti-communist sentiments when delivering a speech to a massive crowd of supporters in Samsun on 24 March 2018: 'We will not give the right of education to these communists, traitors, terrorist youth'. On another occasion, he accused secular Kurdish politicians of godlessness and Zoroastrianism. Erdoğan seeks to enforce 'New Turkey's' victory by establishing full control over the AKP and the state apparatus. In his 'New Turkey', secular and Western-oriented parts of society, elites and their accompanying lifestyles would be shut off from society, and a new generation of pious Sunni citizens (*dindar nesil*) would rise from the ashes of 'Old Turkey'. The victimisation of pious Sunni Muslims and the hegemony of secularism would come to an end.

Conclusion

In spite of the alleged failure of 'New Turkey's' hegemonic project, the ruling elite has made significant progress on its way to establishing Sunni supremacism as the dominant norm in state and society. The vision of an 'authentic and national' (*yerli ve milli*) Turkey has succeeded in weakening and gradually replacing more 'universal' and 'cosmopolitan' conceptions of the Turkish

nation. On the terrain of state institutions, Turkey's new ruling elite appears to be winning the battle for 'New Turkey'. The national education system, as well as the Directorate of Religious Affairs, function as powerful and efficient mediators of Sunniness in society (mandatory religious education at public schools, de-secularisation of school curricula, strengthening of İmam Hatip schools). The powers and capacities of the Directorate of Religious Affairs (which acknowledges only Sunni Islam and serves Sunni citizens) have been particularly enhanced under AKP rule. This development is flanked by a wide array of prohibitions and restrictions that are apparently directed against secular lifestyles – including, for instance, concerted legal actions against alcohol production and consumption (see Chapter 2 by Ivo Furman). The latter illustrates the attempt of the government to de-legitimise alternative concepts of Turkishness. The Sunni hegemonic project or, to put it differently, the Sunni nationalist perspective is also promoted in the field of popular culture; in particular with the help of pseudo-historical TV series (see Chapters 11 and 12 by Burak Onaran and Caner Tekin respectively). Narratives deemed contrary to the dominant Sunni nationalist narrative are actively excluded from Turkish mainstream media on behalf of AKP-controlled state institutions. The ideological instrumentalisation of the past and the reinvention of Turkish history from a Sunni nationalist perspective is also part of the ruling elite's fight for a 'New Turkey'. The glorification of family and motherhood, the labelling of feminism as a corrupted foreign ideology (see also Chapter 8 by Gülşen Çakıl-Dinçer) and the foundation of 'KADEM-type' civil society organisations for the purpose of preventing potential cooperation between Islamic and secular feminists represent another battlefield in this regard. The AKP and Erdoğan's cultural hegemonic project has taken giant steps towards 'naturalising' its ideological concepts in people's minds and turning particular values, sentiments, ideas, worldviews, expectations and behaviour into a commonly accepted norm.

Notes

1. Reading secularisation as a peculiarity of Western experience and practices of secularism in Muslim-populated societies as an extension of the colonisation of Islam is redundant, and far from understanding the inner dynamics of secularism in these societies. Yet, this is, to a great extent, how secularisation is framed

in 'New Turkey'. A closer look at the Ottoman–Turkish case will demonstrate that secularisation is not some sort colonialist takeover. The 'agents' of secularisation cannot be reduced to mere collaborators or 'compradors' of Western colonialism, and the secularisation in the Ottoman–Turkish case is multifaceted, multilayered and not the work of some alienated statecraft intellectual and anti-religious civil–military bureaucratic elites.

2. I use the term 'cultural hegemony' in the sense meant by Antonio Gramsci in *Selections from The Prison Notebooks*: to maintain political power through ideological and cultural means rather than repressive tools. Winning the hearts and minds of the people through a project that consists of values, norms, ideas, expectations, utopias, a particular worldview and conduct which become common sense and appropriated *en masse*. Erdoğan's hegemonic project ('New Turkey') appears to have succeeded in the attempt to establish cultural hegemony in Turkish society.

3. Over the past few years, Erdoğan repeated almost identical lines on several occasions. In a speech at the Istanbul Stock Exchange on 23 November 2016, Erdoğan stated: 'In the last 14 years, we failed in making success in education and cultural policies . . . this is a self-criticism'. At the Ministry of Culture and Tourism Special Award Ceremony on 9 February 2017, he repeated himself: 'Unfortunately, education and culture constitute the weakest links of the great transformation of our country . . . I am terribly sorry that we did not reach the levels I had dreamt of. This is a self-criticism'. On 26 September 2017, he echoed the same 'self-criticism': 'We could not achieve the desired development in two areas: education and culture'. On 2 April 2018, one more time: 'Achievements are important, but despite this, I couldn't stop making a self-criticism. We failed to reach the level we wanted in [the field of] education and culture'. And finally on 10 January 2019: 'When I look back at the past 16 years, I always lament and sigh about the fact that we haven't achieved enough in the fields of education, culture and the arts'.

Bibliography

Barkey, Henri J. and Yasemin Çongar. 'Deciphering Turkey's Elections: The Making of a Revolution'. *World Policy Journal*, vol. 24, no. 3 (2007): 63–73.

Bozkurt-Güngen, Sümercan. 'Labour and Authoritarian Neoliberalism: Changes and Continuities Under the AKP Governments in Turkey'. *South European Society and Politics*, vol. 23, no. 2 (2018): 219–38.

Cizre, Ümit, ed. *Secular and Islamic Politics in Turkey: The Making of the Justice and Development Party*. London: Routledge, 2008.

Dressler, Markus. *Türk Aleviliğinin İnşası: Oryantalizm, Tarihçilik, Milliyetçilik ve Din Yazımı.* İstanbul: Bilgi Üniversitesi Yayınları, 2016.

Erensü, Sinan and Ayça Alemdaroğlu. 'Dialectics of Reform and Repression: Unpacking Turkey's Authoritarian Turn'. *Review of Middle East Studies*, vol. 52, no. 1 (2018): 16–28.

Gençkal Eroler, Elif. *'Dindar Nesil Yetiştirmek'. Türkiye'nin Eğitim Politikalarında Ulus ve Vatandaş İnşası.* Istanbul: İletişim, 2019.

Goffman, Erving. *Frame Analysis: An Essay on the Organization of Experience.* Cambridge, MA: Harvard University Press, 1974.

Göle, Nilüfer. 'Post-Secular Turkey'. *New Perspectives Quarterly*, vol. 29, no. 1 (2012): 7–11.

Gramsci, Antonio. *Selections from the Prison Notebooks*, edited and translated by Quintin Hoare and Geoffrey Nowell Smith. New York: International Publishers, 1971.

Gürel, Burak, Bermal Küçük and Sercan Taş. 'The Rural Roots of the Rise of Justice and Development Party in Turkey'. *The Journal Peasant Studies*, vol. 46, no. 3 (2019): 457–79.

Gürkaynak, Refet and Selin Sayek Böke. 'AKP Döneminde Türkiye Ekonomisi'. *Birikim*, no. 296 (2013): 64–9.

Hall, Stuart. 'Introduction: Who Needs "Identity"?' In *Questions of Cultural Identity*, edited by Stuart Hall and Paul Du Gay, 1–17. London: Sage, 1996.

Heper, Metin. 'Islam, Conservatism, and Democracy in Turkey: Comparing Turgut Özal and Recep Tayyip Erdogan'. *Insight Turkey*, vol. 15, no. 2 (2013): 141–56.

Kalaycıoğlu, Ersin. 'Politics of Conservatism in Turkey'. *Turkish Studies*, vol. 8, no. 2 (2007): 233–52.

Karakaya-Stump, Ayfer. *Vefailik, Bektaşilik, Kızılbaşlık: Alevi Kaynaklarını, Tarihini ve Tarih Yazımını Yeniden Düşünmek.* İstanbul: Bilgi Üniversitesi Yayınları, 2016.

Kuru, Ahmet. *Secularism and State Policies toward Religion: The United States, France, and Turkey.* Cambridge and New York: Cambridge University Press, 2009.

Lord, Ceren. *Religious Politics in Turkey. From the Birth of the Republic to the AKP.* Cambridge and New York: Cambridge University Press, 2018.

Mardin, Şerif. 'Centre-Periphery Relations: A Key to Turkish Politics?' *Daedalus*, vol. 102, no. 1 (1973): 169–90.

Mills, Charles. *The Racial Contract.* Ithaca, NY: Cornell University Press, 1997.

Öniş, Ziya. 'The Political Economy of Turkey's Justice and Development Party'. In *The Emergence of a New Turkey: Islam, Democracy, and the AK Parti*, edited by Hakan M. Yavuz, 207–34. Salt Lake City: University of Utah Press, 2006.

Özbudun, Ergun. 'From Political Islam to Conservative Democracy: The Case of the Justice and Development Party in Turkey'. *South European Society and Politics*, vol. 11, no. 3–4 (2006): 545–57.

Özgür, İren. *Islamic Schools in Modern Turkey: Faith, Politics, and Education*. Cambridge and New York: Cambridge University Press, 2012.

Somer, Murat. 'Moderate Islam and Secularist Opposition in Turkey: Implications for the World, Muslims and Secular Democracy'. *Third World Quarterly*, vol. 28, no. 7 (2007): 1271–89.

Ünlü, Barış. *Türklük Sözleşmesi: Oluşumu, İşleyişi ve Krizi*. Ankara: Dipnot Yayınları, 2018.

White, Jenny. *Muslim Nationalism and the New Turks*. Princeton and Oxford: Princeton University Press, 2014.

Yavuz, Hakan M., ed. *The Emergence of a New Turkey. Democracy and the AK Parti*. Salt Lake City: The University of Utah Press, 2006.

16

'BECAUSE THEY WOULD MISUNDERSTAND': ROMEYKA HERITAGE AND THE MASCULINE RECONFIGURATIONS OF PUBLIC CULTURE IN CONTEMPORARY TURKEY

Erol Sağlam

This chapter draws on ethnographic research on Romeyka-speaking communities in Trabzon to explore the practices and discourses that configure the contours of public culture in contemporary Turkey. I argue that, through discretion of certain sociocultural differences, Turkish selves navigate across limitations of the public sphere and appropriate Turkish identity in different forms – though without necessarily renouncing these distinctions altogether. This analysis thus attends both to the diverse ways in which Turkish nationalist communities in contemporary Turkey retain sociocultural differences, and how locals use peculiar tactics to manoeuvre across the constraints of nationalist ideology. The chapter thus stresses how the fundamental parameters of public culture are negotiated, altered and yet upheld.

My field research in Trabzon, northeast Turkey, coincided with the run-up to parliamentary elections. Daily interactions and dialogue with local people provided valuable insights into how Turkish nationalist discourses could be widely and fervently circulated by a community that still spoke Romeyka – a variant of Greek with archaic linguistic characteristics. I was particularly interested in exploring how locals reconciled this relatively unknown Greek heritage with their staunch Turkish nationalism, and how this was articulated in public. Invited both as a researcher and as a friend of locals, I attended

numerous political gatherings and observed first-hand how Romeyka was implicated in the configurations of public culture.

At one such meeting, several political candidates presented their agenda. The political party holding this meeting is generally considered centre–left, but is nonetheless closely associated with a modernist Turkish nationalism. At this particular meeting, this nationalism was further intensified, because candidates wanted to appeal to a local community well-known for its adamant, even violent, nationalism (see Demirer and Bakırezer 2009). I was not surprised that the first three candidates, all professional men in their forties and fifties, had a lot to say about the contemporary state of the country. The overall tone was set by the speakers' firm conviction that Turkey's problems were caused by foreign powers and exacerbated by the absence of national unity. This they promised to work for.

However, the last speech, delivered by Hasan, a considerably younger candidate from Tonya, provided an intriguing twist. He deviated from the fervent (and rather conspiratorial) narrative of the preceding candidates, but he also went to great lengths to present himself as a local. Hasan began his speech by indicating that he was from Tonya, a valley to the west, and underlined that, similar to his 'brethren' in Akyaka,[1] he could speak *Rumca* [Greek, Romeyka].[2] He further indicated that he could also speak *Yunanca* [Greek (of Greece)]. However, he added that he could list neither in his résumé, because 'others' would have 'misunderstood'. The room suddenly went silent. I was intrigued. Romeyka was glimpsed, albeit hesitantly. To relieve the tension, the chief of the local party organisation intervened with a joke and Hasan delivered the rest of his speech in Turkish.

Hasan disclosed his ability to speak Romeyka/Greek specifically in Akyaka, where Romeyka is also natively spoken. He did not do so in any other town, and he explicitly indicated his desire to conceal this from a wider audience in order to avoid problems. But what does this brief and hesitant glimpse of Romeyka tell us? Why could Hasan not state that he is fluent in Romeyka and Greek? How are we to comprehend this local belief that outsiders are prone to 'misunderstand' the very existence of Romeyka in Trabzon? Is Romeyka a secret, withheld from a wider public? How does public culture in contemporary Turkey handle, accommodate and represent sociocultural differences that are deemed by subjects to fall outside the contours of Turkish identity?

This chapter draws on ethnographic research in Trabzon, northeast Turkey, in order to explore the configurations of public culture in contemporary Turkey. It does so by attending to the public (in)visibility of Romeyka and argues that public culture in Turkey is structured around a regime of (in)visibility. Based on these theoretical premises, I will examine the existing scholarly field. I will then detail how Romeyka is engaged and represented in public in relation to locals' approximations of Turkish identity alongside the imperatives of Turkish nationalist ideology. Drawing on these accounts, I will show how Romeyka's 'discreet' (Mahmud 2014) public status is implicated in the configurations of (local) public culture, hinting how sociocultural differences are accommodated in different modalities. I will conclude with a discussion on how attending to these discreet forms will enhance our understanding of Turkish public culture, as well as offering us clues about the complex ways in which Turkishness is enacted in everyday life.

Theoretical Outlook

Contemporary scholarly discussions on how identities are enacted in public draw largely on critiques of the Enlightenment tradition, according to which a rigid binary is envisioned between public and private, as crystallised in the widely discussed arguments of Habermas (1991). While the private was associated with the individual (and hence with family/the familiar and intimacy), the public (sphere) was envisioned to be the site within which (unfamiliar) individuals came together as autonomous equals to deliberate (Habermas 1991, 3–4).

Various scholars have challenged the gender and class bias of this bourgeois–male public (Calhun 1996; Göle 1997). Moreover, they have underlined how reducing the public–private discussion to a coherent binary fails to account for the dynamism and multiplicity of subjects' ever-changing sociocultural and politico-economic engagements. Critiques stress how Habermasian articulations of the public fail to grasp the dynamic interplay, transitivity and indexicality of everyday life (see Özyürek 2004), in addition to generating a gap between supposedly private matters and the scope of what is deemed to be political and, hence, public (see Darıcı 2011; Fraser 1990; Gal 2002). In opposition to this holistic and mutually exclusive articulation of the public and the private, conceiving public/private as 'indexical signs' might

help us to grasp how public/private are relationally and contextually adjusted in a dynamic manner, sticking to 'spaces, institutions, bodies, groups, activities, interactions, [and] relations' across temporalities (Gal 2002, 80–1).

Against this background, the arguments raised throughout this chapter do not envision a clear-cut separation between public versus private or 'community vs. individual' (Gal 2002, 77–8). Rather, as 'co-constitutive categories', our articulations of public/private must accommodate multiplicities and heterogeneities that structurally hinder any coherent or holistic conceptualisation according to a 'single dichotomy' (2002, 80–2). The reiterative processes through which these indexicalities are configured, experienced and reorganised must be emphasised. This specific conceptualisation, I argue, might allow us to incorporate evanescent, nested, liminal, 'fractal' and transient relationalities (see Darıcı 2011) alongside the more 'lasting and coercive' ones, such as legal institutions (Gal 2002, 85).

The interplay between public and private should be traced along a continuum that incessantly generates fragmentation across relationalities and destabilises the coherence of such categories – if, indeed, they are in any way coherent. This is especially true with respect to attempts by nation states to draft 'appropriate' frames (Üstel 2004) within which subjects are to (publicly) enact their identities. In this sense, what is to be performed in public and what is deemed private are structured around wider sociopolitical processes that mark/represent these practices as public or private, and around a continuum through which public and private performances are co-constituted as indexical signs.

As I underline here, these configurations incessantly change and rebrand relations across different encounters, as illustrated by Gal's emphasis of fractality and indexicality. Supposedly private spaces, for instance, can instantly be transformed into public settings or vice versa. I can recount the lucid example of how I, as an unmarried man, entered the living rooms of local houses in the Valley and thus triggered the radical reconfiguration of these supposedly private/familial spaces into public sites from which unmarried/young women were to be immediately ejected in line with the local customs around gendered relations.

Furthermore, 'the identities put on display [in public] are shaped by events, persons, and' wider sociopolitical transformations (Shryock 2004, 24).

An exploration of these supposedly coherent identities thus forces the analysis to comprehensively tackle the background and basis of these practices/discourses. This often requires us to explore what is left out and firmly underlines 'how central *not* showing is to the task of public display' (2004, 23 (emphasis in original)). As (national) identities are conventionally 'set in relation [or opposition] to imagined others' (2004, 26), nonconforming sociocultural practices are often rendered invisible or turned into caricaturised depictions. As Michael Herzfeld pertinently underlines, these depictions 'are considered a source of external embarrassment but (they) nevertheless provide insiders with their assurance of common sociality' (Herzfeld 1997, 3).

In order to better understand how ordinary subjects come to occupy idealised positions as prescribed by nationalist ideologies and state praxis, we must attend to processes through which subjects manoeuvre across sociocultural and juridico-political limitations and find imaginative ways to accommodate various elements of their socialities in different forms (Shryock 2004; Herzfeld 1997). The public sphere is 'a stage for . . . performance . . . in which the nonverbal, corporeal, and implicit aspects of social imaginaries are consciously and explicitly worked out' (Göle 2002, 177). In this sense, the public sphere emerges as a key site for the construction and representation of subjects, providing us with insights into how such enactments incessantly redefine public culture.

In this chapter, I explore culture not as a high register of art and 'imaginative work' (Williams 1961, 57) in juxtaposition to mundane, everyday practices and engagements. This would inevitably render invisible the 'processual' dynamism of the term culture (Herzfeld 1997, 3). Rather, drawing on Raymond Williams, I trace culture as 'a particular way of life, which expresses certain meanings and values not only in art and learning but also in institutions and ordinary behaviour' (Williams 1961, 57). As Williams writes, 'the analysis of culture, from such a definition, is the clarification of the meanings and values implicit and explicit in a particular way of life', as well as 'the organization of production, the structure of family, the structure of institutions [. . . and] the characteristic forms through which members of the society communicate' (1961, 57–8). Public culture, in this sense, inherently includes minute, mundane details of 'everyday life' (Highmore 2002)

through which subjects come to forge and enact relations, representations, habitus, values, orientations and institutions.

Methodology and Field

Data used throughout this paper was collected in 2012 and 2015 via an ethnographic study with communities inhabiting a valley in Trabzon, northeast Turkey. I relied heavily on conventional ethnographic methods, such as extended participant observation, note-taking and, whenever I had the chance, unstructured interviews (Brewer 2000; Ingold 2014). To get a better grasp of local socialities, I accompanied local men in their mundane routines and engagements, as well as working in some local businesses.

Historical records indicate that settlements in the Valley emerged in the late sixteenth century as Greek-speaking (Orthodox) Christian villages and gradually Islamised under Ottoman rule. By comparison with other parts of the Antolian highlands, the consolidation of the Muslim majority in the area was completed rather late – by the end of the seventeenth century (Lowry 2009; Meeker 2004). Intriguingly though, this gradual Islamisation of the local population did not lead to the replacement of Romeyka by Turkish, as was the case for other communities across Anatolia, where conversion to Islam was invariably accompanied by the adoption of Turkish. Local communities in the Valley retained their pre-Islamic language, Romeyka, and continue using it to this day.

The geography of the region is inimical to any agricultural activity, even on a subsistence level. Consequently, locals have historically shown a strong engagement in wider politico-economic systems. They have excelled beyond the Valley as scholars, imams, bureaucrats, soldiers, craftsmen and merchants (Meeker 2002). Currently, local communities exhibit a strong allegiance to nationalist–statist ideologies and practise Sunni Islam at diverse levels (Sağlam 2018). The region is notable for the strength of reactionary Turkish nationalism (Demirer and Bakirezer 2009; Biryol 2012). Today, almost everyone in Trabzon ardently claims Turkish heritage and vehemently distances themselves from the *Rumlar* [Greeks], who alongside Turkish-speaking Muslims inhabited the littoral until the 1920s.

But despite this staunch support for Turkish nationalism, locals still speak Romeyka, even though fluency has declined consistently. This decline has

been particularly marked in recent decades, due largely to nationalist education policies, the absence of sociocultural support, stigma around Greek heritage and the migration of speakers to urban centres. Although neighbouring communities are aware of the continued presence of Romeyka, the language has not enjoyed the popular attention or revival attempts that other minority heritages experienced (for example, Armenian, Laz or Kurdish) in the early 2000s.

Indeed, it remains difficult to pinpoint Romeyka to a particular community or site. Although a few scholars have initiated some linguistic analysis (see Sitaridou 2014; Özkan 2013), no scholar has yet analysed how these (Turkish) nationalist communities continue to speak Romeyka and how this persistence configures locals' relations to Turkish identity at large. Attending to Romeyka, I believe, might provide us with clues about the way public culture is constructed and experienced in contemporary Turkey.

Speaking Romeyka and Turkish: How Men Move across Languages

Fatma, a local Romeyka-speaking woman in her fifties, recounted the story of her uncle-in-law [*enişte* in Turkish] who in the 1960s had migrated to France with a close friend, *Maçkalı* Ahmet [Ahmet of Maçka[3]]. Arriving in Paris with little money and no contacts to turn to, *Enişte* and *Maçkalı* somehow ended up in Cadet, a Parisian quarter teeming with Greek tailors. *Enişte* was able to ask for help in Romeyka, and succeeded in landing jobs for both himself and *Maçkalı*. Unaware of what was unfolding around him, *Maçkalı* was curious but kept his silence. When they left the shop, though, *Maçkalı* excitedly asked: 'How smart are you! How did you learn French so quickly?' *Enişte* did not reveal the truth, replying simply, 'I learn quite fast'. I could not figure out whether Ahmet was truly naïve or just playing along.

Much has changed since the 1960s. However, the ambiguity around the public (in)visibility of Romeyka seems to have persisted. The language's invisible and inarticulate status still predominates across the Valley, especially in encounters with outsiders. Many of those interviewed for this chapter recounted childhood experiences of being discouraged from speaking in Romeyka when people from outside the Valley were present. Some old men bragged about how, during the 1960s, their village was the first in the Valley to ban the use of Romeyka and to promote instead the use of

Turkish. They also mentioned how local schools discouraged them from using Romeyka and how teachers, both from inside and outside the Valley, eagerly enforced this.

These accounts were complemented by the local peoples' manifest caution around the use of the language in public, and their ostentatious restriction of it to intracommunal encounters, especially in the presence of non-speakers. In such settings, local men prefer to speak in Turkish. They rarely admit to speaking Romeyka in public, and they do not willingly disclose its persistence in the Valley, especially to visitors. When I tried to interview a number of locals on this topic, even close friends displayed anxiety and aversion toward explicitly reflecting on the language, especially if the voice recorder was switched on. When they got 'caught/exposed' speaking Romeyka, locals would resort to using misnomers, naming the language as *Lazca* (the Laz language)[4] or *Latince* [Latin], even though these languages are structurally different from, and not mutually intelligible with, Romeyka.

For the most part, then, Romeyka is secluded into the (collective) privacy of the community. Nonetheless, it must be underlined here that Romeyka has emerged as the only medium through which matters pertaining to sexuality can be communicated in settings where both men and women are present. This is despite the fact that such matters can be comfortably conveyed in (variants of) Turkish or Romeyka in 'homosocial' (Sedgwick 1985) contexts. Osman, a local man in his thirties, indicated that men, including himself, would not use words that are sexual (such as dick/penis) in Turkish when women are present. And yet he was perfectly comfortable using the Romeyka word [*(i)psoli*] in the presence of women. Similarly, Emine, a housewife in her forties, readily uttered swear words in Romeyka in the presence of non-family men.

For both Osman and Emine, then, Romeyka provided the proximity and intimacy through which the socio-linguistic conventions around the relations between sexes are amended. This is in clear contrast to Turkish, which emerges as the language of the public and of gendered separation. Considering the importance given to the separation of genders in the contemporary Valley, as in the case of women's widely recounted unease at walking across the town centre and by coffeehouses 'under the gaze of men', this meddling of Romeyka in relations between sexes is noteworthy.

In a similar vein, I should underline how political/national matters were almost exclusively discussed in Turkish among men in the Valley. Conversely, local issues (related to, for example, kinship, local incidents and events, or casual dialogues) were commonly discussed in Romeyka or the local variant of Turkish. In public, local men use (or at least strive to use) a relatively clear and standardised Turkish, especially when discussing national matters, such as politics. Turkish enjoys a legal hegemony over formal matters in a wide range of fields (for example, banking, business, registration, bureaucracy, health-care, education and so on). Given this, Turkish seems to be geared toward matters that pertain to the public and national spheres, generating associations between Turkish and public/state. No local, as far as I could tell, has attempted to use Romeyka in their formal engagements, or even to demand such provisions. But whereas Turkish exclusively dominates public dealings, Romeyka continues to be accommodated in villages and homes. This configures it as the language of family/the familiar, community and the village.

Nevertheless, it is important to note that these linguistic markings of public/private are relational and subject to change, dependant on context, intersubjective encounters and customs. In coffeehouses – public sites where men come together every day – standard/local Turkish is used in dealings with outsiders, while Romeyka is used among locals. This highlights the heterogeneity of linguistic practices in the Valley. In all cases, the local Turkish dialect (*Trabzon Türkçesi*) and Romeyka emerge as the more intimate and familiar media of communication. The use of standard Turkish might insinuate a sense of aloofness, femininity and arrogance. Upon learning the fact that I am also from Trabzon, many of those I encountered in the field explicitly questioned why I did not speak like them.

Young men, for instance, retain their local accent, even though they are schooled in, and exposed via the Internet and media to, standard Turkish. This contrasts markedly with young women's prevalent use of standard Turkish. The male preference for the local Turkish dialect should also be considered alongside this performance of genuineness/humility as a masculine ideal, one that is strictly attached to locally embedded languages.[5] It should also be stated that almost all male interlocutors recounted a problematic relation to their Romeyka heritage, with some even hating their own ability to speak Romeyka. Mustafa, for instance, recounted how he refused to speak

Romeyka when he was a teenager. This language was, he alleged, a contravention of his Turkishness.

These attitudes should be considered alongside the negative reactions and discrimination endured by these men beyond the confines of the Valley. Some local men revealed how, during their compulsory military service, they were taunted as 'Greek bastards' [*Rum piçi*] by other soldiers. This prevalent, overwhelmingly male unwillingness to be associated with Romeyka should thus not be thought of solely as a reflection of locals' desire to approximate Turkish identity. In fact, it also results from wider ramifications of the way Turkish identity is enacted in public.

While analysing the status of Romeyka in the Valley, then, it should be noted that the language is largely restricted to intra-communal encounters, marking it as a private and non-public aspect of local socialities and culture. To be sure, Romeyka permeated (intra-communal) socialities across generations throughout the Valley. However, its public representations seemed to have been dramatically obscured. Representing Romeyka in public without generating anxiety and discomfort, especially in the case of men, is virtually impossible.[6] This anxiety and reluctance to associate publicly with Romeyka is no doubt rooted in the Turkish name of the language, *Rumca*, which resonates with Greek culture/heritage and Christianity. Within the nationalist matrix, such elements are the declared antagonists of Turkishness.

The elusiveness of Romeyka for outsiders, then, should be read alongside the collective privacy of the language owing to its sociopolitical connotations. A Turkish nationalist who speaks Romeyka categorically goes against the very matrix of nationalist articulations of identity, which operates through mutually exclusive binaries (Yeğen 2004). Romeyka thus emerges both as a central aspect of local subjectivity and socialities, and as a socio-historically alienated feature of local selves *qua* Turkish subjects. Indeed, use of the language is presumed to hinder locals' Turkishness through its sociocultural connotations around genealogy – that is, it is imagined to be a reflection of an 'innate' Greekness. Romeyka is thus an 'uncanny' (Freud 1919) element of local socialities, since it is both familiar and alienable. It disfigures nationalist imaginary by bringing together two supposedly antagonistic categories, Turkishness and Greekness. Such amalgamations cannot be accommodated within nationalist ideologies. Consequently, the only way for this distinct

local heritage to continue its existence is through a muted, discreet and privatised status.

Romeyka is thus largely restricted to the communally private domain. However, this does not necessarily mean that the language is a meticulously concealed social heritage known only to insiders. On the contrary, like other examples of 'secret information' (Simmel 1906), Romeyka's continued presence is communicated in peculiar ways. A 'correctly conjured public would be able to know and to recognize' (Mahmud 2014, 44) its prevalence in the social life of the Valley communities, even though its explicit representation in public is strikingly absent. Alongside mechanisms that obscure its public invocation, there still seems to be a widespread yet elusive knowledge about its persistence, both inside and outside the Valley. This produces critical ambiguities which local subjects are obliged to navigate. I would thus argue that, in the Valley, Romeyka serves as a mark of communal privacy and intimacy. However, despite this privacy, the language is not fixed and spatial, but rather relational and indexical. This is exemplified by the exclusive use of Romeyka for sexual conversations in mixed gender settings.

This 'privatisation' (Darıcı 2001)[7] of the language for the community is rooted in the very historicity of Turkish citizenship, and the way in which this citizenship configures the public and the political. It is called upon to generate subjectivities, socialities and public culture in line with the imperatives of nationalist ideology. Within this configuration, the entry into the domain of Turkish, alongside the concurrent restriction of Romeyka into communal relations and spaces, also serves to integrate the self into a broader national–modernist project. It does so by maintaining the sole utilisation of Turkish across all public dealings. Turkish thus becomes the language of the public and national, while Romeyka is figured as the language of the private sphere, the community/family and the bearer of communal intimacy.

Publicly silent and unarticulated, Romeyka exists in its *privatised* state in the Valley. Its utilisation, albeit in concealed forms, marks the boundaries of the community by generating intimacy, proximity and affinity. Romeyka is 'conspicuously inconspicuous' (Taussig 1999, 30) in its representational forms – it infuses local socialities, but it is not named in public. Its intra-communal use thus emerges as the sole site of its existence and transmission of local heritage. Even in this privatised form, Romeyka's existence is constantly

signalled via a number of narratives and gestures. It allows locals to manoeuvre dynamically in the social terrain to dodge nationalist suspicions around ancestry and conversion: to admit their heritage but also to distance themselves from it, or even deny the affiliation altogether, all depending on the context.

Configuring Public Culture: What is to be (In)Visible and Why?

Given the context within which local men move across and between Romeyka and variants of Turkish, how are we to understand the configurations of public culture in contemporary Turkey? What does the hegemony of Turkish, and the (collective) privacy of Romeyka, tell us about what is, or can be, accommodate(d) in public, and what is to be silenced? As I argue here, attending to the ways in which local men reconcile their discreet preservation of Romeyka with their staunch Turkish nationalism can help us better comprehend the fundamental parameters of public culture in today's Turkey.

Firstly, Turkish seems to be embedded in contexts in which the topic of conversation is geared toward the public/state, such as locals' official dealings with bureaucracy (for example, municipality or schools) or private/economic institutions (for example, banks). By contrast, Romeyka is left out of the picture both juridically and socioculturally. This tendency is further strengthened by the sole use of (standard) Turkish by local and national media. The public arena thus seems to be foreclosed for Romeyka and the local Turkish variant, which are restricted to more private domains, as in intra-familial and intra-community encounters in villages.

In the case of men, this figuration of the public sphere as a space and network mediated through Turkish, and Romeyka's intriguing relationality to it, pave the way for Turkish to emerge as the language of the public, power/state, the formal and the national. Using Turkish in this context seems to denote one's proximity to the state, embeddedness in public affairs and politics, involvement in national discussions and a reiteration of masculinity. The use of Romeyka, by contrast, seems to be associated with the village, privacy, intimacy, familiarity and communality, locality, femininity and difference. Aggravated further through specific configurations of the citizenship and public sphere during the Republican period, Turkish emerges as the marker of the public, while Romeyka is restricted to private domains via its representational banishment from public entanglements.

It seems that the relationship of local men to Romeyka is plagued by nationalist and statist discourses that they adamantly circulate and participate in. Through their proximity to state institutions and discourses, masculine subjects might have become alienated from Romeyka. This language appears instead as a hindrance to the attainment of Turkishness, which is imagined as a homogeneous and coherent identity with no designated site for heterogeneity or incoherence. Romeyka might imply a certain sense of difference and heterogeneity, which could lead to a minority status outside Turkishness. For this reason, men of the Valley, as subjects who align with and participate in the national(ist) ethos of the state, might have come to view Romeyka as an element of their heritage that needs to be secluded or left behind in their quest to be more proximate to power, the state and Turkishness.

Moreover, many families in the Valley have entrenched interests in the echelons of the local bureaucracy. It would not be surprising if the public visibility of Romeyka might be seen as an element that potentially undermines their embeddedness in a nationalist ideology which views all sociocultural distinctions with suspicion. In order to exist as equals in public, to succeed in economic and political life, to avoid being marginalised as a minority within the country, Romeyka is to be distanced from and rendered invisible in public, while Turkish is embraced and used conspicuously. The Kurds' demands for education in their mother tongue have met with staunch opposition from locals, while allusions that imply a Greek heritage or minority position are strongly rejected. This might also be related to a male estrangement from Romeyka.

An intriguing inter-relationality between subjects thus appears to be the cause of these manoeuvres between Romeyka and different variants of Turkish. Turkish, especially in its standard form, seems to be strictly associated with modernity, politics, higher social status, educational attainment, the public, town/city and one's alignment with national ideals and proximity to power. Romeyka, on the other hand, is associated with villages, the private sphere, intimate relationalities, community, rurality, lower social status and local distinctions that are, at least nominally, at odds with national ideals.

I thus argue that only through a concerted distancing from Romeyka can men be inducted as subjects of Turkish nationalist ideology. To be sure, none of my interviewees explicitly articulated this. And yet, for local men

in particular, a severance of their link to Romeyka remains a prerequisite for their establishment as public subjects. The cost of this configuration is the spectral presence of Romeyka in public, where it cannot be named and can only exist in discreet forms. Turkish subjectivity in the case of men thus emerges through such manoeuvres in a public sphere that is constructed and infused by (statist–nationalist) ideology. This intriguing relation to Romeyka, I believe, generates different paths for subjectivation through which men and women come to occupy positions as subjects (in line with Turkish nationalism) within the Turkish public sphere. The peculiar status of Romeyka also highlights how contemporary public culture is shaped through such manoeuvres and how, in today's Turkey, sociocultural differences are accommodated in different modalities.

Conclusion

This chapter has attended to the contemporary status of Romeyka in order to explore the configurations of public culture in Turkey, and to trace the heterogeneous ways this culture is enacted in diverse sociocultural settings. It has aimed to provide an analysis of how the preservation of Romeyka is implicated in the sociocultural composition of Turkish nationalist communities in Trabzon, and to engage with its discreet public existence. In doing so, this chapter not only constitutes a study of the diverse ways in which Turkish public culture is constructed and experienced; it also provides an ethnographic underpinning to the idea that public culture is idiosyncratically woven together by subjects who delicately and incessantly manoeuvre across sociocultural and politico-juridical possibilities/limitations.

This discreet perseverance of Romeyka among nationalist communities illustrates the complexity of sociocultural and politico-historical trajectories through which contemporary selves and socialities are forged alongside (Turkish) nationalist ideology. In this sense, Romeyka and what it stands for within the modern–nationalist matrix are deeply enmeshed in local socialities and subjectivities as they incessantly induce discretion, abjection, distancing or anxieties. And yet, the strength of the uniform Turkish nationalistic outlook and discourses should not automatically lead us to conclude that all non-conforming elements were renounced or forgotten in favour of a uniform, public Turkish identity. The Romeyka-speaking communities of Trabzon, as

noted above, constitute an example through which public culture is not only forged out of diverse and heterogeneous experiences, but might still accommodate these experiences in different modalities.

Turkish identity thus appears as a constellation of diverse experiences, discourses, reminiscences, disarticulation, tensions, materialities, rituals, corporealities, enunciations and practices that take distinct forms in different settings. Public culture in Turkey can be conceptualised as a by-product of subjects' incessant reiterations, enactments and utterances in their everyday lives. This culture is constructed via multiple negotiations, alterations and manoeuvres through which sociocultural distinctions are managed, communicated and accommodated in different modalities alongside sociocultural, politico-economic and historical alignments.

In this chapter, I have underlined the idiosyncratic ways in which distinctions are accommodated in this configuration. The analysis of Romeyka illustrates how non-conforming, or supposedly 'non-Turkish', aspects of sociocultural structure – namely, 'differences' – are accommodated in different forms and modalities. Moreover, I have stressed the importance of attending to how these local distinctions are related and integrated into localised publics. One of the primary elements of this public culture is its incessant negotiation of what it means to be visible and which representations are to be curtailed.

Notes

1. Due to ethical concerns, I have anonymised all names of research participants and particular sites where participants could be identified with relative ease. Names of significant sites, such as Tonya, Maçka or Trabzon, were not included in this anonymisation.

2. *Rumca*, derived from Roman but historically evolved to denote the language spoken by Orthodox Greeks, is currently used to refer to (Orthodox) Greek-speaking communities of Turkey (and Cyprus), while *Yunan-lı/ca*, coined from Ionnian, denotes the people/language (Greek) of Greece – Ελληνικά [Elliniká]. Rome(y)ika as the autoglossonym also follows the same historical logic, hence, means language of Romans.

3. Maçka is another district of Trabzon situated in the south of the city centre.

4. *Lazca* is a Kartvelian language of the South Caucasus region, spoken by the Laz community in Rize and Artvin, provinces to the east of Trabzon, bordering Georgia.

5. Joan Pujolar i Cos (1997, 96) also makes a similar claim in the Catalan case with regards to the Andalusian accent and its sociocultural implications for masculine subjectivities.

6. Here, it is necessary to underline the differences in the ways in which men and women are appealed to in public, both before and throughout the Republican modernisation (see Kandiyoti 1988; Sirman 2002; Koğacıoğlu 2004), conducted largely through the subjectivation of adult males at the expense of women.

7. In Darıcı's work, Turkey also presents a substantiated articulation of such assumed distinctions by deciphering how the Kurdish youth privatise public spaces. For further information, see Darıcı (2011).

Bibliography

Bakırezer, Güven and Yücel Demirer, eds. *Trabzon'u Anlamak*. Istanbul: İletişim, 2010.

Biryol, Uğur, ed. *Karardı Karadeniz*. Istanbul: İletişim, 2012.

Brewer, John D. *Ethnography*. Philadelphia: Open University Press, 2000.

Calhun, Craig. 'Introduction: Habermas and the Public Sphere'. In *Habermas and the Public Sphere*, edited by C. Calhun, 1–49. Cambridge, MA: MIT Press, 1996.

Darıcı, Haydar. 'Politics of Privacy: Forced Migration and the Spatial Struggle of the Kurdish Youth'. In *Journal of Balkan and Near Eastern Studies*, vol. 13, no. 4 (2011): 457–74.

Fraser, Nancy. 'Rethinking the Public Sphere: A Contribution to the Critique of Actually Existing Democracy'. In *Social Text*, vol. 25–6 (1990): 56–80.

Freud, Sigmund. *The 'Uncanny'*, 2003 [1919], http://web.mit.edu/allanmc/www/freud1.pdf (last accessed 07 November 2018).

Gal, Susan. 'A Semiotics of the Public/Private Distinction'. In *Differences: A Journal of Feminist Cultural Studies*, vol. 13, no. 1 (2002): 77–8.

Göle, Nilüfer. 'The Gendered Nature of the Public Sphere'. In *Public Culture*, vol. 10, no. 1 (1997): 61–81.

Göle, Nilüfer. 'Islam in Public: New Visibilities and New Imaginaries'. In *Public Culture*, vol. 14, no. 1 (2002): 173–90.

Habermas, Jürgen. *The Structural Transformation of the Public Sphere: An Inquiry into a Category of Bourgeois Society*. Cambridge, MA: MIT Press, 1991.

Herzfeld, Michael. *Cultural Intimacy: Social Poetics in the Nation-State*. London: Routledge, 1997.

Highmore, Ben. *Everyday Life and Cultural Theory*. London: Routledge, 2002.

Ingold, Tim. 'That's Enough about Ethnography!'. In *HAU*, vol. 4, no. 1 (2014): 383–95.

Kandiyoti, Deniz. 'Bargaining with Patriarchy'. In *Gender and Society*, vol. 2, no. 3 (1988): 274–90.

Koğacıoğlu, Dicle. 'The Tradition Effect: Framing Honor Crimes in Turkey'. In *Differences: A Journal of Feminist Cultural Studies*, vol. 15, no. 2 (2004): 119–51.

Lowry, Heath. *The Islamization and Turkification of the City of Trabzon (Trebizond): 1461 – 1583*. Istanbul: Isis Press, 2009.

Mahmud, Lilith. *The Brotherhood of Freemason Sisters: Gender, Secrecy, and Fraternity in Italian Masonic Lodges*. Chicago: University of Chicago Press, 2014.

Meeker, Michael. *A Nation of Empire: The Ottoman Legacy of Turkish Modernity*. Oakland: University of California Press, 2002.

Meeker, Michael. 'The Black Sea Turks: Some Aspects of Their Ethnic and Cultural Background'. In *Social Practice and Political Culture in the Turkish Republic*. Istanbul: Isis Press, 2004.

Özkan, Hakan. 'The Pontic Greek Spoken by Muslims in the Villages of Beşköy in the Province of Present-day Trabzon'. In *Byzantine and Modern Greek Studies*, vol. 37, no. 1 (2013): 130–50.

Özyürek, Esra. 'Wedded to the Republic: Public Intellectuals and Intimacy-Oriented Publics in Turkey'. In *Off Stage/On Display*, edited by A. Shryock, 101–30. Stanford: Stanford University Press, 2004.

Pujolar i Cos, Joan. 'Masculinities in a Multilingual Setting'. In *Language and Masculinity*, edited by Sally Johnson and Ulrike Hanna Meinhof, 86–106. Oxford: Blackwell, 1997.

Sağlam, Erol. 'Aestethicised Rituals and (Non-)Engagement with Norms in Contemporary Turkey'. In *Anthropology of the Middle East*, vol. 13, no. 1 (2018): 8–23.

Sedgwick, Eve Kosofsky. *Between Men: English Literature and Male Homosocial Desire*. New York: Columbia University Press, 1985.

Shryock, Andrew, ed. *Off Stage/On Display: Intimacy and Ethnography in the Age of Public Culture*. Stanford: Stanford University Press, 2004.

Simmel, Georg. 'The Sociology of Secrecy and of Secret Societies'. In *American Journal of Sociology*, vol. 11, no. 4 (1906): 441–98.

Sirman, Nükhet. 'State, Village and Gender in Western Turkey'. In *Turkish State, Turkish Society*, edited by Andrew Finkel and Nükhet Sirman, 21–51. London: Routledge, 1990.

Sirman, Nükhet. '*Kadınların Milliyeti.*' *Milliyetçilik: Modern Türkiye'de Siyasi Düşünce*, edited by Tanıl Bora, 226–44. Istanbul: İletişim, 2002.

Sitaridou, Ioanna. 'The Romeika Infinitive: Continuity, Contact and Change in the Hellenic Varieties of Pontus'. In *Diachronica*, vol. 31, no. 1 (2014): 23–73.

Taussig, Michael. *Defacement: Public Secrecy and the Labor of the Negative*. Stanford: Stanford University Press, 1999.

Üstel, Füsun. *'Makbul Vatandaş'ın Peşinde: II. Meşrutiyet'ten Bugüne Vatandaşlık Eğitimi*. Istanbul: İletişim, 2005.

Williams, Raymond, *The Long Revolution*. New York City: Columbia University Press, 1963 [1961].

Yeğen, Mesut. 'Citizenship and Ethnicity in Turkey'. In *Middle Eastern Studies*, vol. 40, no. 6 (2005): 51–66.

17

A POLITICS OF PRESENCE: PUBLIC PERFORMANCES OF ROMA BELONGING IN ISTANBUL[1]

Danielle V. Schoon

In the years following the Gezi Park protests of summer 2013, the AK Party, once hailed as a moderate Islamist party with aspirations to the European Union, has responded harshly to all forms of civil dissent. Meanwhile, state-led urban renewal projects demolish minority neighbourhoods and displace their residents. Paradoxically, Turkish *Romanlar* ('Gypsies') frequently appear in the public realm to represent the government's tolerance of diversity and commitment to minority integration. This raises two important questions: first, why is Turkey's Islamist government invested in representing the *Romanlar* as 'happy citizens'? Second, why do the *Romanlar* accept their role as performers of pluralism, and do such performances result in any tangible benefits for them?

Based on ethnographic fieldwork, this chapter argues that Turkey's *Romanlar* engage in the 'art of presence' via public performance. An analysis of several public events in Istanbul demonstrates how Turkey's urban *Romanlar* engage in public performance as a strategy to make their presence known without explicitly resisting the hegemony of the ruling elite. Public performances simultaneously heighten their visibility and perform their belonging in the here and now, against the ideological and physical distancing that defines their marginalisation.

As in much of Europe, the *Romanlar* in Turkey are associated with the entertainment arts. Their skills in music and dance are admired, while

they are otherwise socially, economically and politically marginalised (see Silverman 2012; see Szeman 2018). Multiple actors in Turkey address this imbalance in different ways, including the *Romanlar* themselves. City-sponsored public performances at festival events, such as *Hıdırellez* and *Kırkpınar*,[2] co-opt stereotypes of dancing and singing Gypsies and sometimes employ *Romanlar* entertainers, thereby bringing them and their public activities under state control. Politically active *Romanlar* and their advocates also recycle stereotypes in order to attract popular interest and insist upon their cultural contributions to Turkish society. Both civil society organisations and the state claim to utilise *Romanlar* performances in order to educate the public, increase *Romanlar* visibility and direct new resources toward their integration.

This chapter analyses the complexity of public performances of *Romanlar* culture in Turkey. Other scholars have contributed insightful and important analyses of *Romanlar* music and dance performance, regarding political or ethnic representation and the education of the public (Seeman 2009), the co-option of *Romanlar* culture by the neo-liberal state (Potuoğlu-Cook 2008; 2010) and the strategic use of *Romanlar* music and dance in the cultural market (Girgin-Tohumcu 2014). This chapter contributes to our understanding by analysing performative moments that appear to be in support of the political status quo. These moments occur in between the music and dancing and appear apolitical or even pandering. However, it is argued that these moments, when analysed in the context of music and dance performance, enact the 'art of presence' through which the *Romanlar* occupy present time and space, from which they are generally excluded. Similarly, via public performance, the *Romanlar* create the conditions for co-presence with members of the political elite, establishing a counter-intuitive and uneasy proximity between the representatives of a conservative Islamist party and the *Romanlar*, a people often associated with public entertainment.

The *Romanlar* in Turkey: A Cultural Difference

While there are officially around half a million *Romanlar*[3] in Turkey today, that number is likely much higher, as the census does not account for ethnic designations and some do not publicly espouse *Roman* identity. They also go by many names (Oprişan in Marsh and Strand 2006, 163) depending on

their location and occupation, and have only recently begun to identify with a global, ethnic *Romanlar* identity, due to the influence of international civil society organisations (CSOs) and other non-state actors (Sobotka in Marsh and Strand 2006, 141–56). Unlike the Armenian, Greek, Jewish, Kurdish and Alevi minorities of Turkey, the *Romanlar* identify first and foremost as Sunni Muslim Turks, and the *Romanlar* designation is publicly proclaimed as secondary (Strand in Marsh and Strand 2006, 100), or as merely a cultural difference rather than an ethnic one. Since the founding of the Turkish Republic, a Turk has been officially defined as a Turkish-speaking Sunni Muslim, thereby subsuming ethnic minorities who fit this model into the majority. In the context of Turkey's ongoing contentious relationship with its Kurdish citizens, avoiding claims to ethnic difference is a strategic move for an already marginalised and vulnerable group.

The *Romanlar* make more complex internal social distinctions. Settled, urban *Romanlar* identify themselves first by their *mahalle* (neighbourhood), then their city and then as Muslim Turks (Mischek in Marsh and Strand 2006, 157–62). Those who have been in Istanbul for several generations distinguish themselves against recent migrants and nomadic groups, which they refer to by the derogatory term *çingene* (Kolukırık in Marsh and Strand 2006, 136). The term can also be used to make claims to cultural superiority or inferiority. For example, the residents of the *Roman* neighbourhood, Sulukule, were ostracised by other Istanbul *Romanlar* because of their association with entertainment houses (*eğlence evleri*). A broader sense of identity has only recently emerged to incorporate European notions of *Romanlar* ethnicity with the influence of civil society organisations. In Sulukule this occurred in 2008, when the municipality targeted their neighbourhood as Istanbul's first large-scale urban transformation project and 'right to the city' activists became involved in their community. However, rather than a dispute over the right to recognition as an ethnic minority, the conflict between the *Romanlar* of Sulukule and the Fatih Municipality (which ultimately carried out the demolition) was wrapped up in ongoing contestations over the gentrification of Istanbul's inner-city neighbourhoods. State-sponsored 'urban transformation' (*kentsel dönüşüm*) projects, particularly in Istanbul, systematically demolish neighbourhoods inhabited by minorities, including Kurds and *Romanlar*.[4] Although the municipali-

ties do not explicitly target minorities for dislocation, their discourse of 'cleaning up' inner city neighbourhoods only thinly disguises underlying discriminatory ideologies and practices.

Stereotypes of the *Romanlar* are rampant in Turkish literature, television, film and public performances, as in much of Europe. At the institutional level, the *Romanlar* experience unequal access to employment and social services. Everyday instances of discrimination manifest as a kind of social and physical distancing. *Roman* neighbourhoods are unofficially segregated and are home to some of Turkey's poorest citizens. As the *Romanlar* in Istanbul often work in the informal sector as flower sellers, buskers, beggars, *hurdacı* and trash collectors, they regularly appear in public spaces, but their interactions with non-*Romanlar* are temporary and mostly entail economic transactions. Identified as different by their occupation, clothing and dark complexion, the *Romanlar* are romanticised as freedom-loving, uninhibited and unhindered by modern life, while simultaneously despised as immoral and dirty. While it is not at all unusual for *Roman* musicians to be employed to play at a Turkish wedding, it would be socially shocking for a *Roman* and non-*Roman* marriage to take place. Similarly, while the *Romanlar* are present in the public spaces of Istanbul, they are ignored, overlooked and shunned, thereby rendered invisible.

Since a new associations (*dernek*) law was enacted in Turkey in 2004, *Roman* associations have proliferated and begun addressing their marginalisation through political and social interventions. These associations cannot be legally defined according to ethnicity and so are often associated with particular neighbourhoods. For example, the Sulukule *Roman* Derneği represented the residents of Sulukule until several years after the neighbourhood was demolished. Such associations are run by *Romanlar* and have successfully increased public attention to issues such as unemployment and discrimination in *Roman* communities (Seeman 2009). They have also engaged the support of non-*Roman* activists in Turkey and other European countries, such as the European Roma Rights Centre (ERRC). Along with the Helsinki Citizens' Assembly and the Edirne Roman Association (EdRom), the ERRC launched a Roma rights project in Turkey in 2008 called *Biz Buradayız!* (We Are Here!) that was meant to collect data about Turkish Roma and combat the invisibility of human rights issues affecting them.[5] (The title of

this project highlights the importance of presence in minority rights campaigns and is addressed further below.)

The AK Party elevated the *Romanlar* issue in the public eye when they declared the *Roman Açılımı* ('Roman Opening') in 2010, promising that the state would henceforth invest considerable resources in improving the situation of Turkey's *Romanlar* in the areas of education, employment, housing and healthcare (see also Gençoğlu-Onbaşı 2012). The initiative was part of the government's Democratic Opening Process (*Demokratik Açılım Süreci*) that would supposedly improve the country's standards of democracy and respect for human rights. Multiple initiatives under this process were directed toward Alevis, Kurds and other marginalised groups (see Chapter 15 by Kaya Akyıldız in this volume). The *Roman Açılımı* ironically involved the construction of state housing complexes for dislocated *Romanlar*, as well as mandates to eradicate the term *çingene* from official usage and the provision of identity cards for Turkish *Roman* citizens. The government also funded programmes to combat drug use and early marriage in Turkish *Roman* communities. The initiative happened to coincide with Istanbul's designation as a 2010 European Capital of Culture, which directed significant resources toward both urban development and cultural initiatives. Istanbul's urban *Romanlar* found themselves in a contradictory yet familiar position, in which their music and dance practices were celebrated as part of Turkey's cultural heritage, while their neighbourhoods were undergoing systematic demolitions (see also Potuoğlu-Cook 2010).

The Gezi Park protests in summer 2013 made it clear that, despite significant investment from European Union (EU)-funded entities for the improvement of Roma rights in Turkey, the politics of Turkish *Roman* identity do not align with an EU agenda. While most other marginalised groups, particularly the Alevis and Kurds, participated in massive, country-wide protests against the AK Party, the *Romanlar* were not only officially absent, but several *Roman* association leaders participated in counter-rallies for AK Party supporters (Schoon in Beck and Ivasiuc 2018, 176). The major exception was the *Roman* hip hop group Tahribad-ı İsyan, which was one of the first musical groups to perform in Gezi Park. Their music became part of the soundtrack of the movement (see Schoon 2014) and tied the demolition of Sulukule to the narrative of urban destruction that fuelled the protests

(see also El-Kazaz 2013). In the years following the Gezi Park protests, state-led urban renewal projects continue to demolish *Roman* and other minority neighbourhoods and displace their residents. Yet, Turkish *Romanlar* frequently appear in the public realm in support of the AK Party. As mentioned above, this article will attempt to answer the following questions: why is Turkey's Islamist government invested in representing the *Romanlar* as 'happy citizens'? And why do the *Romanlar* accept their public role as performers of pluralism, and do such performances result in any tangible benefits for them?

What follows is an analysis of moments from the author's fieldwork[6] that demonstrate that, via the public performance of music and dance,[7] the *Romanlar* create opportunities for proximity and thereby work against the social and physical distancing that defines their marginalisation. Public performances simultaneously heighten their visibility and perform belonging, which can be understood as implicitly political, considering that the *Romanlar* have historically not been treated as full members of Turkish society. Such performances do not undo the forced displacement of Istanbul's *Romanlar* or even explicitly threaten the configurations of neo-liberal and Islamist politics at work in Turkey (see Potuoğlu-Cook 2010). Yet, I argue that the public performance of *Roman* bodies can be read as a kind of 'social nonmovement' that involves the struggle of the poor to survive by quietly impinging on the powerful and society at large (Bayat 2010, 15). Asef Bayat proposes that this 'art of presence' simply involves the appearance of the dispossessed in the very zones of their exclusion (2010, 13). In Istanbul, I have witnessed how *Roman* vendors and beggars are systematically ignored in order to avoid unwanted requests or appeals. Yet, in those same spaces, when *Romanlar* play music or dance, a huge crowd gathers around them and praises them with clapping and shouting. The invisible become temporarily highly visible through public performance.

While Bayat focuses on the social space of the streets and use of informal channels, this chapter expands on his theory of presence to suggest that Turkish *Romanlar* also use formal institutional channels, like officially sanctioned stages or television shows, to make their presence known. I zoom in on two moments that occurred in 2010 and 2012 in between the scheduled music and dancing, in order to analyse the way these public performances

enable co-presence – between performers and audiences, *Roman* and non-*Roman*, but most importantly, between *Romanlar* and the political elite.

A Kiss and a Handshake

Karagümrük is a district that has become home to dislocated *Romanlar* from Sulukule, a neighbourhood in central Istanbul that had for several decades been a local hub for *Roman* music and dance. Families who lived there for generations ran entertainment houses where tourists and locals could drink *rakı*, listen to live music and watch belly dancers, until the houses were shut down by the municipality in the late 1990s. The entire neighbourhood of Sulukule was declared an urban transformation site in 2008. The project was fiercely resisted, not only by the residents, but also by a group of non-*Roman* urban rights activists that called themselves the Sulukule Platform. Despite their efforts, the last house was demolished in 2009, and many of the residents moved to state housing built by the Public Housing Development Administration (TOKİ) in Taşoluk, almost 40km away.

By 2012, the majority of Sulukule's *Romanlar* had left the TOKİ housing blocks because they could not keep up with the utility bills or the distance to travel to and from the city for work. Many settled in or around Karagümrük, just up the hill from the newly built condominiums that had replaced their homes in Sulukule. People who grew up in a tight-knit community now live in apartments that cannot accommodate extended families living together or the use of the streets for their celebrations of weddings and *sünnet*. This, along with the noise regulations of the apartment complexes, has succeeded in moving some *Roman* celebrations to private spaces, such as rented halls.

Outside of local urban spaces such as restaurants, tourist venues and street corners, Turkey's *Romanlar* are widely visible as performers on television shows and festival stages.[8] This represents a broader shift that began in the 1990s, from *Roman* music and dance as professional nightlife entertainment and an informal economic endeavour to *Roman* music and dance as a global commodity (Değirmenci 2011, 120; see also Seeman 2002). In the 2000s, staged performances of *Roman* music and dance increased because *Roman* associations often have their own performance troupes. These events follow the model of folk or cultural performances, with matching costumes

and choreographed dances, and generally utilise *Roman* youth as the performers. They are sometimes co-sponsored by municipalities, which serves to contain the event within designated spaces and the formal economy, while simultaneously demonstrating the goodwill of the city towards its minorities. Prime examples of this include the annual celebrations of *Hıdırellez* and *Kırkpınar*, which have both become city-wide festival occasions in Edirne. A city-sponsored celebration of *Hıdırellez* also occurs annually in Istanbul in Park Orman and includes internationally known musical groups, as well as opportunities to pose like a 'Gypsy' behind photo boards and add wishes to a wishing tree. The informal celebrations of *Hıdırellez* that used to be typical in Istanbul's inner-city neighbourhood streets (particularly *Ahırkapı*), involving street musicians and jumping over fire, have been officially prohibited (although people still partake in such activities) or co-opted by the city.

While *Hıdırellez* and *Kırkpınar* are associated with a festival atmosphere, a more recently adopted *Roman* holiday, International Roma Day, is explicitly political. It was designated as 8 April by the International Romani Union in 1990 and has only been officially celebrated in Turkey since 2010, as *Dünya Romanlar Günü*. While events on this day are also sponsored by municipalities, they are of less interest to the general public. Two *Dünya Romanlar Günü* events were staged in Istanbul in 2012, the first by the Fatih Municipality, the EdRom and the ERRC, at the Fırat Kültür Merkezi in Fatih. The mayor, Mustafa Demir, had been highly criticised for his role in the Sulukule urban transformation project; yet, his name was prominently displayed in several places around the hall. This event was clearly intended to be a public display of the municipality's support of Roma rights in Turkey. The audience for this display was not made up of local *Roman* communities, of which very few were in attendance; instead, visiting Roma rights representatives from Europe were regaled with speech after speech made by local politicians and *dernek* leaders from around Turkey who heaped praise upon the AK Party and repeated, '*Ne mutlu Türküm diyene!*' (How happy is the one who calls himself a Turk!).

About a month later, a second celebration was organised by Kobra Murat, a famous *Roman* entertainer who also designs fashions for weddings and *sünnet*. It was billed as a *Roman Şenliği* (festival) and was held on the shore of the *Haliç* (Golden Horn). This event was also co-sponsored by the municipality

and Mustafa Demir's name was still prominently displayed, but it was to be 'cultural rather than political' (personal correspondence, May 2012), and this time the programme would involve no speeches. Rather, the line-up included a fashion show of designs by Kobra and music by the *Sulukule Roman Orkestrası* and *Sulukule Gençlik Orkestrası*. A large elevated stage had been set up and enormous speakers blared the music at a very high volume. Vendors sold cotton candy and *simit*. Directly in front of the stage was an area for dancing; families had claimed patches of grass further back and were sitting around their portable *mangal*, grilling meat, peppers and *pide*. Some were discreetly drinking *rakı*. Kobra was on the microphone calling out spontaneous praises of *Roman* culture and people. Then, to the shock of the urban rights activists in attendance, he invited Mustafa Demir up on stage and shook his hand and even tried to get him to dance along. I received a text message from one of the urban rights activists in response to this performance that read: 'Isn't it disgusting'.

This move by Kobra echoed one made by Kibariye, a well-known *Roman* singer, when she kissed and flung her arms around then Prime Minister Erdoğan at the opening ceremony of the AK Party's *Roman Açılımı* in 2010. Addressing a large crowd at a sports arena in Istanbul, Erdoğan promised structural reforms for Turkey's *Romanlar* and to provide state housing for them across Turkey's major cities. Afterwards, the ceremony was hailed by the media as a *Dokuz Sekizlik Roman Açılımı* (a Roma Initiative in 9/8), a reference to *Roman* music and the celebratory atmosphere in which the announcement of the initiative was apparently received. Activists were appalled by Kibariye's kiss – they felt that Turkey's *Romanlar* were being duped by the government and roped into a publicity stunt meant for the eyes of the EU. Scholar Gençoğlu-Onbaşi analysed the occasion this way: 'This caricatured image [of the Roma singing and dancing] causes major problems, rendering the elimination of discrimination an even more distant possibility' (2013, 63).[9]

These two moments beg questions about the public display of affection between the AK Party and famous *Roman* entertainers. Why is the AK Party invested in representing the *Romanlar* as 'happy citizens'? The simple answer is that the *Romanlar* do not pose a threat because they claim Turkish and Sunni Muslim identity and do not demand recognition as ethnically distinct or official minorities (see Schoon 2016). A deeper look into this uneasy alliance also suggests that the *Romanlar* are embraced by the AK Party's particular

brand of Islamic multiculturalism (Aktürk 2018) and play into Erdoğan's public persona, the overly masculine patriarch (Korkman and Açıksöz 2013).

Islamic Multiculturalism and Patriarchal Authoritarian Masculinity

The *Romanlar* seem unlikely candidates for the role of 'model minority' under an Islamist party. Their music has long been associated with nightlife, belly dancing, drinking alcohol and illicit activities. They have nonetheless become the public face of Turkey's supposed culture of tolerance (see also Tambar 2014; see also Brink-Danan 2012). Potuoğlu-Cook suggests: 'Against the unresolved Kurdish and Armenian issues, Turkey's Roma represent the pleasant, "safe face" of cultural/political pluralism' (2010, 101). I would add that culture is a safe zone for the representation of *Roman* identity in Turkey, where ethnic and religious differences are referred to as sub-identities, or *alt kimlik*, subsumed under the supra-identity of Turkishness and Muslimness. This has generally been espoused by *Roman* association leaders, who disassociate themselves from the Kurds and emphasise their Turkish Muslim identity (see also Strand in Marsh and Strand 2006). They do not insist on recognition as minorities, but rather on cultural difference, embodied and performed most readily in music and dance, but also associated with particular dress, food and holidays such as *Hıdırellez*, all seemingly apolitical activities.

In an interview with Kobra Murat a few days after his show on the Haliç, he described the *Roman* way of life as happy (*mutlu*), warm (*sıcak*) and nice (*güzel*). He portrayed children playing in the streets, the constant sound of music and neighbours cooking on grills (*mangal*) outside and sharing food, like a village (*köy gibi*). He described the *Romanlar* as natural (*doğal*) and sincere (*samimi*). He said that they genuinely love their children, are easily satisfied with small things and value their social and family life above all else and that, for these reasons, he is proud to be *Roman*. Kobra went on to suggest that other people have many things but are still unhappy because they do not know how to live or how to enjoy life.

> We do not look for more. We just sit in front of our door and eat bread and play *darbuka*. I may not have a bank account or a car, but money cannot buy happiness. We never see problems, we are always smiling. We like art, we are joyful. This is God's gift to us.

He continued to contrast the *Romanlar* with other Turks, suggesting that he cannot trust non-*Roman* people because they are fake (*sahte*) and do not do what they say they will. When asked how things are changing for the *Romanlar*, Kobra answered that they are being socialised ('*sosyalleşiyoruz*') and expected to integrate, which is a danger to their culture. He maintains their culture in the face of this by sharing *Roman* music and dance. 'Non-*Roman* people want to be like us. They come to our concerts because they want to share this joy. We add colour to life. They are starting to appreciate our culture and there is less discrimination'. Kobra goes on to praise the government for finally paying attention to *Roman* issues and for starting a dialogue with them, which never seemed possible before. He was pleased that Mustafa Demir supported the recent concert and that the Sulukule *Roman* Orchestra and Fatih Municipality worked together to make the event happen. He felt it was important that they had the opportunity to express pride in being *Roman*, not just for other *Romanlar* and Turks, but for a global audience (interview, May 2012).[10]

This interview with Kobra Murat reflects similar sentiments expressed by other *Romanlar* during fieldwork about their simple, joyful lifestyle. Rather than attempt to judge the sincerity or the validity of this description of *Roman* culture and critiques of modern life, it is essential to recognise that this kind of representation enters into larger narratives. It is easily assimilated into the AK Party's supra-ethnic Islamic identity, an identity that Aktürk proposes was the main motivation behind the Democratic Openings (2018). Rather than electoral gains, security issues, EU accession, the elimination of the opposition or other explanations, Aktürk suggests that the main thrust of the democratic reform process under the AK Party has been ideological, geared toward establishing a 'New Turkey' and reconceptualising the nation (*millet*) as Islamic (5). Tolerance and multiculturalism are justified using Islamic reasoning and, while discrimination is forbidden in this reasoning, so is mobilisation based on ethnic or racial differences within the Muslim community (6). Like other forms of multiculturalism, cultural diversity is celebrated, but social and political grievances are undermined for the sake of unity. The trend in *Roman* associations to emphasise their Islamic identity and disavow ethnic difference contributes to the discourses and practices of Islamic multiculturalism.

Kobra Murat also emphasises the higher morality of village life when he suggests that the *Romanlar* are satisfied with very little and care more about family and love than money. This has become a common narrative in Istanbul against the backdrop of a rapidly globalising city (Young 2020). The AK Party represents itself as a party of the people, and President Erdoğan often references his humble beginnings in the Istanbul neighbourhood of Kasımpaşa in order to appeal to religious, working-class citizens, particularly rural migrants. This goes hand-in-hand with Erdoğan's public persona as a father figure who emphasises family values and keeps the morality of his citizen–children in check (see Kocamaner 2013). Korkman and Açıksöz suggest that Erdoğan embodies a particular kind of gendered power,

> an innovative synthesis of Islamist and urban tough styles [that] orients his voice and his body language, as well as his particular way of exercising power. With an aggressive, uncompromising and domineering 'personality,' he aspires to act as every citizen's father, brother, and husband. (2013)

In Erdoğan's public treatment of the *Romanlar*, they become citizen–children in need of his protection and moral guidance, so that they are simultaneously infantilised and feminised (Mustafa Demir embodied a similar position as the local representative of the AK Party).

Erdoğan's public acceptance of Kibariye's kiss framed their relationship as familial rather than sexual. Yet, this performance of familiarity does not entirely undo lingering associations of *Roman* women with overt sexuality, especially a public female entertainer who does not wear a headscarf. Kibariye's kiss throws into stark relief the places where the AK Party's efforts towards cultural hegemony actually fail. Erdoğan behaves out of character in this encounter, while Kibariye performs the spontaneous, playful *Roman* without apology.[11] Her unveiled body, already present in pop culture, momentarily also enters the realm of mainstream politics, a zone the *Romanlar* have typically been excluded from.

Similarly, at the festival on the Golden Horn, audience members drank alcohol in a public space, danced freely (a dance that is associated with nightlife) and created a lot of noise. As co-sponsors of the event, it would seem that the Fatih Municipality (the most conservative and religious district of Istanbul) actually sanctioned 'deviant' behaviours. The high visibility and audibility of

Roman bodies in public space was not only tolerated but celebrated. Furthermore, we might interpret Kobra's handshake with Mustafa Demir as tongue-in-cheek, a kind of Bakhtinian carnivalesque[12] reversal akin to those witnessed at the Gezi Park protests (Gruber 2013).[13] Understood alongside Kobra's statement that he cannot trust non-*Roman* because they are fake and undependable, the mayor's side of the handshake is undermined. Kobra may have merely been demonstrating the openness and friendliness that he believes are *Roman* cultural traits; or perhaps he was hoping, as the Sulukule Platform activists did, that Demir would take the opportunity to recognise the value of *Roman* culture and hesitate before demolishing another neighbourhood. However, Kobra's symbolic handshake also successfully, if only temporarily, inverted the power dynamics between Sulukule and the Fatih Municipality.

The Art of Presence

To explain why some *Roman* representatives publicly accept their role as performers of pluralism in Erdoğan's 'New Turkey', this chapter views the occupation of public stages by *Romanlar* in Turkey through the lens of Bayat's concept – the 'art of presence' – which he defines as 'the ability to assert collective will in spite of all odds, by circumventing constraints, utilizing what exists and discovering new spaces of freedom to make oneself heard, seen, felt and realized' (2010, 102). The power of presence, he suggests, lies in its ordinariness, an incremental encroachment by the vulnerable and the marginalised that may eventually result in social change (2010, 88). The power of presence in *Roman* public performances lies in its occupation of space. The *Roman* from Sulukule returned to the city centre, after being dislocated to its margins, where they continue to perform their music and dance.

There is also power in occupying time. Roma in many parts of Europe are depicted as a people without history or as indifferent to the past, living in an eternal present (Lemon 2000, 3). The *Romanlar* of Sulukule insist that they have been in Istanbul since at least the early Ottoman period. The art of presence, then, involves claims to history – a past, present and future. The political power of seemingly apolitical performances lies in their 'here and now-ness', a move that simultaneously asserts claims to belonging (as *Roman*, Turkish and *Istanbullu*) and performs temporary occupations of public space, including the soundscape. When the Sulukule orchestras play their music on

public stages, they reclaim Sulukule, even long after the demolition of the neighbourhood is complete.

Occupying space is not always explicitly counter-hegemonic. Utilising humour and sexual innuendo, public performances can enact carnivalesque inversions of social status without seeming to upset the status quo. Neither frivolous nor without real consequences, these public performances enact *Roman* visibility and audibility on their own terms. Just as 'We Are Here!' denotes a shout that must be heard, *Roman* public performances project sound into public spaces, which reverberates beyond the confines of a designated space and challenges a society that ignores or absents them. Furthermore, music co-constructs the urban landscape in which it is sounded (Papadopoulos in Papadopoulos and Duru 2017, 178).

Roman public performances also create co-presence, which is predicated upon proximity. More than simply representations of culture, the affective experience of music and dance may also serve to lessen the mental and spatial gaps between *Roman* and non-*Roman* Turkish communities. Elizabeth A. Povinelli discusses how the limits of cultural recognition become clear when people are faced with the socially and culturally repugnant. 'They discover that their reasoning and their affect are out of joint: I should be tolerant but you make me sick; I understand your reasoning but I am deeply offended by your presence' (2003, 5). Islamic multiculturalism may be able to assimilate *Roman* Muslims on the basis of a shared faith, but moral judgements about behaviours that are stereotypically associated with the *Romanlar* (as well as a thinly veiled racism) are more difficult to overcome. However, via music and dance, the *Romanlar* create moments of shared pleasure (see Shank 2014, 2–3). As Carol Silverman has argued, *Roman* performance mediates between fascination and rejection (2012, 3–4). Through the enjoyment of music and dance (as Kobra suggested: 'They come to share this joy'), audiences are challenged to replace their feelings of aversion with some sense of admiration or appreciation. Ioana Szeman proposes that Roma public performances in Romania influence representations of the collective 'we' and even work against the citizenship gap. These 'expressions of belonging and cultural citizenship for Roma' insist that the Roma are not only vehicles for the transmission of national culture and folklore, but also have their own culture (2018, 7). Turkish *Romanlar* may hope that audiences would recognise their legitimacy

as full citizens in the Turkish nation and its social imaginary; however, even if audiences fail to recognise the legitimacy of *Roman* belonging, their public performances enact co-presence between segments of society that do not otherwise mingle. Public performances create spaces of possible encounter and opportunities for audiences to recognise the contributions of the *Romanlar* to Turkish society and its cultural heritage. By asserting their physical presence in the neighbourhoods and cities that belong to them, they also assert their symbolic presence in national and global narratives of belonging.

Conclusion

Following Asef Bayat's concept of the 'art of presence', it has been argued that *Roman* public performances occupy the here and now. Their being 'here' is contentious in a city that systematically displaces them from their neighbourhoods and questions their belonging. Their being 'now' works against popular narratives that portray the *Romanlar* as timeless villagers. The author analysed two moments that occurred in between the music and dancing in order to suggest that Kobra and Kibariye, by making use of humour and play, were able to create proximity between the marginalised and the political elite. Not only were they able to enter a zone of politics without appearing to upset the status quo, they also succeeded in garnering the public recognition by the mayor and Turkey's prime minister.

The art of presence does not involve a takeover of the streets, as activists may hope. However, as Potuoğlu-Cook has suggested, the power and potential of cultural performance as a political tool should not be dismissed (2010, 102). Aesthetic practices, Seeman argues, serve to respond to and shape self-understanding and political representation (2010, 207). Similarly, William Washabaugh has demonstrated via flamenco performance that the lack of overt political ideas does not preclude 'embodied politics' (1995, 87). The public performance of *Roman* music and dance plays an important role in their 'becoming political', even though it may not look like politics. This argument does not intend to overemphasise the power of these performances – radical inequalities remain. Yet, Turkish *Romanlar* have been somewhat successful in affecting political and social changes in recent years. In 2015, the *Roman* Özcan Purçu was elected to parliament as a CHP representative from Izmir. *Roman* associations continue to proliferate and impact local policymaking. A

Roman youth movement that is critical of the government has been growing, epitomised by the *Roman* hip hop group Tahribad-ı İsyan. It remains to be seen how the increasing public presence of *Roman* voices and bodies, insisting 'We Are Here!', will continue to shape Turkey's sociopolitical and physical landscapes in the coming years. The implications of the power of presence for other marginalised groups, such as migrants and the undocumented, have recently been discussed by James Ferguson (2015). He proposes that a new politics of distribution would be predicated upon presence, rather than legality or citizenship, because not only is this more practical than trying to determine who 'belongs' where, but 'co-presence, with all of its entailments, is not a political choice but simply the most elementary sort of social fact' (2015, 215).

Notes

1. I extend gratitude to Brian Silverstein, Salih Can Açıksöz, Anne Betteridge, Zehra Aslı Iğsız, Carol Silverman and Özge Demir. My research in Turkey was made possible by the financial support of the Ohio State University Migration, Mobility, and Immobility (MMI) Project Faculty Grant, the Fulbright-Hays Doctoral Dissertation Research Abroad Fellowship, the Institute of Turkish Studies (ITS) Summer Research Grant and Dissertation Writing Grant, several Foreign Language and Area Studies (FLAS) fellowships and many intramural grants from the University of Arizona. Special thanks to Funda Oral for her contributions to this research and translations. Many thanks to Pierre Hecker and Kaya Akyıldız for their helpful edits. Any remaining errors are my own.

2. *Hıdırellez* (or *Kakava*) is a Byzantine era spring festival that was incorporated as an Islamic holiday in Ottoman times, and *Kırkpınar* is the annual oil wrestling festival in Edirne.

3. I use the Turkish *Roman* (singular, or adjective) and *Romanlar* (plural) to refer to Roma in Turkey, as that is the term they use to refer to themselves. I use the more common terms, Roma (sing/pl) and Romani (adjective), to refer to the global Roma rights movement or to refer to Roma living in Europe or when the terms appear in quotes. I do not include an analysis of *Dom* or *Lom* identity politics here.

4. Istanbul's Tarlabaşı neighbourhood, in the Beyoğlu district, is a case in point. It was home to Kurds, *Romanlar* and trans communities for decades, but has been undergoing demolitions since 2011.

5. Their final report can be viewed here: http://www.errc.org/reports-and-submissions/we-are-here-discriminatory-exclusion-and-struggle-for-rights-of-roma-in-turkey.

6. The author conducted ethnographic fieldwork in Turkey in summer 2010, from August 2011 to November 2012, and in summer 2019. Fieldwork consisted of participant observation, interviews and surveys, as well as the collection of relevant media coverage. While the bulk of the research was done in Istanbul, data was also collected in Izmir and Edirne. Fieldnotes and interview transcripts were mined for keywords and repeated themes.

7. When I reference *Roman* music, I mean *Roman havası*, generally in the 9/8 time signature, which became associated specifically with Turkey's *Romanlar* in the 1980s (so that now their music is often referred to simply as *dokuz sekiz*). The dance that accompanies it is characterised by playful hand gestures and rhythmic movements; it usually prescribes footwork for the men and a rocking pelvis, or *göbek atma*, for the women, although gender reversals are also common (see Potuoğlu-Cook 2010; Girgin-Tohumcu 2014). This dance is immediately recognisable as *Roman* by most Turks.

8. Although there isn't room to discuss it in this chapter, another emergent space of *Roman* performance is YouTube, where young dancers can upload and share instructional videos or recordings of their performances, on stage or in their living rooms.

9. More recently, in 2016, at the *29 Ekim Cumhuriyet Bayramı Resepsiyonu*, Kibariye laughingly tweaked Erdoğan's cheek in the presence of his wife, Emine. Although she was criticised in the press following the event, Kibariye reiterated her love for the president and his wife and referred to Erdoğan as '*bizden biri*' (one of us) (https://www.yenisafak.com/hayat/cumhurbaskani-sevgisi-nedeniyle-kibariyeye-cirkin-muamele-2798511).

10. Interpretation from Turkish to English during this interview was by Funda Oral.

11. A few years later, Kibariye met with Ahmet Davutoğlu and afterwards made a public statement of praise that could be interpreted as tongue in cheek (http://www.hurriyetdailynews.com/turkeys-roma-singer-praises-itsy-bitsy-chirpy-pm-for-reform-promises-81334).

12. A carnival atmosphere, Bakhtin suggested, built a 'second world' or 'second life' outside of the official, political and ecclesiastical world (Morris 1994, 197). This double aspect of the world allowed laughter and play to temporarily blur the boundaries between art and life. The carnival spirit in this liminal moment presented the real and the ideal at the same time; it celebrated temporary liberation from the established order; and it marked the suspension of hierarchical rank, privileges and norms. What was unequal became equal; what was central was made peripheral; what was separate became united. This lessened the distance

between performer and spectator, using laughter to mock and deride those in authority in a way that would be prohibited in the real world (1994, 198–201).

13. In the context of the Gezi Park protests, 'chapulling' was reappropriated from a speech made by Erdoğan in which he accused protestors of being marauders (*çapulcu*). To 'chapul' was to fight for one's rights using peaceful and humorous means, and often involved music and dancing.

Bibliography

Aktürk, Şener. 'One Nation Under Allah? Islamic Multiculturalism, Muslim Nationalism and Turkey's Reforms for Kurds, Alevis, and Non-Muslims'. In *Turkish Studies*, vol. 19, no. 4 (2018): 523–51.

Bayat, Asef. *Life as Politics: How Ordinary People Change the Middle East*. Stanford, CA: Stanford University Press, 2010.

Brink-Danan, Marcy. *Jewish Life in 21st-Century Turkey: The Other Side of Tolerance*. Bloomington and Indianapolis: Indiana University Press, 2012.

Değirmenci, Koray. '"Local Music From Out There": Roman (Gypsy) Music as World Music in Turkey'. In *International Review of the Aesthetics and Sociology of Music*, vol. 42, no. 1 (June 2011): 97–124.

El-Kazaz, Sarah. 'It is About the Park'. In *Jadaliyya*, 16 June 2013.

Ferguson, James. *Give a Man a Fish: Reflections on the New Politics of Distribution*. Durham, NC and London: Duke University Press, 2015.

Gençoğlu-Onbaşı, Funda. 'What went Wrong with the "Romani Opening" in Turkey?' In *Turkey and Human Security*, edited by Alpaslan Özerdem and Füsun Özerdem, 56–70. London and New York: Routledge, 2013.

Girgin-Tohumcu, Gonca. 'From Social Stigma to the Ultimate Genre: The Romani Dance of Turkey'. In *Romani Studies*, vol. 24, no. 2 (2014): 137–64.

Gruber, Christiane. 'The Visual Emergence of the Occupy Gezi Movement'. In *Jadaliyya*, 6 July 2013.

Kocamaner, Hikmet. 'Delinquent Kids, Revolutionary Mothers, Uncle Governor, and Erdogan the Patriarch'. In *Jadaliyya*, 5 August 2013.

Korkman, Zeynep Kurtulus and Salih Can Açıksöz. 'Erdogan's Masculinity and the Language of the Gezi Resistance'. In *Jadaliyya*, 22 June 2013.

Lemon, Alaina. *Between Two Fires: Gypsy Performance and Romani Memory from Pushkin to Post-Socialism*. Durham, NC and London: Duke University Press, 2000.

Marsh, Adrian and Elin Strand, eds. 'Romanlar and Ethno-Religious Identity in Turkey: A Comparative Perspective'. In *Gypsies and the Problem of Identities*, 97–104. London: I. B. Tauris, 2006.

Morris, Pam, ed. *The Bakhtin Reader: Selected Writings of Bakhtin, Medvedev and Voloshinov*. London, New York, Melbourne and Auckland: Edward Arnold, 1994.

Papadopoulos, Alex G. and Aslı Duru, eds. *Landscapes of Music in Istanbul: A Cultural Politics of Place and Exclusion*. Bielefeld: Transcript Verlag, 2017.

Potuoğlu-Cook, Öykü. 'Summer of Shame: Displaced Roma in Istanbul, Turkey'. In *Anthropology News*, March 2011.

Potuoğlu-Cook, Öykü. 'The Uneasy Vernacular: Choreographing Multiculturalism and Dancing Difference Away in Globalised Turkey'. In *Anthropological Notebooks*, vol. 16, no. 3 (2010): 93–105.

Potuoğlu-Cook, Öykü. 'Beyond the Glitter: Belly Dance and Neoliberal Gentrification in Istanbul'. In *Cultural Anthropology*, vol. 21, no. 4 (2008): 633–60.

Povinelli, Elizabeth A. *The Cunning of Recognition: Indigenous Alterities and the Making of Australian Multiculturalism*. Durham, NC and London: Duke University Press, 2002.

Schoon, Danielle V. 'Between Global Solidarity and National Belonging: The Politics of Inclusion for Romanlar in Turkey'. In *Roma Activism: Reimagining Power and Knowledge*, edited by Sam Beck and Ana Ivasiuc, 174–96. Oxford: Berghahn Books, 2018.

Schoon, Danielle van Dobben. '"Sulukule is the Gun and We are its Bullets": Urban Renewal and Romani Identity in Istanbul'. In *CITY: Analysis of Urban Trends, Culture, Theory, Policy, Action*, vol. 18, no. 6 (2014): 720–31.

Seeman, Sonia. '"A Politics of Culture": Turkish Roman Music and Dance at the Dawn of European Union Accession'. In *Voices of the Weak: Music and Minorities*, edited by Zuzana Jurkova and Lee Bidgood, 206–15. Praha: NGO Slovo21, 2009.

Seeman, Sonia. *'You're Roman!': Music and Identity in Turkish Roman Communities*. PhD Dissertation, UCLA, 2002.

Shank, Barry. *The Political Force of Musical Beauty*. Durham, NC and London: Duke University Press, 2014.

Silverman, Carol. *Romani Routes: Cultural Politics and Balkan Music in Diaspora*. New York: Oxford University Press, 2014.

Szeman, Ioana. *Staging Citizenship: Roma, Performance and Belonging in EU Romania*. New York and Oxford: Berghahn Books, 2018.

Tambar, Kabir. *The Reckoning of Pluralism: Political Belonging and the Demands of History in Turkey*. Stanford: Stanford University Press, 2014.

Washabaugh, William. 'The Politics of Passion: Flamenco, Power, and the Body'. In *Journal of Musicological Research*, vol. 15, no. 1 (1995): 85–112.

Young, Nathan. *Modernity's Other: Nostalgia for Village Life in Turkey*. PhD diss. The Ohio State University, 2020.

INDEX